Painter IX Creativity:
Digital Artist's Handbook

Painter IX Creativity: Digital Artist's Handbook

Jeremy Sutton

ELSEVIER

AMSTERDAM • BOSTON • HEIDELBERG
LONDON • NEW YORK • OXFORD
PARIS • SAN DIEGO • SAN FRANCISCO
SINGAPORE • SYDNEY • TOKYO

Focal Press is an imprint of Elsevier

Focal Press

The image on the front cover, "Quinn Between" is a portrait of Quinn based on a photograph by her mother, Lisa Evans, taken at a swing dance camp in Mendocino, CA. Quinn is reading her favorite magazine, *Archie's*. You can learn how this was created in Chapter 4.

Acquisition Editor: Amy Jollymore
Project Manager: Paul Gottehrer
Assistant Editor: Cara Anderson
Marketing Manager: Mark Hughes
Cover Design: Eric DeCicco

Focal Press is an imprint of Elsevier
30 Corporate Drive, Suite 400, Burlington, MA 01803, USA
Linacre House, Jordan Hill, Oxford OX2 8DP, UK

Jeremy Sutton
Painter Creativity
465 Utah Street #1
San Francisco, CA 94110
Tel: 415-626-3971
Fax: 415-626-3901
jeremy@paintercreativity.com
www.paintercreativity.com

♾ Recognizing the importance of preserving what has been written, Elsevier prints its books on acid-free paper whenever possible.

Library of Congress Cataloging-in-Publication Data
Application submitted

British Library Cataloguing-in-Publication Data
A catalogue record for this book is available from the British Library.

ISBN: 0-240-80669-7
ISBN: 0-240-80676-X (CD-ROM)

For information on all Focal Press publications
visit our website at www.books.elsevier.com

05 06 07 08 09 10 9 8 7 6 5 4 3 2 1

Printed in China

For my Mum, Margaret Ruth Sutton—thanks for your artistic inspiration and loving support—and in memory of my dad, Maurice Sutton, who lives on in my heart and soul.

Contents

CONTENTS

CONTENTS

Foreword

Each of us is on a personal creative odyssey, seeking a unique expressive voice. For some, creativity is realized through words or music. For others, it is articulated via images. Whatever medium this voice takes, tools are necessary to create the expression. The more flexible the tool, the greater the potential range of expression.

In 1992, I had the good fortune of becoming involved with the creation and development of Painter. Previously, Mark Zimmer and Tom Hedges had written both the groundbreaking Letraset *ImageStudio* and *ColorStudio* graphic applications for the Macintosh. I had been involved with Time Arts *Oasis*, the first Mac application to exploit the expressive pressure-sensitive capabilities of the Wacom tablet. While on our individual, yet remarkably similar quests, we repeatedly crossed paths at various trade shows until our shared vision brought us together. At that point, our individual creative odysseys became one and the result was Painter.

Painter was envisioned to be the ultimate image-making tool enabling personal expression. Mark, Tom, and I were passionate about transplanting the vocabulary of traditional expressive mark-making tools into the digital realm and putting them into the hands of artists. The initial vision of Painter may have been ours, but the users of Painter quickly became participants in the creation of new tools as we sought their input.

Jeremy was among the initial wave of Painter aficionados. I remember seeing him at the 1993 Digital Be-In one evening during Macworld in San Francisco, entertaining the crowds with his soon-to-be famous portraiture sessions. He was using Painter! I was intrigued and watched for several minutes until I got an opportunity to speak with him. His enthusiasm was immediately apparent. He was full of questions about various aspects of Painter's inner workings. It was obvious that he possessed an innate understanding of Painter's expressive tools.

Over the years, Jeremy has been one of Painter's principal goodwill ambassadors. His good-natured enthusiasm has been responsible for launching many on their creative odysseys, with Painter acting as their compass. Jeremy has taken both his enthusiasm and teaching experience and poured it into these pages. And you, now holding this book, are about to be the beneficiary of his efforts. If you are considering starting, or are already on your own creative odyssey, you couldn't be in better hands.

Yes, each of us is on a personal creative odyssey. A bit of experienced guidance goes a long way towards helping us finding our own path. In this book, Jeremy graciously shares his journey with us. If Painter is a compass, this book is the map. Bon voyage!

John Derry
Overland Park, Kansas
January 2005

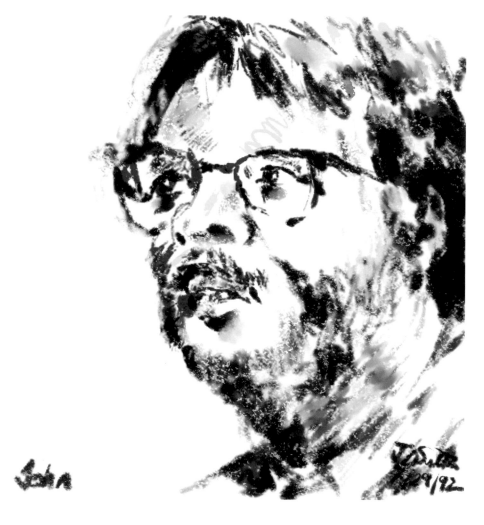

Portrait of John Derry created by Jeremy Sutton (using Fractal Design Painter 2) at the 1992 SIGGRAPH tradeshow in Chicago.

Preface

In casting your inspirational net as an artist, you become familiar with the humility that comes with watching your best-laid plans veer sideways. So, you set out to travel to Rome . . . and end up in Istanbul. You set off for Japan . . . and you end up on a train across Siberia. The journey, not the destination, becomes a source of wonder.

In the end, I wonder if one of the most important steps on our journey is the one in which we throw away the map. In jettisoning the grids and brambles of our own preconceptions, perhaps we are better able to find the real secrets of each place.

—*Loreena McKennitt, from the liner notes of her album* the book of secrets

Welcome

Welcome to the wonderful world of painting on the computer and your continuing journey of creative self-expression. I am honored to be your guide along the way and hope that this handbook acts as an enjoyable, educational, and inspirational catalyst in your life.

The Goal

The goal of this handbook is for you to realize your full creative potential and express yourself in your art with soul and passion.

To achieve this goal you have to become the master of your tools so you are free to fully express yourself. The tools we have at our fingertips for making art now include state-of-the-art digital imaging technology such as Corel Painter IX software and the Wacom graphics tablet. Even with these cutting-edge tools, when we translate our vision onto our canvas we apply the same fundamental artistic principles that have been used by artists throughout history:

1 Overcoming the fears that block creativity

2 Accurate observation and awareness of the world

3 Imagination to generate a story to tell and to envision a goal

4 Use of composition and design to create a balanced, harmonious picture with a focal point and a path for the viewer's eye to follow

5 Use of color, tone, and other contrasts to depict depth, form, and mass

6 Use of color and brush strokes to express emotion, mood, and feel in your artwork.

7 Ongoing, regular practice to maintain, hone, develop, and expand your skills.

8 The confidence and commitment to be true to yourself in your art and to follow your intuition.

These fundamental principles underlie everything in this book and are independent of whatever media you use to make art.

The relationship between the artist and technology follows a long, ancient tradition that has spanned all eras of mankind, from the use of crude painting tools 15,000 years ago in the caves of Lascaux, France; to the use of the camera obscura in the 15th century by Leonardo da Vinci, to the use of early photographic processes by Edgar Degas and many other 19th century painters, through to the use of Corel Painter IX and the Wacom graphics tablet by today's artists. No matter what the tools and technology, the artist creates imagery to be seen, to move others, to convey their vision, to tell their story, to share their interpretation.

My hope is that through use of this handbook your tools will become invisible and the artist in you will be completely empowered.

Who This Book Is For

This handbook is for everyone. It is designed to develop your technical and artistic skills whatever your experience level, whether you're a "never seen Painter before" newbie first-time user who wishes to explore and expand your creative potential or are a seasoned, professional "I live, sleep, eat, and dream Painter" power-user, a professional fine artist, an illustrator, a photographer, a videographer, or a designer who wishes to enhance, personalize, and creatively enliven your professional products and services. Throughout I have included Tips aimed at the more advanced Painter user.

If you have used traditional art media, you will be amazed how natural Painter feels once you get into it and get used to the computer. In fact, you are likely to find yourself getting addicted to this wonderful new medium!

If you are unsure what the computer terms *cursor*, *window*, *icon*, *menu*, and *slider* mean and are unfamiliar with clicking, double-clicking, and dragging with your cursor and locating, naming, opening, and closing folders and files, then please familiarize yourself with these basic computer operations and terminology before proceeding with the exercises in this book. If you are coming to the computer for the first time and feel intimidated, confused, or frustrated by the technology, let me reassure you that you'll do just fine. Take your time with the exercises. Be patient. If something doesn't work, don't panic—just relax, take a deep breath, and stretch. I always find turning every-thing off, taking a tea break, and then coming back to things works wonders for overcoming most problems.

This book is designed to be a textbook suitable for college-level digital art classes as well as for individual study and self-development. I explain everything from the basics without assuming familiarity with Painter.

What You'll Learn

You will learn how to master the amazing paint program Corel Painter IX to create expressive paintings (from observation, imagination, and photography), animations, and collages, and at the same time you will develop your artistic vision and your ability to translate what you see and what you feel onto your canvas. The breadth of material covered in this handbook will be of interest to anyone who wishes to explore and expand their creativity on the computer.

You will find that for some specific technical details and definitions, the best resource to refer to is the standard Painter IX documentation (*Painter IX Getting Started Guide Tutorial* and a very thorough, well-indexed online Help > Help Topics menu). In writing this book I have endeavored to balance thoroughness and comprehensiveness with a focus on practical results and selectively communicating just the information that is relevant to being creative on the computer.

A Personal Approach

In this book I share my personal approach to using Painter. Everything I suggest is based on what works for me. It may work for you, or you may find a better way to do things (in which case, please let me know!). Every artist develops his or her own particular way of using tools. There is no right or wrong way to create artwork. There are no absolute rules. What I share here is one perspective that I hope you will find useful, educational, fun, and inspiring.

This book has evolved from more than 40 years of drawing and painting, from more than 14 years of experience using the computer as my main art medium, and from more than 10 years of teaching Painter classes (online and offline), workshops, and seminars. I am sharing in this book an organized, structured approach to learning Painter that I have found works well. My analytical physics training has influenced my approach to structuring information in an organized and systematic way. My 12 years in professional sales and marketing have helped shape the way I communicate through words and pictures with as much clarity, brevity, and effectiveness as possible.

I encourage you to draw on diverse resources and stimuli, to follow the ways of different artists and different teachers, and then to develop your own unique personal style and way of doing things. Learning from others creates an opportunity to find and express your own voice.

Focus on Creativity

My own lifelong passion for making art has led me to focus this handbook on creativity, rather than simply on learning techniques. Learning Painter, the premier digital art painting tool, is a means to an end, not an end in itself.

Filling a Gap

I wrote this book because I saw a need that wasn't being met by any other resource—a need for a creative empowerment learning tool that balances the yin and yang of art and technology, in other words a book that takes you beyond the tools and techniques into the art and the creative process. For the experienced artist this is a book that expands possibilities and opens up a whole new medium for expression. The beginning artist will find attention paid to the improvised spontaneity of the actual creative process and an overall structure with projects and exercises that helps in mastering both the technical and artistic sides of creating. Understanding and exploring the creative process is particularly pertinent to learning Painter since it is a program ideally suited to experimentation and improvisation.

This book is a tool to develop and enhance your creativity on the computer and is a complement to other Painter books, courses, and resources. This book is not a replacement for the Painter IX User Guide or for other excellent Painter resources. While you will gain a lot of knowledge about the inner workings and subtleties of Painter as you work through the exercises, this book is not intended to cover everything there is to know about Painter.

Unlimited Creative Possibilities

Painter is a wonderful creative tool, and it allows you to express your heart and soul in your artwork. Painter, used with a pressure-sensitive tablet, is a magical medium that opens up unlimited creative possibilities. It is this exciting world that I want to share with you. Creating artwork on the computer offers a wonderful vehicle for accessing your creative potential and learning useful skills that you can apply in other aspects of your life. By overcoming the fears you may associate with digital art tools, you expand and empower your creativity.

Imagine yourself let loose in a magical art studio where you can do exactly what you want without any concern about cleaning brushes, using up precious paper and paint, or clearing up the mess. That is the world you are about to enter. Like Loreena McKennitt says, "the journey, not the destination, becomes a source of wonder." Enjoy your journey of creative exploration. Experiment and take risks. There is no such thing as a mistake or a bad painting. You are not trying to please or impress anyone. Be empowered! Be bold! Have fun and enjoy!

What's New in Painter IX?

Painter IX is the mature big brother of Painter 8 and offers a greater versatility of brushes and vastly improved workflow efficiency, consistency, and stability on every level. If you are in any doubt at all about the value of upgrading from an earlier version of Painter, let me reassure you that there is absolutely no question about it—do it! Listed next are some of the main enhancements and new features in Painter IX.

New Artists' Oil Brush Technology

A new brush category, Artists' Oils, contains wonderful brushes and palette knives that emulate the way colors mix, blend, and streak within the brush stroke in traditional oil painting. (See Figure P.1.)

This technology alone is worth the upgrade to Painter IX. You can now pick up multiple colors in the Mixer (using the new multiple-color Dropper tool) and have those colors streaked into the Artists' Oil brush strokes. With the Artists' Oils Dirty Mode activated, your Artists' Oil brushes pick up color from the underlying canvas as if painting over a still-wet oil painting (wet-on-wet technique).

Significant Digital Watercolor Enhancements

These are now closer to emulating the beautiful watercolor effects originally introduced in Painter 6, but painted right on to the background canvas or image layer, not into a separate special watercolor layer.

Dramatic Performance Increases

The performance increases are particularly noticeable when working on larger files. The Watercolor and Liquid Ink brushes have been dramatically improved in speed (and also the Impasto brushes and

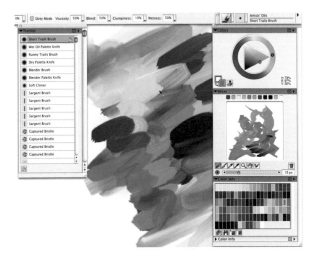

Figure P.1 The new Artists' Oils.

the Liquid Metal plug-in layer), which allows them to be integrated smoothly and efficiently into your creation workflow.

Timesaving User Interface Improvements

Significant improvements to the user interface will save you time and increase your productivity, comfort, and ease of use. The Window menu has been redesigned for ergonomic efficiency, with the palettes and libraries grouped within logical submenus.

Quick Clone

Quick Clone is handy for working with photographs and allows you to achieve in one command what used to take several steps.

Iterative Save

Iterative Save is a helpful facility for documenting your process with sequentially numbered files.

Customizable Shortcut Keys

The Customizable Shortcut Keys allow you now to create your own convenient custom shortcuts for almost any menu item within Painter.

New Boost Slider

The "Boost" slider is in the General Brush Control palette (Window > Brush Controls > General), and it speeds up your brushes. Try it with an Impasto variant such Tapered Flat and watch the difference between no boost and full boost.

Entire Canvas Rotation

The entire canvas rotation and flip feature, available from the Canvas > Rotate Canvas menu, makes Painter IX a powerful tool when preparing your digital photographs for painting.

Snap-to-Path Painting

Snap-to-path is achieved by holding Option-Shift-Cmd/Alt-Shift-Ctrl with a brush in hand (or checking the "brush in a circle" snap-to-path icon in the Brush Property bar) and then, on the background canvas or on an image layer, painting along a vector path. A vector path can be created in Painter using the Pen, Quick Curve, Rectangular Shape, or Oval Shape tools or by acquiring an Adobe Illustrator document. The real benefit of snap-to-path painting is for achieving smooth curves with brushes or for concept artists and the like who bring a vector illustration into Painter and then want to recreate it using Painter's brushes.

Area-Averaging for Zoomed-Out Views

Area-averaging gives quicker and more accurate zoomed-out views.

Improved Tracker Palette

The revised brush Tracker allows you to lock in favorite brushes for future use. The Tracker Palette now has an option to lock variants in the pop-up menu in Mac OS X.

Brush Control Palette Accessible in Painting Mode

The extensive Brush Control palette, which allows you to adjust and experiment with every brush characteristic and property, is now accessible in painting mode as well as within the Brush Creator mode.

Enhanced Color Capabilities

The color capabilities of Painter have been improved all around, from the completely revised Color Management system (Canvas > Color Management) to the redesigned Mixer palette with its improved painting tools and the new default Color Set with its rich colors based on the traditional artists' oil colors.

Improved Layer Capability

Painter IX includes the ability to collapse layers with different merge modes (known as Composite Methods) while preserving the effect of those modes. There is also compliance with industry standards so that channels, masks, mask editing tools, and keyboard shortcuts are, on the whole, consistent between Painter and Photoshop.

And More

The improvements listed here are just a selection of what is new in Painter IX. Other new features include return of the Triangle Cursor and cursor options, support for multiuser environments (such that each user can have his or her own customized Painter settings) and frames-per-second control for replay of Frame Stack animations.

What's New in the Wacom Intuos3 Tablet?

The Wacom Intuos3 pressure-sensitive graphics tablet represents a significant leap forward in the areas of tablet sensitivity and ergonomic and workflow efficiency. This new generation of tablets allows you to work more comfortably and productively.

Higher Resolution

The Intuos3 tablet coordinate resolution is 5080 lines per inch (lpi), or 200 lines per millimeter, a significant increase in sensitivity over earlier models, which were typically 2000 lpi or less.

Improved Stylus: Three Nib Types Included as Standard

The Intuos3 Grip pen (stylus) has 1024 levels of pressure and is supplied, as standard, with three types of nibs: Standard, Stroke (spring-loaded), and Felt. The Stroke nib, my favorite, has a softer, more

flowing, and more responsive feel than the Standard nib. Wacom also offers an Airbrush and Inking pen as accessories.

Tablet Keys

The customizable Tablet Keys allow you to perform frequently used functions and keystrokes with your nonfavored hand while holding the stylus with your favored hand (Figure P.2). The Tablet Keys can provide quick and convenient access to tools such as the Grabber Hand or Dropper tool in either Photoshop or Painter.

Touch Strip

By sliding your finger over one of the customizable Touch Strips you can scroll, zoom, or perform other custom keystroke actions (Figure P.2). All Intuos3 tablets except the smallest (4❸5/A6) come with Tablet Keys and Touch Strips on both sides of the tablet to suit right- or left-handed people. The 4❸5/A6 tablet has the Tablet Keys and Touch Strip on just the left of the tablet's active area.

Customizable Pop-Up Menu

Tool buttons can be assigned to show a customizable pop-up menu for convenient access to functions and commands.

What's New in this Book?

This handbook includes much new exciting content, both technical and artistic. I summarize here just a taste of what's to come.

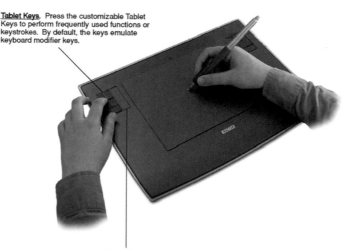

Tablet Keys. Press the customizable Tablet Keys to perform frequently used functions or keystrokes. By default, the keys emulate keyboard modifier keys.

Touch Strip. Slide your finger over the Touch Strips to zoom, scroll, or perform custom keystroke actions. By default, the Touch Strips enable you to zoom in most graphics applications and to scroll in other applications. You can also set them to issue custom keystrokes.

Figure P.2 The new Tablet Keys and Touch Strip.

Incorporation of the New Features of Painter IX and the Wacom Intuos3

This book has been completely rewritten since the Painter 8 edition, with inclusion of all the relevant new features and capabilities that have been introduced with Painter IX and the Wacom Intuos3 technology.

Revised and Improved Structure

The structure and flow of the chapters has been improved. The material is broken down in a way that makes learning easier. Tips have been introduced throughout the book so that it is easier for you to adapt your reading to suit your level of experience with Painter.

New Visual Glossary

Following the Acknowlegments you will find a visual glossary of every brush category supplied with Painter, plus the Jeremy Faves 2.0 brush category that comes with the Painter Creativity Resource CD (at the back of this handbook). This visual glossary is designed as an at-a-glance quick reference to help you locate brushes with the look and feel you are seeking.

New Chapter on Brush Customization

An entirely new chapter has been introduced in this handbook: Chapter 3, "Foundation III: Brush Creation." This chapter takes you through different ways to create your own unique custom brushes and how to save and organize them for optimum efficiency.

New Techniques

You will find newly researched techniques employing the latest developments in Painter and also incorporating ways to use the strengths of Painter and Photoshop in tandem (an example of this is the new Watercolor Sketch Technique in Chapter 4). Projects and assignments have been revised and improved.

New Artwork

I have created fresh new artwork especially for this edition. In addition to my own work, you will see inspiring recent artwork by students who attended my Painter Panache workshops and also by selected guest artists.

New Custom Brushes

You can take advantage of a whole new set of brushes in the Jeremy Faves 2.0 brush category on the Painter Creativity Resource CD that accompanies this book. You'll find instructions for loading these and other Painter goodies on the Read Me file on the CD and in Chapter 1. The Jeremy Faves 2.0 category includes new unique custom brushes, created especially for this edition, that you won't find anywhere else. These brushes alone are worth the price of admission!

PREFACE

The Journey Ahead

This book is divided into four parts and twelve chapters.

PART I FOUNDATIONS

Chapter 1—Foundation I: *Getting Started*

Chapter 2—Foundation II: *Creative Empowerment*

Chapter 3—Foundation III: *Brush Creation*

PART II PHOTO TECHNIQUES

Chapter 4—Photo Techniques I: *Pastel, Watercolor, and Oil*

Chapter 5—Photo Techniques II: *Printmaking and Mosaics*

Chapter 6—Photo Techniques III: *Adventure in Collage*

PART III PAINTING FUNDAMENTALS

Chapter 7—Painting Fundamentals I: *Tune In*

Chapter 8—Painting Fundamentals II: *"Muck Up"*

Chapter 9—Painting Fundamentals III: *Refine and Focus*

Chapter 10—Painting Fundamentals IV: *Replay*

PART IV PAINTING MASTERY

Chapter 11—Painting Mastery I: *Color*

Chapter 12—Painting Mastery II: *Being Yourself*

The first three "Foundation" chapters get you set up for action, give you an overview of the technical aspects of Painter, get you into good habits, equip you to make the most of Painter's amazing brushes, and lay the foundations for everything else that follows. For the intermediate to advanced Painter user, I recommend skimming the first two chapters and getting your teeth into the brush customization of Chapter 3. For Painter "newbies," I recommend taking a deep breath and working your way through the first two chapters, probably skipping Chapter 3 until you are more familiar with Painter (that's up to you. I just know how overwhelming it can be at first). Though the first three chapters are weighted more on the technical side than the creative, they provide you with the solid grounding from which you will be free to soar as an artist. The time you invest up-front in technical and organizational matters, such as customizing your palette arrangements, loading extra brushes, and deciding on a consistent naming methodology, will pay big dividends down the road and help make your art creation experience all the more fun and productive. Even the great Renaissance artist Michelangelo had to devote time and effort to mastering his tools and developing his artistry. As he explained, "If people knew how hard I worked to get my mastery, it wouldn't seem so wonderful at all."

The three chapters on Photo Techniques get down to specific techniques for transforming your photographs into paintings and collages. As with all the case studies I share in this book, my Photo Technique examples are intended to give you a basic methodology to follow, not to be used as a rigid recipe. The Photo Technique chapters are more technique oriented than art oriented, though I include artistic concepts and thinking in all that I share.

The Painting (Fundamentals and Mastery) chapters are the heart and soul of this book, and I recommend you take the time to look through those chapters and try out the exercises, whatever your area of interest. All the artistic principles of the Painting chapters apply equally to working from photographs and to painting directly from observation.

At the end of the book you'll find three appendices: a project checklist with useful reminders, a troubleshooting guide, and a summary of handy keyboard shortcuts. There is a comprehensive index designed to help you quickly and efficiently locate and cross-reference topics. The index also serves as a glossary, leading you to definitions of different terms used. The Contributors List includes contact information and, where applicable, Web sites.

Notation and Terminology

This book is cross-platform, that is, suitable for both Macintosh and Windows users. In this book Mac commands precede Windows commands. For instance, the keyboard shortcut for Edit > Undo is Cmd/Ctrl-Z. This abbreviation means Macintosh users hold the Command (Cmd) (or Apple) key down and click once on "Z," whereas Windows users hold the Control (Ctrl) key down and left click once on "Z." Where a series of steps differs significantly between platforms, I have provided separate sets of instructions for the Macintosh and Window platforms. Some of my suggested file names include periods, such as the use of the reverse date notation YY.MM.DD. Windows users should ignore the periods or replace them with dashes. The only period in a Windows file name should be the one immediately prior to the file format tag, such as ".rif".

For simplicity I refer to *folders* (rather than *directories*) for both the Mac and Windows. Occasionally the names of some items or folders I refer to may be abbreviated or capitalized on Windows systems.

There are several occasions when I refer to the Painter IX application folder; this means the folder called Painter IX installed on your hard drive when you install Painter.

I use the ">" symbol to indicate that you need to drag from one item in a menu to another, as in Effects > Tonal Control > Adjust Colors. I also use the ">" symbol in the context of brushes, to indicate the brush category followed by the brush variant within that category, as in Artists > Sargent Brush. Spelling and grammar follow American English (e.g., *color* instead of *colour*). Generally, I use the Painter User Guide conventions for terminology and capitalization and have abbreviated Corel Painter IX to "Painter," and Adobe Photoshop CS to "Photoshop."

There are two units commonly used to specify resolution:

ppi, pixels per inch, specifically refers to digital files, which are made up of pixels. This unit is used as the default in programs like Photoshop and Painter.

dpi, dots per inch, comes from the printing industry and refers to the density of dots of ink per inch on a printed surface. It is a characteristic of a printing device.

For clarity, in this book I use ppi when referring to pixels and dpi when referring to a printed image.

Since this book was written prior to the release of the final Painter IX master, there may be small differences between the interface and variant names you see referred to in this book and what you see on your computer screen.

Screen Captures

The screen captures were captured on a Macintosh computer with system Mac OS X. The precise look and feel of the icons and the interface may differ slightly on other Macintosh operating systems and on Windows PCs.

Photo and Artwork Credit

Unless otherwise stated, I have created all the artwork and photography that appear in this book.

What You'll Need Besides This Book

This is what you need to get going and dive in to the wonderful world of Painter creativity!

Computer (Required)

Either Mac OS X (version 10.2 or higher, highest best) with Power Macintosh G3 or higher or Windows 2000 or Windows XP with Pentium II, 200 MHz or higher (most recent OS highly recommended for either platform to maximize performance and reliability)

128 MB RAM minimum (the more the better)

24-bit color display (Windows users please make sure your computer is set to 32-bit color display, not 16-bit)

1024 ❸ 768 screen resolution

CD-ROM

125 MB hard drive space for minimum installation (at least 1 GB free space recommended)

Corel Painter IX Software (Required)

If you have an earlier version of Painter or have Painter Classic (shipped with Wacom tablets), upgrade to the most recent version of Painter. Painter IX users keep an eye out for any upgrade patches on the Corel.com Web site.

Pressure-Sensitive Tablet and Stylus (Required)

A graphics tablet with a pressure-sensitive stylus (the name given to the pen you hold) is essential to harnessing the computer as an art tool. Many aspects of brush behavior in Painter are controlled by pressure. I highly recommend the Wacom Intuos3 6❸8/A5 tablet for overall comfort and convenience (an alternative is the Wacom Cintiq, which is a combined display screen and tablet). Visit the Wacom Web site (www.wacom.com) to ensure you have the latest driver suitable for your tablet.

Mirror (Required)

Small self-standing table mirror for self-portraits. You will need to be able to place this mirror next to your computer screen so you can conveniently look from the mirror to the screen.

Notebook/Sketchbook (Recommended)

This means a spiral-bound or hardback sketchbook for writing notes and sketching. Also feel free to write in the margins of this handbook. I encourage you always to keep a notebook close at hand when using Painter. When you come across questions, write them down in your notebook. When you find a particular brush variant or paper texture you really love, make a note of it. When you come across a problem, note down the exact sequence of events leading up to it and the content of any error messages that appear. You will find these notes an invaluable source of reference information at a later date.

Besides using your notebook for written notes, I encourage you to use it for sketching from nature. This will help develop your drawing skills and complement the exercises you do on the computer as part of this course. Jot down quick sketches, scribbles, and doodles of scenes or people that catch your eye. Don't worry about details or perfection.

A Good Chair (Recommended)

Invest in a comfortable chair with good lower-back support and adjustable height, angle, and arm rests. A comfortable chair frees you up to be creative. I was amazed at the difference it made when I invested in a Herman Miller Aeron chair (there are many other models and makes of chairs—best to try them out and see what feels best).

Seven Ways to Make the Most of this Book

1. Make Stuff!

Don't just read this book. Use this book interactively as a guide and stimulus to make stuff. Try out the exercises as you go. The more you do, the more you practice, the more art you make, the more you learn and the more fun you have.

2. Be Bold

Be bold and take risks. There's no such thing as a mistake. You won't break the computer!

3. Let Go of "Masterpiece Mentality"

The exercises in this book are intended to help you learn and develop. The works of art you create along the way are studies, byproducts of the learning process. They are not intended to be finished masterpieces. Let go of the "masterpiece mentality," which is the inner critic that says everything you do has to be a masterpiece. Accept whatever emerges on your canvas for what it is—a study, nothing more, nothing less.

4. Work with Others

Team up with others who are interested in being creative on the computer. Work through the book together, comparing experiences, asking and answering questions (there's no such thing as a dumb question), constructively critiquing each other's artwork, and encouraging and inspiring each other as you go. Create personal goals like making portraits of your loved ones. Create communal goals like mounting a group exhibition of your paintings when you complete the book. Learning to critique your own and others' work is a powerful tool for self-improvement. By seeing what works and doesn't work, you'll continually be able to grow and develop your skills. Be supportive and nonjudgmental of each other and yourself.

5. Visit the Companion Web Site

I invite you to visit the companion Web site for this book, paintercreativity.com. There you'll find articles, tutorials, resource links, artwork, and updates. You can also join my mailing list from the Web site, to be kept informed of my future publications, classes, and so on. If you wish to see more of my Painter artwork, then please visit my online art gallery at jeremysutton.com.

6. Persevere

If you find yourself getting frustrated with a painting or with your computer, take a break, even a short one, and return to it later. Don't give up or panic. There is great power in perseverance.

7. Have Fun!

All of the preceding is academic unless you're having fun, and with Painter it's difficult not to have fun.

Bon Voyage!

Enjoy your journey into creative expression on the digital canvas.

Happy painting!

By the way, your feedback and comments are always appreciated. I strive to make every edition of this book better than the last, and your suggestions do make a difference. Please e-mail your suggestions and feedback—what you liked most and least, and why, and what you'd like to see in the next edition—to <jeremy@paintercreativity.com>. Many thanks.

Acknowledgements

Thank you to all my students over the years who have been the inspiration and motivation behind this book. Thank you to everyone who contributed to this book, including those who kindly modeled for my portraits, those who generously provided artwork, allowed me to share their custom brushes, and those that shared specific techniques. You will find a list of contributors at the back of this book.

Thank you to my family for your support and encouragement. Debbi and Mum—thank you for your excellent art critiques and suggestions.

Thank you to Lisa and Quinn for your love and inspiration (as well as for being the photographer and model behind the front cover image).

Thank you to John Derry for writing the foreword and sharing your personal creative odyssey.

Thank you to Sean Young, Rick Champagne, the whole Corel Painter IX Team, Wes Pack, and everyone else at Corel who has contributed to creating an outstanding product and have been so supportive in this project, answering all my questions and always being supportive and encouraging.

Thank you to Will Reeb, Jim McCartney, Kelly Ann Schroeder, Mark Mehall, and everyone else at Wacom who have been so supportive over the years and have provided wonderful graphic tablets that have been the key to harnessing the computer as an art tool.

Thank you to my editor, Amy Jollymore, and everyone at Focal Press, including Christine Degon and Cara Anderson, for your outstanding efforts and support in seeing this project through from inception to completion, and for doing such a great job designing, producing, and publishing this book.

COREL® painter™ IX

Congratulations to author Jeremy Sutton, a Corel Painter Master, for producing *Painter IX Creativity: Digital Artist's Handbook*. Jeremy's art serves as inspiration, and his book is an invaluable resource for professional photographers, commercial designers and artists at all levels. It is an exceptional handbook for learning and mastering Corel Painter IX. Jeremy has worked closely with the product team at Corel to ensure readers have the information they need to reach their creative ambitions. He has also provided invaluable input during our development cycle and continues to be a valuable resource and representative for our users. Thank you Jeremy and Focal Press for producing another fantastic edition of the *Painter Creativity* handbook!

The introduction of Corel Painter IX—the world's most powerful Natural-Media painting and illustration software—reflects Corel's commitment to understanding and meeting the diverse needs of artists by providing a product that both delights and inspires.

Corel Painter IX features unique digital brushes, art materials and textures that mirror the look and feel of their traditional counterparts. It takes digital design to unprecedented levels with the revolutionary Artists' Oils Painting System, Snap-to-Path Painting, Quick Clone for photographers, and brushes that perform up to 10 times faster than in previous versions. Corel Painter enables some of the world's most accomplished creative professionals to extend their natural talents and techniques to create original works of breathtaking digital art.

While you enjoy Corel Painter as your digital art studio, you may also be interested to know about another Corel product, Paint Shop Pro, for your digital image-editing needs. Paint Shop Pro continues to set the standard for affordable, professional image editing. Version 9 builds on the Paint Shop Pro legacy of creative innovation, delivering a new suite of art media features, professional photo-editing tools, and precision graphic design capabilities.

To find out more about Paint Shop Pro, as well as Corel's other graphics products, please visit **www.corel.com**

Nick Davies
General Manager, Graphics
Corel Corporation

Other graphics products available from Corel:

Visual Glossary

To give you a taste of the amazing diversity of Painter's brushes I have made a series of small paintings, shown here with short comments below them. Each painting was created using just the variants from one brush category. Some brushes, like the Blenders, do not add color to the canvas but move paint already on the canvas. The images for these brushes were created by painting over other paintings. I refer to variants by their main names but ignore the numerical size–related appendages, such as "30" in Variable Oil Pastel 30. At the end of Chapter 1 I expand on my comments and suggestions about some of the brushes (the Cloners, Impasto, Image Hose, Liquid Ink, and Watercolor). Treat these pictures as a convenient guide to the types of brushstrokes you can expect from each category, though not as a substitute for exploring and experimenting with the brushes on your own. You'll be amazed at what gems you discover when you do!

Acrylics

These are brushes with a fine bristle structure. My favorite variants in this category are the Captured Bristle, for a tight oil paint look, Glazing Acrylic, for subtle colorizing, and Wet Acrylic and Wet Soft Acrylic, for a rich, bristly, oily look.

Airbrushes

There is a lot of variety within the Airbrushes. I like the Digital Airbrush variant for straightforward, soft airbrushing and the Graffiti variant for its tilt-sensitive spray of paint.

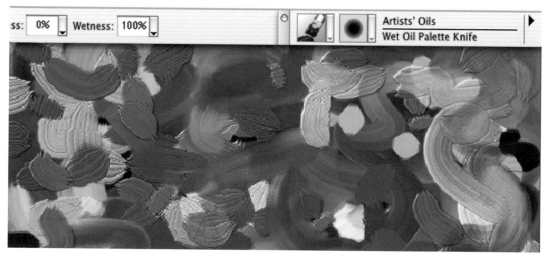

Artists' Oils

Great brushes that mix in streams of color, pulling from color already on the canvas. Also nice oily palette knives. My favorite variants are the Blender Palette Knife and Wet Oil Brush.

Artists

The Impressionist and Sargent Brush variants are "must try" brushes. The Sargent Brush is one of my all-time favorites.

Blenders (Applied to the Artists Painting)

These are great brushes for blending color already on your canvas. My favorite Blenders include Grainy Water and Just Add Water with very low opacity and soft pressure, and Runny and Smear for luscious oily edges.

Calligraphy

As the name suggests, this type offers some good variants for calligraphic handwriting. Dry Ink is good for a spontaneous Sumi-e style of gesture painting.

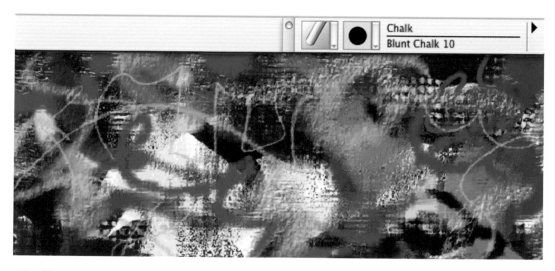

Chalk

Large Chalk (soft-edged) and Square Chalk (harder-edged) are my favorite variants. Both are good for showing paper texture.

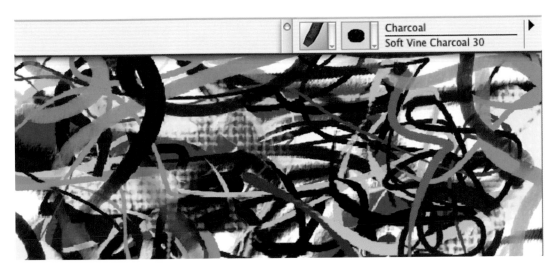

Charcoal

These are similar to the Chalks. The Charcoal variant has nice, grainy edges.

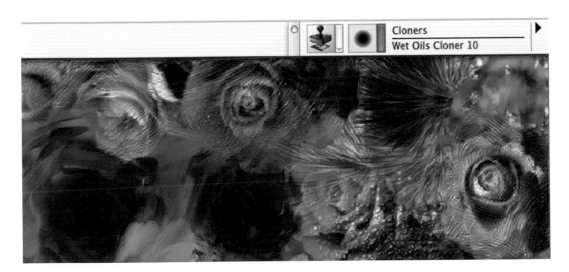

Cloners

All these variants take color from the clone source, which by default is the current pattern (Window > Library Palettes > Show Patterns) or which can be your own photograph. An incredible range of variants from the funky Fiber Cloner and Furry Cloner to the wet Watercolor Run Cloner (watch out—this one creates a watercolor layer) and subtle Soft Cloner.

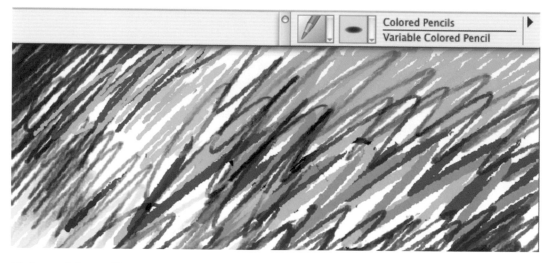

Colored Pencils

These are good for simple line work. Most variants are the buildup method (except the Cover Color Pencil), meaning they are translucent brushes that show through what's underneath (therefore light colors don't show up on top of dark colors), and they build up to black, not to a pure saturated color.

Conte

The Square Conte and Tapered Conte offer very nice, grainy effects. Some overlap with Chalks and Charcoals.

Crayons

Grainy brushes with heavy build-up to black. My favorite is the Grainy Hard Crayon variant which creates a thick dramatic textured brush stroke.

Digital Watercolor

This is one of those categories you just have to explore. All the variants can produce wonderful effects, either on your background canvas or on a regular image layer. Though they do not create a special layer like the Watercolor or Liquid Ink brushes, some Digital Watercolor brushes only affect other Digital Watercolor brushstrokes (for instance, with Salt).

Distortion (Applied to the Crayons Abstract)

These are great brushes for distorting, blending, and bending what is already on the canvas. My favorites include the classic Distorto (add a little opacity for an interesting oily brush stroke) and Confusion, for a watercolor fringing effect. Just experiment with these and have fun!

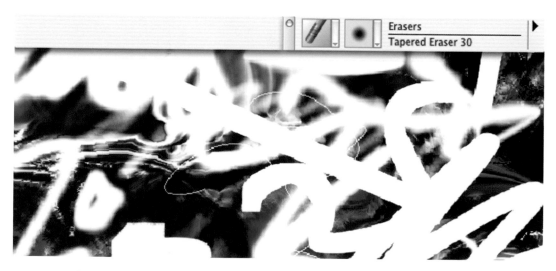

Erasers (Applied to the Distortion Painting)

This category is a mix of variously shaped erasers, bleaches, and darkeners. I tend simply to paint with white when I need white, rather than use erasers.

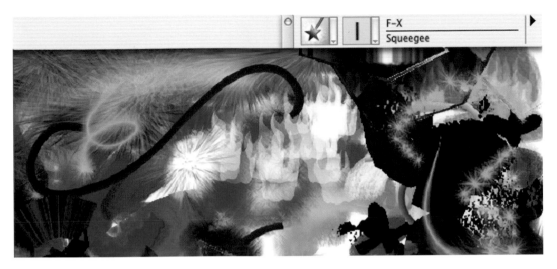

F-X

A bunch of bizarre and wild effects worth exploring. Where the word Gradient is mentioned in a variant title, such as Gradient Flat Brush, the brush uses two colors (from the regular and additional color swatches of the Colors palette) and alternates between the two, dependent on pressure.

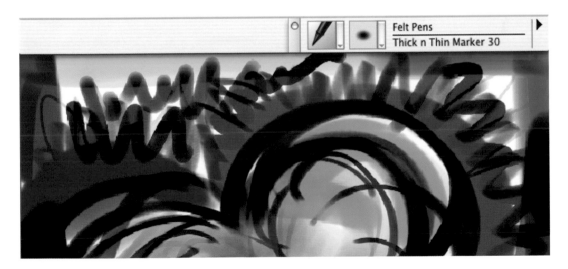

Felt Pens

These are bold, dramatic, translucent brushes. Design Marker is good for the big lines, and Thick and Thin Marker (particularly the largest) is better for filling in color.

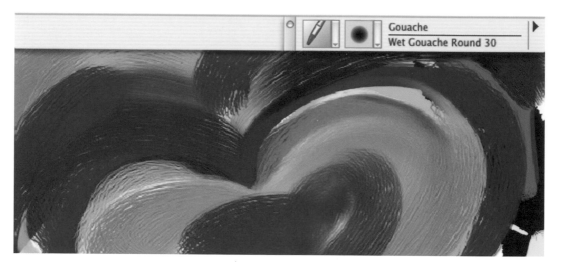

Gouache

Luscious, bristly brushes. My favorite variants in this category are the Fine Round Gouache and Wet Gouache Round.

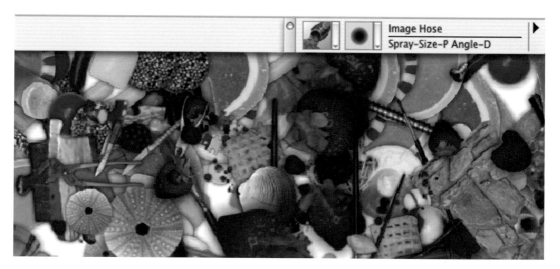

Image Hose

The Image Hose is unlike any other brush. Instead of adding, moving, or removing paint from your canvas, the Image Hose is a device for delivering a string of images. These images are arranged in sets called *nozzles*. The library of nozzles is accessed through the Nozzle Selector in the lower right corner of the Tools palette. The Image Hose variant choices determine the way the images emerge as you paint (size, orientation, and placement on the canvas).

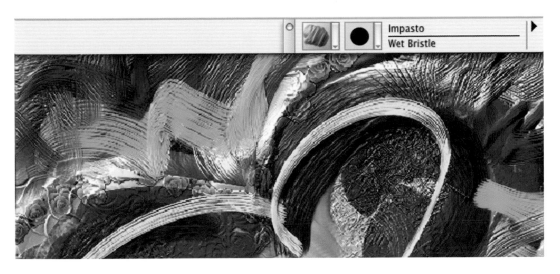

Impasto

Impasto is a traditional art technique, meaning thick paint. The Impasto brushes endeavor to overcome the inherent flatness of a two-dimensional digital image. The result can sometimes be pleasing, sometimes distracting. Impasto depth, which acts as if it is a separate layer, can be turned on and off via a small purple star "bubble gum" icon on the upper right of the canvas window.

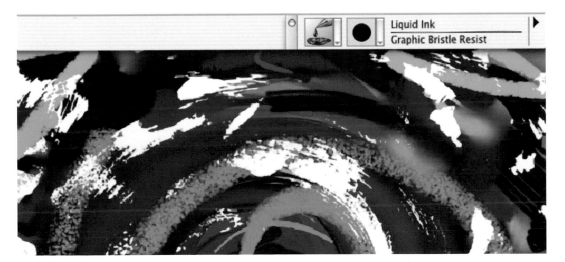

Liquid Ink

Liquid Ink brushes paint into a special Liquid Ink layer, which is generated automatically when you use one of these brushes (and which you can see in the Layers palette). To use a brush from another category after using a Liquid Ink brush you need either to drop the Liquid Ink layer (flatten your image) or to select the Canvas in the Layers palette. These brushes have a nice graphic feel, especially when you apply any of the resists, which give an effect similar to the way waxy crayon resists water-based paints. I like the Smooth Thick Bristle, Graphic Bristle Resist, and Soften Edges and Color variants.

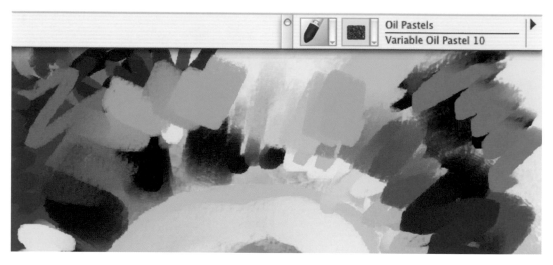

Oil Pastels

These are wonderful grainy brushes that have a nice way of mixing and blending color as they paint. My favorite variant in this category is the Variable Oil Pastel.

Oils

These brushes are close to the Acrylics in look and feel, though I find the Oils somewhat softer. I like the Thick Wet Oils variant for its smoothness and subtle blending and the Glazing Round for its gentle coloring effect.

Palette Knives (applied to the Oils painting)

These provide some different ways to move paint around. The Sharp Triple Knife gives an interesting decorative way to embellish an image.

Pastels

Very similar to the Chalk, Charcoal, and Conte, the Pastels offer some nice variations of grainy brushes, such as the Square Hard Pastel and Square X-Soft Pastel.

Pattern Pens

Pattern Pens are brushes whose behavior is filtered by the current pattern, which sometimes spews the pattern out in a continuous stream for the duration of the brushstroke. With the right pattern or combination of patterns, you can get some great results. My favorite variants in this category are the Pattern Chalk, Pattern Pen Soft Edge, and Pattern Pen Transparent.

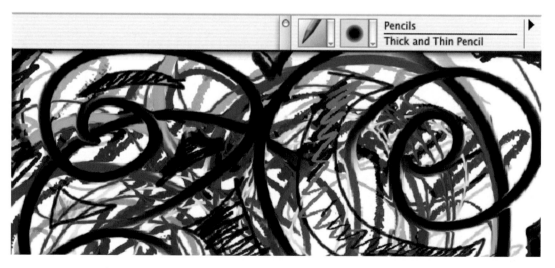

Pencils

Pencils behave rather like thin charcoals or chalks, except that they are buildup-method brushes that build up to black rather than cover up with pure saturated color. A couple of Pencil variants I particularly like are the Grainy Variable Pencil and the Greasy Pencil.

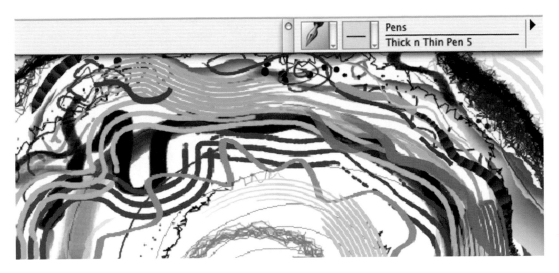

Pens

There is a wide variety of pen-like mark-making implements. Two of my picks are the Nervous Pen and the Leaky Pen, both aptly named.

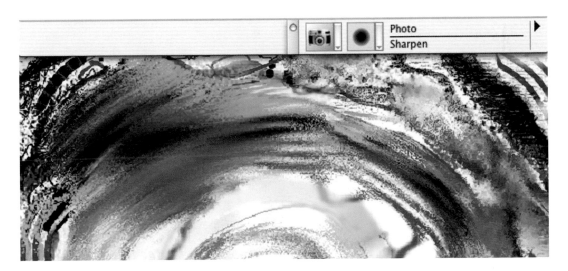

Photo

Named because of their application of to photographs, the Photo brushes include many variants you may wish to apply to painterly images. I often end a portrait with a little Dodge (lightens highlights) and Burn (darkens shadows). The Diffuse Blur gives a nice oily blending effect.

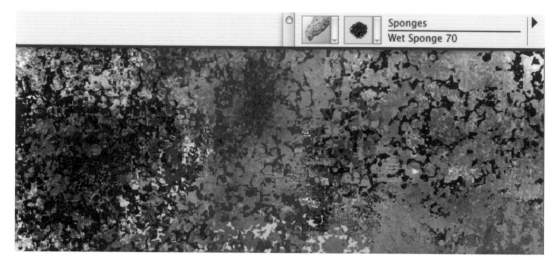

Sponges

The Sponges, as the name suggests, act like absorbent sponges loaded with paint that you dab on or drag over your canvas. I like the way you can build up overlapping organic structures with varied colors and create an almost Impressionistic visual mixing of color. I use the the Sponge variant most, though I also like the Glazing Sponge.

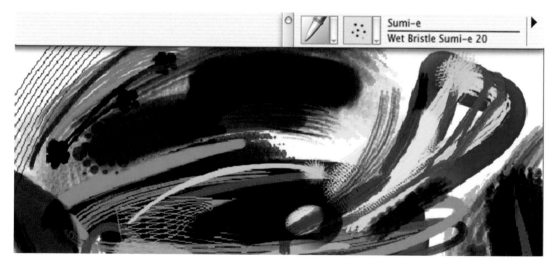

Sumi-e

I have to make an in-book confession here. I had previously neglected these wonderful Sumi-e brushes, and now that I've made the effort to explore them I find I love them! There's something fresh and spontaneous about the way they respond and the brushstrokes they make. It's difficult to single any out because they work so well in combination. The Coarse Bristle Sumi-e is good for building up background, Digital Sumi-e adds a thin rake effect, and the Thin Bristle Sumi-e adds an interesting flower-like artifact at the ends of each brushstroke.

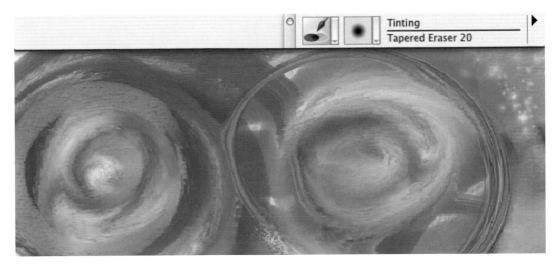

Tinting

These comprise a useful collection of brushes for both painting and blending. The Blending Bristle and Bristle Brush are good for brushwork, while the Diffuser2 is unbeatable for a rich diffusion of paint into the canvas.

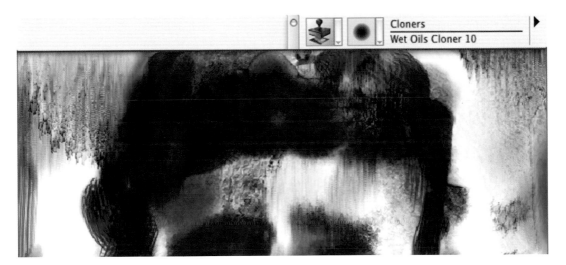

Watercolor

These Watercolor brushes embody many characteristics of "real-world" watercolor in the way the paint runs, drips, fringes, and diffuses into the paper. Though I can't highlight specific favorites, I like the way they work in combination. Like the Liquid Ink brushes, Watercolor brushes paint into a special Watercolor layer that is generated automatically when you use one of these brushes (and which you can see in the Layers palette). To use a brush from another category after using a Watercolor brush, you need either to drop the Watercolor layer (flatten your image) or to select the Canvas in the Layers palette.

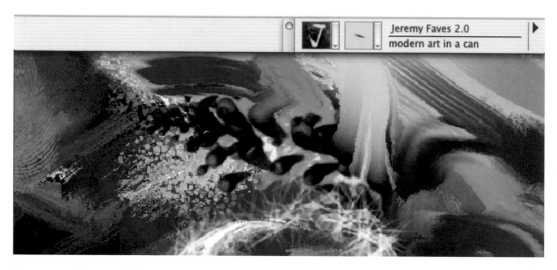

Jeremy Faves 2.0

You won't find this category installed with Painter IX. It is contained on the companion Painter Creativity Resource CD at the back of this book (loading instructions included. The brushes in this category are all favorites of mine. They include my pick of the best brushes from earlier versions of Painter (such as the classic Big Wet Luscious) and some custom brushes made by me and by others who have kindly given their permission for me to share their wonderful creations with you (such as the all-time super-favorite Den's Oil Funky Chunky, made by Denise Laurent of London, UK).

I

Foundations

Foundation I: *Getting Started*

Every child is an artist. The problem is how to remain an artist once he grows up.

—*Pablo Picasso*

1.1 Introduction

The journey we are embarking on is to unleash your full creative potential, the potential in all of us that Picasso alludes to in his quote. We start this journey with the Fundamentals, building up a solid foundation from which to grow. The first two Fundamentals chapters cover essential knowledge and skills. The third Fundamentals chapter covers advanced brush creation and customization, not essential but ultimately useful if you wish to fully realize your creative potential.

This first chapter introduces you to Painter and guides you through some initial setting up and getting to know the "where to" and "how to" for basic operations, such as opening a new canvas, selecting a brush, changing color, clearing your canvas, saving your image, and so on. The chapter concludes with an exploration of some types of brushes that can confuse the first-time Painter user.

By the end of this chapter you'll be familiar with the Painter interface and you'll be comfortable choosing, applying and controlling the brushes, which are at the heart of Painter.

1.2 What's This Thing Called "Painter"?

In a Nutshell

Corel Painter IX is a phenomenal image creation program, with the richest variety and versatility of brushes available anywhere, as well as offering powerful special effects, pattern-making, and animation capabilities and industry standard text, layers, channels, and masking. Painter is a valuable tool for fine art, photography, and all forms of image manipulation, design, illustration, collage, and video. Whatever your application, the key to Painter's magic is the ability it offers to apply brushstrokes by hand (using a graphics tablet with pressure-sensitive stylus), as opposed to just applying uniform special effects (though Painter has many great special effects that may be successfully incorporated into a final image). Through the use of your hand you express your heart in your art.

The brushes are at the heart of Painter's uniqueness and strength. Some brushes emulate traditional natural media, such as chalks, watercolors, and oils, while other brushes create unique effects that don't exist outside Painter in the "traditional," nondigital world. There are so many brushes that come with Painter that they have been divided into 33 groups, or types, known as *categories*. Within each brush category is a collection of individual brushes known as *variants*. See the Visual Glossary at the front of this handbook to get an overview of the variety of brush looks available in each category.

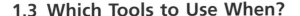

1.3 Which Tools to Use When?

Painter and Photoshop—Your Foundation Tools

Corel Painter IX, your digital art studio, is an essential part of your digital imaging toolkit and is a perfect complement to Adobe Photoshop CS, your digital darkroom. These two foundation tools, Painter and Photoshop, are primarily bitmap programs; that is, they deal primarily in imagery composed of pixels (though there are resolution-independent text and vector shapes in Painter). Besides these two great tools, you may also find it useful to have a good graphics drawing program with powerful vector-based drawing and text capabilities, such as Adobe Illustrator, CorelDRAW, or Macromedia Freehand. I have outlined here the main digital workflow tasks you might come across as you work on a digital image and shared my opinions as to which tools are best suited to each task. There is some overlap in functionality between all of the programs mentioned, and consequently there are many alternative ways to accomplish the same task. There are no hard and fast rules here, and you will find many different approaches to workflow. Do what works best for you and what you're most comfortable with.

Photographic Capture, Cropping, and Orientation

For browsing, scanning, rotating, adjusting perspective, and cropping photographs, Photoshop is often the best tool (though Corel Painter IX has introduced entire canvas rotation, so if it's just rotation you need, you can do that equally easily in either program). Digital photo image capture software packages, such as iPhoto, ACDSee, and iView Media Pro, also offer browsing, rotating, and cropping capability.

Basic Image Editing

Photoshop is great for almost any kind of image-editing need, such as enhancing your source image and adjusting levels, hue, saturation, contrast, and brightness. Photoshop offers the optimum control and flexibility for image adjustments using Adjustment Layers. When using Photoshop's Adjustment Layers I recommend saving a Photoshop file format master document with the Adjustment Layers and then flattening the layers and resaving a flat version of the file in TIFF format for opening in Painter. The reason for making a flattened version of the file is that Painter does not recognize the Photoshop Adjustment Layer properties. If you are already working on an image in Painter and want to make tonal or color adjustments, then you could use Painter's built-in tools under Effects > Tonal Control, though these are not as editable or as powerful as those offered through Photoshop's Adjustment Layers.

Hand-Painted Artistic Effects

Corel Painter IX is the tool to use when you want an organic, artistic, painterly, hand-painted look and feel to your image. This applies equally whether you are creating a painting from scratch or transforming a photographic image. While Photoshop has an extensive set of brushes and numerous wonderful built-in and third-party filters and effects, there is no substitute for the versatility, variety, and richness of Painter's brushes and textures. You can also start with effects and brushes in Photoshop and then rework your image in Painter, finally bringing it back to Photoshop for final refinement and color adjustment.

Selections and Layers

Both Painter and Photoshop have comparable and largely compatible facilities for making and saving selections (including compatible Channels and Alpha Channels) and for controlling, adjusting, and organizing layers.

The Photoshop Lasso tool has the added flexibility of having a feather setting (in the Tool Property Bar) and a point-to-point feature when the Option/Alt modifier key is held down. This makes precise selections easier and faster to do in Photoshop than in Painter (where, for the most precise selections, you would use the Bezier Pen tool to create a Shape and then convert that Shape to a Selection).

Layer Masks are compatible between the two programs (providing you save your files as Photoshop format files). Although Photoshop Layer Blending Modes are similar to Painter Layer Composite Methods, there are Photoshop Layer Blending Modes, such as Color Burn and Vivid Light, that don't exist in Painter, and there are Painter Layer Composite Methods, such as Gel and Magic Combine, that don't exist in Photoshop. When either program comes across a layer blending mode/composite method it doesn't recognize, it just substitutes the Normal (Photoshop) mode or Default (Painter) method. When using Layer Composite Methods in Painter, save your file in RIFF file format. RIFF is the native file format for Painter. RIFF files preserve the most data but cannot be opened in Photoshop. Before being able to open a RIFF file in Photoshop you will need to resave the image in Photoshop or TIFF file format. If you are using Gel or Magic Combine composite methods it is best to flatten your image in Painter before resaving, to preserve the effect of the composite methods on the colors in your image.

Note that besides some Layer Composite Methods, there are other special layers and modes in Painter (Watercolor, Liquid Ink, Impasto, Digital Watercolor, and Mosaic) that lose their special properties and editability when you convert from a RIFF format file to a Photoshop format file (the full editability of these special Painter layers and modes is preserved only in the RIFF format).

Type and Design

Generally vector programs, such as Adobe Illustrator, CorelDRAW, or Macromedia Freehand, are great for sharp, editable, scalable, resolution-independent type, for setting type on a curve, and for keeping file sizes small. Use type in Photoshop or Painter only when you wish to apply a special effect to it or the sharpness of the type is not crucial.

Both Photoshop and Painter have versatile text tools that allow you to experiment with different fonts, orientation, positioning, alignment, and spacing. In Painter, by converting to resolution-independent vector-based Shapes you can also skew and distort lettering individually or as a group. The special properties of Painter's Text and Shape layers are only preserved in the RIFF file format. If you convert the file to Photoshop format so that it can be opened in Photoshop, the Painter Text and Shape layers are converted to regular bitmap image layers. Likewise Photoshop Text layers are converted to regular bitmap image layers when opened up in Painter. Thus while you need editability of your text layers, you should stay in the program in which you created the text and keep the file format appropriate (RIFF format for Painter Text, Photoshop format for Photoshop Text). By converting your Painter Text or Shape layers to default image layers in Painter, you can apply all of Painter's brushes and effects, including instant drop shadows (Effects > Objects > Create Drop Shadow).

If you want to wrap text accurately around a circle or a path, then you should create the text in a vector-based program like Adobe Illustrator, CorelDRAW, or Macromedia Freehand. If you wish to add effects to the text or integrate the text into a bitmap (pixel) image in Painter, then you can always import the Illustrator- or Freehand-generated text as a layer, or series of layers, into either Photoshop or Painter. In Painter, Illustrator text is imported as a group of Shapes (File > Acquire > Adobe Illustrator File).

If you are preparing a piece for print and want the most precise, accurate, sharp-looking text possible and the text will be a plain color without gradients, transparency, or drop shadows, then you are better off either creating the text in Illustrator (or other vector program) and converting it to outlines or saving as a PDF document. Keep a copy of the original (non-outline) document for your records for future editing and resolution-independent resizing. You can also create sharp text mixed in with graphics in layout programs such as Adobe InDesign and Quark Xpress.

Publishing on the Web

Publishing artwork on the Web involves a number of conflicting considerations:

1 Keeping your file size as small as possible to minimize download time and avoid the need for scrolling and thus create a better viewer experience.

2 Showing your artwork in sufficient scale, detail, quality, accuracy, and consistency of color to impact viewers and do justice to your talents.

3 Protecting your imagery from being used without your permission and therefore not publishing such high-quality imagery that people can make good prints from them.

Similar considerations apply to preparing images to send and share as e-mail attachments. With regard to digital imaging workflow, Photoshop CS offers a useful File > Save for Web option, which allows you to see how your image will look depending on what quality or format you choose. I recommend that you use this option when saving from Photoshop for the Web. For further Web imaging capabilities you can choose File > Edit in Image Ready.

My Web gallery images typically end up being about 400 to 600 pixels in the maximum dimension at 72 ppi. I create my original artwork at higher resolution as RIFF files in Painter and then resize and resave them (also in Painter) as High-Quality JPEGs. Every time you save anything as a JPEG, the quality of the file is reduced, and if you resave as a JPEG, then the quality is reduced even more. Only save as a JPEG once. Creating images at higher resolution gives you the flexibility to reuse the images for printing at a later time.

For helping protect your files from misuse you can, in Photoshop, choose Filter > Digimarc, which allows you to embed a watermark with your copyright notice.

Printing

I have successfully printed from both Painter and Photoshop with excellent results. If you print from Photoshop I recommend using the File > Print with Preview option, which allows you more control in positioning your image on the paper. A key concern when you come to print your digital artwork is getting good consistency between the colors you see on the screen when you create your artwork and the colors you see in your final printed image. Painter IX has new color management tools built into it that are worthwhile using. Refer to the User Manual and Help > Help Topics for further information on that. Here are two books that can help you color manage your creative workflow:

Mastering Digital Printing by Harald Johnson (Muska & Lipman, 2003, ISBN 1-929685-65-3)—this is a comprehensive book on digital printing that is written in a chatty, easy-to-follow style and has a chapter on Understanding and Managing Color.

Real World Color Management by Bruce Fraser et al. (Peachpit Press, 2003, ISBN 0-201-77340-6)— a highly detailed technical book that tells you all you could wish to know about the ins and outs of color management.

One factor to be aware of with regard to printing is that different printers and printing technology may require your files to be in one of two different color modes, namely, RGB (red–green–blue) for most fine art inkjet printers and CMYK (cyan–magenta–yellow–black) for commercial offset printing. Painter is an RGB program, in that all color data is stored with RGB values, and I recommend only saving RGB files from Painter. Photoshop allows you to work in different color modes. If you are working with traditional offset lithography printers, use Photoshop to convert your files from RGB to CMYK. Be aware that many options and filters are not available in Photoshop when working in CMYK, so leave CMYK conversion to the end of your workflow, always saving a backup RGB version of your file before changing color modes.

Video

When working on a QuickTime movie for video, I generally start my projects in Painter at the required final video resolution, typically 720 pixels × 480 pixels at 72 ppi. This keeps everything simple and straightforward and allows me to use the resulting QuickTime movie directly without any need for resizing. You can generate a frame stack from the replay of a script and subsequently generate a QuickTime movie (or AVI movie or numbered files) from the frame stack. (This is explained in Chapter 10.) You can also open numbered files or a QuickTime movie in Painter, where it appears as a frame stack. You can then paint on and apply effects to individual frames or across the whole movie. Once your frame stack is exported as a QuickTime movie you can then open that movie in any animation or special effects program (such as Adobe Premiere and After Effects, and Apple Final Cut Pro).

1.4 First Things First

Get Comfortable

It's important to feel good about your environment. Take a look around. Is the surface on which the computer monitor and keyboard are situated clear of clutter? Is the computer screen in a position and orientation where you won't be disturbed by reflected light from a window? Adjust your environment so you feel good about it. You want to avoid distractions once you sit down to create art on the computer.

Before sitting down at your computer, do some simple stretching and relaxation exercises. These could be as simple as some deep breaths accompanied by slowly raising and lowering your arms, gently rotating your head, and softly rolling your shoulders. You may find it pleasant to put on some relaxing music to accompany this movement. When you've completed some stretching and relaxation exercises, finish by shaking out your feet and hands. Stand upright with your arms relaxed at your side. Observe your posture. Breathe deep into your diaphragm, hold your head upright, and keep your shoulders down. Now sit at your computer.

I recommend getting up and stretching (and drinking some water) at least every hour, preferably every 20 minutes. Since time flies by when you're absorbed in a project, you may find it useful to set a small kitchen timer as your stretch time reminder.

Creating should be fun! Make it easy and comfortable for yourself. Observe your posture now that you are sitting. Maintain a relaxed upright posture with your head held high (not slouched forward) and shoulders down (not hunched up). Sit comfortably facing the screen. Make sure your eyes are in line roughly with the center of your screen. If you find you are straining your neck by being forced to look up or down, then adjust your seat and/or monitor height until you are comfortable.

Make the Tablet Your Friend

Harmony Between Human and Computer

The graphics tablet is the key to unlocking the computer as an art tool. The graphics tablet is an input device that replaces the mouse or trackball (though you can still use other input devices if you wish). The graphics tablet has an active surface which corresponds to the computer screen. You apply a special pen, also known as a 'stylus', to this active surface and thus control the cursor on your screen. The tablet will become your friend, an extension of yourself. The company that supplies almost all tablets is Wacom (pronounced wah'-kum). *Wa* is from the Japanese word for "harmony" and *com* is short for "computer." Thus Wacom means harmony between human and computer. This is a very apt name since that's exactly what we need as artists—harmony between our tools and ourselves. The tablet I personally use, and highly recommend, for most of my art is the Wacom Intuos3 6×8/A5 (Figure 1.1).

I also enjoy using the Wacom Cintiq 18SX tablet, particularly for my live portrait sessions. The Cintiq combines an LCD display with the tablet so you actually paint directly on your screen. It is very intuitive and can be easily rotated and positioned for comfort. When painting live subjects I like the fact that the Cintiq avoids having a vertical computer display screen between my model and I.

I share here some tips for using the Intuos3 and setting up the Wacom tablet Control Panel for optimum ease of use in Painter. The new series of Wacom Intuos3 tablets come with an excellent User's Manual in PDF format. Take some time to review the manual so that you are aware of the content. Wacom has kindly permitted me to reproduce some of the illustrations from their Intuos3 User's Manual in this book. The Intuos3 Control Panel screen shots were taken on a Windows PC.

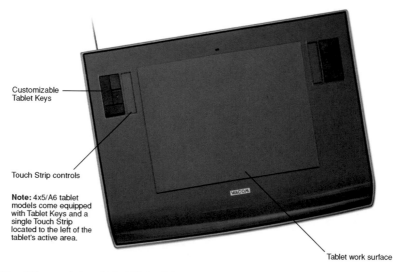

Customizable Tablet Keys

Touch Strip controls

Note: 4x5/A6 tablet models come equipped with Tablet Keys and a single Touch Strip located to the left of the tablet's active area.

Tablet work surface

Figure 1.1 The Wacom Intuos3 6×8/A5 tablet.

Relaxed Grip

Place your tablet centrally in front of you, between you and the screen. I find it most comfortable with the tablet resting on my lap, and sometimes with the upper section of the tablet resting on the edge of the desk. Rest the side of your favored hand on the tablet active surface. The standard Wacom pen that comes with the Intuos3 tablet is known as a Grip Pen. Lightly hold the Grip Pen with a relaxed grip close to the tip and slightly more upright than you would a normal pen or pencil. Your hand and arm should feel totally relaxed. There should be no strain (Figure 1.2).

Keep the side of your hand in contact with the tablet at all times. This gives you maximum comfort and much greater control. If you hold the pen with your hand floating in the air, which is a natural tendency for many, it is difficult to control and you'll find yourself accidentally clicking when you don't intend to.

Using the Wacom Grip Pen

The Grip Pen position determines precisely and uniquely where the cursor appears on the screen. The Grip Pen is not relational like a mouse. There is absolute and unique correspondence between every point on the tablet surface and every point on the screen. A Grip Pen does all the functions of a mouse (and more). A light tap is a click. Two light taps is a double-click. Click and drag is a depression of the pen at one position, maintaining the pressure while sliding the pen to another position, and then lifting the pen tip away from the surface of the tablet. From now on put your mouse or trackball to one side and use the Grip Pen for all operations on the computer, both within Painter as well as outside Painter. You'll find once you get used to it you won't ever want to use a mouse again!

The Grip Pen is supplied with three replacement standard white nibs, a grey spring-loaded Stroke nib which gives a dampened feel to the pen and is designed to feel more like a brush, and a black Felt nib which gives the feel of more resistance as you paint and is designed to feel more like a marker pen. I personally like using the Stroke nib.

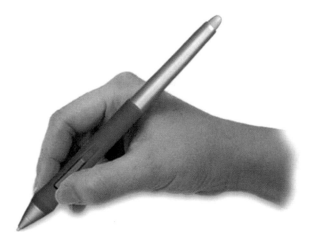

Figure 1.2 Holding the Wacom Grip Pen.

CHAPTER 1 FOUNDATION I: GETTING STARTED

Wacom Intuos3 Control Panel

1 The tablet driver installs a Control Panel (Figure 1.3). Make sure you have the most up-to-date driver installed on your computer (see www.wacom.com for free download of the current drivers).

2 In Mac OS X select System Preferences > Other > Wacom Tablet. In Windows click Start > Settings > Control Panel and double-click on the Wacom Tablet icon. If you ever need to uninstall the Wacom control panel in Mac OS X, you'll find an uninstall icon in Applications > Tablet.

Making Double-Clicking Easier

1 Select the Grip Pen icon in the Tools menu at the top of the Wacom Tablet Control Panel (Wacom Tablet Properties on Windows).

2 Select the Pen tab.

3 Move the Tip Double Click Distance slider towards the right (Large). This makes it easier to double-click (Figure 1.4). The compromise here is that you don't want to make it too easy to double click or you'll find yourself accidentally double clicking when you don't wish to.

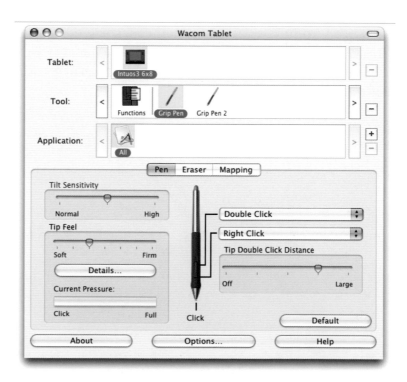

Figure 1.3 The Wacom Control Panel with Pen Tab selected.

Customizes the amount of pressure
needed to click or draw. Drag the
slider to a softer or firmer setting.

Displays the tip FEEL DETAILS dialog
box where you can further
customize the tip sensitivity.

Press down on the tablet with your
pen tip to test the current tip feel
setting. You can use the CURRENT
PRESSURE bar to determine how
hard you must press on the pen to
reach maximum pressure.

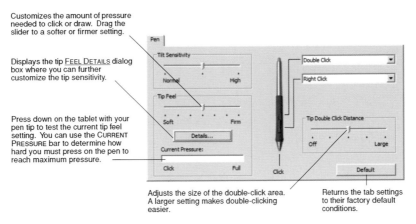

Adjusts the size of the double-click area.
A larger setting makes double-clicking
easier.

Returns the tab settings
to their factory default
conditions.

Figure 1.4 Adjust the Tip Double Click Distance.

Figure 1.5 The Feel Details window.

4 Click on the Details button in the Pen tab. This reveals the Feel Details window (Figure 1.5).

5 Lower the Click Threshold slightly. This will make your pen more sensitive to registering a click when you tap lightly. Experiment after you've set this. If you find you are accidentally clicking too much, then return to this setting and increase the Click Threshold slightly.

6 You may also wish to adjust the Sensitivity setting in this Feel Details window to suit your hand. If you find it difficult to make a mark in the Try Here: scratch pad (lower right corner of the Feel Details window), then see if a higher Sensitivity setting helps. Click OK.

7 You are now back in the main Pen tab window. The Tip Feel slider in the Pen tab window also gives you control over the pressure sensitivity of your pen tip. You will be further fine-tuning your pressure sensitivity within Painter, so don't worry about getting it exactly right at this stage.

Figure 1.6 The button-function pop-up menu.

Selecting Button Functions

The button on the side of the stylus is a two-function button. Each end of the button can be programmed to choose a separate function.

1 Click on the upper button-function pop-up menu, located in the upper right of the Pens tab window. You will see a pop-up menu with a list of optional functions that you can set that button function to be (Figure 1.6).

2 Select the function you desire for the back of the button (that is, the end of the button furthest from the stylus tip). This is a matter of personal choice and convenience. Some Windows users like to set this function to be Right Click or Alt. Personally I like simplicity and I set both button functions on my stylus to be Disabled.

3 Repeat this for the lower button-function pop-up menu, which controls the function of the front of the button (the end that is nearest the stylus tip).

Customizing the Tablet Keys

1 Click on the Functions icon in the Tools menu at the top of the Wacom Tablet Control Panel.

2 Click on the Tablet Keys tab.

3 Go through the pull-down menus and decide what you wish to set each Key to be (Figure 1.7).

Customizing the Touch Strip

1 Click on the Touch Strip tab.

2 Set your Touch Strip function and speed (Figure 1.8).

You may find your stylus hand inadvertently activates the Touch Strip as you move around the tablet and in that case you may wish to set the Touch Strip function on that side to disabled.

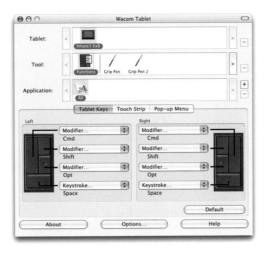

Figure 1.7 The Tablet Keys customization window.

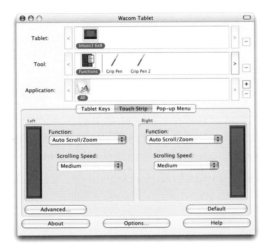

Figure 1.8 The Touch Strip customization window.

Please note that there are other functionalities within the Wacom Intuos 3 tablet that I haven't covered here, such as the Pop-Up Menu option. See the Intuos 3 User's Manual for further details.

Basic Stylus Tasks

If you are new to using a tablet, it is useful first to get used to some basic tasks. If you are already comfortable using a Wacom tablet, then skip this section.

1 With your Finder/Desktop visible on your screen, click on one of the icons (for instance, the hard drive icon on the Macintosh or the My Computer icon on Windows) so that it becomes highlighted. Then click on the desktop background so that the icon is no longer highlighted.

2 Repeat this and see how light a tap can cause a click. You'll be amazed at how little pressure you need to apply. Remember to relax your grip.

3 Click on the same icon, and this time keep pressure applied to your Grip Pen so that it remains in contact with the tablet active surface, and drag the stylus across the tablet. Observe the icon being dragged across the desktop.

4 Double-click on the icon so that it opens into a window (or an application, depending what the icon is).

5 Close the window.

6 Drag the icon back to its original position.

7 Move the cursor to each corner and along the edges of the screen, keeping the stylus tip about 1/4 inch above the tablet surface at all times. It is important to be able to move the cursor around without accidentally clicking or dragging. Get a feel for the physical relationship between the boundaries of the screen and the boundaries of the tablet.

Create a Painter Alias (Mac OS X)

1 Locate the Painter IX folder in your computer.

2 Open the Painter IX folder and locate the Painter IX application icon.

3 Click and drag the Painter IX application icon into the Dock (usually located at the bottom of the screen). You will see a Painter alias appear in the Dock.

4 A single click on the Painter icon in the Dock opens Painter.

5 I like to set up the Dock with small icons on the right of my screen. You can do this through the Apple > Dock > Dock Preferences.

Create a Painter Alias (Windows)

1 Locate the Painter IX folder in your computer.

2 Open the Painter IX folder and locate the Painter IX application icon.

3 Right-Click on the Painter IX application icon and select Shortcut.

4 Drag the Shortcut onto your desktop.

Add Painter to the Start Menu (Windows)

1 If a Painter shortcut icon is on your desktop, hold down the Alt key and then click and drag the Painter shortcut icon onto the Start button. Painter can now be launched from the Start menu.

Figure 1.9 The Brushes folder containing the Painter Brushes library folder.

2 If the Painter icon is not on your desktop, click Start > Run and type Explorer.

3 Open the Program Files folder and then open the main Corel Painter IX folder.

4 Hold down the Alt key and then click and drag the Painter application icon (.exe file) over the Start button. This creates a Painter shortcut icon and places it in the Start menu. Painter can now be launched from the Start menu.

Load Jeremy Faves 2.0 Brush Category (Macintosh)

On the Companion Resource CD that comes with this handbook you will find the Jeremy Faves 2.0 brush category which contains many great brush variants, some from older versions of Painter and some unique custom brushes made by myself or generously shared by others. These brushes will enrich your experience in Painter.

1 Put the Companion Resource CD that comes with this handbook in your computer.

2 Double-click on the CD icon.

3 Locate and open the "Goodies_Mac_OSX" folder. You will see a folder "Jeremy Faves 2.0" and a JPEG file "Jeremy Faves 2.0.jpg." Keep this window open and drag it to the right of your screen.

4 Choose Go > Applications.

5 Open the Corel Painter IX application folder.

6 Open the Brushes folder within the Corel Painter IX application folder.

7 You will see a Painter Brushes folder within the Brushes folder (Figure 1.9). Place this window, showing the Painter Brushes folder, on the left of your screen.

8 Drag the "Jeremy Faves 2.0" folder and the "Jeremy Faves 2.0.jpg" file into the Painter Brushes folder. You have now successfully added the "Jeremy Faves 2.0" brush category to your Painter Brushes library (Figure 1.10).

Figure 1.10 The Painter Brushes folder after the Jeremy Faves 2.0 brush category has been added.

Figure 1.11 Copying Jeremy Faves 2.0 brush category folder and icon to the Painter Brushes directory.

The Painter Brushes folder, the default brush library in Painter, contains all the brush categories. If you open the Painter Brushes folder you'll see a long sequence of folders with brush category names, each accompanied by a JPEG file of the same name, for instance, "Artists" and "Artists.jpg." These JPEG files are 30 × 30-pixel icons that represent each brush category in the Brush Selector Bar within Painter. The brush category folders contain the individual brush variants. Open one of the brush category folders and observe the mixture of .xml and other files, which contain the brush data for each individual Painter IX brush variant. Seeing this will give you a good understanding of the Painter brush hierarchy (Library > Category > Variant).

Double check that both the Jeremy Faves 2.0 folder and JPEG have been added to the Painter Brushes folder. If they are not in that folder you will not be able to access the Jeremy Faves 2.0 brushes. Note that since there is a space at the front of the file name the Jeremy Faves 2.0 brush category is located at the top of the list of categories.

Load Jeremy Faves 2.0 Brush Category (Windows)

On the Companion Resource CD that comes with this handbook you will find the Jeremy Faves 2.0 brush category which contains many great brush variants, some from older versions of Painter and some unique custom brushes made by myself or generously shared by others. These brushes will enrich your experience in Painter.

1 Open My Computer.

2 Locate the Companion Resource CD (typically on the D Drive, but this may vary from computer to computer).

3 Open the "Goodies_Win_XP_2000" folder if using Windows XP or Windows 2000.

4 Select the"Jeremy_Faves_2" folder and Jeremy_Faves_2.jpg JPEG.

5 Right-click on the two highlighted items and drag to Copy to Folder (or choose Edit > Copy to Folder).

6 In the Copy Items window locate Local Disk C > Program Files > Corel > Corel Painter IX > Brushes > Painter Brushes. Copy both items into that location (Figure 1.11).

If you are on Windows XP or Windows 2000, insure the Read Only property is unchecked for all the files you've copied.

7 Locate the two copied items.

8 Select each item (Jeremy_Faves_2 folder and Jeremy_Faves_2.jpg file).

9 Right-click and choose Properties (File > Properties).

10 Uncheck the Read Only box if you find it is unchecked.

11 Click Apply.

12 Choose the option "Apply to this folder, subfolders and files."

13 Click OK.

14 Check the individual files to make sure the Read Only property has been removed.

What to Do with Your Old Jeremy Faves Brush Category?

If you already have the earlier version of my custom brush category, Jeremy Faves, loaded onto your computer from the Painter 8 Creativity: Digital Artist's Handbook, I suggest you do not copy it over to Painter IX but instead use the new Jeremy Faves 2.0 category that comes with this handbook. If you've already copied it over, you may wish to remove it to keep your brush library efficient (you don't want to have too many categories because the category list becomes too long). I have kept key brushes from my earlier Jeremy Faves category and added some wonderful new ones, so Jeremy Faves 2.0 is an even bigger and better collection of brushes.

Make a Backup Copy of Your Brushes Folder

At this stage make a backup copy of your Brushes folder, the one that is within your Corel Painter IX application folder. On Macintosh OSX hold down the Option key while you drag the Brushes folder to another location within the Corel Painter IX folder. This will create a copy of the folder called Brushes Copy. On Windows first select the Brushes folder and then choose Copy (Ctrl-C) followed by Paste (Ctrl-V). This will generate a folder called Copy of Brushes. It will be useful to have the Brushes folder backed up in case if you ever have a brush variant file become corrupt and need replacing (which unfortunately may happen from time to time).

Backing Up Custom Data

In Chapter 3, "Brush Creation," you will find further instructions about backing up the Painter customization data, which is stored in another location on your computer. I recommend that you back up custom data every few months to ensure your custom brushes are preserved.

Loading Other Goodies

Copy the remaining contents of the appropriate Goodies folder into your Corel Painter IX application folder. This extra content includes extra papers, patterns and color sets. The extra color sets are contained in a special custom folder "Jeremy Xtra Color Sets" / "Jeremy_Xtra_Color_Sets". I suggest you copy this folder, along with the extra paper textures and patterns, directly into the Corel Painter IX application folder. This will mean you end up with the default Color Sets folder, the standard Painter Colors color set and the custom folder "Jeremy Xtra Color Sets" / "Jeremy_Xtra_Color_Sets", all at the same level of hierarchy.

If you are using Windows XP or 2000 make sure the Read Only property is unchecked for everything you copy over from the Companion Resource CD.

1.5 Welcome to Painter

Open and Mount a Canvas in Painter

In this section we're going to start by opening a new canvas in Painter so that you have a scratch pad to try brushes out on. We'll make some basic adjustments in the Preferences to make things more comfortable and convenient.

Opening a New Canvas

1. Open Painter.
2. Select from the top menu bar File > New (Cmd/Ctrl-N).
3. In the New Picture window set the canvas size to 700 pixels wide by 750 pixels high. Leave the resolution at 72 pixels per inch, the paper color white, and the picture type as Image.
4. Click OK.

Mount and Reposition Your Canvas

1. Mount your canvas by selecting the keyboard shortcut Cmd/Ctrl-M. This is equivalent to going to the top menu Window > Screen Mode Toggle. You now see your canvas appear-

ing against an inert gray background that you can click on and drag over without accidentally going back to the Finder (Mac users). It is also visually simpler than having the canvas border frame around the canvas. Always work in screen mode unless there's a specific reason not to.

2 Move the cursor over the canvas.

3 Hold down the spacebar on your keyboard (or you can use the lower function button on the Wacom Intuos3 tablet which is set by default to be the space bar). The cursor changes into a hand (the same Grabber Hand as in the Tools palette). Click and drag the canvas, still holding the spacebar down, and move the canvas so it fits snugly in the top left corner.

Set Up Painter Preferences

In this section you will be introduced to each of the Preferences in Painter. Some you may not need to adjust, but it is still useful to be aware of the default settings and how to access them.

General Preferences

1 Choose Cmd/Ctrl-K (Corel Painter IX / Edit on Windows > Preferences > General).

2 In the General Preferences window adjust the cursor angle. If you are right-handed you may prefer your cursor to point toward the upper left (Figure 1.12). If you are left-handed, you may prefer it pointing to the upper right.

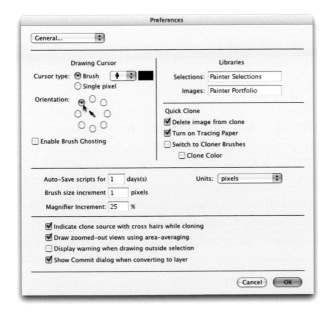

Figure 1.12 General Preferences window.

3 You may wish to uncheck the "Enable Brush Ghosting" checkbox. By default this option is checked, which results in a preview of the brush shape and size, visible on the canvas when you're about to paint, which disappears when you actually paint. The advantage of brush ghosting is that you know immediately when you place your cursor on your canvas how big your brush size is and the shape of the brush. The disadvantage is that with very small brushes it is difficult to see where your cursor is, and with large brushes it is difficult to know exactly the point at which your brushstroke will start. Try it with and without the brush ghost and decide for yourself. I personally prefer to have the brush ghosting disabled.

4 Under Quick Clone uncheck Switch to Cloner Brushes.

5 Check "Draw zoomed-out views using area-averaging."

6 Click OK to return to your canvas.

Brush Tracking Preferences

1 In the top right corner of your Painter desktop you will see a brush selector with two icons and a description of the current brush category and variant (these terms will be explained in more detail later in this chapter). Click on the left icon. You will see a pop-up menu that lists the brush categories.

2 At first you will just see five categories listed in the pop-up menu. Click and drag the bottom right corner of the category pop-up menu downward until you see a complete list of categories visible on your screen (ends with Watercolor).

3 Select the Artists category.

4 Click on the right-hand icon. You will see a pop-up menu that lists the brush variants contained within the Artists category. It is a good idea to get into the habit initially of clicking and dragging down the bottom right corner of each variant pop-up menu to make sure you are seeing all the variants available.

5 Select the Sargent Brush variant.

6 Make a brushstroke on your canvas starting with very soft pressure and ending with hard pressure. Does your brushstroke smoothly go from thin to thick, or is there an abrupt "jog" in the stroke where it suddenly gets thick? If the latter, then adjusting the Brush Tracking Preferences can help. Try a few brushstrokes like this to be sure. Don't be afraid to press hard! Note how the thickness responds to pressure. Make sure you test out the full range of thickness by going to extremes of light and heavy pressure. You should be able to comfortably control the thickness across the full range. Sometimes you may find that the brush is either too sensitive or too insensitive in response to the pressure you apply. We all apply a different natural range of stylus pressure when we paint. Brush Tracking allows Painter and your stylus to be sensitive to your natural pressure range.

7 Choose Cmd/Ctrl-K.

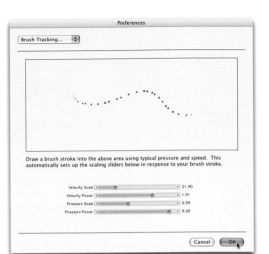

Figure 1.13 Brush Tracking Preferences window.

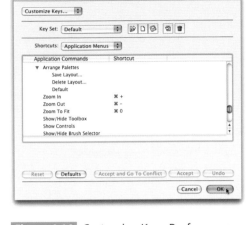

Figure 1.14 Customize Keys Preferences window.

8 Click on the Preferences pop-up menu (where you see the word General) and select Brush Tracking.

9 Make a note of the four slider settings, since once you adjust them and click OK to try out the new settings, you can't go back and cancel or reset the sliders to their previous values.

10 Make a single light stroke in the Brush Tracking Preferences window (Figure 1.13).

11 Click OK.

12 Try out a light to hard brushstroke on your canvas and see if the transition from thick to thin is now smoother and better controlled than before. If needed you can return to the Brush Tracking Preferences and repeat the process.

Customize Keys Preferences

1 Choose Cmd/Ctrl-K.

2 Click on the Preferences pop-up menu (where you see the word General) and select Customize Keys. You will see here a summary of all the main menu and submenu application commands (those that you see along the top of your screen) with all the default keyboard shortcuts (Figure 1.14). You can click in the shortcuts column next to any menu item and type in your own shortcut. This incredible facility is heaven for anyone who likes using keyboard shortcuts in their workflow. If you find there is an operation you keep doing regularly that doesn't have a shortcut, this is the place to go to create one.

The two Customize Keys shortcuts I recommend adjusting immediately for ease of use are the shortcuts for Tools > Scissors and Other > ColorTalk (ColorTalk is a programming language that

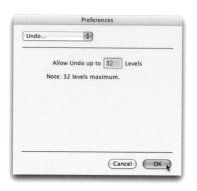

Figure 1.15 Undo Preferences window.

Figure 1.16 Shapes Preferences window.

allows you to automate tasks). The default for Scissors is "Z," which is easily accidentally chosen if you try to choose Cmd/Ctrl-Z (undo) and miss depressing the Cmd/Ctrl key in time. I recommend making the Scissor shortcut "Shift-Z". The default shortcut for Other > ColorTalk is "N," which is easily accidentally hit when you mean to hit the "B" key. I recommend changing the ColorTalk short-cut to Option-Shift-N/Alt-Shift-N (Shift-N is already taken by ColorTalk Movie).

Undo Preferences

1 Click on the Preferences pop-up menu and select Undo. You will see that the default is set to the maximum of 32 (Figure 1.15). I suggest leaving this as is. This means you can repeat Cmd/Ctrl-Z 32 times and sequentially undo your last 32 actions on the canvas (brushstrokes, commands, effects).

Shapes Preferences

1 Click on the Preferences pop-up menu and select Shapes (Figure 1.16).

2 Uncheck the defaults of Stroke in Current Color on Draw and Fill with Current Color on Close.

3 Check Big Handles.

These settings help keep your paths simple and unobtrusive when you use the Pen tool to create and edit a path for the purposes of selection.

Note that the Shapes Preferences window also contains an Align Brush to Path Tolerance setting for the snap-to-path painting feature.

Internet Preferences

1 Click on the Preferences pop-up menu and select Internet. You will see the default library address used by the Help menu. Just leave this as is.

Figure 1.17 Save Preferences window.

Figure 1.18 Palettes and UI Preferences window.

Save Preferences

1. Click on the Preferences pop-up menu and select Save.

2. For Mac users choose Append Always (the default is Never) and check Use Lower Case (Figure 1.17).

3. For Mac and Windows users make the Color Space RGB for both TIFF and Photoshop (PSD) files. The defaults are Prompt on Save.

Palettes and UI Preferences

1. Click on the Preferences pop-up menu and select Palettes and UI.

2. If you wish to change the window background color from gray (this is the background color you see surrounding your canvas when it is mounted in Screen Mode), then select the color in your Colors palette and click on the Window Background: Use Current Color button. I use this for presentations when I prefer a dark gray or black background color rather than the default mid gray (Figure 1.18).

Memory and Scratch Preferences

1. Click on the Preferences pop-up menu and select Memory and Scratch (Figure 1.19).

2. If you wish to maximize the potential power of Painter when working on large files, you change the Memory Usage from 80% to 100% of available.

3. Make sure the Scratch Disk you have assigned has plenty of free space.

Register

If you haven't registered your copy of Painter, do so by selecting Help > Register.

CHAPTER 1 FOUNDATION I: *GETTING STARTED*

Figure 1.19 Memory and Scratch Preferences window.

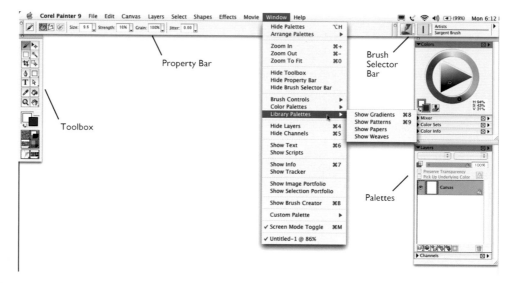

Figure 1.20 The default Painter desktop with the Window > Library Palettes menu.

Set Up Your Painter Desktop

We take a look at the Painter desktop and review what's what and what's where. We look at how you can control your desktop and explore the brushes hierarchy.

Desktop Overview

The Painter IX desktop comprises four main interface elements: Toolbox, Property Bar, Brush Selector Bar, and Palettes. The palettes that are initially displayed by default when you first open Painter are the Color palettes (Colors, Mixer, Color Sets, and Color Info) and the Layers and Channels palettes. There are many other palettes available through the Window menu (Figure 1.20). Palettes are listed under the Window menu with either Hide or Show preceding the palette name, depending on whether

they are already visible on your desktop. Under the Window menu some palettes have been grouped together by type (Brush Controls, Color Palettes, Library Palettes).

All of these elements can be moved around, rearranged, or hidden. Thus you have complete flexibility in controlling your Painter IX environment. My intention here is to give you a quick overview of what's where rather than go into detail and describe every palette and menu item in detail. For a more detailed description of the Painter desktop elements please refer to the Painter IX User Manual and Getting Started Guide.

Toolbox

The Toolbox lets you access the Painter IX tools plus a variety of art materials, such as the papers, patterns, gradients, nozzles, weaves, and brush looks (Figure 1.21). Note that a small triangle in the bottom right corner of a Toolbox icon indicates that a pop-up menu is accessible if you hold your cursor down on the icon. Take a few moments to explore the Toolbox.

Property Bar

The Property Bar provides easy access to commonly needed parameters related to the currently selected tool. Notice as you change the tool choice how the Property Bar changes. For the Brush tool the parameters displayed in the Property Bar are dependent on the specific brush variant that is currently selected. Greater in-depth adjustment of brush parameters is possible through the Brush Controls group of palettes (Window > Brush Controls) or by choosing the Brush Creator mode (Window > Show Brush Creator).

Brush Selector Bar

Brushes are at the heart of Painter's magic. The phenomenal range and ability of Painter's brushes empowers you to express yourself freely on the digital canvas. The Brush Selector is where you choose the specific brush you wish to use. It comprises a Category pop-up menu on the left and, immediately to the right of the Category pop-up, the Variant pop-up menu (Figure 1.22). Always select Category

Figure 1.21 The Toolbox.

CHAPTER 1 FOUNDATION I: GETTING STARTED

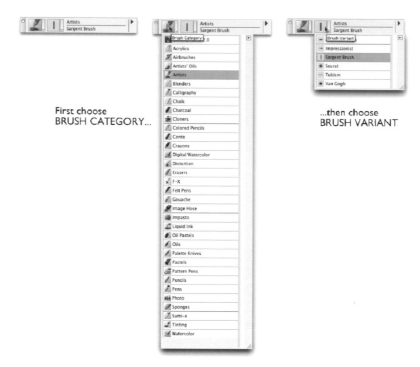

First choose
BRUSH CATEGORY...

...then choose
BRUSH VARIANT

Figure 1.22 The Brush Selector Bar.

first and Variant second, since each brush category (grouping, type, or family of brushes with similar behaviors) contains a separate set of brush variants (individual brushes). You can think of brush categories like drawers in an art cabinet, with each drawer containing a different collection of related art tools (oil paint brushes, crayons, pens, pencils, etc.). When you first open either the Category pop-up menu or the Variant pop-up menu, you will see just the first five items listed and a scroll bar on the right of the menu. I recommend you drag the bottom right corner of the menu down as far as it will go to show the complete list.

The consistent hierarchy of brushes in Painter is Library > Category > Variant. Understanding this hierarchy is vital to using Painter.

There is a Brushes pop-up menu (Figure 1.23), accessible by holding the cursor down on the triangle in the top right of the Brush Selector window. This menu allows you to choose commands for saving custom variants when you create a new brush you like and for returning the current variant to its default settings.

Palettes

There are thirty five palettes that come with Painter (more can be created using Window > Custom Palettes). Nineteen of these palettes are grouped within the Brush Controls palette. Many palettes have pop-up menus on the far right of the palette title bar (click on the triangle). You may find you want different combinations of palettes showing for different tasks. For instance, when painting you

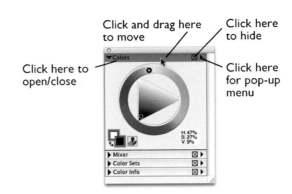

Click and drag here to move

Click here to hide

Click here to open/close

Click here for pop-up menu

Figure 1.23 The Brush Selector Bar pop-up menu.

Figure 1.24 Palette title bar functionality.

may just want to see Colors and Layers. For working with text you will also want to see the text palette. For working on collage the layers and channels palettes will be needed. Palettes can be conveniently grouped or ungrouped (for instance, the Color palettes are initially all grouped together) and opened or closed (when closed, you just see the palette title bar), as well as hidden or shown. Thus you can make the best use of your working space and avoid getting it too cluttered.

Moving Palettes

To move palettes into or out of a group of palettes or to change their order within a group of palettes, you simply click and drag on the center of the title bar (the cursor becomes a Grabber Hand as you pass over the center of the palette title bars).

Opening and Closing Palettes

To open or close a palette you click on the left of the palette title bar, where the solid black triangle and palette name are visible.

Hiding and Showing Palettes

To hide a palette you click on the close button on the right side of the palette title bar. To access the palette pop-up menu you click on the small solid black triangle on the far right of the palette title bar (Figure 1.24).

Custom Palettes

Custom Palettes are ideal for making convenient desktop shortcuts for frequently used commands and menu items. They can also be used to create shortcut buttons for your favorite brushes.

Make a "Save As" Button

A "Save As" button encourages you to save versions of your work regularly and avoids your accidentally overwriting your files with File > Save instead of File > Save As. The Save As command takes you to the Save As window, in which you can enter the file name, determine file format, and choose

where to save the file. I recommend that you save your work in progress as a RIFF file (the native format of Painter) and your final image for printing as an RGB TIFF. You will find a detailed discussion regarding strategies for naming and saving your artwork in the next chapter. For the remainder of this chapter I suggest you save any images you create as RIFF files in an appropriately named folder, such as "Painter Projects Chpt01."

Iterative Save

There is an Iterative Save command (File > Iterative Save), which automatically saves your work in progress with sequentially named files. Each Iterative Save file name ends with a three digit number, such as _001, _002, and so on, immediately preceding the file format tag (such as .rif or .tif tag). The Save As command is useful even if you choose to use the Iterative Save function, since there will be times you wish to rename a file, such as after making a clone copy (duplicate).

1. Make sure there is a file open in Painter (File > New, Cmd/Ctrl-N, or File > Open. Cmd/Ctrl-O).

2. Drag down to Window > Custom Palette > Add Command.

3. Select File > Save As. You will see Menu Item: Save As in the Add Command window (Figure 1.25).

4. Click OK. This generates a custom palette called Custom-1 containing a "Save As" button.

5. Choose Window > Custom Palette > Organizer.

6. Locate the new Custom-1 palette in the Organizer and click on it so that it is highlighted.

7. Choose Rename and rename Custom-1 "Shortcuts."

Figure 1.25 The Add Command window.

Figure 1.26 The Add to: menu in the Add Command window.

Make a "Quick Clone" Button

Quick Clone is a useful feature that does several steps in one command. The steps are determined in the General Preferences. It is handy to have this as a shortcut button when you are working from photographs.

1 Choose Window > Custom Palette > Add Command.

2 Choose Shortcuts, or whatever you named your custom palette, from the Add to: menu in the Add Command window (Figure 1.26).

3 Choose File > Quick Clone.

4 Click OK.

Adding Other Menu Commands to Your Shortcuts Custom Palette

Other menu commands you may find useful to add to your shortcuts custom palette, besides Save As and Quick Clone, are File > Clone, Window > Screen Mode Toggle, and Window > Zoom To Fit. You may eventually wish to create different custom palettes for different types of projects, such as one specifically for working with photographs and another for working with layers (including a Layers > Drop All button). Name each custom palette appropriately so that you can easily recognize which one it is.

Adding Brush Variants to Your Custom Palette

Besides using the Add Command function to add further buttons to your Shortcuts custom palette (such as adding the File > Clone command, which is very useful for photography), you can drag icons from any of the libraries (Brushes, Gradations, Papers, Patterns, Scripts, etc.) into your custom palette. This is very useful if you find yourself using the same few brush variants for a particular project.

Moving Buttons and Icons within Your Custom Palette

By default, icons and buttons line up horizontally in the custom palette. If you want a vertical arrangement of icons and buttons in the custom palette or wish to move the buttons around and change their order, hold down the Shift key and click and drag on the icons and buttons.

Hiding and Showing Custom Palettes

To hide a custom palette, click on the palette close button (top left on Macintosh, top right in Windows). To show a custom palette, choose Window > Custom Palette > palette name.

Deleting Custom Palettes

You can use the Custom Palette Organizer to delete extra custom palettes that you no longer want or that you create accidentally (easily done when dragging brush icons onto your desktop). To delete icons or buttons, choose Window > Custom Palettes > Organizer. Select the name of the custom palette you wish to delete in the custom palette Organizer. Click the Delete button in the Organizer to delete the selected custom palette.

Showing Brush Size

I find it useful to see a graphical representation of my brush size as I paint and therefore recommend the following:

1 Choose Window > Brush Controls > Show Size.

2 Drag the Size palette up to the top of the Brush Controls group of palettes.

3 Drag the bottom right corner of the Brush Controls upward until you can just see the Brush Size palette down to the Size slider.

Library Selectors and Palettes

Painter has a variety of Libraries, or collections, that can be accessed through Selectors. In the case of the brushes, the brushes library is a collection of brush categories, each of which is a grouping of individual Variants. As we have seen, to select a brush you use the Brush Selector Bar to choose first the Brush Category and then the Brush Variant.

The Paper, Gradient, Pattern, Weave, Look, and Nozzle Selectors are all accessible at the bottom of the Toolbox as well as via the Window menu (except for Look and Nozzle Selectors, which are only accessible through the Toolbox). The Scripts, Selection Portfolio, and Image Portfolio Library Selectors are accessible through the Window menu. The content of all libraries, other than the brush library, are edited and controlled via Movers (typically listed at or near the bottom of the corresponding palette pop-up menu).

Initially the library palette you are most likely to want to see on your desktop is the Papers palette (Window > Library Palettes > Show Papers). This gives you a preview and control of the paper texture applied with grainy brushes.

Saving Palette Arrangements

As you work in Painter you'll find you rearrange your desktop to suit different tasks, hiding or showing those palettes that are relevant, creating custom palettes as appropriate. When you have a palette arrangement you like and that you wish to be able to return to in an instant at any time, choose Window > Arrange Palettes > Save Layout (Figure 1.27). Name your layout with a descriptive name that relates to the task it is good for (e.g., Simple Paint).

Figure 1.27 Saving a palette arrangement.

If you ever wish to return to the standard palette arrangement, select Window > Arrange Palettes > Default.

1.6 Foundation Skills

Foundation skills are the nuts and bolts of painting. You've already learned how to open, mount, and save a canvas and how to select your brush variant from the Brush Selector Bar. The remaining foundation skills you need to learn are how to control your brush size, how to pick color, and how to remove paint.

Controlling Your Brush Size

Some brushstrokes vary in width according to the pressure you apply with your stylus. If you want more variation of brush thickness than that provided by pressure control, then you need to adjust the Brush Size. You can do this by a number of different means.

Selecting Size in the Property Bar
Click on the right side of the size box in the Property Bar to reveal the pop-up size slider.

Figure 1.28 Size Palette showing diameter preview for Artists > Impressionist variant.

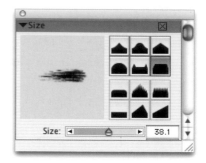

Figure 1.29 Size Palette showing brush shape preview for Artists > Impressionist variant.

The Size Preview and Slider in the Size Palette

1 Choose Window > Brush Controls > Show Size if it is not already showing on your desktop. The preview window on the upper left indicates brush diameter (Figure 1.28). The outside of the solid black circle is the brush diameter. Some brushes, such as the Artists > Impressionist variant, have a variation of diameter built in (Min Size slider less than 100%), in which case you will see an inner solid black circle, indicating the minimum diameter, and an outer gray ring, indicating the maximum diameter.

If you click on the Brush Dab Preview Window in the Size section you see a depiction of how the pigment is distributed (Figure 1.29). Click again and it returns to the original solid circles. Have the preview set to show the solid black (or black and gray) circle.

The twelve small brush dab profile icons, located on the upper right of the Size preview, show the way pigment will be distributed across the width of the stroke.

Key Shortcuts

You can use the key command combination Cmd-Option-Shift/Ctrl-Alt-Shift and click and drag on the canvas to change size rapidly over a large range. For a small incremental increase or decrease in the brush size, you can use the bracket keys (the "['key for decrease, the']" key for increase).

Picking Color

Painter has four Color Palettes: Colors, Mixer, Color Sets, and Color Info. You can adjust and select color from any of these four palettes, plus you can sample color from an existing image using the Dropper tool. These different ways (except the Color Info palette) to pick color are reviewed here.

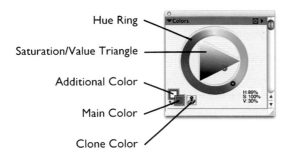

Hue Ring

Saturation/Value Triangle

Additional Color

Main Color

Clone Color

Figure 1.30 The Color Palette showing the Standard Colors color picker.

Color Palette

Standard Colors

The Color palette has two ways of displaying color. The default display is the Standard Colors color picker, with an outer Hue Ring (based on a representation of the color spectrum known traditionally as the color wheel) and a Saturation/Value Triangle in the center. The other color picker, Small Colors, combines a single horizontal hue bar with a Saturation/Value Triangle. You choose between the Standard Colors and the Small Colors in the Color palette pop-up menu (small solid black triangle in the top right of the Colors palette). I recommend sticking with the Standard Colors color picker, which is the one that will be shown throughout this handbook (Figure 1.30).

To choose a color in the Standard Colors color picker you have to adjust both the small circular cursor in the outer Hue Ring and the one in the central Saturation/Value Triangle. To select either white or black in the Color Picker, take the Saturation/Value Triangle cursor to the upper left corner for white or to the lower left corner for black. The hue is not relevant when selecting white or black. It is easy to leave the Saturation/Value Triangle cursor in one of the corners (black lower left or white upper left) and wonder why you are not getting the color indicated by the cursor position in the hue ring. You will find a more in-depth discussion of color in Chapter 11.

Main and Additional Colors

Notice the two overlapping squares of color in the lower left corner of the Colors section and also in the Tools palette. These are the Main and Additional colors. The Main Color is indicated by the foremost of the two overlapping squares. Behind the Main Color square is the Additional Color square. You make the square active by clicking on it. The active square is highlighted by a bold black border in the Tools palette. When you first open Painter, the Main Color square is always active.

Although these color squares closely resemble the Foreground and Background color of Photoshop, they have quite different functions in Painter. Most brushes apply only the Main Color. The Additional Color has several uses, such as specifying a two-color gradient (the Two Point gradient in the Gradients palette), the pressure-sensitive colors seen in the F-X > Gradient Flat Brush), and providing a tint color for Image Hose nozzles (when the Grain slider in the Property Bar is moved to the left). I recommend that you always have the Main Color active and use the exchange arrows to toggle between the Main and Additional colors when you need to.

Choosing Paper Color

Do not confuse the Additional Color with background or Paper Color. The Additional and Main Color squares in Painter look deceptively similar to the Background and Foreground color rectangles in Adobe Photoshop. The Paper Color in Painter is determined in the New File dialog box or by choosing Canvas > Set Paper Color, at which point the Paper Color becomes the current Main Color for the current active image (if you then open another image, the Paper Color will return to the default white). The Eraser family of brushes—and the Select All > Delete commands—erase to the current Paper Color. When you enlarge a canvas by choosing Canvas > Canvas Size, the extra canvas added on is the color of the current Paper Color. You can use this fact to add colored borders to your work. The default Paper Color is white.

Clone Color

The little icon that looks like the Photoshop Rubberstamp icon, located below the Hue Wheel in the Colors palette, is the Clone Color button. It can be activated/deactivated for any brush by clicking on it or using the keyboard shortcut "U." When the Clone Color button is activated, the Hue Wheel, Value Saturation Triangle, and Main and Additional Color rectangles are all grayed out, and the current color is determined by the current clone source (see File > Clone Source). Note that the Cloners brushes have clone color activated but that the Hue Wheel, Value Saturation Triangle and Main and Additional Color rectangles are not grayed out.

Mixer Palette

The Mixer palette (Figure 1.31) is based on a traditional artist's palette. There is a scratch pad known as the Mixer Pad on which you can apply, mix, blend, and sample colors using a variety of special Mixer tools. These tools are accessed by clicking on small icons displayed below the Mixer Pad.

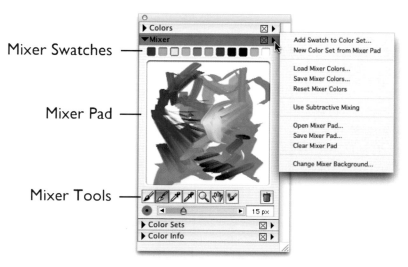

Mixer Swatches

Mixer Pad

Mixer Tools

Figure 1.31 The Mixer palette.

From the Mixer pop-up menu (small solid black triangle in upper right corner) you can save the Mixer Pad colors and image or convert the Mixer colors into a new color set.

Color Sets

Color Sets can offer you power, elegance, and consistency in your choice and application of color. Color sets allow you to restrict your palette to a particular range of colors and easily pick those colors just by clicking on the color squares. They are ideal if you wish to limit your palette of colors and keep consistency of colors throughout a project. There are many different color sets supplied with Painter, and it is easy to create your own custom color sets.

When you first open the Color Sets palette you'll see a series of color swatches displayed, with the name of each color listed beside the swatch. Unless you need to know the actual names of colors, I recommend going to the Color Sets pop-up menu (click on the small solid black triangle in the upper right of the palette) and uncheck Display Name (Figure 1.32). You will then see all the swatches visible simultaneously. The Color Sets principle is simple: you click on a swatch, and that becomes your current color.

The default color set has a range of traditional oil paint pigment colors. To access other color sets, choose Open Color Set from the pop-up menu. Then locate the Color Sets folder in the Corel Painter IX application folder and select a color set from those listed within the folder. Note that the default color set is called Painter Colors and is located in the Corel Painter IX application folder *outside* of the Colors Sets folder. The JeremyXtraColorSets folder can be copied over from the Painter Creativity Companion CD into the Corel Painter IX application folder, and its contents will then be accessible through the Open Color Set command.

If you choose New Empty Color Set from the Color Sets pop-up menu, you can pick your own colors from the Colors palette or from an image and save them one at a time into your new custom color set (you would simply click on the Add Color to Color Set button, second from the right at the bottom of the Color Sets palette). You can edit any color set, adding or taking away colors, at any

Figure 1.32 The Color Sets palette showing pop-up menu.

time from within the Color Sets palette. Adding colors to a color set as you work can be useful in building up a color set of your favorite colors over time.

One of the useful applications of creating your own color sets is when you wish to emulate the color palette of an artist. You can open a scanned image of that artist's artwork and then select New Color Set from Image in the pop-up menu. You'll instantaneously generate a new color set based on the colors that artist used. After creating a custom color set, choose Save Color set, give it a suitable name, and save it in the Color Sets folder (or any other location) in the Corel Painter IX application folder.

Sampling from an Image

The Dropper tool can be used to sample color from any active image in Painter. When you have the brush tool selected and do NOT have the clone color button checked in the Color palette, then the Option/Alt key turns your cursor into the Dropper tool.

Resetting the Clone Source Point

If you use the key shortcut Option/Alt when painting with the clone color button checked, you will reset the clone source point to wherever you click in the image (your cursor will become a crosshair when you press the key followed by a green dot and the number "1" when you click in the image).

Removing Paint

When you're painting, I encourage you to avoid the temptation of erasing, deleting, and undoing brushstrokes to get things perfect. Although the computer offers many convenient ways to edit and remove paint, your paintings will take on greater depth, richness, and interest if you build up your brushstrokes, even when you're not happy with them, rather than deleting them. Be committed to your marks. Let every mark contribute to the fabric of your painting. Having said that, here's a brief synopsis of what options are at your fingertips when you do wish to remove paint.

Erasing

The Eraser variants in the Erasers category of brushes erase to the paper color (which is white by default but can be set for the active canvas to be the current Main Color by selecting Canvas > Set Paper Color). The Bleach variant simply bleaches out the color on the canvas until it is white, independent of the Paper Color. The bleach gives a similar effect to the Dodge variant in the Photo category of brushes. Try the Eraser variants on your painted image. You can also simply turn your stylus over on its end and use the large eraser at the opposite end of the stylus tip (although I find this a bit cumbersome). You can also just paint with white using any brush that adds color to the canvas.

Deleting Selected Regions of Your Canvas

You can use a selection tool (e.g., lasso or rectangular/oval selection tool) to select a region of canvas. If you want a soft edge to your deletion, choose Select > Feather and feather the selection by 10 pixels or so. Then select Delete/Backspace to delete to the Paper Color.

Clearing Your Whole Canvas

1 Select Cmd/Ctrl-A (equivalent of choosing Select > All). You'll see dancing ants around the perimeter of your canvas (unless the perimeter is beyond the limits of the screen).

2 Click the Delete/Backspace key on the keyboard. Your canvas clears to the paper color, white by default, unless you have created any Watercolor or Liquid Ink layers, in which case you'll see those remaining (you cleared only the background canvas).

Undoing Individual Brushstrokes

To undo individual strokes, use the Cmd/Ctrl-Z (up to 32 levels of undo).

Fading a Brush Stroke or Effect

It is also possible to partially undo a brushstroke or effect by selecting Edit > Fade. This is a particularly useful feature for effects, since the small preview windows in the effects dialog boxes often lead you to underestimate the influence of the effect when applied to the whole canvas.

1.7 Brushes That May Make You Scratch Your Head

Most brushes are straightforward to use and behave in logical, predictable ways. You just pick the brush and then paint with it directly on your canvas. You'll typically see color painted onto the canvas or interaction with color already on the canvas or both. You'll notice a myriad of subtle differences in behavior, such as some brushes covering up other colors, some mixing with other colors, some showing paper textures, some changing size with pressure, and so on. You don't need to know anything special; just try them and see what they do.

As you explore Painter's brushes you will inevitably run into some mysteries. Some brushes don't seem to paint any color (some Blenders and Distortion brushes, for instance). Some brushes paint with a color different from that chosen in the Colors palette color picker (cloners take color from the default clone source, the currently selected pattern in the Patterns library). Some brushes (Watercolor and Liquid Ink) paint into special layers, and when you try painting with other brushes after using either of those, you get a warning telling you that only Watercolor/Liquid Ink brushes can be used on Watercolor/Liquid Ink layers. These are all examples of brushes that may make you scratch your head.

What follows are the few extra steps you need to follow to realize the full potential of these "scratch your head" brushes: Image Hose, Cloners, Watercolor, Liquid Ink, and Impasto.

Image Hose

Painting with Sequences of Image Elements

The Image Hose Brush Category is represented by the icon showing a garden hose nozzle with green clover leaves spewing out of the end. When you paint with it, you will see a succession of images being painted onto the canvas.

Nozzle Selector

The set of images that are being painted are known as a Nozzle. The Nozzle selector is located in the lower right corner of the Toolbox (Figure 1.33).

Image Hose Variants

The variants for this brush category are unlike all others (Figure 1.34); they do not indicate different brush variants but simply different ways that the nozzle elements are distributed as they leave the Image Hose. For instance, in the "Spray-Size-P Angle-D" variant, "Spray-Size-P" means the size of the elements, and their proximity to each other as they are sprayed out is determined by stylus pressure. "Angle-D" means the direction of the Nozzle image elements follows the direction of your brushstroke.

Figure 1.33 The Nozzle selector.

Figure 1.34 The Image Hose variant list.

Select different nozzles and try them out. Choose different variant options and see their effect. Try light pressure as well as heavy pressure. Try short dabs as well as long strokes.

Picking up the Additional Color in the Image Hose

1. Choose a bright color in the Color Picker.
2. Click on the exchange arrows to make that bright color go to the Additional Color rectangle.
3. Move the Grain slider to the left in the Property Bar.
4. Make a brushstroke and note how the nozzle color changes when you paint.

Creating Your Own Image Hose Nozzles

1. Paste your nozzle contents as layers in a file.
2. Select all the layers in the Layers palette by clicking on each one with the Shift key held down or choosing Select All in the Layers pop-up menu.
3. Select Cmd/Ctrl-G to group the layers.
4. Select Make Nozzle from Group from the Nozzles pop-up menu located in the top right of the Nozzles selector in the Tools palette.
5. Save the resulting file as a RIFF file with the name you wish to call your nozzle.
6. Choose Cmd/Ctrl-L.
7. Locate your nozzle file and click Open.
8. Apply the nozzle on your canvas.
9. Select Add Nozzle to Library. Your custom nozzle will now be part of the current Nozzle Library.

Cloners

Powerful Image Transformation Tools

The Cloners variants look at a clone source for their source of color, rather than the Colors palette color picker (which is usually grayed out when Clone Color is active). There are numerous different Cloner variants, many of which act as artistic filters that you selectively apply by hand rather than apply instantaneously and globally over the whole image, as you do when applying an effect.

You are not restricted to the Brush Variants of the Cloners Brush Category to clone from one image (source image) into another (destination image). You can turn almost any brush in Painter into a Cloner brush simply by checking the Clone Color Box in the Colors palette. This makes Painter

a phenomenally powerful image transformation tool, since you can hand-paint a clone transformation using an almost unlimited variety of brushes. Please refer to Chapters 4 and 5 for in-depth information on how to transform photographs with the use of cloning brushes.

The Default Clone Source

The default clone source in Painter is the currently selected pattern (Window > Library Palettes > Show Patterns). When you first use the Cloners you'll often see a mysterious grey pattern appear on your canvas, which happens to be the colors in the default current pattern. Changing the pattern in the Pattern Selector will change what the cloning brushes paint if the pattern is the current clone source. The current clone source can be identified by choosing File > Clone Source and seeing what has a checkmark by it (Figure 1.35).

Starting with a Photograph

If you start with a photograph open in Painter and then choose either File > Clone and File > Quick Clone, a duplicate image is generated (clone copy) and the original photograph is automatically made the clone source. The Quick Clone function may also delete the clone copy image and turn on Tracing Paper. All this is explained in Chapters 4 and 5.

Watercolor and Liquid Ink

Layers

Watercolor brushes give beautiful, soft watercolor washes and effects. Liquid Ink brushes produce some astounding graphic and resist effects. Both Watercolor and Liquid Ink brushes paint into special

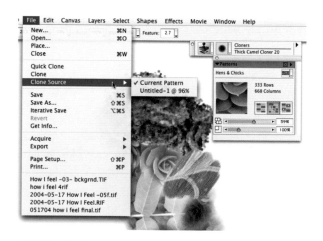

Figure 1.35 The current pattern is the default clone source.

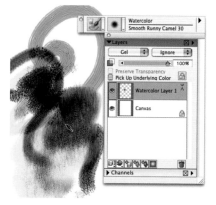

Figure 1.36 The Watercolor brushes generate a special watercolor layer.

layers that are separate from, and sit above, the regular background canvas (Figure 1.36). These layers are generated automatically as soon as you apply a Watercolor/Liquid Ink brush to your image. You can see these layers listed in the Layers palette.

After you've applied Watercolor /Liquid Ink brushes, if you then try to apply a non-Watercolor/ Liquid Ink brush, you'll get a warning "Only Watercolor / Liquid Ink brushes can be used on Water-color/ Liquid Ink layers." Outlined next are several alternative ways you can overcome this error.

Painting Beneath a Watercolor/Liquid Ink Layer

To preserve the Watercolor/Liquid Ink layer and paint underneath it with other non-Watercolor/Liquid Ink brushes, click on the Canvas layer in the Layers palette. The Canvas layer will now be highlighted and you can continue painting with non-Watercolor/Liquid Ink brushes on the background canvas beneath the Watercolor/Liquid Ink layer. Any time you wish to add Water-color/Liquid Ink brushstrokes to the Watercolor/Liquid Ink layer, just reselect that layer. Note that the editability of Watercolor/Liquid Ink layers with Watercolor/Liquid Ink brushes is only preserved in the RIFF file format.

Deleting Watercolor/Liquid Ink Layer

1 Click on the Watercolor/Liquid Ink layer in the Layers palette. If you have more than one layer you wish to delete, hold down the Shift key as you select each layer.

2 Click on the trashcan icon in the lower right of the Layers palette.

Dropping Watercolor/Liquid Ink Layer

1 Click on the Watercolor/Liquid Ink layer in the Layers palette. If you have more than one layer you wish to delete hold, down the Shift key as you select each layer.

2 Click on the left-hand icon in the lower left of the Layers palette and drag down to Drop.

This flattens your image, placing what was in the Watercolor or Liquid Ink Layer onto the background canvas, and allows you to paint over those marks with other brushes.

Digital Watercolor

The Digital Watercolor brushes paint directly onto either the background canvas or a regular image layer. They act as if they are in a separate layer and are not affected by the blending tools in other brush categories. If you wish to paint over Digital Watercolor or blend it into the background, choose Dry Digital Watercolor from the Layers palette pop-up menu.

Impasto

Adding the Illusion of Depth

The Impasto category of brushes is a group of brushes that add three-dimensional depth to their brushstrokes, almost as if you are embossing the canvas as you paint. They are designed to emulate

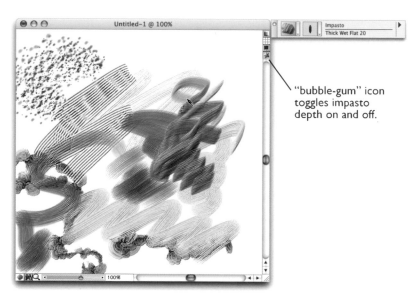

"bubble-gum" icon toggles impasto depth on and off.

Figure 1.37 Impasto brushes add the appearance of depth.

the traditional painting technique of applying thick paint to your canvas (Figure 1.37). They can give you some fabulous effects but also cause much confusion and frustration. Once you have painted with an Impasto brush, the three-dimensional embossing appears to remain in your image, even when you try to paint over it with other, non-Impasto brushes. It is as if the Impasto depth is recorded in a separate layer (one that does not appear in the Layers palette). You can control whether an Impasto brush actually generates the depth by choosing Window > Brush Controls > Show Impasto. By changing the "Draw to" pop-up menu from "Color and Depth" to "Color," you change the Impasto brush into one that doesn't add depth. Whether you like the depth is a matter of taste.

Turning Off the Impasto Layer

You can turn the impasto effect off and on by clicking on the small purple "bubble-gum" star-shaped icon that appears in the upper right of the image window frame. You have to go out of screen mode to see this icon by choosing Cmd/Ctrl-M if your canvas is mounted.

Dropping the Impasto Layer

If you wish to drop the impasto depth layer onto the background canvas, either so you can paint over it in Painter or so you can preserve the impasto depth effect when you open the image up in Photoshop, then choose Save As and save the file as a TIFF file. Close the TIFF file and then reopen it. This will automatically flatten the impasto depth layer.

Erasing a Portion of the Impasto Layer

There are two erasers within the Impasto brush category, the Depth Color Eraser, which erases everything, including the depth effect and any color on the canvas, and the Depth Eraser, which seems to leave a subtle indentation. If you wish to erase just a portion of the impasto depth, I suggest you save two versions of your file, one with impasto on and one with impasto off, clone one, set the other as clone source (File > Clone Source), and then use the Cloners > Soft Cloner to clone from one into the other.

1.8 Foundation Projects

The "How I Feel" Painting Project

1 Choose Cmd/Ctrl-N.

2 Open a new canvas 700 pixels wide by 700 pixels high.

3 Choose Cmd/Ctrl-M to mount the canvas in screen mode.

4 Play with the brushes on the canvas. Create an image that expresses how you feel. It can be abstract. Don't undo or erase, just keep building up brushstrokes on top of one another. Use this painting as a way to explore the multitude of wonderful brush variants contained in all the different brush categories. Explore the effect of different pressure, speeds, and directions. Spend 30 minutes on this project.

The "Visual Glossary" Project (Optional)

This project is the creation of your own visual glossary of brushes. The goal is to create a series of paintings that capture the look and feel of the brushes from each category, like the ones shown earlier in this chapter. The experience of making your own visual glossary will familiarize you with the brushes. You could choose a theme and make each painting a variation on that theme.

1 Choose Cmd/Ctrl-N.

2 Open a new canvas 500 pixels wide by 500 pixels high.

3 Choose Cmd/Ctrl-M to mount the canvas in screen mode.

4 Paint with all the variants from the Acrylics brush category.

5 When you have filled your canvas with paint, select File > Save As and save the file as acrylicspainting.rif into your "Painter Projects Chpt01" folder.

6 Repeat steps 1 through 5 for all the brush categories. Note some categories, such as Blenders, will require painting over an existing image. You can use another category of painting for this purpose.

1.9 Wrap

Congratulations on mastering the Painter basics. You are now familiar with the Painter desktop and know how to select, control, and apply brushes. If you run into any problems, refer to Appendix II: Troubleshooting.

You are ready to move onto the next step, which is not just how to use Painter, but how to use it smartly. In Chapter 2, "Foundation II: Creative Empowerment," you'll learn about the three guiding principles of making the most of Painter—Simplify, Organize, and Optimize. These principles will help you be more creative, more productive, and more efficient.

2

Foundation II: *Creative Empowerment*

We are what we repeatedly do. Excellence, then, is not an act, but a habit.

—Aristotle

2.1 Introduction

Now that you have set up Painter's preferences and become familiar with Painter's user interface and basic operations, you are ready to enact the three guiding principles for making the most of Painter: Simplify, Organize, and Optimize.

Applying these three principles will help you be more creative, more productive, and more efficient when using Painter. The most important advice to glean from this chapter is to be thoughtful about the way you save, organize, and name your files and to establish the good habit of regularly documenting and backing up your work. Painter IX assists in this with the introduction of the new Iterative Save feature.

2.2 Overview

Here is an overview of the three guiding principles.

Principle I: Simplify

Keep things simple. Simplify your palette groups and save your palette layouts.

Make things easy and comfortable.

Avoid distractions. Be selective about what is visible on your desktop. Work with images in screen mode whenever possible.

Principle II: Organize

Be organized (inside and outside Painter).

Always start Painter afresh when beginning a new project and close Painter at the completion of a project.

Adopt consistent, meaningful naming conventions for everything. That includes files, custom variants, layers, scripts, custom palettes, custom libraries, and so on.

Organize and maintain a consistent file and folder hierarchy so you always know where everything is saved.

Begin with the end in mind. Work backward in determining the file size and resolution you need to begin a project with.

Meticulously document the progress of every project. Save stages and versions, each with a sequentially numbered file name, especially immediately prior to dropping layers or applying effects.

Where possible, record and save scripts of your painting sessions.

Back up and archive all of your data, in duplicate (stored in two separate dark, cool, dry locations), onto CD-ROM or DVD, on a regular basis. Catalog the contents of your archive disks for convenient and easy access to old files.

Principle III: Optimize

Maximize the power of Painter. Maximize your choices of brushes and art materials.

Take advantage of the full dynamic range and versatility of each brush you use.

Customize and save brush variants to suit your individual needs and preferences.

Customize and personalize your arrangement of variants and categories within your Painter brush library.

Save meaningfully named, efficient palette arrangements to suit different tasks, operations, and, where relevant, different screen resolutions.

Conduct brush research prior to commencing on a project as well as during a project. Since brush research and creation is such an important and major subject the whole of chapter 3 is devoted to this.

We now look at each principle in more detail.

2.3 Principle I: Simplify

Figure 2.1 Simplify.

Painter Feng Shui

Adopting well-organized strategies and principles when using Painter makes all the difference between being able to flow with your creativity and continually getting frustrated and caught up in technicalities. You can apply the organizing principles of Feng Shui (pronounced "fung shway") to Painter with great success. Feng Shui is the ancient Chinese art of creating a harmonious, beautiful, and balanced environment that nurtures and supports your health, happiness, and success. Such an environment allows your creative energy, or *chi*, to flow freely. Harmony, beauty, balance, and free flow of energy are exactly what you need within your digital environment, the virtual workspace on your computer screen, to realize your full creative potential and to express yourself in your art with soul and passion.

The Painter workspace has a tendency to get cluttered and busy. It is like the law of nature that says that entropy, or disorder, in the universe tends to increase. After some time working in Painter, you may well find palettes overlapping and obscuring each other. At this point the tools become barriers to creativity, distracting rather than empowering. That is why being organized and systematic makes such a big difference.

Adopting consistent principles, methodical strategies, and good habits makes everything flow more easily and, ultimately, frees you up to be totally immersed in your creative process. Your tools should empower you, not distract you.

In Painter you have the capability to customize almost every aspect of brush behavior. You also have the ability to personalize and customize the interface and palette layout. Being spoiled by choice is a double-edged sword: It gives great power but also can distract and overwhelm.

The key to harnessing the full power of Painter is to constantly simplify. Make life easy for yourself. Simplicity makes an enormous difference in the ease of use of Painter and in sorting out problems when you come across them.

Simplify Your Palettes and Minimize Your Desktop Clutter

Have Visible Only the Palettes You Need to Access

You can show or hide individual palettes simply by choosing Windows > Hide or Show (palette name) or by using the palette keyboard shortcuts. Show just the palettes you need for any given task and hide the others. When painting on an image, you may find it useful to hide all the palettes, which you can do by clicking with the Tab key (shortcut for Window > Hide/Show Palettes), which toggles between hiding and showing the palettes. When you want the palettes back again, you just press the Tab key again. It is also useful to hide all the palettes when taking stock of where you are at in your image creation. Just like a traditional artist stepping back from his or her canvas, from time to time you should mount your image so it fills your screen (Cmd/Ctrl-0), hide your palettes (Tab), and step back from your computer.

Group Your Palettes to Suit Your Task

You can group and ungroup palettes simply by placing your cursor over the central part of the palette title bar and then dragging it into or out of a group of palettes. You can hide palettes by clicking the close button (the square with the "X" in it), located on the right side of each palette title bar. Once you have selected which palettes you need for a task, then I suggest you group them together so that as you open one palette it doesn't obscure any others (which happens easily if you just place ungrouped palettes on top of each other). For some tasks where you need to see more palettes, such as working with text and collage, where you may wish to see layers, text, and channels all at the same time, then it may be better to make two groups of palettes and to place them on either side of your screen (or on a second monitor if you have one). Your palette grouping may depend on your monitor size and resolution and on whether you have a second monitor dedicated to your palettes.

Save Your Palette Layout

When you've set up your palettes in a convenient and efficient arrangement for basic painting, save your palette layout (Window > Arrange Palettes > Save Layout).

If I am doing a presentation, my screen resolution may be smaller (800 × 600, for instance) than when I am working on a project in my studio. Including the resolution in the layout name makes it easy to get the appropriate layout to suit the screen resolution. Otherwise you may find that palettes mysteriously seem to disappear off the edge of the screen.

You can always save more layouts and delete old layouts. As you use Painter more and more, you'll find that certain layouts work well for certain tasks. It is useful to be able just to go to Window > Arrange Palettes and select your custom layout instantaneously.

2.4 Principle II: Organize

Figure 2.2 Organize.

Files and Folders

Organize Your Files and Folders on Your Hard Drive

Think ahead about how you are going to name your files and folders and where you are going to save work for different projects. Be consistent and methodical. Think about how you may want to search

for and access specific files in the future. I suggest a simple system such as folders titled by project title containing files titled by subject, version number, and file type.

Adopt a Consistent and Logical Naming Convention for All of Your Files Right from the Start

One naming methodology you may wish to consider is reverse date: project name: version number: brief note: file format tag. By having the reverse date (YY-MM-DD year/month/day notation, e.g., 05-10-25 for October 25, 2005) at the beginning of your file names, you ensure that your files line up chronologically when displayed as a list (providing you separate your pre–January 1, 2000, files from your post–January 1, 2000, files). An example of applying this naming methodology is: "05-10-25slfprtrt03-sqchlk.rif," where the date is October 25, 2005, the project name is self-portrait, the version is 03, and the brush used between the time version 02 was saved and the time version 03 was saved is the Square Chalk.

If your project spreads out over some time, I suggest you save your project files in a single folder and do not include the reverse date notation. This also allows more space for a brief note in the file name that is useful for recording what brush you used or effect you applied in that particular version of the image (file names on the Macintosh are limited to 27 characters, excluding the file format tag).

On the Macintosh I prefer to use a period rather than a dash for the reverse date and a dash before the version number, so my file names look like "05.10.25 slfprtrt-03-sqchlk.rif." You may wish to keep your file names shorter and simpler, in which case "subject_001.rif" would work fine and allow you to take advantage of the Iterative Save function as well. Whatever system you decide on, keep to it and be consistent with file naming. You'll be pleased with this approach later on when you're searching for specific files from a particular project.

Differentiating Between Save, Save As, and Iterative Save, and Knowing Which to Use When

One safe approach to saving is to start with a Save As, naming that first file as version -01. As you work, regularly select the keyboard shortcut Cmd/Ctrl-S, or File > Save, which updates the file. When you are about to apply an effect or drop a layer or make any other significant change, do a final Cmd/Ctrl-S, make the change, and then click the Save As button and rename the file as version -02. Continue as before with regular saves until the next major transition in the image. This methodology is the safest way to avoid losing work in the event of a computer crash or program freeze. It also minimizes the versions saved to just those necessary to preserve the main transitions of the image.

There is also a File > Iterative Save option (Option-Cmd-S on Macintosh or Alt-Ctrl-S on Windows). The Iterative Save automatically adds a three-digit sequential version number (_001, _002, _003, etc.) to the end of the file name (before the file format tag) and saves the new file version in the same folder as the original file. Although this is a handy option, it has the disadvantage of not including any notes about what brushes you used and the like. I would recommend you get in the habit of using Save As and adding brief notes to your file names.

This organizing principle extends to immediately and consistently renaming all custom palettes, clone copies, and layers within Painter. Painter automatically generates default names, such as

Custom 1, Clone of . . . , Layer 1, etc. When working with complex projects, these default names start to get confusing, and you'll find yourself wasting a lot of time trying to work out which file is which and which layer is which. Rename meticulously and immediately whenever a default name is generated. You'll avoid any confusion and save yourself a lot of time in the long run.

File Format

In the Save As dialog box, you have a choice of file formats. As a general methodology to follow I recommend that you save your works in progress within Painter in the RIFF (raster image file format) format, the native format of Painter. RIFF files can only be opened in Painter. RIFF files preserve the most data of any file format within Painter. RIFF files preserve the ability to edit all types of layers, including text layers, watercolor layers, liquid ink layers, and dynamic plug-in layers (accessed through the Dynamic Plugins icon, second from left at the bottom of the Layers palette). RIFF files also preserve the full functionality of composite methods, digital water color, impasto, and mosaics. The only other file format available to you in Painter that preserves layers is the Photoshop format. However, in the Photoshop format certain types of layers (such as watercolor, liquid ink) are converted to default image layers and lose their special properties.

Always make a backup file in Photoshop file format before you close Painter, even if you are still in the middle of a project, and when you complete a project. This backup file is important. There have been cases where large RIFF files in earlier versions of Painter became corrupted. Your Photoshop file format backups will allow you to conveniently go back and forth between Painter and Photoshop. The reason I suggest backing up into Photoshop file format instead of TIFF file format is that saving in the TIFF format from within Painter doesn't support layers or save channel or mask information. TIFF format is good for printing, but Photoshop file format is better for safe, versatile, and high-quality backup. Be aware that the Photoshop format will, as mentioned earlier, automatically convert special layers such as Watercolor and Liquid Ink into regular bitmap image layers (you cannot use Watercolor or Liquid Ink brushes on image layers) and merge the impasto depth layer into the background canvas. You will find when you save a file in Painter in both RIFF format and Photoshop format, the RIFF file is usually more compact (takes up less memory) than the Photoshop format file.

If you know in advance that you are not going to use Watercolor or Liquid Ink brushes or change composite methods, then you could save all your versions in Photoshop format. As a general practice I recommend saving your working files as RIFFs since that way you are not limiting yourself from spontaneous experimentation with the full range of tools at your disposal in Painter.

Keyboard Shortcuts

1 Choose Edit (or Corel Painter IX in Mac OS X) > Preferences > Customize Keys. You will find in the Customize Keys window a comprehensive summary of all keyboard shortcuts in Painter and the ability to add further shortcuts and modify default shortcuts (in the process

creating your own customized "Key Set"). You can create shortcuts for almost every menu item in Painter. The Customize Keys preferences window allows you use any keys, including F keys, either alone or combined with a modifier such as Shift or Cmd/Ctrl or Option/Alt, to be a shortcut for any menu item in Painter. Thus if you're more comfortable with keyboard shortcuts than with clicking buttons onscreen or selecting items in menus, then take advantage of this facility. Here's how to set your own keyboard shortcuts.

2 Select menu item from within the Customize Keys window.

3 Type in the desired shortcut to the right of the name.

4 Select Accept.

5 Select OK.

6 Continue assigning other function key actions.

The Wacom Intuos3 tablet control panel has Tablet Keys and a Touch Strip that can be customized to represent commands and menu actions (see Chapter 1).

Document and Archive

What Is Meant by Document?

Document in this context means to:

1 Document the brush looks at your disposal.

2 Document your process and methodology meticulously as you work.

3 Back up, archive, and safeguard your data on a regular basis.

Document Your Work Meticulously

Keep versions as you work on a project (do not just overwrite files). That means frequent use of Save As rather than Save. Back up regularly. Backup in both RIFF and Photoshop file formats. Memory and storage is relatively inexpensive. The digital medium presents us with a wonderful opportunity to save a progression of stages as we create a painting. Save separate versions regularly.

Document Your Process

It is important to save separate versions regularly. I emphasize saving separate versions, each with a distinct file name, rather than simply overwriting an existing file, because of the versatility you gain in being able to go back to earlier versions of a project. As a habit click on your Save As or Iterative Save buttons (in your custom Shortcuts palette) and save a new version number rather than File >

Save (Cmd/Ctrl-S), which simply updates the file. I also recommend you get in the habit of recording scripts of your painting sessions. This is easy to do and can be powerful as well as fun. Please refer to Chapter 10 for detailed instructions regarding recording and playing back scripts.

Back Up Regularly

One big difference between creating a traditional painting and creating a digital one is the fragility of the digital file. Almost everyone creating art on the computer has experienced the accidental loss of a piece of artwork at some time or another. It is easy to accidentally lose your artwork at the flick of a keystroke or when your computer crashes.

Meticulous documentation and regularly backing up pays big dividends down the road, sometimes when you least expect it. For instance, you may find a new use many years later for an intermediate version of an artwork. The need to edit or repurpose artwork is not always predictable. It is better to prepare for future versatility than to regret not doing so. The bottom line: Back up regularly!

2.5 Principle III: Optimize

Figure 2.3 Optimize.

Thus far you've familiarized yourself with Painter's interface and taken care of your workspace organization. The next step is to maximize your creative power within Painter. The creative power offered by a tool is related to the variety of choices the tool offers you—for instance, the type of marks that can be made and the control you exert over those choices and how they are applied. This can be summarized as: Power = Choice × Control.

The goal here is to maximize both your choices and your control. You increase your brush choices by loading extra brushes not normally installed with Painter. You maximize your control over the brushes by creating, saving, and organizing customized brush variants.

Maximize Your Choices

Load Extra Brushes

The Painter IX Creativity Companion Resource CD contains a wealth of fabulous extra brushes that do not get automatically installed when you install Painter on your computer hard drive. I have put together a special custom category of brushes, Jeremy Faves 2.0, that include my favorite brushes from earlier versions of Painter as well as brushes made by artists who have generously allowed me to share them with you. For detailed instructions as to how to load the extra brushes from the Painter Creativity Companion CD please refer to Chapter 1.

Maximize Your Control

Controlling Your Brushstroke: Enso Paintings

In this exercise you will follow in a Zen-painting tradition of painting circles known as *enso* (look up "zen painting enso" on the Internet search engine www.google.com to find links where you can see examples of ensos and learn about their historical background). The purpose of asking you to paint circles is to focus you on controlling your stylus and, consequently, your brushstroke. Without learning to fully control a single brushstroke, all other attempts to maximize your power within Painter are meaningless.

Background

Ensos were popular expressions of spiritual vision and discipline in the sumi-e tradition (Japanese ink painting) among the Zen monks during Japan's Edo period (18th century).

The Sumi-e Society Midwest has an elegant description of the Sumi-e philosophy on their Web site (http://www.silverdragonstudio.com/sumi-e). Here is an excerpt.

The philosophy of Sumi-e is contrast and harmony, expressing simple beauty and elegance. The balance and integration of the two dynamically opposed forces of the Universe are the ultimate goal of Sumi-e.

The art of brush painting aims to depict the spirit, rather than the semblance, of the object. In creating a picture the artist must grasp the spirit of the subject. Sumi-e attempts to capture the Chi, or "life spirit," of the subject, painting in the language of the spirit.

Patience is essential in brush painting. Balance, rhythm, and harmony are the qualities the artist strives for by developing patience, self-discipline, and concentration.

The goal of the brush painter is to use the brush with both vitality and restraint, constantly striving to be a better person because his character and personality come through in his work.

The enso has many interpretations and levels of meaning. The expressiveness of the circle is created by a synergy of control and accident. Every enso is unique, influenced by the way the brush hairs spread out on the paper, the texture of the paper, the way the artists load their brush with ink, and the speed and pressure variation of their brush as they make the circle. Similarly, in Painter every enso is different, depending on the way you change pressure, the speed of your stroke, and so on. Traditionally, painting an enso was part of meditation and was a way to attain an enlightened state of mind. In more modern times the enso has been adopted as the basis for corporate logos, such as Bell Labs' Lucent Technologies division (see www.lucent.com).

The following two paragraphs are excerpts from an enso gallery Web site that is no longer on the Web.

How is the enso created?
The enso is created when the Zen calligrapher (traditionally a monk) takes a large sumi brush full of ink while meditating on the emptiness of the blank paper. At the decisive "perfect moment" the monk quickly lays out the circle on the page. The circle contains both the perfection of the expressive moment and the imperfections of the ink, page, and brush. Outcomes vary from thin, smooth, nearly perfect circles to fat, rough squares, triangles, and spirals.

What does an enso symbolize?
The dynamic circle of the enso symbolizes many Zen ideas. On the surface, it may represent the full moon, the empty teacup, the turning wheel, the eye or face of the Buddha or the monk Bodhi Daruma, the dragon chasing its tail, and other poetic visual symbols. On a deeper level, the circle may symbolize the emptiness of the void, the endless circle of life, and the fullness of the spirit. Deeper still is the representation of the circle as the moment of enlightenment, the moment when the mind is free enough to simply let the body or spirit create, the moment when the perfection of the circle is committed to the emptiness of the page, and the moment of the chaos that is creation. Each enso shows the expressive movement of the spirit in time.

It is interesting, in the context of this Enso exercise, to read the comments made by the Russian painter Vasily Kandinsky in 1930 on what a circle means to him:

Why does the circle fascinate me? It is:

1 the most modest form, but asserts itself unconditionally,

2 a precise, but inexhaustible, variable,

3 simultaneously stable and unstable,

4 simultaneously loud and soft,

5 a single tension that carries countless tensions within it.

The circle is the synthesis of the greatest oppositions. It combines the concentric and the eccentric in a single form, and in equilibrium. Of the three primary forms, triangle, circle, and square, it points most clearly to the fourth dimension.

Instructions

1 Open Painter.

2 Open a new canvas 600 pixels wide by 600 pixels high (Cmd/Ctrl-N).

3 Mount your canvas (Cmd/Ctrl-M).

4 Make sure black is the selected color in the Colors palette.

5 Select the Sumi-e brush category > Thick Blossom Sumi-e variant from the Brush Selector.

6 Start with very light pressure and slowly paint a circle, steadily increasing pressure as you go.

7 Take your time.

8 Complete the brushstroke as you just start to overlap the beginning of the stroke (Figure 2.4).

9 Choose Save As and save the enso as enso-01.rif.

10 You may initially find it difficult to get a smooth, gradually increasing brush diameter as you initiate the stroke. If you find that the brush goes straight into a full-thickness stroke, then select Corel Painter IX/Edit > Preferences > Brush Tracking.

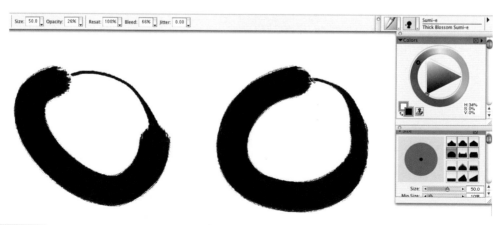

Figure 2.4 First-try enso on the left, second try on the right. Notice the smoother transition from small to large diameter in the second try.

11 Make a firm single brushstroke in the Brush Tracking window scratch pad.

12 Choose OK.

13 Repeat the enso stroke and see if you can achieve a smoother, more satisfying circle.

14 Choose Save As and save the enso as enso-02.rif.

15 Repeat the enso at least eight more times, saving each enso with a sequential version number (-03, -04, etc.), varying the way you increase pressure (for instance, waiting longer before increasing pressure) and varying the speed with which you make the stroke. You may find that adjusting the brush size will give a more satisfying result.

One-Brush Painting

Another great way to exercise and develop your brush control is through one-brush painting. This is when you create an entire painting using just one brush variant. You can change the brush size and opacity and the pressure you apply. Within this limitation see how rich a diversity of brush marks you can make with a single brush. Choose a brush that has an interesting/challenging brush shape or structure, such as the Pens > Leaky Pen or the Jeremy Faves 2.0 > Uncle Wiggly. This is a good exercise to try with a specific subject, such as painting from observation or based on a photograph. I suggest you try something now, and then come back to this same exercise again later, when you've developed more skills in Painter.

Maximize Responsivity

Good Memory Habits

Exit out of Painter periodically (always when you finish a project) and reopen it afresh. Painter generates a large temporary file that takes up memory, and reopening Painter clears this temporary file out of the memory and thus makes Painter work more efficiently and reduces the risk of crashes.

Work from Files on Your Hard Drive

Painter works most efficiently when it is working with files directly on a hard drive (internal or external), rather than working from files that are on removable media, such as Zip, CD, or DVD. As you use Painter, the program creates a temporary file that takes up space on your hard drive. If you are working with very large files, it is best to make sure that Painter creates this temporary file in a volume or partition that has plenty of available memory. This may mean assigning an external hard drive, rather than the default, which is your computer hard drive, as your Temporary File Volume. You can assign the Temp File Volume in the Corel Painter IX/Edit > Preferences > General window.

Keep Your File Sizes Manageable

Painter slows down with large file sizes, especially if there are layers. This is particularly noticeable with certain memory-intensive brushes. Work at the final resolution you need. If you find that Painter is responding too slowly, consider either working at a lower resolution or splitting your canvas up into sections and working on the sections separately. Painting your image in sections may be needed when you are working on a very large project, such as a mural, billboard, or extra large wall print.

Keep Your Libraries Lean

As you get deeper into using Painter, you may gradually build up a variety of custom art materials, such as papers and patterns, that will expand the size of your libraries. These extra items within your Painter libraries is a drain on the memory usage of Painter and acts to slow the program. This is especially noticeable if, for instance, you save very large images as papers or patterns (see Chapter 5 for a technique that uses this feature). To overcome and avoid overloading Painter, you will need to use the appropriate Mover to keep your libraries lean. Here's an example of how to create a custom paper and a custom paper library, copy that custom paper from your default Papers library to your custom paper library, and then delete your custom paper from your default library so that it no longer takes up memory. Whenever you wish to use the custom paper again, you can use the same Mover to copy the paper back into your current Papers library, or you can temporarily load your custom library as the current library. Everything that is said here about papers applies to every other type of library in Painter (patterns, gradients, scripts, nozzles, and so on) except the brushes library.

1. Open photograph.
2. Choose Cmd/Ctrl-A (Select > All).
3. Choose Window > Library Palettes > Show Papers.
4. Choose Capture Paper from the Papers pop-up menu.
5. Name your custom paper. You will now see the paper appear in the preview window of the Papers palette. You can apply this paper with any of the grainy brushes.
6. When you wish to clear this large texture from your current Paper library (called "Paper Textures"), choose Paper Mover from the Papers pop-up menu (Figure 2.5).
7. Click on the New button on the lower right of the Paper Mover.
8. Name your custom paper library (make the name different from your current default library—for instance, in this example I called mine "Jeremy's Papers"). For convenience for future access I suggest you save this custom paper library in the Corel Painter IX application folder, the same location as the default Paper Textures library. Note the new paper library you are creating is not a paper texture itself but simply a place where you can collect paper textures. It'll start off empty.
9. Click OK.
10. Click on the thumbnail that represents your custom paper texture in the Paper Textures library (the set of thumbnails on the left of the Paper Mover).

Figure 2.5 Selecting the Paper Mover from the Papers pop-up menu.

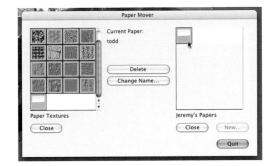

Figure 2.6 Copying a custom paper from one library to another in the Paper Mover.

11 Click and drag that thumbnail to the new empty library on the right of the Paper Mover. You'll see the thumbnail appear in that new library on the right (Figure 2.6).

12 Select again the custom paper thumbnail in the current Painter Textures library on the left of the Paper Mover.

13 Click the Delete key. You have now deleted the custom paper from the current library and thus freed up memory. Whenever you wish to use that custom paper in the future, choose Open Library from the Papers pop-up menu and locate your custom paper library. To return to your default library, choose Open Library again and select the Paper Textures library in the Corel Painter IX application folder.

2.6 Wrap

The principles outlined in this chapter are more a matter of good habits and attitude than of specific technique. Put these principles in the back of your mind and let them sink into all that you do and the way that you do it.

The next chapter, Chapter 3, Foundation III: Brush Creation, is valuable but not essential for the first-time user. Thus, if you're eager to get started on an art project right away, you may wish to skip to Chapter 4, Photo Techniques I: Pastel, Watercolor, and Oil. You can always come back to the brush creation chapter later.

3

Foundation III: *Brush Creation*

Every artist dips his brush in his own soul, and paints his own nature into his pictures.

—*Henry Ward Beecher*

3.1 Introduction

Why Create More Brushes?

With so many fabulous brush variants already supplied in Painter, why create more? It is true that you can get good results using just the default brushes in Painter without any modification. To help you cope with the vast preponderance of brushes, I have included in this chapter a review of some of my favorite brushes, grouped by look and feel. If you are new to Painter and are already feeling a little overwhelmed by the scope and depth of the program, I suggest you skip this chapter and come back to it at a later time, after you've become more familiar and more comfortable with the brushes. If you're eager to dig deep and stretch your creativity, then read on.

As you start working into different parts of your imagery you'll find you want to adjust the default properties of your brushes. There will be places where you want to use a broader, softer brush, for example, in the background, or a finer, sharper brush, for example, in bringing out detail in the focal region. You can often achieve the right balance of brush characteristics by modifying the size and opacity/strength sliders (in the Brush Properties Bar). You may be surprised at how much dynamic range is possible from a single brush just by adjusting size and opacity.

By extending your adjustment of brush behavior beyond just size and opacity you can create and control wonderful brush effects that enrich your paintings and provide exactly what you seek for your imagery. Beyond that there is also the joy of serendipity—the unexpected results that come of venturing into new territory. As Edward de Bono says: "It is better to have enough ideas for some of them to be wrong, than to be always right by having no ideas at all." In other words, nothing ventured, nothing gained. You have to be prepared to try out lots of brush customizations that don't light you up to find the few that set you on fire. This is part of how "every artist dips his brush in his own soul," to refer back to the chapter-opening quote. Creating your own brushes pushes your creativity and can also produce a unique signature look in your paintings that differentiates your artwork from that of anyone else.

Make Brush Research Part of Your Creative Process

Before diving into a painting project in Painter, take time to conduct brush research. Make it part of your creative process. Brush research can be simple, complex, or anything in between. At the simple

end of the spectrum, brush research could involve making just a single brushstroke and varying from light to heavy pressure. You can then adjust the Size and Opacity sliders accordingly. At the complex end of the spectrum, brush research can involve in-depth experimenting with the Brush Control palettes and the Brush Creator.

Welcome to the Wild West of Painter

In this chapter you will learn about customizing brush behavior by modifying settings at three levels: (1) the Property Bar, (2) the Brush Control palettes, and (3) the Brush Creator. The intention here is to give you sufficient knowledge to make your own unique discoveries. Any specific settings and customizations shared here are purely arbitrary and are the result of experimentation, trial and error. There are no fixed rules in brush creation—it's the wild west of Painter: anything goes!

By adjusting brush properties you are creating new custom brush variants, some of which may be slight modifications of the default settings and some of which may be completely different from the original variant. As you make changes to sliders and settings you will undoubtedly stumble across great brush looks that you love. If you don't save them as custom variants at the time you come across them, it is unlikely you'll be able to recall the exact setting from memory. Thus when you come across custom brush variants you like and would like to be able to return to and reuse in the future, then you will need to know how to save a custom variant. Since it's important to know how to save variants prior to generating brushes that you may want to save, we are going to start this chapter, after a review of my favorite brushes, with learning how to (a) save your custom brush variants and looks, (b) make your own brush categories, and (c) organize and edit your variants within brush categories. We will then go into examples of specific brush customization techniques. You'll find in the Jeremy Faves 2.0 brush category some of the custom variants shown here as examples.

3.2 Favorite Brush Review

I summarize here a few of the brushes I like to use. Some of the variants referred to are contained in the Jeremy Faves 2.0 brush category, which you'll find on the Painter IX Creativity Companion Resource CD. Instructions for loading these extra brushes are given in Chapter 1. To get a visual overview of brush looks, I recommend you also refer back to the Visual Glossary of brush categories at the beginning of this book. When I paint I typically adjust the Property Bar parameters, such as size and opacity, from their default values. I normally work with medium-to-low brush opacity so that I have more control and subtlety and can build up effects gradually. This list is not meant to be exhaustive or to be used as recipe. I encourage you to experiment and explore all the Painter brushes for yourself. I'm sure you'll discover lots of great brushes I've overlooked! Please let me know of any overlooked gems you discover.

For Diffuse and Oily Blending Effects (Figures 3.1 through 3.10)

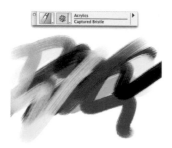

Figure 3.1 Acrylics > Captured Bristle.

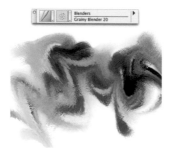

Figure 3.2 Blenders > Grainy Blender (shown blending the Captured Bristle strokes).

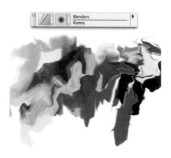

Figure 3.3 Blenders > Runny (shown blending the Captured Bristle strokes).

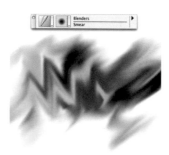

Figure 3.4 Blenders > Smear (shown smearing the Captured Bristle strokes).

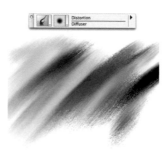

Figure 3.5 Distortion > Diffuser (shown diffusing the Captured Bristle strokes).

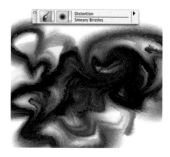

Figure 3.6 Distortion > Smeary Bristles (shown smearing the Captured Bristle strokes).

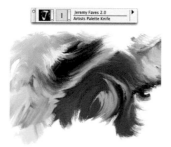

Figure 3.7 Jeremy Faves 2.0 > Artists Palette Knife (shown blending the Captured Bristle strokes).

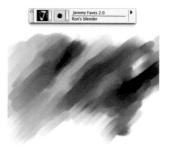

Figure 3.8 Jeremy Faves 2.0 > Ron's Blender (shown blending the Captured Bristle strokes).

Figure 3.9 Jeremy Faves 2.0 > Shmear.

Figure 3.10 Sponges > Smeary Wet Sponge.

For Diffuse Soft Water Color Blending (Figures 3.11 through 3.16)

Figure 3.11 Blenders > Just Add Water (lower opacity, shown blending the Captured Bristle strokes).

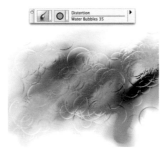

Figure 3.12 Distortion > Water Bubbles (shown applied over the Just Add Water).

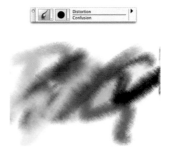

Figure 3.13 Distortion > Confusion (shown applied to the Captured Bristle strokes).

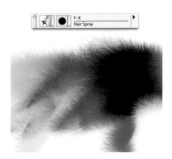

Figure 3.14 F-X > Hair Spray (shown applied to the Captured Bristle strokes).

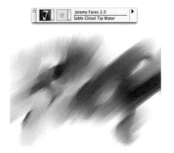

Figure 3.15 Jeremy Faves 2.0 > Sable Chisel Tip Water (shown applied to the Captured Bristle strokes).

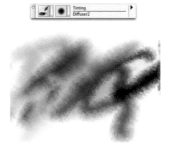

Figure 3.16 Tinting > Diffuser2 (shown applied to the Captured Bristle strokes).

For Diffuse Soft Water Color Coloring (Figure 3.17)

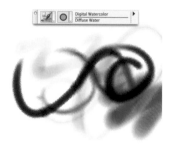

Figure 3.17 Digital Watercolor > Diffuse Water.

For Pastel/Chalky Looks (Figures 3.18 through 3.21)

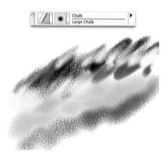

Figure 3.18 Chalk > Large Chalk.

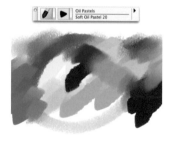

Figure 3.19 Oil Pastels > Soft Oil Pastel (adjust Jitter).

Figure 3.20 Oil Pastels > Chunky Oil Pastel (adjust Jitter).

Figure 3.21 Pastels > Square Hard Pastel.

For Artistic Thick Oily Looks (Figures 3.22 through 3.34)

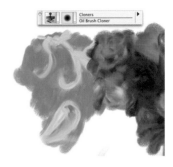

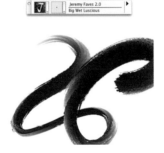

Figure 3.23 Artists > Sargent.

Figure 3.22 Artists > Impressionist.

Figure 3.24 Cloners > Oil Brush Cloner (Brush Controls: Impasto set to Color Only).

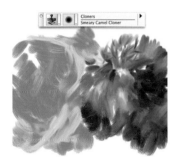

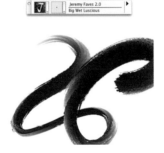

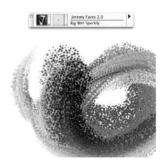

Figure 3.25 Cloners > Smeary Camel Cloner.

Figure 3.26 Jeremy Faves 2.0 > Big Wet Luscious.

Figure 3.27 Jeremy Faves 2.0 > Big Wet Speckly.

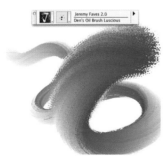

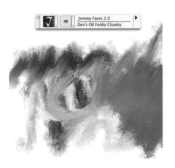

Figure 3.28 Jeremy Faves 2.0 > Den's Oil Brush Luscious.

Figure 3.29 Jeremy Faves 2.0 > Den's Oil Funky Chunky

Figure 3.30 Jeremy Faves 2.0 > Jeremy's MishMash.

CHAPTER 3 FOUNDATION III: *BRUSH CREATION*

Figure 3.31 Jeremy Faves 2.0 > Jeremy's MishMashPull.

Figure 3.32 Jeremy Faves 2.0 > modern art in a can.

Figure 3.33 Jeremy Faves 2.0 > Sherron's Blender Wood.

Figure 3.34 Jeremy Faves 2.0 > Wood.

For Smooth Oily Face and Skin Work

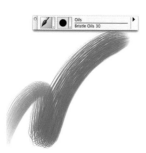

Figure 3.35 Oils > Bristle Oils.

3.3 Saving and Organizing Brush Variants

Saving Custom Brush Variants

You will first create a simple custom brush and then save it.

1 Select the Distortion > Distorto brush variant in the Brush Selector Bar.

2 In the Brush Property Bar, adjust the Opacity from 0 percent to about 24 percent (the exact value is not critical).

3 Try this modified Distorto out with different colors. Note the beautiful oily and smeary nature of the brushstroke and the way that the brushstrokes drag any underlying color along with them. I like to use this brush for eyes, in particular.

4 Select Save Variant from the Brush Selector pop-up menu (Figure 3.36).

5 Name the new variant something appropriately descriptive.

6 Click OK. The new variant appears as one of the variants listed in the current brush category and can be conveniently accessed at any time in the future.

Naming Custom Variants

I recommend you adopt an organized system for naming custom variants. For instance, begin each new custom variant with a space so that it goes to the top of the current variant list, followed by your initials so that you can easily identify and differentiate your custom variants from the default variants (allowing you easily to move your custom variants into a category of their own later). Finally, alter the variant name to indicate what it looks like.

If you made simple changes to the default settings, such as brush size and/or opacity, you may wish to keep the original variant name and add a modifier, such as "JS-Dry Ink Fine" or "JS-Dry Ink Huge". If your changes are dramatic you may wish to create a completely new name, as Denise Laurent did with her "Den's Oil Funky Chunky" (an all-time favorite, which you'll find in the Jeremy Faves 2.0 brush category).

Figure 3.36 The Save Variant command in the Brush Selector Bar pop-up menu.

Figure 3.37 Saving a custom variant in Brush Creator mode.

Saving a Custom Variant When Using the Brush Creator

The Brush Creator is a separate mode of Painter dedicated to brush customization and experimentation. You can open the Brush Creator with Cmd/Ctrl-B (Window > Show Brush Creator). The main Brush Creator window has three tab options: Randomizer, Transposer, and Stroke Designer. The three tabs provide you with three different ways to experiment with generating new brush looks. The Randomizer randomizes properties of a variant, the Transposer transposes the properties of one variant with those of another, and the Stroke Designer allows you to adjust advanced control settings. Note that the Stroke Designer settings are all contained in the Brush Control palettes, which you can access through the Window menu while in painting mode.

In all three Brush Creator tabs you can try out the current settings in the scratch pad. There is a Tracker palette that allows you to go back to any earlier versions you created along the way. The Brush Creator tools, art materials, and color palettes are accessible through the Window menu (different from the standard painting mode Window menu). When you are ready to save a custom variant created in the Brush Creator, you choose Variant > Save Variant from the top menu.

Restoring Default Variants

As you make changes in the variant settings, Painter remembers those changes. The next time you open Painter and return to that variant, you'll find it in the state you left it. Sometimes you may wish to return to the original default settings for the variant. You can do this for an individual variant by selecting the variant in the Brushes palette and then selecting Restore Default Variant from the Brush Selector Bar pop-up menu. If you'd like to restore every variant to its original default settings, you can do so in one fell swoop by selecting Restore All Default Variants from the same Brush Selector pop-up menu (or from the Brush Creator Variant menu). This will reset all of your brush variants to Painter's default settings. It will not get rid of your custom brushes.

Saving Your Custom Brush Looks

When you select a Paper Texture other than the default basic Paper, and if you change the paper scale (in the Papers Palette), this information is *not* saved with the variant information. In other words,

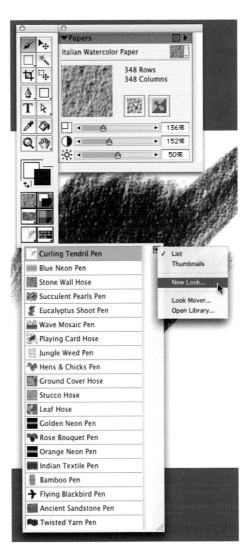

Figure 3.38 Saving a Brush Look.

when you return to a project and select the same variant, you have lost your custom paper settings. The way to save variant information *with* paper (and all other art material) information is to save the Brush Look.

1 Choose the rectangular selection tool.

2 Drag a square selection over a portion of your image that shows the look. This will become your new Brush Look icon.

3 Click on the small Brush Look selector in the bottom left corner of the Tools palette. This shows you the Brush Looks library pop-up.

4 Click on the small black triangle in the upper right corner of the Brush Looks pop-up.

5 Choose New Look. Name the look. It will now appear in the Brush Look library.

Making Your Own Brush Categories

As you use Painter you'll find there are certain brushes you love to use. You may find it useful to group these brushes together in a special "My Favorites" brush category. Alternatively, you may just wish to group together a collection of default or customized brushes that have common behaviors (e.g., "Smeary Brushes"). Creating new brush categories and then copying variants into those new brush categories makes it easy to group together your brushes in whatever way you wish.

1 Open a preexisting image (or paint an image) that you can use for the little icon, which will represent the new brush category in the Brush Library drawer. It can sometimes be useful to include simple lettering to indicate what the category is. Bear in mind that this icon will be very low resolution, only 30 pixels by 30 pixels, so it is best to keep the icon swatch simple.

2 Select the Rectangular Selection tool (middle lower row of the Tools palette, shortcut "r").

3 Drag the Rectangular Selection tool over the patch of image you want to capture as the new category icon.

4 Choose Capture Brush Category from the Brush Selector Bar pop-up menu (Figure 3.39).

5 Name the new Brush Category.

6 Click OK.

Note that the new brush category is now selected in the Brushes palette and has a single variant in it, which carries the same name as the category (categories can not be empty).

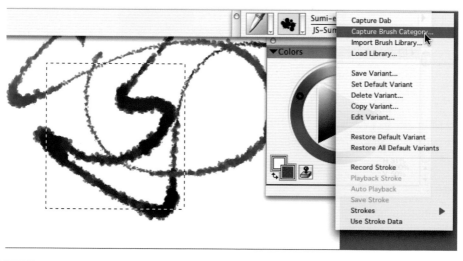

Figure 3.39 Creating a new a Brush Category.

Organizing and Editing Your Variants Within the Brush Categories

Once you have created different custom variants, spread throughout your brush library in different categories, you may wish to consolidate them by copying them into a single category so that they are all easily accessible in one location. This is where putting your initial at the beginning of the custom variant names helps you quickly identify them. Once you have copied them, you may wish to delete the duplicate that's left behind in the original category.

Copying a Variant from One Category into Another

1 Select the first brush variant from another brush category that you'd like to copy into the new brush category.

2 Select Copy Variant from the Brush Selector pop-up menu (or Copy from the Brush Creator Variant menu).

3 In the Copy Variant window, select the new brush category from the "Copy variant to:" pop-up menu (Figure 3.40).

4 Click OK.

Deleting an Unwanted Custom Variant

If you copied across a custom variant, you may wish to delete the earlier version so that you don't have duplicates of the same variant. Once you have copied other variants into your new custom brush category, I recommend you delete the variant with the same name as the category that was generated automatically when you first made the new category. Here's how you delete a variant.

1 Select the variant you wish to delete. Be careful not to accidentally select a default Painter variant.

2 Select Delete Variant from the Brush Selector Bar pop-up menu (or Delete from the Brush Creator Variant menu).

3 You'll be asked to confirm that you want to delete this variant in this particular category. If it is the correct variant, click Yes.

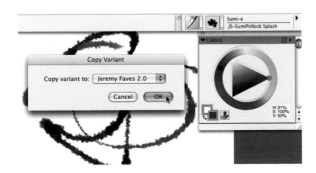

Figure 3.40 Copy Variant window.

Note that you can't undo the deletion of a variant, so always take great care. Also note that you can't delete the last variant in a category; there always has to be at least one variant in the category.

Sharing Variants Between Computers

To share a variant between computers, just copy the appropriate .xml file, together with any associated .jpg file, from one computer into the appropriate brush category folder of the Painter Brushes library in the other computer. It will then appear in the list of variants for that category when Painter is opened. This works across platforms. When copying a variant generated on a Macintosh computer into a Windows computer, you may need to select the Properties for the variant (right-click on the variant and drag it to Properties) and uncheck the "Read Only" box.

It is easy to get confused if you are downloading a custom brush from, say, the Web, and you are not sure where to place the file you have downloaded. It's always crucial to know exactly what you are introducing to Painter:

1 If it is a brush variant file (.xml), place it in a brush category folder (Corel Painter IX > Brushes > Painter Brushes > Brush Category).

2 If it is a brush category folder (with 30 by 30 pixel .jpg icon), place it in a brush library folder. The default brush library is Painter Brushes (Corel Painter IX > Brushes > Painter Brushes).

3 If it is a Brush Library folder (containing brush category folders, which in turn contain the brush variants), place it in the Brushes folder in the Corel Painter IX application folder (Corel Painter IX > Brushes).

Creating a New Brush Library

As you work with Painter you may find you want to rearrange the brushes to better suit your particular style and workflow. This may involve regrouping your favorite brushes into more meaningful categories that relate to how you use them. In this situation it can be useful to create your own Brush Library. If you are new to Painter I suggest you skip this. Here are the steps to make your own library.

1 Make sure you have first made a backup copy of your Corel Painter IX > Brushes folder.

2 Create a new folder within the Corel Painter IX > Brushes folder on your hard drive. This will be your new Brush Library folder. Name it appropriately.

3 Copy Brush Category folders and their associated .jpg files from the Painter Brushes library into your new library folder (holding down the Alt/Option key to make sure you leave a copy behind).

4 I recommend altering the Brush Category JPEGs in any new library so that you can immediately see which library you have in your brushes palette.

5 Finally, if you'd like your custom brush library be the one that appears every time you open Painter, select from the top menu bar Corel Painter IX/Edit > Preferences > General and replace Libraries Brushes: Painter Brushes with the name of your own brush library.

Backing Up Your Custom Data (Complex but Important)

When you customize Painter, whether through creating a custom variant or a brush dab or a category or a library or a palette layout or preferences or paper or a pattern or any other customizable item, you generate custom files. These custom files, and anything that is user-generated in Painter, are stored on your computer in a user's folder, where the data can be changed, edited, and deleted, not in the application folder, which is treated as "read-only" by Painter.

Here is why this has been introduced in Painter IX. In situations where one computer is shared by many users, such as in a classroom or business, having the custom data in a user folder allows every user to have his or her own individual customization of Painter. In the past, if one user logged in and completely "messed up" the brushes, the next person who logged in would have had to deal with the same mess. Now users can work independent of one another.

Consequently, to effectively back up your custom data and make it part of the "default" for Painter, you need to copy across your custom data from your user's folder to the application folder. This will ensure that all your custom settings will always be part of Painter and will not be erased if you reset Painter to its factory settings. After you have copied across your custom variant data to your application folder location, Painter will see them there and will allow you to use them and modify them by creating "c_brush.xml" files in the user folder. Any brush in the user folder has precedence over one in the application folder, so if you have a custom brush variant in both the user and application folders, only the one in the user folder will be seen in Painter.

For added security, after backing up data from your user folder to your application folder, I also recommend making a duplicate backup copy of your application folder in a different location. Here are the locations for you to find your custom data.

Custom Data Location in Mac OS X

Your custom variant data is stored at Users > User Name > Library > Application Support > Corel > Painter IX > Brushes > Painter Brushes > Category. For a given variant you would open the category folder, select the variant files, hold down the Option key (to leave behind a duplicate), and then copy them over to the Applications > Corel Painter IX > Brushes > Painter Brushes > Category folder.

Custom Data Location in Windows XP and 2000

To view your custom variant data in Windows, you first have to choose Start Menu > Control Panel > Folder Options > View (tab) > Hidden files and folders > Show hidden files and folders (check radio button and click Apply). You then find the files at My Computer > Local Disk (C:) > Documents and Settings > Username > Application Data > Corel > Painter IX > Brushes > Painter Brushes > Category. Select your custom variant files and copy them to My Computer > Local Disk (C:) > Program Files > Corel > Painter IX > Brushes > Painter Brushes > Category.

Resetting Painter to Factory Default Settings

You can reset Painter to its factory settings by holding the Shift key down as you open Painter. This process clears out all your custom files from your user files, so you will lose all custom variants, preferences, papers, and so on, unless you backed them up in the manner just described.

3.4 Brush Variant Customization Techniques

Property Bar Customization

The brush Property Bar displays different sliders according to the current variant selected. The sliders influence brush behavioral characteristics and change the look of the brushstrokes. In this case I selected the Oil Pastels > Chunky Oil Pastel 30. You can apply these principles to any brush. I encourage you to experiment.

Size and Opacity

These two Brush property bar sliders go hand in hand. A very low-opacity, large brush gives a large, soft, diffuse, almost airbrush-like stroke, especially when applied with light pressure. Beware of making your brush size too big. This can slow the brushstroke down considerably, sometime causing the program to give an error message that there is "insufficient memory to complete this operation." If you see this message, click OK and reduce your brush size. A high-opacity, small brush gives a more linear brushstroke suitable for detailed line work with medium pressure. I find that I need to lower the opacity on almost all default variants, where the default opacity is often 100%. I typically work with opacity in the 10–30% range (Figure 3.41).

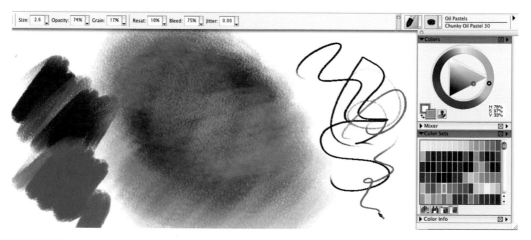

Figure 3.41 Three variations of size and opacity, from left to right: default settings, large size with low opacity, and small size with high opacity.

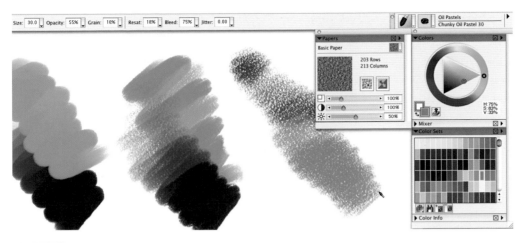

Figure 3.42 Three variations of the grain setting, from left to right: high to low grain, with the default setting in the middle.

Grain

The Grain slider is somewhat anti-intuitive—the higher the grain, the *less* grain you see and the more solid the brushstroke. The lower the grain, the *more* defined grain you see (until it is too low, when you don't see anything). Note that the grain setting does not relate to the size of the paper grain— you can adjust the paper texture scale within the Papers palette (Window > Library Palettes > Show Papers). The grain setting relates to how deep the brush pigment sinks into the depth of the paper grain. I find the default setting for grain is usually a little higher than I like, and I therefore nudge the grain down to around 10–12% (Figure 3.42).

Resat

The resat (short for resaturation) value determines how much the current chosen color is exhibited in the brushstroke. Where you want a brushstroke that does more blending than painting, then choose very low resat, for example, 1%. Note that if you take the resat value all the way to 0%, then the brush doesn't paint at all, it just blends underlying color (Figure 3.42).

Bleed

Bleed controls how much of the underlying color at the start of the brushstroke is pulled along with the brushstroke. This slider does not seem to make much difference with this variant. I test out the sliders by taking them to their extreme (maximum and minimum) settings and trying them out. I then back off the extreme settings slightly and try them again. Finally I try out a medium setting.

Jitter

As the name suggests, jitter adds randomness, spreads the brush dabs out in a spray, and creates a rougher edge to your brushstroke. A little extra jitter can produce some very interesting results (Figure 3.44).

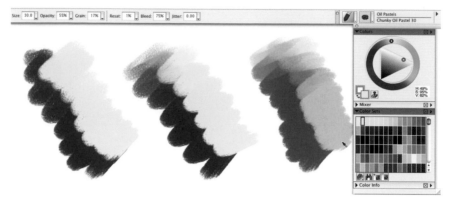

Figure 3.43 Three variations of the resat setting, from left to right: high to low resat, with the default setting in the middle.

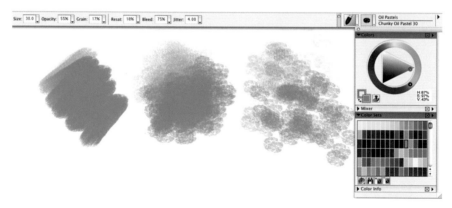

Figure 3.44 Three variations of the jitter setting, from left to right (low to high): 0 (default value), 1.8, and 4 (maximum value).

Other Sliders and Settings

Each brush variant has it own set of parameters that show up in the Property Bar, depending on the type of brush it is. I show here variations of a couple of other brushes.

Creating Grainy Oil Dabs (Figure 3.45)

I took grain almost to the maximum for this brush. The result was a textured effect within the brushstroke that reminded me of viscosity rejection effects you see in traditional media when you use a water-based paint over a waxy crayon and the paint bubbles up a little. Greater viscosity gives a slightly more translucent oily brushstroke that blends in the color underneath. Clumpiness clumps the bristles together almost as if you'd left oil paint on them and they got stuck together in clumps. The effect gives a brushstroke with streaks showing through the paint underneath. Wetness mixes in some of the underlying color. With 0% wetness, the stroke is more pure, saturated, and intense.

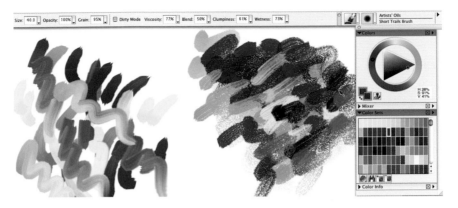

Figure 3.45 The default Artists' Oils > Short Trails Brush (left) and the modified brush (right), which I subsequently saved as JS-Grainy Oil Dabs, with increased grain, viscosity, clumpiness and wetness.

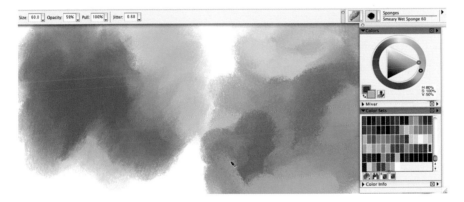

Figure 3.46 The default Sponges > Smeary Wet Sponge 60 and the modified brush (saved as JS-Oily Smeary Sponge) with increased pull and jitter.

Creating Oily Smeary Sponge (Figure 3.46)

Pull literally pulls the underlying paint along with the brushstroke.

Brush Controls Customization

Creating Luscious Squiggle

To demonstrate Brush Controls customization, I will share the way I transformed the Acrylics > Captured Bristle brush into a completely different brush that I called Luscious Squiggle. This was a two-part process, first capturing a new brush dab (the shape of the brush) and then going through the active Brush Control palettes and experimenting with the setting until I liked the resulting brush. I suggest you first follow along the process as described next and then choose a completely different default variant and make your own special brush from it.

CHAPTER 3 FOUNDATION III: *BRUSH CREATION*

Making Your Own Brush Dab

1 Select black as your current color.

2 Open a blank canvas (Cmd/Ctrl-N).

3 Choose a brush variant to make your dab. I chose the Pens > Leaky Pen. I like the globular nature of its brushstroke.

4 Make a black mark on the white canvas. This will be the brush dab shape you capture. (You may wish to save this canvas just in case you want to return to the brush shape another time.)

5 Choose the Rectangular Selection tool from the Toolbox (second down on left).

6 Make a selection over the dab shape (Figure 3.47). This selection should be approximately square, though it doesn't matter exactly since the selection will be stretched to fit into a square automatically when you capture the dab.

7 Choose a brush variant you wish to start with as a basis for creating a new brush. You can choose almost any variant for this. I started with the Acrylics > Captured Bristle.

8 Open the Size palette, if it is not already showing (Window > Brush Controls > Show Size).

9 Click on the size preview so you see the default dab shape.

10 Choose Capture Dab from the Brush Selector Bar pop-up menu (Figure 3.48).

11 Look at the Size palette preview. You should see your newly captured brush dab showing.

12 Choose Cmd/Ctrl-D (Select > None). Make some test brushstrokes. Adjust the Property Bar sliders until you're happy with the look of the brushstroke.

13 Choose Save Variant from the Brush Selector bar pop-up menu (Figure 3.49).

14 Name the variant. I called this JS-Squiggle Blobs.

15 Your current variant, as shown in the Brush Selector Bar, will still be the original variant you chose. Choose Restore Default Variant from the Brush Selector bar pop-up menu. You should see the brush dab restored to its original shape. (If not you may have to replace the variant jpg files from your back-up copy of your brush library.)

16 Now click on the variant selector and select your newly named custom variant. Continue tweaking it.

17 If you find you make your custom variant even better then update the settings by choosing Set Default Variant from the Brush Selector Bar pop-up menu. You will be asked "do you want to

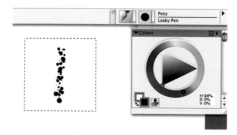

Figure 3.47 Make a rectangular selection over your custom brush dab.

Figure 3.48 Preview of default brush dab shape showing in the Size palette while selecting Capture Dab.

Figure 3.49 Choosing Save Variant.

create your own default for this variant?" Choose Yes. Be careful to avoid accidentally resetting the defaults for the standard brushes that come with Painter (unless you specifically want to, of course).

Restoring Default Variants

I have found that the Artists > Impressionist and Sargent Brush variants do not return to their original dab after you capture a custom dab, so I would avoid using those two brushes for this. To be safe, make sure you have your Brushes folder backed up and can therefore easily replace

a variant jpg file if you accidentally alter your default variant brush dabs (you will need to reload the brush library or restart Painter).

On Mac OS X the files that contain your custom variants are not located in the regular Corel Painter IX application folder but instead in the Users > User Name > Library > Application Support > Corel > Painter IX > Brushes > Painter Brushes folder within the appropriate category folder.

If you find, after replacing the jpg file, that you are still unable to return a variant to its default settings and dab shape, then, as a last resort, you can reset Painter to its default factory settings. Before you do this, back up all your custom variants into a folder outside the Brushes folder in your Corel Painter IX application folder. If you don't back up your custom variants, you will loose them. Then hold down the Shift key and start Painter. You will see a message that says: "Do you want to restore Painter to its factory default state? This will erase all of your modifications, including brushes, papers, textures, and other customizations." Choose "Yes." Note that this operation is irreversible and, as the message states, it will erase all your custom settings, including Preferences and Palette Layouts.

Experimenting with the Brush Controls

The next step in the process is to work our way through the Brush Control palettes. We will work our way down the active palettes (not all palettes are active for any individual brush—you can tell those that are inactive because their settings are grayed out).

1 Choose your custom variant selected in the Brush Selector Bar (Acrylics > JS-Squiggle Blobs in my case), open the Brush Controls > General palette.

2 Notice the Dab Type is Captured. Leave this as it is.

3 The Stroke Type is Single. I changed this to Multi so that it gives a multiple-stroke effect. Although this option slows the painting process down a little, I like the look of the effect.

4 The Method was originally Cover with Method Subcategory Soft Cover. The Method and Method Subcategory determine how the paint interacts with underlying paint and whether the edge is hard or soft and whether it displays grain or not. Cover covers up (so light colors cover up dark colors, unlike the build-up method, where light colors show dark colors through and build up to black). I changed the Method and Subcategory to Drip: Grainy Hard Drip (Figure 3.50).

5 Open the Size palette. Click on the preview window so that you see the gray and black circles, not the dab shape. (The black and gray shapes may be elliptical for some brushes, such as the Calligraphic brushes.)

6 Reduce the Min Size slider so there is a substantial proportion of gray around a small central black circle. This establishes the minimum and maximum size of the brush.

7 Set the Expression to be Pressure if it isn't already. This means that you'll have a small brush with light pressure and it'll get bigger as you press harder (Figure 3.51).

8 Open the Spacing palette. These sliders affect the spacing of the bristles and the features in the brushstroke. Increasing the Spacing slider gives an interesting jagged look to the brushstroke.

Figure 3.50 The new settings in the Brush Controls: General palette.

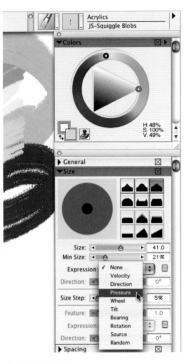

Figure 3.51 Setting the Size Expression to be Pressure in the Brush Controls: Size palette.

Figure 3.52 The new settings in the Brush Controls: Spacing palette.

The Continuous Time Deposition speeds up the multistroke painting, but I prefer the effect when that option is left unchecked (Figure 3.52).

9 Open the Well palette. Play with the sliders. The Resaturation determines how much of the current color is applied in each stroke as the stroke progresses. If you want a brush that paints mainly from the underlying color where the brushstroke starts, then uncheck Brush Loading. For this variant I preferred the effect with Brush Loading checked (Figure 3.53).

10 Open the Color Variability palette. By adding a little variability to the hue, saturation, and value of every stroke, you create a little more richness and complexity in your painting (Figure 3.54).

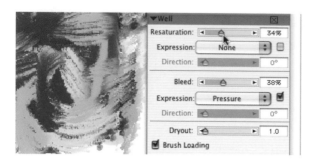

Figure 3.53 The new settings in the Brush Controls: Well palette.

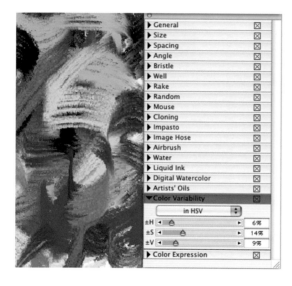

Figure 3.54 The new settings in the Brush Controls: Color Variability palette.

11 Having experimented with all the sliders that are not grayed out and reached a point at which you like the brushstroke, choose Save Variant from the Brush Selector pop-up menu. I called mine JS-Luscious Squiggle. You never know whether you may improve the brush even more, so be assured that you can always choose Set Default Variant to update the default settings in the future or simply save a different variant with a different name later.

Try capturing a brush dab and then altering the Brush Controls for a different brush. See what you come up with!

The Plug-in Subcategory Experiment

1 Open Painter.

2 Open a new canvas 600 pixels wide by 600 pixels high (Cmd/Ctrl-N).

3 Mount your canvas (Cmd/Ctrl-M).

4 Take any brush variant from any brush category.

5 Open the Brush Controls General palette (Window > Brush Controls > Show General).

6 Ensure the Dab Type is Circular, Single-Pixel, Static Bristle, or Captured.

7 Change the Method to Plug-in.

8 Select the first choice in the Plug-in Subcategory, which is the Confusion Brush. Try out this brush setting on the canvas.

9 Work your way down all of the Plug-in Subcategories. This is guaranteed to produce really bizarre results!

10 Try this with different brush variants, saving any good variants as you go.

The Extreme Brush Controls Experiment

1 Open Painter.

2 Open a new canvas 600 pixels wide by 600 pixels high (Cmd/Ctrl-N).

3 Mount your canvas (Cmd/Ctrl-M).

4 Take any brush variant from any brush category.

5 Open the Brush Controls General palette (Window > Brush Controls > Show General). Go through all the accessible Brush Controls and adjust all the sliders to their extremes, continually testing out the effect on the brushstroke, saving those variants you like. Be fearless! You are not going to break Painter. You have your Brushes folder backed up, you can delete any custom data files you wish, and you can choose the Restore Default variant command in the Brushes pop-up menu, so you can always restore any brush to its default settings no matter what you do.

Brush Creator Randomizer Customization

1 Choose Cmd/Ctrl-B (Window > Show Brush Creator). This opens the Brush Creator window. When the Brush Creator window is open you can no longer paint on your image. Instead, you can try brushes out on the Brush Creator scratch pad. You may notice the palettes and menus are different when you are in the Brush Creator mode of Painter, compared to the regular painting mode (when the Brush Creator is closed). The Brush Creator has three tabs in the upper left: Randomizer, Transposer, and Stroke Designer. The Stroke Designer is the same as the Brush Control palettes.

2 Choose the Randomizer tab. As the name suggests, the Randomizer is a facility for taking the brush properties of a selected variant and then creating random changes to those properties to create different variants.

3 You will notice a Brush Selector in the upper left of the Randomizer window, above a series of stroke preview windows (you can increase the Brush Creator window size to increase the number of preview windows). Choose a variant that you like or that you feel has an interesting look. In this example I chose the Sumi-e > Thin Bristle Sumi-e 20 (Figure 3.55).

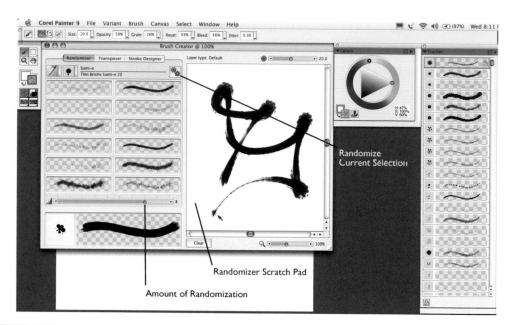

Figure 3.55 The Brush Creator: Randomizer window.

Figure 3.56 Saving the custom variant generated in the Randomizer.

4 Make sure the Amount of Randomization slider is set to at least 8. You could just take it to the maximum (10). This slider will determine the degree of variations from your original variant that you'll generate.

5 Click on the Randomize Current Selection button (looks like two cogs). This generates a series of variations based on the originally selected variant.

6 Click on each of the stroke preview windows and try out each variation on the scratch pad on the right of the Brush Creator window.

7 After each test you can click on the Clear button to clear the scratch pad.

8 If you find a variation you like, choose Cmd/Ctrl-S (Variant > Save) (Figure 3.56). Note this key shortcut works only for Save Variant in the Brush Creator mode. I saved my favorite variation as JS-Sumi-Pollock, since it reminded me a little of Jackson Pollock. If you are not completely satisfied with the variations or just feel like exploring further, click on the randomizer button again and generate further variations.

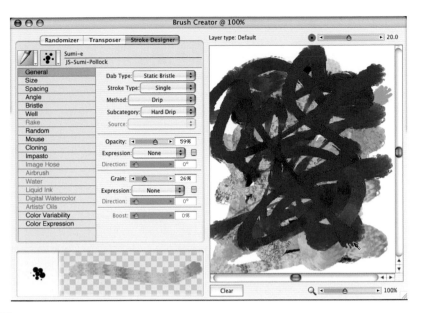

Figure 3.57 Modifying the Method in the Stroke Designer: General palette.

9 In this case I found, while liking some aspects of the JS-Sumi-Pollock variant I created, I wanted to experiment further. I choose the Stroke Designer tab, General palette and changed the Method: Method Subcategory from Buildup: Grainy Hard Buildup to Drip: Hard Drip. I loved the effect I then got and saved this variant as JS-Sumi-Pollock Splash (Figure 3.57).

Now let's take a look at the middle tab, the Transposer.

Brush Creator Transposer Customization

1 Select the middle tab in the Brush Creator window, the Transposer. *Transpose* means to change in position, form, or nature, in this case alluding to the superimposing of two variants together in a way that generates a unique third variant that is distinct from the two source variants. Thus the Transposer is a facility for mixing, or transposing, two variants together to produce a third.

2 You'll see two Brush Selector Bars, one upper left and one lower left, with stroke preview windows separating them (the larger the Brush Creator window, the more stroke preview windows you see). Select two different variants you'd like to mix in some way. I recommend picking variants that are very different to get the most interesting results. In this case I chose the F-X > Squeegee in the upper Brush Selector and the Pencils > Greasy Pencil in the lower Brush Selector.

3 Click on the Transpose Current Selection button (to the right of the upper Brush Selector).

4 Click on each of the stroke preview windows and test out the variations (Figure 3.58).

5 Select your favorite variation.

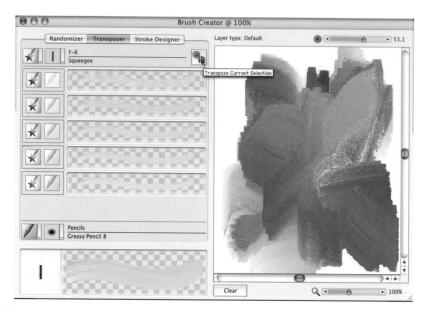

Figure 3.58 Generating variations in the Transposer.

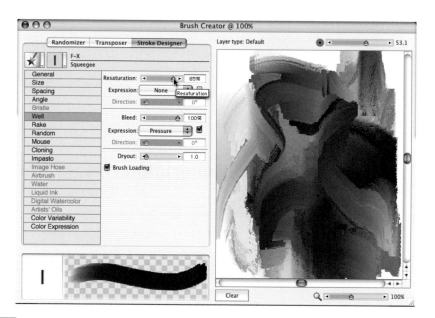

Figure 3.59 Generating variations in the Transposer.

6 Choose the Stroke Designer tab.

7 Choose the Well palette and increase the Resaturation (Figure 3.59). I liked this effect and saved the variant as JS-GreasySqueegee.

Now's time to experiment with your own variations. Have fun!

Mixing Techniques

All of the customization techniques covered here can be mixed together. As you can see from the last two examples, I frequently go back to the Stroke Designer after generating a variant in the Randomizer or Transposer. You can mix and match the way you create your brushes. Whenever you come across a variant you love and want to keep for later use, then, within the Brush Creator mode, choose Cmd/Ctrl-S (or Variant > Save Variant). As you generate more and more custom variants, you may need to organize them or edit them down (explained at the beginning of this chapter). Creating brushes is just like painting itself, a journey of discovery and adventure, which leads you down many paths before you reach the pot of gold!

3.5 Wrap

Congratulations! You're now ready for action. You've got all the basics behind you. You've got Painter running at optimum efficiency, like a finely tuned engine. You've started on the road to good habits, such as organized file naming and regular saving of versions, which will make life much easier for yourself years hence. You are familiar with how to customize, save, and organize brushes. Now it's time to put your newfound skills and knowledge to good use.

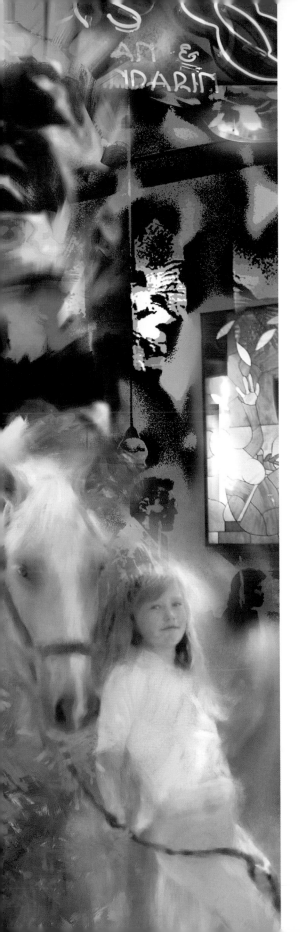

II
Photo Techniques

4

Photo Techniques I: *Pastel*, *Watercolor*, and *Oil*

There are painters who transform the sun into a yellow spot, but there are others who, thanks to their art and intelligence, transform a yellow spot into the sun.

—*Pablo Picasso*

4.1 Introduction

This chapter introduces a few techniques and ideas for transforming your photographs into artistic interpretations that emulate the look of traditional drawing and painting media, such as pencil, charcoal, pastels, watercolors, and oils. I use the word *transform* in the context of basing an artwork on a photographic source reference image. The artwork that results is an "interpretation" or "painterly rendition" of the original photograph. Your source photograph serves as an inspiration and foundation for your creative process.

This chapter is not intended to be a comprehensive and exhaustive analysis of natural media techniques, but simply a starting point from which you can explore further and develop your own techniques. The techniques shared here are intended to be not exact formulae or recipes to follow precisely, but helpful guidelines and suggestions to set you on your journey. In practice every picture suggests its own path, and I encourage you to continually experiment. You may find yourself mixing many different types of media together when using Painter. The beauty of Painter is that it offers unlimited possibilities—the only limit is your imagination.

The individual techniques presented here are each described in the context of a case study, where I lead you through my process in creating a painting from start to finish (as much as any artwork is ever finished) and share the transitions that each painting goes through along the way. I share some of the specific brushes I use, my custom settings, and other technical details. There is some repetition of steps that are common to the different case studies, though I go into more detail the first time I address a particular step. Repetition of these steps helps solidify the basic working method until it becomes second nature. I suggest you first follow along the step-by-step techniques with one of your own images. If you are new to Painter and want to quickly grasp the basic techniques, then ignore all the Tips that go into deeper technical detail. Conversely, if you are an experienced Painter user and want to understand the program at a deeper level, then take the time to read the Tips.

Following my case studies will help you understand my decision-making process as I paint and also familiarize you with the brushes I use. However, once you have followed my case studies in detail I recommend that you start experimenting, discovering your own favorite brushes, exploring your own custom settings, and seeing what gives you effects you like. The goal here is not for you to learn precise recipes but to empower you to create your own unique style of artwork that reflects who you are and how you see the world. As musician Loreena McKennitt so eloquently says: "One of the most important steps on our journey is the one in which we throw away the map".

Although in this chapter I concentrate on emulation of a few traditional drawing and painting media, there are numerous other amazing painting effects you can achieve with Painter. Many of

them are unique to Painter and take you into realms that cannot easily be categorized and that cross the boundaries of painting and printmaking. I've selected a few of these to highlight in the following chapter.

4.2 Goals

Before embarking on the process of transforming your photographs into paintings, take a moment to consider what your goals are. Why bother to transform your photographs? How does painting add to your image? What is special about paintings? Visit a local art museum or gallery and look at paintings. Look closely at the richness of colors, textures, and abstract forms in the brushstrokes. Step back and look at the way the artist's use of color, texture, tone, lighting, and brushstroke movement have succeeded in creating a powerful evocative image. Notice the way the artist draws you into the painting, taking away detail here, adding detail there, leading your attention to the focal point. The successful painter, as Picasso says, is able to "transform a yellow spot into the sun." In other words a successful painter can create an effective illusion with the use of color, tone, texture, and so on. Paintings offer a greater range and depth of color and tone than a photograph and hence can create a more striking image. Painting also offers you complete control over the level of detail and contrast in all parts of an image, allowing you to selectively focus the viewer's attention and take your photographic image to the next level.

We are going to start this journey of transformation by going back to basics and creating a simple black-and-white sketch from a photograph (Figures 4.1 and 4.2).

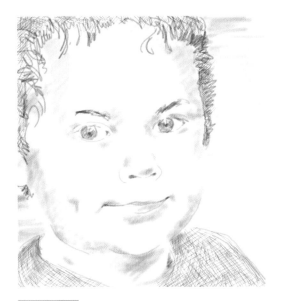

Figure 4.1 "Quizzical," a pencil sketch.

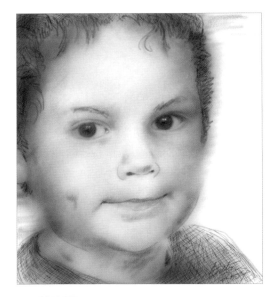

Figure 4.2 "Quizzical," a pencil sketch with the original photograph cloned in.

4.3 Pencil Sketch

Technique Overview

This technique uses the Tracing Paper facility of Painter in its most basic form, as a simple visual reference for creating a pencil sketch. This is an example where the File > Quick Clone command saves time in preparing your canvas. Getting an authentic pencil look may take a little brush research. The variant choice and brush settings I share with you here were the end product of considerable trial and error. Although the plain pencil sketch could be the final image, I couldn't resist mixing a little of the original photograph with the pencil drawing. While the mix is not an authentic pencil sketch look, I still liked the result and wanted to share it with you here in case it is something you wish to try yourself.

Steps

Start with a Vision

The model for my sketch is my cute nephew, Bradley, whom I photographed on a recent visit to Brighton, England, where he lives. I liked the quizzical look he had on his face in this picture and wanted to capture his curiosity in the drawing.

Prepare your Canvas

1. Enhance and crop your source image in either Photoshop or Painter.
2. Open your source image in Painter.
3. Choose File > Quick Clone (or click your Quick Clone button if you've created one in your shortcuts custom palette) (Figure 4.3).

As discussed in Chapter 1, you can set the action of the Quick Clone command in the Corel Painter IX/Edit > Preferences > General window. I have the Quick Clone set to make a clone copy of the original photograph, clear the clone copy canvas to the paper color (default is white), and turn Tracing Paper on. Thus when I applied Quick Clone, a new white canvas opened up, the same size as the original photograph, with the original photograph showing through at 50% opacity. Choose Cmd/Ctrl-T to turn the Tracing Paper off and on (it toggles between the two states). Leave the Tracing Paper off for the next step, which is brush research.

Brush Research

Now that we have a blank white canvas before us, we can start experimenting with different brushes and brush settings to get the right look and feel. There's no fixed formula for getting a particular look, and much depends on your personal preference and the goal you have in mind for your image. In the example shown here I wanted the look of a soft lead pencil, 3B or 4B, that makes a grainy mid-gray

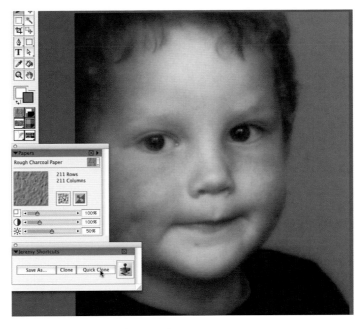

Figure 4.3 Clicking the Quick Clone shortcut button.

mark when you press lightly and gradually gets darker as you press with more pressure. I tried out all the brush variants in the Pencils category. The one that seemed to give the effect closest to what I was looking for was the Thick and Thin Pencil variant. Here's how you would get what I did.

1. Choose a middle gray in the Colors palette by dragging the cursor in the Saturation/Value Triangle all the way to the left (making the Hue and Saturation 0%) and in the middle (making the Value about 50%).

2. Lower the brush opacity from 100% (the default) to about 15%.

3. Lower the Grain in the Brush Property bar from 24% (the default) to about 15%.

4. Choose Window > Library Palettes > Show Papers. Select a suitable paper from the Papers Selector. I chose the Rough Charcoal Paper.

5. Adjust the brush size to suit the scale and resolution of your canvas.

Save Your New Variant

At this point you may wish to save this variant for future use. To do that choose Save Variant from the Brush Selector pop-up menu. If you wanted to save the paper texture information as well as the special brush settings, then you'd need to save a brush look. You do so by selecting New Look from the Look Selector pop-up menu (the Look selector is in the bottom left corner of the Toolbox).

Create Line Work

1 Now that you have selected the Pencils > Thick and Thin Pencil, clear any trial marks off the canvas (Cmd/Ctrl-A followed by Delete/Backspace).

2 Turn on Tracing Paper (Cmd/Ctrl-T).

3 Start sketching in the main contours (Figure 4.4).

4 Choose File > Save As. Rename the clone copy canvas with the subject, version number, and a note about which brush you used. I called my file "bradleysketch-01-thkthnpncl.rif." Since I was not using any special layers I could have saved my file in Photoshop or TFF format.

Create "Soft Shading" Effect

Once you have established a framework of contours on your canvas, increase the size of your brush and lower the opacity. Now make soft brushstrokes to block out areas with soft shading (Figure 4.5).

In addition to adding shading with a large, low-opacity brush, you can create the effect of shading in a sketch by use of crosshatching with a small, high-opacity brush. Crosshatching is the technique where you make a close series of parallel lines and then go over the same region with another series of parallel lines at right angles (or thereabouts) to the first series. You can see a little crosshatching in Bradley's hair and sweater.

At this stage you have completed the sketch. Save your file.

Mixing the Original Photo with the Sketch

1 Choose the Cloners > Soft Cloner.

2 Lower the brush opacity.

3 Choose Cmd/Ctrl-T to turn Tracing Paper off.

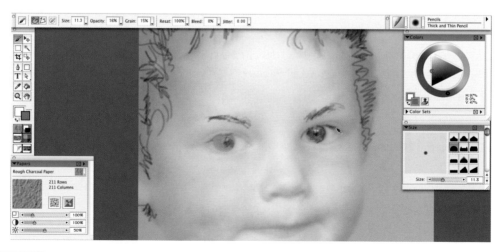

Figure 4.4 Sketching in the main contours with Tracing Paper on.

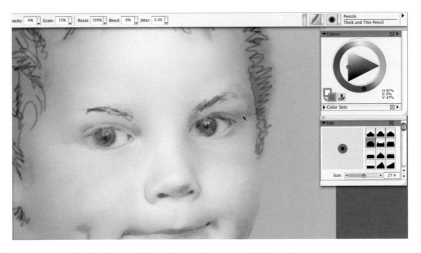

Figure 4.5 Creating soft shading with a large, low-opacity brush.

4 With soft pressure gently clone some of the original photograph into the sketch (Figure 4.6).

5 Choose File > Save As and save this version, with the photograph cloned back in.

If you go too far (and clone too much of the original photo), you can either use Cmd/Ctrl-Z to undo your brushstrokes or open the sketch version, set it as clone source (File > Clone Source), and then use the Soft Cloner to restore the sketch.

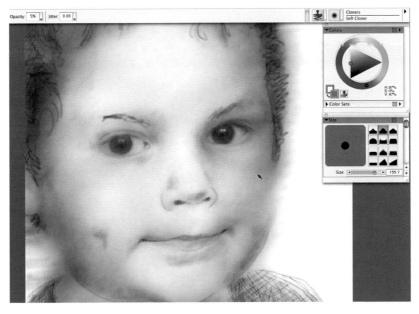

Figure 4.6 Cloning in the original photograph.

4.4 Charcoal Drawing

Technique Overview

This technique, suggested by Wes Pack of Corel Corporation, involves using a black-and-white source image, working into it with chalky brushes, capturing it as the current paper texture, and then using a chalky brush with varying degrees of grain on a white canvas. The result mixes different textures in a way that gives more richness to the chalk marks on your paper than simply creating a straight-forward grainy brush clone drawing. The example shown in Figure 4.7 is based on a photograph I took of the legendary pioneer of the Lindy Hop swing dance, Frankie Manning. Frankie toured internationally with Whitey's Lindy Hoppers in the 1930s and appeared in a number of films, such as *Hellzapoppin'*. Since the 1980s Frankie has been teaching the Lindy Hop, inspiring and enthusing people all over the world. This photo was taken as he walked into a surprise 90th birthday party arranged for him at the Jumpin' at the Woodside swing dance festival in Gloucester, England. You can see from his big smile what a joyful man he is.

Steps

1. Open the source image in Painter.
2. If the image is a color image, as in my case, choose Effects > Tonal Control > Adjust Color (Figure 4.8).
3. With Using: Uniform Color, take the Saturation slider to the minimum (−139%). Click OK. This makes the image appear black and white (Figure 4.9) (in fact all images in Painter are RGB images—Painter does not have other color modes like Photoshop).
4. Choose File > Clone.
5. Choose File > Save As and rename the clone copy.
6. Choose Cmd/Ctrl-M.
7. Choose a chalky brush. In my case I chose Chalk > Square Chalk 35.
8. Check the Clone Color icon in the Colors palette.
9. Choose a paper texture in the Papers palette (Window > Library Palettes > Show Papers). In my case I chose Load Library from the Papers pop-up menu and opened one of my custom paper libraries, Papers Artsy, which you can find on the Painter Creativity Resource CD. I selected the paper Forest Unryu. It is a Japanese paper with a great hairy texture. I increased the contrast setting in the Papers palette (second slider down) from 100% to about 184%. This makes the paper texture stronger.
10. Lower the Grain setting slightly to get more texture showing in your brushstrokes.
11. Apply the Square Chalk in the image (Figure 4.10).

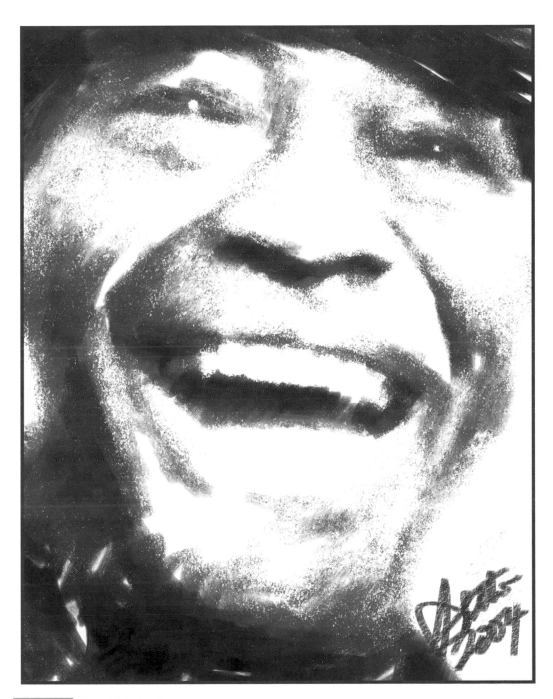

Figure 4.7 "Frankie's Joy."

Figure 4.8 Choose Adjust Color in effects menu.

Figure 4.9 Desaturate the image.

Figure 4.10 Applying the Square Chalk with clone color in the image.

Figure 4.11 Increasing the contrast in the image.

12 Resave the image.

13 Choose Effects > Tonal Control > Equalize (Cmd/Ctrl-E). Adjust the settings to increase the contrast of the image. This will make it a better paper texture (Figure 4.11).

14 Resave your image with another version number.

15 Choose Cmd/Ctrl-A (Select > Select All).

16 Choose Capture Paper from the Papers palette pop-up menu (Figure 4.12).

17 Name the paper and move the Crossfade slider to zero (this avoids softening of the edge) (Figure 4.13).

18 Choose Backspace/Delete so you clear your canvas.

19 Choose Cmd/Ctrl-T so you turn on Tracing Paper and can see your original image through the paper.

Figure 4.13 The Save Paper window.

Figure 4.12 Capturing the image as a paper texture.

Figure 4.14 Applying the Square Chalk with clone color in the cleared canvas with Tracing Paper turned on.

20 Start applying the chalk on the canvas, varying the Grain setting to control the texture effect (Figure 4.14).

21 For the final touch I added a signature using Hand Made paper from the same paper library (Figure 4.15).

4.5 Chalky Pastel

Technique Overview

Figure 4.16 shows the original photograph, taken by a client of her daughter, Lindsay, with her horse, Oscar; Figure 4.17 shows the final painting, a chalky pastel rendition that was reproduced as a magnificent 48-inch print on 100% rag fine art paper.

Figure 4.15 Adding the signature.

Figure 4.16 The original source photograph of Lindsay and her horse, Oscar (photography: Julie Douglass).

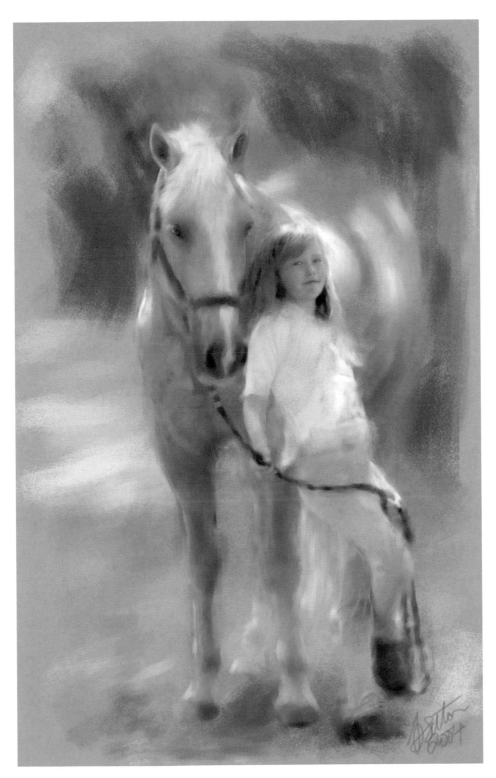

Figure 4.17 "Lindsay."

Steps

1. Start with a Vision

As you compose and design your photograph prior to capturing an image with your camera, think ahead about the mood, feel, and artistic style you wish to end up creating in your final artwork. In this case Julie wanted to express the close bond between Lindsay and her horse, Oscar. She envisaged a dreamy, gentle, and feminine painting with soft pastel colors, nothing too harsh or garish.

2. Capture Your Source Image

In capturing your source imagery, work with the maximum flexibility and quality. If using a digital SLR or digital back camera, save your files in RAW format. This will give greater latitude later to adjust for exposure than capturing JPEG files. If you are using a consumer digital camera, adjust your settings for maximum resolution. Download your pictures from your digital camera memory card onto an appropriately labeled folder on your computer. It is generally best (and fastest) to use a dedicated card reader to download pictures rather than connecting your camera directly to the computer.

If you are downloading JPEG files from your digital camera, you can open these up in Painter right away; there is no need to use any other software. There are a number of software programs you may find convenient to use that are dedicated to browsing and organizing your digital photographs and running slide shows. Photoshop, the industry standard for photographic workflow, offers the most in-depth and versatile image adjustment tools available, plus it has a very convenient browse function that will show you thumbnails of all your photographs. For that reason the following initial steps are in Photoshop.

3. Select Your Image (Photoshop)

Open Adobe Photoshop CS and use the File > Browse function to conveniently select an image. If you are using RAW images, make sure you have the most current RAW plug-in for Photoshop CS. This will provide you with a convenient window where you can adjust such characteristics as the color temperature, tint, exposure, and contrast. If your image needs rotating, then use Image > Rotate Canvas > 90°CW or 90°CCW, as appropriate.

4. Crop to Maximize Impact (Photoshop)

Consider your overall composition—will it be enhanced by cropping? Experiment with cropping the image. To crop, select the Crop tool (third icon down on the left of the tools palette) and drag in the image (Figure 4.18). Use the crop control handles to adjust the boundaries if needed, drag in the crop to change its location on the canvas, and press the Return/Enter key when you wish to finalize the crop. If it doesn't look right, use Cmd/Ctrl-Z to undo the crop and try again. See if closer crops improve the power and impact of the image. The key here is to have a vision of what you want to say and where you want to go with your image. In this case I found a closer crop created a more dynamic composition for use as a basis for a painting.

Figure 4.18 Cropping your image.

5. Determine File Size (Photoshop)

File size can mean a number of things when dealing with digital files.

1. The number of megabytes (MB) of computer memory the file takes up.
2. The number of pixels it contains in total (such as the use of the units of megapixels in describing how large a file a digital camera can capture).
3. The pixel size (number of pixels wide by number of pixels high).
4. The physical dimensions, for instance, in inches, of a printed image based on the digital file when printed out by a printer at a particular resolution of a certain number of dots per inch (dpi). The dots that are referred to in printer resolution correspond to the pixels in a digital file, whereas the typical unit of pixel resolution is pixels per inch (ppi).

In this case the painting I am creating is a commissioned artwork that must end up being delivered to my client as a beautiful print, not as a digital file. Thus what concerns me is the ultimate size of my print and ensuring that I have sufficient pixels for a high-quality image (too few pixels can lead to a soft, pixilated printed image). The physical size and medium you envisage for your final printed artwork determines the pixel resolution (ppi) you need to work at in Painter, and thus the file size you need to start with. Generally you will find an adequate range of digital file resolutions will lie between 300 ppi at final printed size for commercial offset reproduction in magazines, down to 150 ppi for an inkjet print on fine art paper or artist's canvas (also known as Gicleés, pronounced jee-CLAY, in the fine art world).

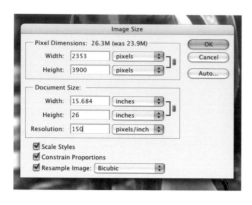

Figure 4.19 The Photoshop Image Size window.

With Painter images I generally work at 150 ppi at final size. I started off planning a final print 26 inches high and therefore wanted to make my image height, in pixels, at least $26 \times 150 = 3900$ pixels. I selected Image > Image Size. In the Image Size window (Figure 4.19) I unchecked Resample so that I could change the number of pixels in the file. The source photographic file I was using was 3720 pixels high, slightly smaller than I wanted. In the Document Size section of the Photoshop Image Size window I entered 26 in the Height box and 150 in the Resolution box.

Note that you cannot change the aspect ratio (height:width ratio) in the Image Size window. If you need a specific aspect ratio, for instance, 24 inches wide by 30 inches high at 150 ppi, then it is best to select the Crop tool and write in "24 in" in the Crop tool property bar Width box, "30 in" in the Crop tool property bar Height box, and 150 in the Crop tool property bar Resolution box, with pixels/inch selected as the unit. Drag the crop tool in the image and it'll be restricted to the aspect ratio set in the Crop tool property bar. You can move the crop around and change its scale. When you choose Return/Enter, the crop and resizing occur simultaneously.

In the end I created a magnificent 48-inch print from the final image. My final digital file, after my painting was completed, was resampled up by the Master Printer I used (Gus Grubba, Aeon Master Printer, 415/462-5702) from a 25-MB file to a 133-MB file (36 inches by 48 inches at 180 ppi). The bottom line is that you do not need to work on huge files in Painter to be able to get great results. This is important to know since some of Painter's brushes and effects are quite memory intensive, and it can be slow working on files that are very large (for instance, 100 MB and up).

6. Optimize Tone and Color in Your Source Image (Photoshop)

Working on an image with Painter gives you a lot of latitude with regard to adjusting color, tone, lighting, level of detail, sharpness of contrasts, texture, and composition. Fine adjustments to your source image are not always a necessity since you can always adjust them with paint. Having said that, I add that a stronger source image can only help your final image. Choose Layers > New Adjustment Layer > Levels, click OK, and look at the histogram (Figure 4.20), a graphical display of the dif-

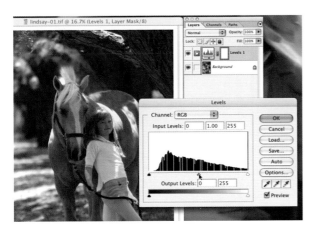

Figure 4.20 The Photoshop Levels window.

ferent amount of lights and darks in the image. Move the black-and-white cursor triangles so they are close to the outer edges of the histogram, where the mountains rise up from the plateau. Does the overall image need lightening or darkening? Experiment with the black, gray, and white sliding triangle cursors immediately along the base of the histogram. In this case I moved the gray triangle slightly to the left to lighten the image and bring out a little more detail in the shadows.

If you feel the color needs adjusting I recommend using the Hue/Saturation Adjustment Layer. There are many more ways to approach fine-tuning an image in Photoshop, and if you are interested in this area there is a wealth of excellent resources available (see www.paintercreativity.com for links to some). When you are satisfied, save your file in Photoshop (PSD) file format. This will be your master file that preserves the flexibility of all the Adjustment Layers for future editing in Photoshop (the special properties of Adjustment Layers are not recognized in Painter). Flatten the file (Layers pop-up menu) and resave a flat TIFF version. This will be the source image you open in Painter.

7. Continue Your Vision (Painter)

Open your prepared source image in Painter. Choose Cmd/Ctrl-M (Window > Screen Mode Toggle), followed by Cmd/Ctrl-0 (that's a numeral zero, not the letter oh) (Window > Zoom to Fit), and finally the Tab key (Window > Hide Palettes). Take some time to look at the photograph and open yourself to a vision of where the photograph suggests going, continuing the process that started with your vision before you took the original photograph. What inspires you about the image? What do you wish to communicate? What is the story you wish to tell? What needs emphasizing or omitting in the photograph to most powerfully communicate the story you wish to tell? In this case I was inspired by the beautiful bond between Lindsay and Oscar and their harmony with the natural setting. These were the themes that I envisioned expressing in my painting.

8. Decide on a Border

Consider what style of final artwork you wish to end up with and how it will be mounted and displayed. This will determine whether or not you should add a border to your source image. For works on paper, such as a watercolor or pastel style of painting, where the print may well be float mounted

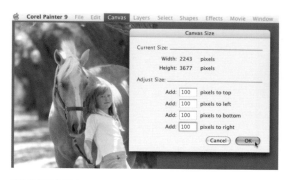

Figure 4.21 Adding a border.

Figure 4.22 The Save As window.

and where you may want your brushstrokes to blend softly into the paper at the edge of the picture, choose Canvas > Canvas Size to add a border around your image before you start painting (Figure 4.21). Type in the number of pixels to add, followed by Tab, and repeat that four times to fill in each box (for each direction). By default these pixels will be white, which is what you want for a water-color. Use the ppi resolution to determine how many pixels to add. I chose to add 100 pixels in each direction, which, for a 150-ppi file, adds three quarters of an inch in each direction.

For an oil style of painting I typically do not add a border to my original image since I print onto canvas and either frame it to the edge or stretch it with a gallery wrap.

9. Save Your Source Image

Choose File > Save As (Figure 4.22). Rename your source image with a name that includes the subject, version number (-00), and a note that this is your original image on which you are going to base your painting (-orig). If you added a border, you may want to indicate that as well (brdr). Save this source image as a TIFF. Thus your file name should have a format similar to: subject-00-origbrdr.tif.

If you wish to take advantage of the convenient Iterative Save feature (under the File menu) introduced in Painter IX, save your original as subject_000.tif. The advantage of Iterative Save is that it instantly renames each iterative-saved file with a sequential number at the end of the file name: _000, _001, _002, etc. The disadvantage is that it doesn't give you the opportunity to add a useful note into the file name indicating, for instance, what brush you just used. If you add any notes after the three-digit number, you will disrupt the Iterative Save sequence (it'll start from _001 again). If you add a note before the three-digit number, the alphanumeric order of the files will not match the version number sequence. This you need to adopt one system or another. If you choose Iterative Save, then you won't be making notes in the file names. Since I am a meticulous documenter and I want

to be able to recall every brush I use, I add notes in my file names and therefore don't use the Iterative Save. Whatever naming system you adopt, save this file in the project folder where you will be saving all the versions of the image for this project as you work on it. This is important, since it is easy to lose track of your original image if you leave it with its default name in a folder full of other photographs with similar names.

10. Make a Clone Copy

When you are working from photographs in Painter, always work on a clone copy (duplicate), not on your original image. In making a clone copy in Painter you have two choices: either choose File > Clone, which makes a clone copy duplicate of your original image (with the duplicate image on the clone copy canvas), or choose File > Quick Clone, which, by default, makes a clone copy and which then automatically deletes the image from the clone copy (leaving a plain white canvas) and turns on Clone Color in the Colors palette. You can adjust the Quick Clone settings in the General Preferences window (Figure 4.23). I generally choose my brushes, and adjust whether or not they use clone color, after creating a clone copy. I typically use brushes that are not in the Cloners category. For this reason I uncheck Switch to Cloner Brushes and leave Clone Color unchecked in the Quick Clone settings.

The Quick Clone command, where an image in cloned and then the clone copy canvas is cleared automatically, can be useful for all styles of artwork, while the File > Clone command, where the duplicate image is left on the clone canvas, is particularly suited to oil styles. In this case I wanted to make a duplicate image and fill the canvas with a color, so File > Clone worked fine for me.

11. Mount Clone Copy

Choose Cmd/Ctrl-M (Window > Screen Mode Toggle).

Figure 4.23 The Quick Clone Preferences.

Figure 4.24 Picking up color with the Dropper tool.

Figure 4.25 The Fill window.

12. Pick Color from Image

Select the Dropper tool (Figure 4.24). You can do this either by clicking once on the "D" key or by holding down the Option/Alt key while you have the brush tool selected and Clone Color inactive in the Colors Palette. Click in your image on a color you wish to use as a background color.

13. Fill with Current Color

Choose Cmd/Ctrl-F (Effects > Fill) (Figure 4.25). Fill with the Current Color (which you have just picked from the image with the Dropper tool). Watch out: If you accidentally fill with Weave, you may be shocked by the bright tartan pattern that fills your canvas!

At this stage you may want to consider adding a subtle texture to the background. If you are going to print out your final image on a textured fine art paper, it may be unnecessary since your image will be imbued naturally with the paper texture of the print substrate. That is what I decided in this case. If you do wish to add a paper texture, first choose Window > Show Papers and click on the papers selector pop-up library menu (upper right of the Papers palette). Choose your paper (I like the Italian and French Watercolor Papers). The effect I like to use to apply paper texture is Effects > Surface Control > Dye Concentration (Figure 4.26). Change the Using menu from Uniform Color to Paper. Adjust the Maximum and Minimum sliders until you like what you see in the preview window. Click OK.

If overdone, as effects so easily are, select Edit > Fade and fade back the effect.

14. Rename the Clone Copy

Choose File > Save As (even if you intend to use the Iterative Save) (Figure 4.27). Delete the default "Clone of . . ." at the beginning of the file name. Change the version number to −01 in the naming system if you are going to add notes, or change it to _001 if you are going to use the Iterative Save feature. If you are following the note system and have "origbrdr" written in, replace that note with "bkgnd" (you only want to have one file that has "orig" in the name so that you can immediately identify which file should be the clone source). Save the file as a RIFF file. RIFF is the native format of Painter and preserves maximum flexibility, though it cannot be opened in Photoshop.

Figure 4.27 The Save As window.

Figure 4.26 The Dye Concentration window.

Always Back Up Your Work

As a precaution I recommend that before you close down Painter, when in the middle of a project, you first make a backup of your most recent working image as a TIFF (if no layers) or as a Photoshop format file (if there are layers). You can do this simply by choosing File > Save As and altering the file format from RIFF to either TIFF or Photoshop. There have been cases in earlier versions of Painter where very large RIFF files became corrupted. This should no longer be a problem with Painter IX, but I would still recommend erring on the side of caution.

Resetting Your Clone Source Manually

The Clone (or Quick Clone) operation automatically assigns the original image from which you are cloning to be the Clone Source. You can see a checkmark by the file name of your original under the File > Clone Source menu. If you are working on a project, close Painter and then return to the project later; you will need to open up both the latest working image and your original image. You will also need to manually reset the original image to be the clone source (which defaults to the current pattern) by going back to the File > Clone Source menu and selecting your original image.

15. Select Brush Category and Variant

Select the Chalk brush category (click on the left-hand icon of the Brush Selector Bar to reveal the brush category pop-up menu). Then select the Square Chalk brush variant from within the Chalk category (click on the right-hand icon of the Brush Selector Bar to reveal the brush variant pop-up menu) (Figure 4.28). Make a test brushstroke on your canvas. This grainy brush gives a nice chalky effect that reflects the current paper texture.

Please note that there are many wonderful grainy brushes you could choose from that would work just as well as the Square Chalk. Another one of my favorites is the Pastels > Artist Pastel Chalk. I encourage you to take time to do brush research prior to finalizing your selection of which brush to use.

16. Select Paper Texture

Choose Window > Show Papers (unless you already have the Papers palette visible). Click on the Papers palette selector icon (upper right of the palette). This reveals a pop-up menu with a list of all the papers available in the current paper library. You may need to drag down the bottom right corner of the pop-up menu to see the whole library in one go. As mentioned earlier, my favorite papers in the default library are the Italian and French Watercolor papers. Pick a paper you like. Make another test brushstroke on your canvas and see the effect of the new paper texture (Figures 4.29, 4.30, and 4.31).

About Paper Texture

Paper texture in Painter is actually a repeating grayscale tile that acts like a mask to filter certain grainy brushes. The paper preview you see in the Papers palette shows the grayscale

Figure 4.28 Selecting the Square Chalk variant.

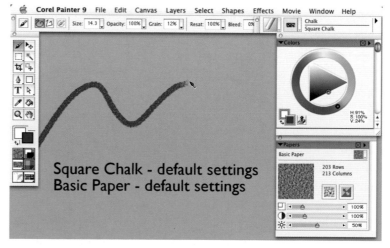

Figure 4.29 Square Chalk and Basic Paper with default settings.

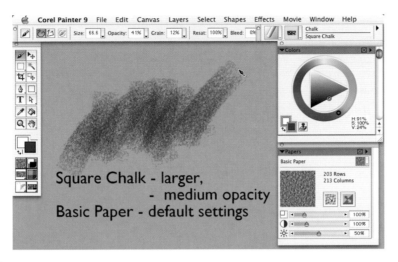

Figure 4.30 Square Chalk modified slightly.

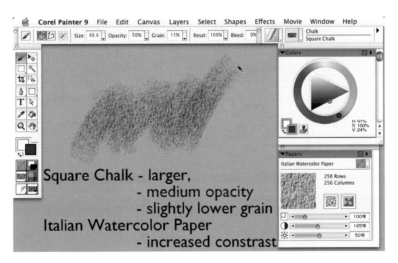

Figure 4.31 Square Chalk and Italian Watercolor Paper.

tile, or a portion of it, where the dark regions act like the mountains of the paper grain, picking up pigment, and the light regions act like the valleys of the paper grain, remaining clear of pigment. Only certain brush variants reflect paper grain, such as those contained in the categories Chalk, Charcoal, Colored Pencils, Conte, Crayons, Digital Watercolor, Oil Pastels, Pastels, Pencils, and Sponges. There are also brush variants in other categories that exhibit the property of graininess, such as the Blenders > Grainy Water brush. If you select Window > Brush Controls > Show General, or select Cmd/Ctrl-B (Window > Show Brush Creator) and look under the Stroke Designer > General subpalette, you will see that all brushes that respond to paper texture have the word *grainy* included in their Method Subcategory property (Figure 4.32).

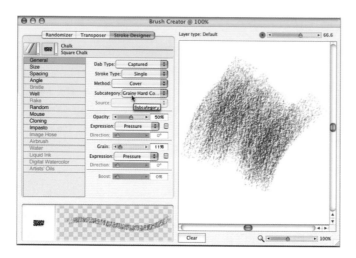

Figure 4.32 The Brush Creator > Stroke Designer window.

All grainy brushes have a Grain slider included in the Brush Property Bar (visible in the regular painting mode of Painter). You can alter the scale of the paper texture (also referred to as *grain*) in the Papers palette (first slider). You can also make the grain more distinct by increasing the grain contrast (second slider in the Papers palette) and by reducing the Grain slider in the Brush Property Bar, though not to zero (at which point there is no pigment deposited anywhere).

About Brush Looks

When you customize the settings of a brush variant, such as changing the size and opacity or changing any other settings in the Brush Property Bar or in the Brush Creator, you can save those settings for repeated future use by saving your custom variant (Brush Select Bar pop-up menu > Save Variant). After naming your custom variant, you'll find it has been added to the variant list of the current brush category, handy for future use. The custom variant information does not, however, include any changes you may have made to the Paper Texture settings, such as scale or contrast, or changes made to any other art materials. To save custom paper settings with your custom variant settings, you need to save a Brush Look.

1. Make a brushstroke on the canvas for you to use as an icon.

2. Choose the rectangular selection tool (second tool down on the left of the Tools palette).

3. Drag the rectangular selection tool over a portion of your brushstroke.

4. Choose the Brush tool.

5. Click on the bottom leftmost icon in the Tools/Selectors palette. This reveals the Brush Looks library.

6. Click on the small black triangle in the top right of the Brush Looks library. This reveals the Brush Looks pop-up menu (Figure 4.33).

Figure 4.33 Saving a Brush Look.

7 Select New Looks.

8 Give your new Brush Look a name and click OK. It will now be added to the Brush Looks library.

16. Activate the Clone Color Button

Click on the Clone Color button in the Colors palette (looks like the Photoshop Rubber Stamp icon). Notice that the color wheel and value-saturation triangle become grayed out and inactive. Activating the Clone Color button causes the current brush variant, in this case the Square Chalk, to pick up its color from the current clone source rather than from the color picker. The clone operation you did earlier automatically defined the original image as clone source (look under File > Clone Source, where you will see a checkmark by the original file name). Thus the Square Chalk now paints color based on your original photograph.

About the Clone Color Button

The Clone Color button is a very powerful feature of Painter, especially for photographers, since it allows you to covert almost any brush that paints color onto the canvas into a Cloners brush that you can use to pick up color from your original source photograph. For this reason I sometimes refer to this button as the photographer's magic button. Note that when using any brushes from the Cloners brush category you do not need to activate this button, since the default behavior of all Cloners has the function automatically activated. Note also that every

Figure 4.34 Setting Clone Source.

Figure 4.35 Rough general brushstrokes.

time you close Painter and then reopen it, the clone source defaults back to the current pattern. Thus you will need to reopen both the original image as well as your working file and then manually reset the clone source (File > Clone Source) in order to be able to continue working on your artwork with cloners (Figure 4.34).

17. Apply Large General Brushstrokes

Use a large, medium-opacity Square Chalk with the Clone Color button checked to make large, rough brushstrokes that follow the forms of your composition and that block out the main regions of tone and color, particularly in the main center of focus. Turn Tracing Paper on and off using Cmd/Ctrl-T (Canvas > Tracing Paper) for a visual reference of where you are on the canvas as you paint. Don't get attached to details. Keep your brush size large (Figure 4.35) so that you are forced to work in an abstract way. Don't be afraid of making a mess, or a *muck up*.

These rough, general, gestural brushstrokes capture movement, energy, and flow. They form a foundation, or underpainting or muck up, onto which you will build up finer details. Figure 4.36 shows the resulting roughed-out image.

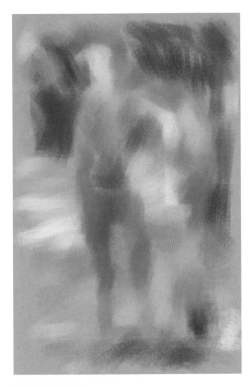

Figure 4.36 Roughed-out image, or muck up.

Figure 4.37 Tracing Paper command.

Figure 4.38 Tracing Paper activated.

All About Tracing Paper

What Is Tracing Paper?

The Tracing Paper function in Painter, which is toggled on and off by the Cmd/Ctrl-T shortcut or Canvas > Tracing Paper (Figures 4.37 and 4.38), allows you to see a 50% opacity representation of a clone source image (that may or not be your original photograph) superimposed on a 50% opacity representation of a destination image (which may or may not be a clone copy of your original), where both images must have exactly the same pixel dimensions (width and height). If your destination image is the same as your clone source, then you don't see any effect of Tracing Paper. The Tracing Paper function in Painter creates an illusion of traditional tracing paper, where you appear to be able to see through your destination image into the clone source image "behind." It is very useful when starting off painting on a clone copy after you've cleared the copy or filled with a background color, since you can then make brushstrokes that correspond to the features and forms in your original image. Note, though, in the two figures that once Tracing Paper is turned on, you can't see the brushstrokes.

The Problems with Tracing Paper

The problem with Painter's Tracing Paper is that it is very misleading—you can't see what you're painting and are often surprised when you turn Tracing Paper off. It is also very easy to accidentally have Tracing Paper turned on without realizing it and work for a considerable time before recognizing that you are not seeing your actual image. Tracing Paper has no flexibility—you cannot vary the percentage of each image (source versus destination). Finally, if you really like how your image looks with Tracing Paper turned on, you can't save the image like that—it's only a mirage, a temporary visual illusion.

An Alternative

One solution to these problems is to recreate the effect of Tracing Paper by making a special Tracing Paper layer in your working image (destination image). Here are the steps to do this.

1. Go to your original (clone source) document.
2. Select > All (Cmd/Ctrl-A).
3. Edit > Copy (Cmd/Ctrl-C).
4. Select > Deselect (Cmd/Ctrl-D).
5. Go to your working image.
6. Hold down the Spacebar and click once. This centers your image. An alternative is to choose Cmd/Ctrl-0 (that's the numeral zero, not the letter oh) to Zoom to Fit, which also centers the image. Centering the image is important since otherwise your pasted Tracing Paper layer will be misaligned.
7. Edit > Paste (Cmd/Ctrl-V).
8. In the Layers palette double-click on the Layer 1 that you've just pasted.
9. Rename the layer Tracing Paper.
10. Reduce the Tracing Paper layer opacity to suit (20% often looks about right).
11. Select Canvas in the Layers palette. This is important since otherwise you may end up accidentally painting on your Tracing Paper layer.
12. Use the little eye icon to the left of the Tracing Paper layer to turn it on and off.
13. Save the file as a RIFF to preserve the layer. Before closing Painter, back up as a PSD.

18. Save Your Rough Version

At this stage choose File > Save As (changing the version number and adding a note like "squchlk-rough") or Iterative Save. Keep saving sequentially numbered versions at regular intervals, especially just before you are about to change your brush or make a strategic step in the creative path of transformation (such as changing from working in large abstract forms to working on smaller levels of detail).

Figure 4.39 Adding detail with a smaller brush.

19. Finer Brushstrokes for Finer Detail

After creating the general foundation, reduce your brush size and start bringing out more detailed forms, particularly in the focal points of your image. In this case I concentrated the finer brushstrokes on the faces of Lindsay and Oscar (Figure 4.39).

20. Soft Cloner for Focal Point Detail

There were some details in the image, such as the eyes, where I wanted to bring in a greater degree of realism. To do this I selected the Cloners category > Soft Cloner, a soft-edged variant that brushes in the original photograph without any distortion (Figure 4.40). The Soft Cloner gives you the freedom to take risks and be bold with your transformations—no matter how messy you make an image, you can always use the Soft Cloner to brush back the original.

After applying the Soft Cloner I went back over the region with a fine Square Chalk at low opacity to bring back the rough texture of the chalk. Smooth photographic detail in the middle of a painterly or chalky painting stands out and looks wrong. That is why I recommend discretion and subtlety when applying the Soft Cloner.

21. Add Your Own Color

With the Square Chalk selected, uncheck the Clone Color button. Hold down the Option/Alt key while clicking in the image to pick up colors already there. Then apply those colors back into the image, making adjustments to the hue and luminosity according to what effect you want to achieve. In my case I wanted to reduce the intensity and contrasts in the background and on Oscar's flank in order to bring the viewer's attention to the heads. My goal wasn't to add wild colors. I had been

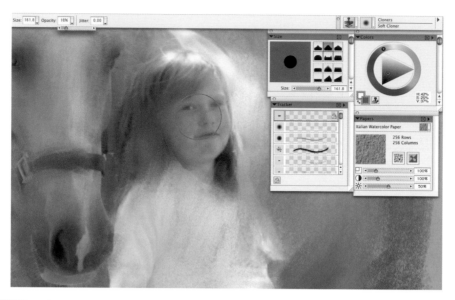

Figure 4.40 Soft Cloning in very fine detail.

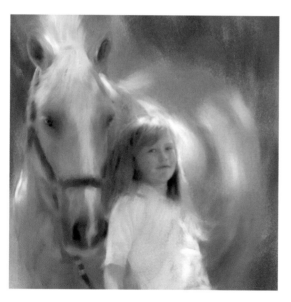

Figure 4.41 Colors added to blend in Soft Cloner work and sculpt Oscar's flank to recede into the background.

asked specifically by my client to keep my palette muted, so I decided to use just colors already there (Figure 4.41).

22. Final Touches

My final touches in Painter were to add a few highlights in the face. I also took a step back from the painting and ensured that the over tonal balance worked. I added my digital signature in the bottom

right corner, using a small, high-opacity version of the same Square Chalk and picking the signature color from within the image. I then saved a TIFF version of the final image, adding an F after the version number so I could easily identify which file it was. I reopened the final TIFF file in Photoshop and adjusted the Levels to get the file ready for printing. I worked closely with my printer to further adjust the digital file for the best-quality print possible.

Chalky Pastel Example: The Ballerina

I based the Ballerina image on a photograph taken by David Taylor (Figure 4.42). David's intention when capturing his photograph was to create the feel of an Edgar Degas pastel drawing. I continued that vision with use primarily of the Pastels > Artist Pastel Chalk brush, following a similar technique to that described earlier for Lindsay. With the Ballerina image I added color patches and then softly blended these color patches into the rest of the picture using the Artist Pastel Chalk with Clone Color and using the Blenders > Just Add Water variant with soft pressure, low opacity, and medium size (Figures 4.43 and 4.44).

Figure 4.42 The original source photograph (photography: David Taylor).

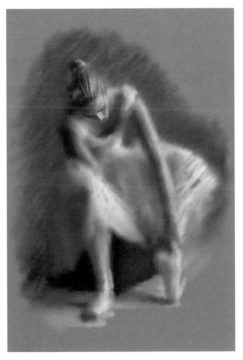

Figure 4.43 An intermediate stage.

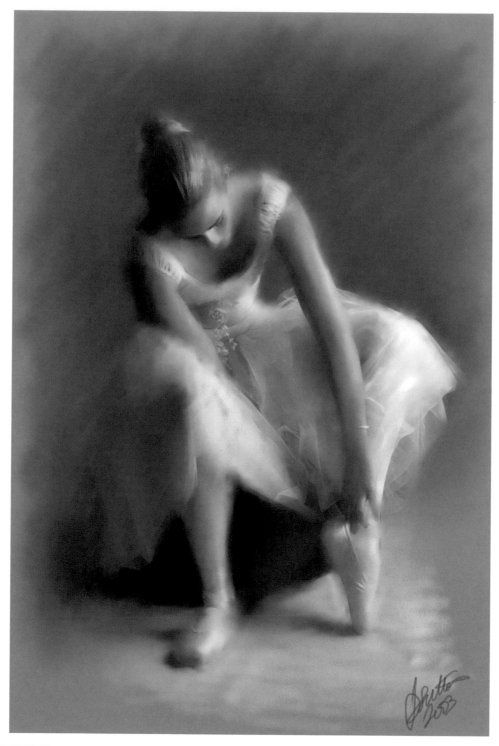

Figure 4.44 "Ballerina."

Chalky Pastel Example: Strummin'

Strummin' is based on a photograph I took of musician Todd Gilbert playing guitar and singing in Half Moon Bay, California (Figure 4.45). My goal in painting was to convey the soul and passion with which Todd plays his music. I used the Chalks > Square Chalk for the main brushwork and brought back some detail with the Cloners > Soft Cloner, adding some color accents with a small Artists > Sargent brush and blending with Blenders > Grainy Water (Figures 4.46 and 4.47). You will find another version of Strummin', one that uses the Woodcut effect, in the following chapter.

4.6 Watercolor Sketch

Technique Overview

This case study shares an approach that emulates the look and feel of a loose watercolor sketch, where watercolor paint and a pencil sketch are combined and the paint fades off at the edges into the white paper. The subject is Columbus Avenue in San Francisco's North Beach neighborhood. These techniques can equally be applied to portraiture or any other subject matter. The watercolor style typically works best with high key (predominantly light-valued) images.

Figure 4.45 The original source photograph.

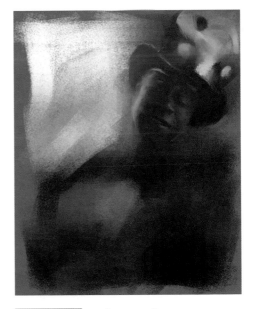

Figure 4.46 An intermediate stage.

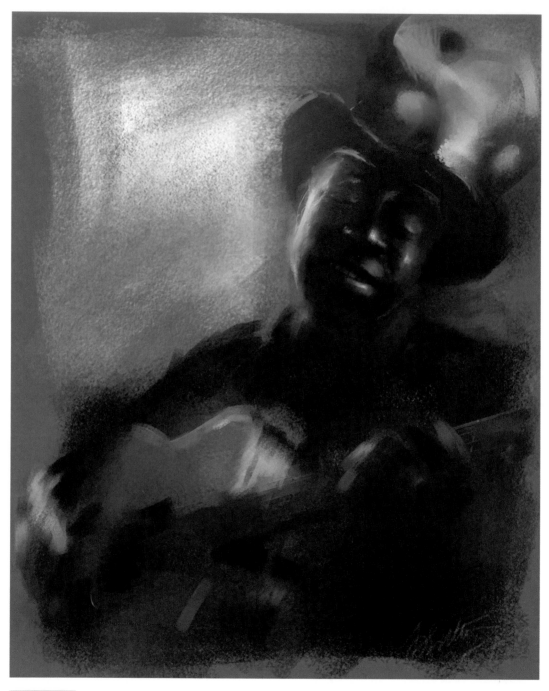

Figure 4.47 Strummin'.

An Aside on Watercolor

Traditional watercolor paintings are typically built up from light washes to darker colors, often with a translucent quality to the paint. Digital watercolor tools allow the creation of watercolor paintings that have much greater color depth and intensity than traditional watercolors. When building up paint in a traditional watercolor, you can wait until one layer of paint is dry and then add your next layer (wet-on-dry), allowing fine detail and well-defined edges, or you can add paint on top of still-wet paint (wet-on-wet), which results in running, mixing, and blending of colors on the paper.

The artifacts associated with both wet-on-dry and wet-on-wet techniques can be emulated with brushes and effects in Painter. There are two categories of dedicated watercolor brushes in Painter: Digital Watercolor (whose variants paint directly onto the background canvas though sometimes acting as if on a separate layer) and Watercolor (whose variants paint into a separate Watercolor layer). The special properties of both these types of brushes are only preserved within RIFFs. These brushes can give some beautiful effects that emulate natural watercolor phenomena, such as the dispersion of paint into the grain of the paper, wet fringes, running paint, and the absorption of salt. These watercolor brushes involve mainly a "buildup" method (see Windows > Brush Controls > General), which means they build up to a dark value quite quickly when brushstrokes overlap, and this sometimes makes it difficult to achieve subtle light colors.

Steps

1. Start with a Vision

The final image called "North Beach" (Figure 4.48) was based on the photographic image in Figure 4.49, which appealed to me because of its strong diagonals, its nostalgic pastel coloring, and the classic Edwardian architecture counterbalanced by the distant spires of Saints Peter and Paul Church. My vision for this was a loose, rough sketch style of painting in the tradition of *plein air* painting (from the French *en plain air*, meaning "in the open air"). I was particularly inspired by the beautiful watercolor sketches of John Singer Sargent made during his visits to Italy. In Sargent's watercolors the heavy grain of the watercolor paper was visible in the way the paint soaked into the paper, and the paint was applied lightly, with patches of white paper showing though here and there. The details of people and buildings were not there, but the quality of light, the mood, and the atmosphere were conveyed.

2. Prepare Your Source Image (Photoshop)

This photograph was captured as a RAW file. I opened it from the Photoshop browser and made some initial adjustments to the exposure and saturation in the RAW window (Figure 4.50).

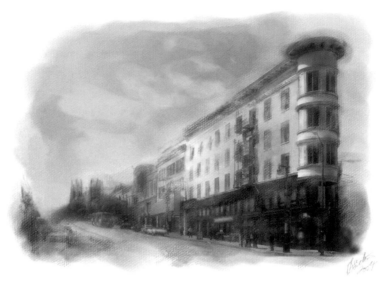

Figure 4.48 "North Beach."

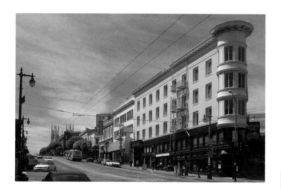

Figure 4.49 The source photograph.

As you can see, my initial image had a slight perspective distortion due to the wide-angle lens. I used the Photoshop Crop tool, with the perspective option checked in the Tool Property Bar to correct the perspective (making the buildings vertical) and crop the image. I saved a TIFF version of this cropped image (named nthbch-00-orig.tif). Note that the same proviso applies here as in the earlier case study: If you are intending to use the Iterative Save, then end your file name (before the .tif) with _000.

2. Apply Watercolor filter (Photoshop)

I am a great believer in the power of hand brushstrokes and tend to avoid applying any form of global filter or effect. However, the Photoshop Watercolor filter can provide you with a handy shortcut to generating a rough undercoat painting from which to base a painting in Painter (Figure 4.51). In this case I selected, in Photoshop, Filter > Artistic > Watercolor, increased the Brush Detail setting,

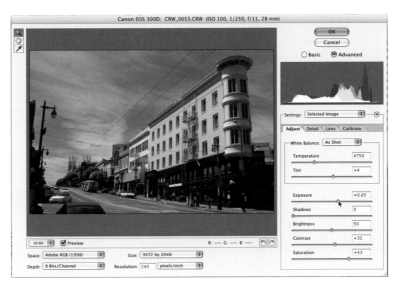

Figure 4.50 Making adjustments in the Photoshop RAW window.

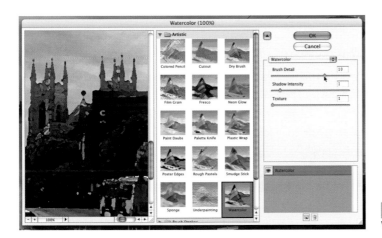

Figure 4.51 The Photoshop Watercolor filter window.

CHAPTER 4 PHOTO TECHNIQUES I: PASTEL, WATERCOLOR, AND OIL

and reduced the Shadow Intensity and Texture settings. For an even more drastic effect, the KPT Collection Pyramid Paint offers an interesting plug-in filter you can use from within either Photoshop or Painter.

I saved the resulting image as nthbch-01-wcorig.tif ("wc" for watercolor). This filtered image is the one I then opened in Painter.

3. Choose Paper Texture (Painter)

With the filtered image open in Painter, choose Window > Library Palettes > Show Papers. Click on the small Papers selector icon (upper right of Papers palette) to reveal the Papers library menu. Select a paper you feel will suit your image. In this case I selected the Coarse Cotton Canvas (Figure 4.52),

Figure 4.52 Selecting the Coarse Cotton Canvas Paper Texture.

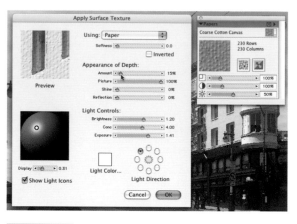

Figure 4.53 Applying Paper Texture to the filtered image.

since this texture seemed closest to the look and feel of the texture of paper that Sargent used, which was a very coarse, thick watercolor paper.

3. Apply Paper Texture to the Filtered Image

Choose Effects > Surface Control > Apply Surface Texture (Figure 4.53). Make sure the Using: menu is set to Using: Paper. Reduce the Shine slider to zero. Reduce the Amount slider so the texture is not overwhelming the image. This is the time to decide whether or not to adjust the scale of the paper. If you have a very large file size, your paper grain may look a little small with respect to the features in the image. In that case, increase the Scale slider in the Papers palette (first slider). In this case the default scale (100%) worked fine.

Click OK to apply the texture. If the texture appears overwhelming, choose Edit > Fade and fade back the effect accordingly. Save the resulting image with a name that indicates the addition of texture, keeping consistent with the file-naming convention you are adopting (I called this stage nthbch-02-wctxtrorig.tif).

4. Add Border

Since the loose watercolor sketch technique requires a rough edge where the paint blends and fades away into the watercolor paper, it is a good idea to add a white border to your source image before making a clone copy of it. This white border acts as breathing space into which you flow with your brushstrokes, extending the paint beyond the original photographic border. Choose Canvas > Canvas Size (Figure 4.54). Decide on how large a border to add. You may need to do this by trial and error. In this case I added 200 pixels all the way round (using the Tab key to go to each box in turn on the Canvas Size window).

Click OK and a plain white border will be added. There is no need to add any texture to this white border since the goal is to end up printing onto fine art paper that has its own paper grain.

Figure 4.54 Adding a white border.

White is the default paper color. If you find that a color other than white is added, choose Cmd/Ctrl-Z to undo the Canvas Size operation, select white in the Color palette, choose Canvas > Set Paper Color, and repeat the Canvas Size operation.

5. Rename Your Source Image
Choose File > Save As and rename your source image with a note about the border (I called this stage nthbch-03-orig200brdr.tif).

6. Create Clone Copy
Choose File > Quick Clone. This makes a clone copy of the filtered image, automatically clearing the canvas and turning Tracing Paper on.

7. Rename Clone Copy
Choose File > Save As. Get rid of "clone of" in the file name and add the next sequential version number and, if you wish, a note that this is the image on which you will start painting (I named my file nthbch-04-start.rif). Save your working files as RIFF files to ensure maximum versatility, remembering to back up as TIFF or Photoshop before closing Painter.

8. Mount Clone Copy
Choose Cmd/Ctrl-M (Window > Screen Mode Toggle). This mounts your clone copy, simplifying your desktop and ensuring that you do not accidentally paint on your original.

9. Brush Research
You are now ready for real painting action! I decided with this image to start with a rough pencil sketch and then paint over those lines so they show through a little, combining the dynamism, spontaneity, and energy of pencil line with the power and impact of broad brushstrokes. Thus I knew I wanted to start with a pencil but was not sure which one. I decided to do some research, just like the research I did for the pencil sketch technique at the beginning of this chapter. I choose Cmd/Ctrl-T,

which turns the Tracing Paper effect off so that I just had a plain white canvas. I then selected the Pencils category in the Brush Selector Bar (click on the small left-hand icon). I then went through all the variants in this category (the variant menu is accessed by clicking on the small right-hand icon in the Brush Selector Bar). With each variant I made test brushstrokes on my canvas and played with the Property Bar sliders. I was aiming at a pencil stroke that displayed some grain, that was not too dark or thick, and yet that was not too soft either. I ended settling on the Flattened Pencil variant with lower Opacity, Grain, and Resat values than the default settings.

Saving Custom Variants

After finding settings for a brush that you like, you may subsequently change the settings of the variant or return all variants to their default settings, in which case you'd lose your custom settings unless you had saved the variant. The advantage of saving custom variants is that your brush settings will be preserved for future use. In this case, having found a brush I liked, I selected Save Variant from the Brush Selector Bar pop-up menu (click on the small black triangle in the upper right corner) (Figure 4.55).

I then named the custom variant "JS-Flattened Pencil." Notice that I name my custom variants with a space at the beginning of the name so they go to the top of the variant menu (which lists items alphanumerically) and with my initials so that I can easily differentiate my custom variants from the default ones. After clicking OK, this custom variant will be added to the Pencils variants list. The variant listed in the variants list will still be the original variant (in this case Flattened Pencil). To access your custom variant in the future, you'll need to select it in the variants list.

You can always restore the original factory settings for your current variant by selecting Restore Default Variant from the Brush Selector pop-up menu. You can reset all variants to their default settings by choosing Restore All Default Variants. In one fell swoop, you can also, by holding down the Shift key when you launch Painter, reset every setting in Painter to the factory default settings. Be wary when doing the Shift key reset since you can easily loose your custom variants and art materials when doing this (you need to back them up first).

Figure 4.55 The Save Variant menu option.

Locking Your Favorite Brushes in the Tracker

The Tracker is a useful device in Painter that, as the name suggests, keeps track of all the brush variants you use. They are listed with the most recently used variants at the top. I recommend having the Tracker set up so that it lists the names of the variants (it is difficult to identify variants from their thumbnails or strokes). If your Tracker shows thumbnails or strokes, click on the Tracker pop-up menu (small black triangle in upper right corner of the Tracker palette) and select List.

The Tracker retains its contents from Painter session to painter session. If you find there are a few brush variants you keep using, you can lock them in place at the top of the Tracker window. You do this by selecting that variant in the Tracker menu (you will see it highlighted) and then clicking on the padlock icon in the lower left corner of the Tracker palette (Figure 4.56).

You will see a padlock icon appear to the right of the variant name in the Tracker. All locked variants appear at the top of the Tracker for convenience. To unlock a locked variant, select that variant and click on the padlock icon in the lower left corner.

Note that you can also drag variants out into custom palettes (literally just drag the variant icon onto your desktop or into an existing custom palette). When you click on the icon in the custom palette, that particular variant becomes the current variant. The problem with variant shortcuts in custom palettes is that all you see is the category icon without any way to iden-

Figure 4.56 Locking a variant in the Tracker.

tify which variant it is. That can make it confusing, especially if you drag in more than one variant from the same category.

If you accidentally create custom palettes and need to clean up and delete some, you can do so by choosing Window > Custom Palette > Organizer, selecting the unwanted custom palettes, and clicking the Delete button.

10. Clear Canvas

Choose Cmd/Ctrl-A (Select > All) followed by Backspace/Delete. This clears your canvas of your brush research marks.

11. Turn on Tracing Paper

Choose Cm/Ctrl-T (Canvas > Tracing Paper) to turn on Tracing Paper.

12. Make Pencil Sketch

With the Tracing Paper image as reference and using your selected pencil variant, make a quick line sketch (Figure 4.57). Don't worry about getting all the detail. This will just form a loose framework over which to build your painting.

From time to time, turn off Tracing Paper (Cmd/Ctrl-T toggles Tracing Paper on and off) to see what you've drawn (Figure 4.58). Also intermittently choose File > Save As (or Iterative Save). I saved the file as nthbch-05-fltpencil.rif). When complete, leave Tracing Paper off.

12. Save Pencil Sketch

When you have completed your pencil sketch stage, choose File > Save As and save your image with the next sequential version number and note that it is the final pencil sketch stage (I saved the file as "nthbch-06-pencilsketchfinal.rif").

Figure 4.57 Pencil sketch with Tracing Paper on.

Figure 4.58 Pencil sketch with Tracing Paper off.

13. Find Good Brushes for Painting

Having completed the initial underlying pencil sketch stage, the next step is to select brushes for the painting. In this example I decided to explore the Tinting brush category. As with the Pencils brush category, I used my canvas as a scratch pad for trying out all the variants in the Tinting category, making adjustments to the Brush Property Bar settings as I explored. When I came across brush variants I liked, I locked them into the Tracker (Figure 4.59). If I had also changed the Brush Property Bar settings, then I saved the variant (as described earlier).

If you change the paper texture settings from the defaults, you may wish to save your brush variant as a brush look (see earlier), since this saves paper texture as well as brush setting information. I found, during my brush research, that increasing the Coarse Cotton Canvas paper scale from 100% to 178% and the paper texture contrast from 100% to 230% worked better with this image than the default paper settings. I therefore saved a brush look to preserve that setting.

14. Revert Canvas Back to Pencil Sketch

When you are satisfied with the variants you have found, choose File > Revert and revert the canvas back to the last saved version, which was the pencil sketch.

14. Build Up Background Brushwork

Choose the Tinting > Grainy Glazing Round 15 brush variant. Increase its size and decrease its opacity. Check the Clone Color button in the Colors palette so the color wheel is grayed out. Now apply soft brushstrokes in the background regions of your image (Figure 4.60). In this case I worked into the sky first. I also saved this variant as a custom variant.

Where possible, make your brushstrokes follow the forms and compositional lines of your source image. The Grainy Glazing Round 15 variant is well suited for this style of painting since its graini-

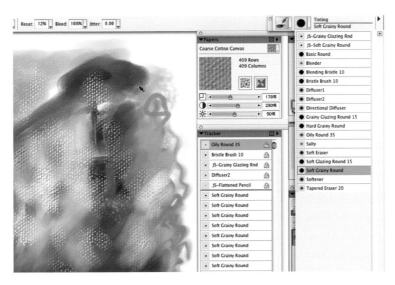

Figure 4.59 More brush research.

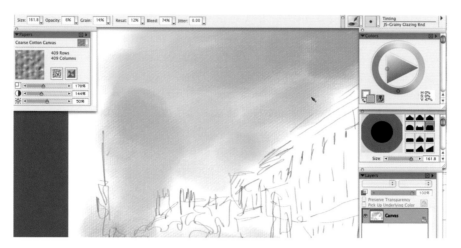

Figure 4.60 Working with large, soft brushstrokes into the background.

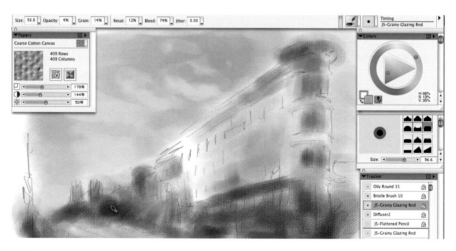

Figure 4.61 Adding detail with a smaller brush.

ness exhibits the paper texture nicely and its translucency allows the pencil line work to show through.

15. Reduce Brush Size and Add More Detail

Slightly reduce your brush size and start working into more detail, though still with light, general, and slightly abstract brushstrokes (Figure 4.61). From time to time turn Tracing Paper on (Cmd/Ctrl-T) for reference of specific features. Remember to turn Tracing Paper off again, though, so you can see what you're painting (otherwise you'll tend to paint too heavily and be in for an unpleasant surprise when you turn Tracing Paper off later). Also start to turn the Clone Color button off and add your own color. In this example I added clouds by turning the Clone Color off, picking a light blue from the sky, and then lightening the value (moving the cursor upward in the Value-Saturation tri-

angle of the Colors palette). I also added a little extra green for the trees and maroon for the base of the building in the foreground.

16. Further Refinement with the Soft Grainy Round

Choose Tinting > Soft Grainy Round. Increase the Grain setting slightly and lower the opacity and size. Use this brush to apply further refinement to the image (Figure 4.62).

Make sure you do a File > Save As at this stage and at every stage when you are about to change brushes or brush size, in each case giving an appropriate file name with sequential version number and short descriptor.

17. Subtle Application of the Soft Cloner

Choose Cloners > Soft Cloner. Increase the size and lower the opacity (Figure 4.63). Very gently start cloning in portions of the source image (the textured watercolor version, not the pure photographic

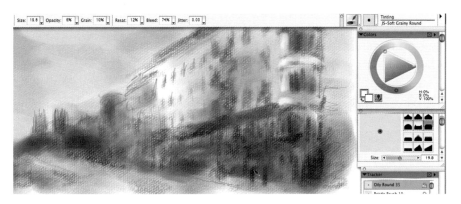

Figure 4.62 Using Soft Grainy Round for more detail.

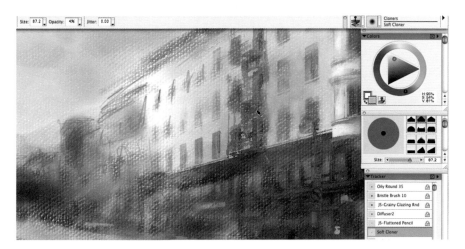

Figure 4.63 Applying the Soft Cloner.

version). The trick here is to leave enough of the rough brushwork and not bring in too much detail. Bring in more detail in the focal points of your image. In this case I brought back most detail in the nearest part of the foreground, the Edwardian building, with its round corner and fire escape trellis-work on the side.

Getting Rid of Too Much Detail

If you find you bring back too much detail or there's a particular feature that stands out too much, open the last saved version, the one just before you applied the Soft Cloner. The quickest way to do this is from the bottom of the File menu, where the five most recently saved files are listed. Then choose File > Clone Source and set this file, the one before you applied the Soft Cloner, to be clone source (by dragging to its name in the Clone Source pop-up menu). The use the Soft Cloner to clone from the earlier version into the current version, getting rid of the excess detail or unwanted contrast.

18. Softening Edges with the Diffuser2

Cloning in the filtered source image has two effects, one good, one bad. The good effect is that the crisp edges, applied subtly, give the illusion of the wet fringe that occurs in traditional watercolor painting. The bad effect is that the edges are sometimes too sharp, too perfect, too straight and have too much contrast. The solution is to choose the Tinting > Diffuser2 variant (Figure 4.64). Apply this softly along those edges that need softening. The Diffuser2 creates the illusion that the paint is diffusing into the paper grain, just as it would in a traditional watercolor painting on an absorbent fine art paper.

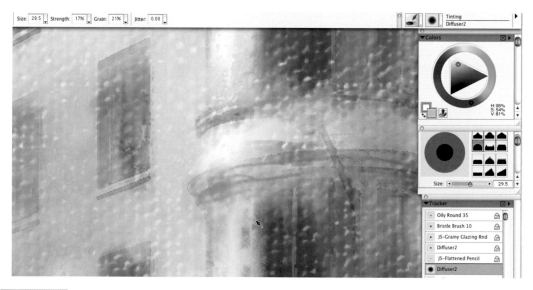

Figure 4.64 The Diffuser2 variant being applied to soften edge details.

After you've applied the Diffuser2, choose Cmd/Ctrl-0 (zero) or Window > Zoom to Fit. Hide the palettes (Window > Hide Palettes). Step back and look at your image. Are there any hard edges? Look out for any signs of the rectangular edge of your original photographic image. If you see any hard edges, soften them with the Diffuser2 or by painting over them with the Grainy Soft Round.

19. Signature

For the signature, return to the Tinting > Flattened Pencil with low opacity (Figure 4.65). Using the same variant that you did the sketch with keeps the signature in harmony and consistency with the rest of the picture.

This could be considered the completion of the artwork. However, I wanted to push it a little further, adding to its intensity and photographic detail (Figure 4.66). For that reason I returned to the original source photograph (before applying the Photoshop watercolor filter) and opened that photograph in Painter.

20. Prepare an Unfiltered Photographic Clone Source

1. Open up your original source photograph in Painter.
2. Add the same 200-pixel white border to your photo that you previously added to your filtered image using Canvas > Canvas Size.
3. Set this image as your clone source (File > Clone Source).

21. Mix from Different Clone Sources

Gently clone in (using the Soft Cloner and light pressure) directly from the source photograph, not from the filtered version. You may find you need to go back and forth between different clone sources (pure photo versus filtered image versus painted image) to get the right balance. You may also find

Figure 4.65 Adding the signature with the Flattened Pencil variant.

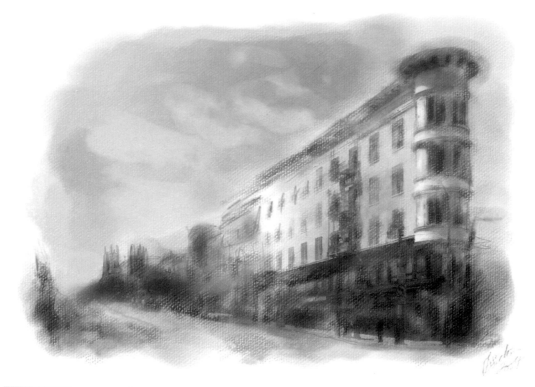

Figure 4.66 Version of "North Beach" with no added photorealism.

you wish to add more of your own coloring, blending your added colors with clone colors. Subtly blend the photo and paint with Blenders > Grainy Water and Blenders > Just Add Water, both at low opacity.

22. Equalize

As a final touch you may wish to pump up the contrast of the image with Cmd/Ctrl-E (Effects > Tonal Control > Equalize).

Mixing More Photorealism with the Watercolor Sketch Technique

There may be cases where you wish to have more realism than is apparent in "North Beach," particularly in the professional portrait industry. Treat the technique demonstrated here as one arrow in your quiver. For a more photorealistic image, follow a similar methodology to the one described here, except reduce the prominence of the paper texture and clone in more of the original photograph. Keep the paper texture contrast setting low and the Brush Property Bar Grain settings slightly higher than the values shown here.

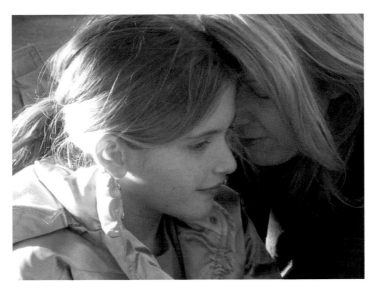

Figure 4.67 Original photograph of Lisa Evans and her daughter Quinn.

Watercolor Example: Precious

I based my next image on a photograph I took of Lisa Evans and her daughter Quinn (Figure 4.67). The moment caught in this photograph was very precious and captured the special loving relationship between mother and child. It was those feelings I wanted to convey in my painting (Figure 4.68). I added a white border to the original photograph in Painter, cloned it, and then worked over the clone copy with a variety of brushes, mainly from the Acrylic category. I blended with some Blenders > Just Add Water. This is an alternative approach to the Watercolor Sketch technique, but one that still has a watercolor feel. This picture received the Northern California Professional Photographers 2003 People's Choice First Place Award.

4.7 Classic Oil Realism

Technique Overview

By *classic oil realism* I am referring to a painting that remains close to the original photograph in terms of colors and forms and where brushstrokes are kept subtle. This form of painting uses paint to subtly retouch and enhance the photograph, enriching and altering colors slightly but not to the extent that the original photograph is lost. There is paint everywhere on the canvas, even though that may not be obvious at first glance.

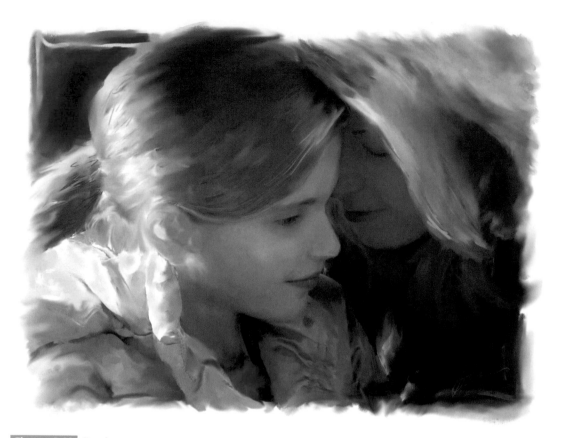

Figure 4.68 Precious.

Steps

Start with a Vision

The example shown in Figures 4.69 and 4.70, "Story Time," was a commissioned portrait of Joyce with two of her grandchildren, Mia and Robin. I picked this image from the photo shoot since it showed all three engaged and connected and was at the same time an interesting composition with strong positive and negative spaces. The hand-crocheted blanket that Mia was leaning on was knitted for her by Joyce when Mia was born, which brings a circle of time into the picture and adds an extra layer of significance to the image. Joyce had mentioned that she liked the bold colors that her late husband, Fred, used in his paintings, so I photographed one of his paintings and used that to create a color set for use in this project. My primary goal was to create a beautiful work of art that captured the warmth and love between a grandmother and her grandchildren.

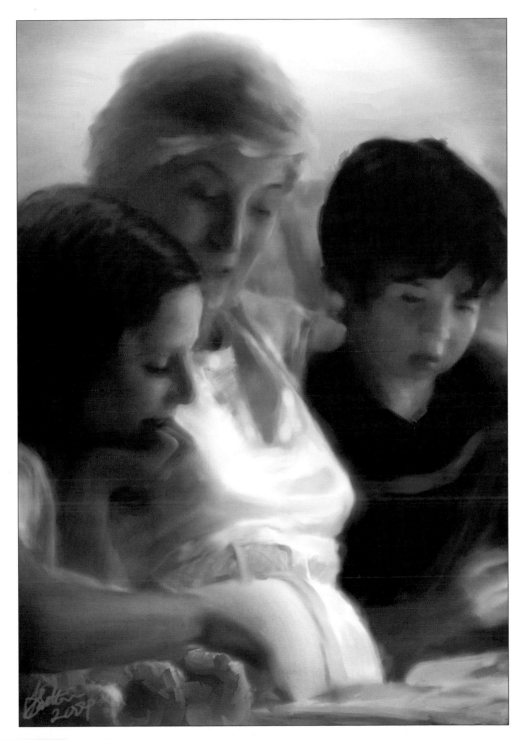

Figure 4.69 "Story Time."

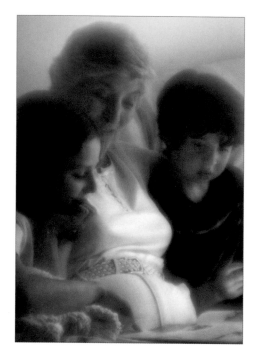

Figure 4.70 Original photograph.

Figure 4.71 Selecting New Color Set from Image.

Capture a Custom Color Set

Before I started painting I first opened the image of Fred's painting and selected New Color Set from Image in the bottom left-hand icon pop-up menu of the Color Sets palette (Figure 4.71). I named the new color set and kept it visible as I was painting. This is an optional step. I did this only because I was endeavoring to fulfill my client's request for inclusion of certain colors.

Prepare Your Canvas

1 Open your source photograph in Painter.

2 Choose File > Clone. Do not use Quick Clone for this technique since we do not wish to clear the canvas.

3 Choose File > Save As. Rename and save the clone copy as a RIFF file. Include a version number.

4 Choose Cmd/Ctrl-M. This mounts your canvas.

Create a Mild Muck Up (Figure 4.72)

1 Choose Artists > Sargent Brush.

2 Click on the Clone Color icon in the Colors palette. You should see the Hue Wheel and Saturation/Value Triangle grayed out (indicating that clone color is active).

3 Start painting brushstrokes that follow the forms of your composition. The result is that you lose detail. This may seem contrary to the "realism" of this technique, but in fact creating a mild *muck up* (meaning slight mess) is a valuable part of the technique. It will serve as your underpainting.

Refine the Painting

1 Once you have covered the entire canvas with Sargent Brush brushstrokes, choose the Cloners > Oil Brush Cloner.

Figure 4.72 Creating a mild muck up.

2 Choose Window > Brush Controls > Open Impasto.

3 Change the Draw To: from Color and Depth to Color. This turns off the impasto depth effect and results in a smooth oily brush with fine bristly structure (Figure 4.73).

4 Choose Save Variant from the Brush Selector pop-up menu. Save this variant for future use.

5 Apply this brush in the areas of the image that need smoothing, such as the skin (Figure 4.74).

Figure 4.73 Modify the Oil Brush Cloner to turn off the impasto depth effect.

Figure 4.74 Applying the modified Oil Brush Cloner.

Figure 4.75 Using the Soft Cloner to bring back some of the original photograph.

6 Where needed, use the Cloners > Soft Cloner to bring back some of the original photo-graph (Figure 4.75).

Add Your Own Color

1 Choose the Acrylics > Captured Bristle brush.

2 Ensure the Clone Color icon is not active.

3 Hold the Option/Alt key down as you click in a highlight area. This turns the cursor into a Dropper tool and picks color from the spot where you click in the image.

4 Increase the value and saturation of the selected color by lifting the cursor in the Satura-tion/Value Triangle upward and slightly to the right.

5 Paint in this lighter, brighter color in the highlight (Figure 4.76).

6 Check the Clone Color icon and use the same Captured Bristle brush with clone color to blend the added color into the surrounding color (Figure 4.77).

7 Continue this process of adding your own color and then blending it in with varying size brushstrokes and color choices to suit different areas of the image (Figure 4.78).

Increasing Contrast and Saturation

In looking at the image I felt that it lacked punch and vibrancy. Therefore I took steps to increase the contrast and saturation of the image. These steps may or may not be needed for your own image.

Figure 4.76 Adding lighter, brighter color.

Figure 4.77 Adding color to Mia's hair.

1 Choose Cmd/Ctrl-E (Effects > Tonal Control > Equalize) (Figure 4.79).

2 When you select Equalize in Painter there is an automatic adjustment to your image that increases contrast. Sometimes this is enough and you do not need to make any further adjustments. Other times it helps to adjust the black-and-white points (Figure 4.80).

3 After applying the Equalize command, select Effects > Tonal Control > Adjust Colors (Figure 4.81).

4 Increase the saturation slider in the Adjust Colors window until you're satisfied with the result (which you can see in the preview window) (Figure 4.82).

Figure 4.78 Accentuating the highlight on Robin's nose.

Figure 4.79 Choosing the Equalize command.

Figure 4.80 The Equalize window.

Final Touches

1 Choose Acrylics > Captured Bristle, if it is not already selected.

2 Make sure clone color is off.

3 Hold down the Option/Alt key as you click in the image to pick a color.

4 Now apply that color in another part of the image. In this example I picked some of the pinks from the lower left and added them as background atmosphere brushstrokes in the upper right (Figure 4.83).

5 I then picked an orange color from Robin's hand in the lower right and applied that color in the upper left background. This approach creates subtle resonances that unify the composition and create a sense of harmony and balance.

Figure 4.81 Selecting Adjust Colors.

Figure 4.82 The Adjust Color window.

Figure 4.83 Adding background atmosphere brushstrokes.

6 Choose the Blenders > Smear.

7 Smear areas that need further blending or smoothing out. In this example I applied the Smear brush in the background to make the brushstroke structure more diffuse and less obtrusive. I wanted the background to fade away and the viewer's attention to go to the faces and to circle around between the faces and the hands (Figure 4.84).

Figure 4.84 Smearing the background.

4.8 Expressive Oil Impressionism

Technique Overview

This case study (Figure 4.85) shares an approach to interpreting a photograph (Figure 4.86) in a style influenced by the use of impressionistic color by artists such as Monet and the use of thick, expressive brushstrokes by artists such as Vincent Van Gogh, hence the term *expressive oil impressionism*. The basic principles and methodology covered here can be applied to rendering a photograph in almost any painting style or media. The key part of the process described here, as in the previous case study, is the muck up, the letting go of detail and perfection, the creating of a simple foundation on which to build up your image.

Art Movements That Influenced "Hand in Hand"

The art movements that influenced the creation of "Hand in Hand" included Impressionism, Post-Impressionism, Fauvism, and Expressionism. Impressionism, which began in France in the mid- to late 19th century (examples include Claude Monet and Pierre-Auguste Renoir), is a spontaneous style of art that strives to capture the impression of natural light in a scene. The Post-Impressionists were artists in the late 19th century, such as Paul Cezanne, Paul Gauguin, and Vincent van Gogh, who were influenced by Impressionism, though they took their art in different directions, using bold brushstrokes and gestures. Fauvism, based primarily in France at the end of the 19th century (examples include Henri Matisse and André Derain), was a style of art that used "wild," unnatural colors (a critic had labeled the artists *les fauves*, or "wild beasts"). Expressionism, centered in Germany in the first half of the 20th century (examples include Wassily Kandinsky and Egon Schiele), is a movement where the artists express their inner feelings and state in the way they depict a subject.

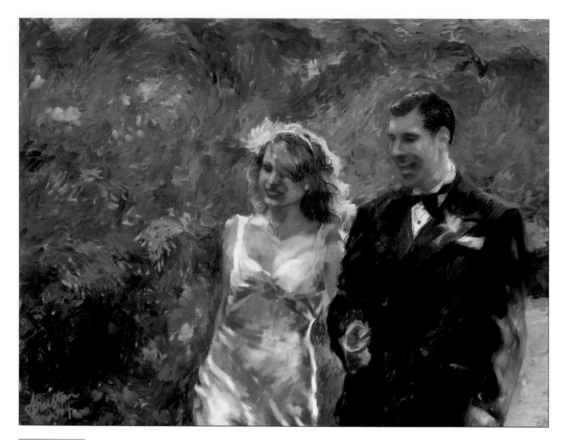

Figure 4.85 "Hand in Hand."

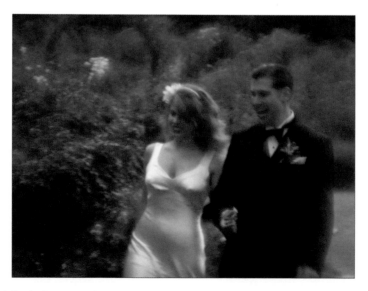

Figure 4.86 Original photograph.

Steps

Start with a Vision

The inspiration for this image was a photograph I took of my friends Heidi and Steve (www.balboaswing.com) at their wedding. They were walking past the roses in the Descano Gardens, La Cañada, California, just minutes after getting married. The play of light and shade suggested so many colors. I envisioned thick, luscious brushstrokes that followed the forms in the image, picking up the rich, warm colors of the afternoon sun and of nature. I envisioned focusing in on Heidi and Steve in a style of brushstroke that was both impressionistic, in catching the effect of natural light, and expressionistic (and a little fauvist) in using intense and sometimes contrasting colors that came from my imagination as well as what was in the original photograph.

Prepare Your Source Image (Photoshop)

As with the techniques described earlier in this chapter, start by preparing your digital file for painting, first in Photoshop, where you use Adjustment layers to optimize the tonal and color balance of the image. Flatten the file and then crop if needed. Resize if needed. Resave as a TIFF (or Photoshop) file and open it in Painter.

Decide on Border (Painter)

Before making a clone copy to paint on, you must decide whether or not to add a border to your original source image. In this case, since we are emulating an oil painting and the final image will be printed on canvas, stretched or mounted in a frame or with a gallery wrap (stretched canvas with either paint or thin wood or tape over sides), the paintwork will go right until the edge of the canvas. Thus there is no need, in this case, for adding any border.

Create a Custom Shortcuts Palette

For convenience I recommend setting up a custom shortcuts palette with buttons for such frequently used commands as Save As and Clone. Here's how to do it.

1. Choose Window > Custom Palette > Add Command
2. Choose File > Save As. The advantage of making a Save As button is that you can avoid accidentally selecting File > Save instead of File > Save As.
3. Click OK. You have now created a custom palette called Custom 1 with a Save As button in it.
4. Choose Window > Custom Palette > Organize.
5. Select Custom 1.
6. Click Rename. Rename the Custom 1 palette "Shortcuts" (or you can be more task specific and have different custom palettes for different tasks).

7　Choose Window > Custom Palette > Add Command.

8　Choose Add to: Shortcuts.

9　Choose File > Clone. Click OK. You can add any menu commands you wish, plus you can drag in variants from the Brush Selector Bar. If you are going to use the Iterative Save feature, I recommend also creating an Iterative Save button.

If you accidentally generate too many custom palettes, you can delete them in the Window > Custom Palette > Organizer. To rearrange buttons in the custom palettes or to drag them out of the palettes, hold the Shift key down while you drag on the buttons.

Resave Original Photograph

With your original source image open in Painter, choose File > Save As. Name this file with a consistent beginning that you will use for all files in this project, and then add version number, for instance, "handinhand-00-orig.tif" (unless you plan to use the Iterative Save feature, in which case you'd use "subject_000.tif"). I often save my original image as a TIFF file and then subsequent working files as RIFFs, backing up periodically as either TIFF or Photoshop. Save your original image into a prepared folder for this project. All subsequent versions of this file as you work on and develop the image will be saved into the same folder location with consistent file names and consecutive version numbers. Doing this ensures you have easy access to your original image and all intermediate versions any time you wish to continue working on the project.

Save Your Palette Arrangement

Once you have gotten used to Painter and have your palettes arranged in a way that works for you, it is a good idea to save the palette arrangement. That allows you to conveniently access the same palette arrangement at any time in the future. It also allows you to create a variety of arrangements for different tasks.

1　Choose Window > Arrange Palettes > Save Layout.

3　Name your layout. In this case I named it Basic Paint. The layout has now been added to the Arrange Palettes drop-down menu.

Note that palette arrangements are screen resolution dependent, so if you go between different screen resolutions you may wish to include a note of resolution in the layout name. If in doubt you can always select Window > Arrange Palettes > Default, which will fit to whatever your current screen resolution is.

Make a Clone Copy

Choose File > Clone (or click on your Clone shortcuts button). This creates a duplicate image that has Clone of . . . at the beginning of the file name. This clone copy is referred to here as your working image since it is the image you will be painting on.

Original Automatically Defined as Clone Source

In using the Clone command on an original image, you automatically define your original image as Clone Source and will see the image name with a checkmark by it when you look at the File > Clone Source menu. This means that all cloner brushes (brush variants from the Cloners category or brushes that have the Clone Color icon activated in the Colors palette) will look to the original image for their color. Cloning in Painter is like using the Rubber Stamp tool in Photoshop, except it is much more versatile. In Painter you can turn almost any brush that adds color to the canvas into a cloner brush just by activating the Clone Color icon in the Colors palette.

Mount Your Working Image

Choose Cmd/Ctrl-M (Window > Screen Mode Toggle). This mounts your working image so your desktop is as uncluttered as possible. I recommend working in screen mode whenever possible.

Fill Your Working Image with a Background Color

Choose a background color in the Colors palette (or by using the Dropper tool to pick color from within the image). I chose a blue color to contrast with the greens, pinks, and yellows in the image (Figure 4.87).

Figure 4.87 Filling the Working Image with a background color.

Save Your Working Image

Choose File > Save As (or click on your Save As shortcuts button). Delete "Clone of . . ." from the file name, change the version number, and add a note that this is your start image. Save the working file as a RIFF for maximum versatility. In this case I called the clone copy "handinhand-01-bkgnd.rif." Remember to save sequentially numbered versions regularly as you work, and always back up your most recent version as a TIFF or Photoshop document before you close Painter.

Choose a Good Muck up Brush

The first stage of this painting is the muck up stage. Creating a muck up involves working over the entire canvas with thick brushstrokes. These brushstrokes simplify the image into regions of light and dark tone and the main color blocks. The muck up brushstrokes embody movement, energy, and flow that form a dynamic foundation, or underpainting, on which you can selectively bring back detail and add color and contrast as required.

There are many brushes and combinations of brushes that can work well as muck up brushes. My all-time favorites are Den's Oil Funky Chunky and Big Wet Luscious, both of which you'll find in the Jeremy Faves 2.0 brush category (contained on the companion Resource CD). Other great muck up brushes include Artists > Sargent, Artists > Impressionist, Palette Knives > Loaded Palette Knife, and Blenders > Oil Blender 40. In the example shown here I decided to use the Artists > Impressionist brush.

Brush Research

Use a section of your working image to do brush research and explore different oily brushes. Check the Clone Color icon in the Colors palette as you test muck up brushes so that the colors are based on the original photograph. Don't be afraid of experimenting with the sliders in the Brush Property Bar at the top of your screen. The jitter slider, when it appears, can give great results. If you find a brush setting you love, save the variant and lock it into the Brush Tracker.

When you have completed your brush research, use multiple Cmd/Ctrl-Z commands to undo the strokes (you have up to 32 levels of undo) or select File > Revert and revert the file back to its last saved version.

Create a Muck Up

1 Turn Tracing Paper on (Cmd/Ctrl-T) so that you can see the original photograph through the working image.

2 Make sure the Clone Color icon is activated in the Colors palette.

3 Start moving, smearing, and blending imagery with your chosen muck up brush. Cover the entire canvas in brushstrokes using clone color. Don't worry about preserving detail anywhere. The goal is to create a painting that embodies the essence of the original composition. Use brushstrokes that follow the form of the features (Figure 4.88).

Figure 4.88 Using the Impressionist brush with Tracing Paper turned on.

Increase Saturation of the Clone Source

As part of the process of introducing more "punch" and vitality into the final image, I increased the contrast and saturation in my clone source and cloned in colors from the adjusted clone source. You can do this from within Painter by doing the following.

1. Select your original image from the bottom of the Window menu.
2. Choose Effects > Tonal Control > Equalize (Cmd/Ctrl-E).
3. Adjust the sliders until satisfied
4. Click OK.
5. Select Effects > Tonal Control > Adjust Color.
6. Leave the Using pop-up menu on Uniform Color. Adjust the Hue and Saturation sliders to generate an interesting color scheme in the image preview.
7. Click OK.

An alternative would be to prepare a saturated version of the original image in Photoshop using the Layers > Adjustment Layers > Levels and Hue Saturation. In this case you'd need to flatten your image prior to opening it in Painter (Figures 4.89 and 4.90).

Whichever way you choose to increase the saturation of your original image, resave the saturated version with a new name, to identify it. Then manually set it to be clone source by choosing it in the File > Clone Source menu. (Figure 4.91)

Clone In from Adjusted Clone Source

Choose the Cloners > Soft Cloner. Lower the Opacity slider in the Brush Property Bar to about 20%. Gently brush in some of the newly adjusted original image. Use other clone brushes too to bring in the more vibrant colors (Figure 4.92).

Figure 4.89 Increasing the original photograph saturation in Photoshop.

Figure 4.90 Flattening the Hue Saturation Adjustment Layer in Photoshop.

Figure 4.91 Setting the saturated original as clone source.

More Brush Research

Once you've mucked up the image and introduced some more saturated color, the remaining stages of the painting process involve selectively adding detail, color, and contrast. I wanted to get a rich, organic feel to my brushstroke texture. Experiment with more brushes until you find several that will work well with your image (Figure 4.93).

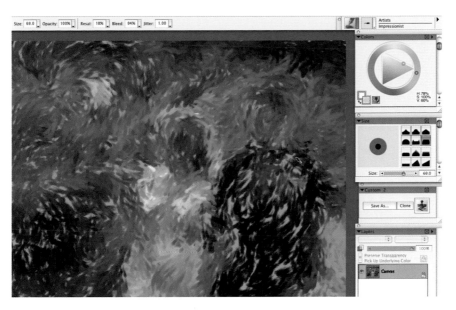

Figure 4.92 Adding Impressionist clone brushstrokes with color from the saturated original.

Figure 4.93 Adding JS-Impasto Luscious brushstrokes with clone color.

Add Your Own Accent, Highlight, and Shadow Colors

At this stage click on the Clone Color icon in the Colors palette to deactivate it. Choose your own color from the Colors palette (or from the Mixer or Color Sets palettes or from sampling color from within the image with the Dropper tool). Add color accents that liven the image, bring attention to your focal points, and help shape the forms (Figure 4.94).

CHAPTER 4 PHOTO TECHNIQUES I: *PASTEL, WATERCOLOR, AND OIL*

Figure 4.94 Adding your own color (not clone color) with the JS-Impasto Pressionist brush.

Defining Form Through Value

As you add your own colors, always bear in mind the value, or luminance, the perceived light-ness and darkness of a color. Value informs our perception of three-dimensional form. The per-ceived value of the colors you apply in your image shape the shading and highlights and thus define form on your canvas. A painter develops the skill of judging value independent of color. You can use Painter's Effects > Tonal Control > Adjust Colors with the Saturation slider set all the way to the left (–39%) to simulate a luminance-only (grayscale) version of your artwork. Choose Cmd/Ctrl-Z (Edit > Undo) to get back to full color (Figure 4.95).

Blend in Colors as Needed

After adding your own color, you can blend them by reactivating clone color or by using brushes such as Jeremy Faves 2.0 > Sable Chisel Tip Water, Blenders > Smear and Blenders > Oily blender.

Use Brush Resize Shortcut

When you wish to change brush size while painting, you can hold down Shift-Option-Cmd/Shift-Alt-Ctrl. Then click and drag and you will see a circle that indicates the adjusted brush diameter. This shortcut allows you to rapidly make big changes in brush size.

Work into the Face and Hands.

In the closing stages of your painting, work to bring out your focal points. In this example I worked into the faces, trying out different approaches (Figure 4.96). In the end, with Steve's head, I wasn't satisfied with my initial brushstrokes, so I used the Cloners > Soft Cloner to bring in a little of the

Figure 4.95 Adding color to the dress.

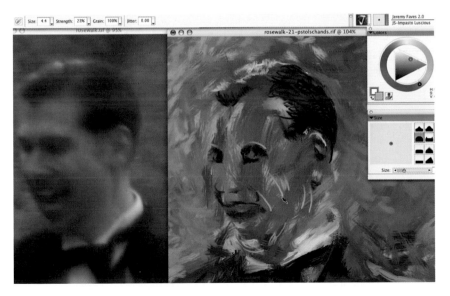

Figure 4.96 Adding color to Steve's head.

original photograph and then worked over that region with the Impasto Luscious brush, making sure I completely covered all the photographic image that had been soft-cloned in. When you do use the Soft Cloner, do so sparingly, and make sure you brush over and blend out any photographic grain that appears.

Add Surface Texture

My intention with this image was to have the effect of thick paint. Some of the brushes I used had a small amount of Impasto depth in their brush behavior. When I got to this stage of the painting I decided to experiment with adding a little extra brush texture. I chose Effects > Surface Control > Apply Surface Texture. I selected Using: Image Luminance in the Apply Surface Texture window, reduced the Amount slider to a small value, and took the Shine slider to zero (Figure 4.97).

After applying the Apply Surface Texture effect I used the Edit > Fade command to fade the effect back a little (it's easy to overdo an effect). I then saved the image as another version. I then opened the version from before applying this effect, made it the clone source, and used the Soft Cloner to clone away some of the texture.

Increase Contrast and Saturation of Final Image

When you have completely covered your canvas in brushstrokes and gone back over the image to add selective detail and color, take a step back and look at your image. You may find you want to generate more value contrast and color saturation. To do this you can follow a similar procedure to that described earlier for increasing the contrast and saturation of the clone source, using

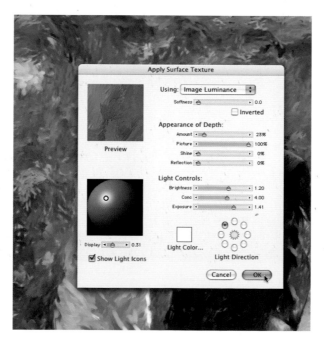

Figure 4.97 Apply Surface Texture window.

either Equalize and Adjust Colors in Painter or the Levels and Hue Saturation adjustments layers in Photoshop.

Add Final Highlights and Accents

Add final detail touches. Take a look at where highlights need to be brought out and accents added.

Sign Off

Don't forget to add your digital signature. I added mine with a small Jeremy Faves 2.0 > Big Wet Luscious, picking up a color from within the image.

Example Image: Quinn Between

Figures 4.98, a photograph of Quinn taken by her mother, Lisa Evans, at Camp Swing (a swing dance camp) in Mendocino, California, was the basis for the muck up stage (Figure 4.99) and then for the final painting (Figure 4.100), which is also featured on the front cover of this book. In this case I added a white border and left a rough edge to the work. I used a variety of different brushes, including Jeremy Faves 2.0 > Sherron's Blender Wood, Pastels > Artist Pastel Chalk, and Acrylic > Captured Bristle, for mucking up and refining the image. This image combines media and has qualities of both pastel and oil paint. I show this both as an illustration of the muck up process and as an example of alternative media approaches. In other words don't feel yourself bound to accurately emulate one specific traditional medium or another. Painter offers you a whole new vista of combined media.

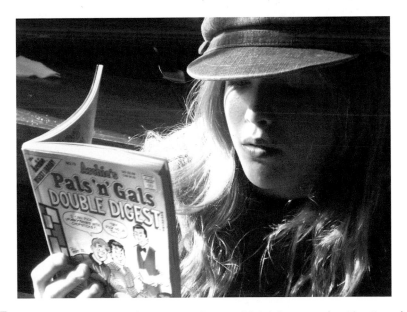

Figure 4.98 Original photograph of Quinn reading *Archie's* (photography: Lisa Evans).

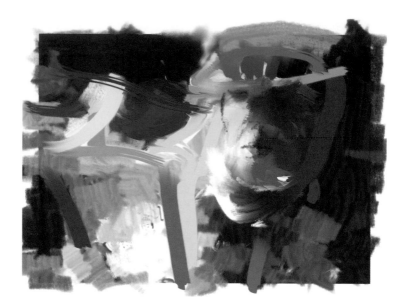

Figure 4.99 Muck up stage.

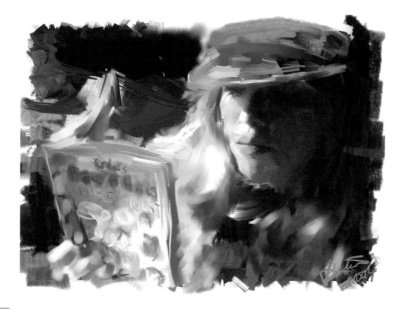

Figure 4.100 "Quinn Between."

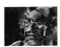

4.9 Student Gallery

Appreciation

I wish to take this opportunity to thank all my students over the years for their inspiration and enthusiasm. I would like to share all their wonderful artwork with you, but space allows only a few pieces to be included in this Student Gallery. I have selected a small sampling of student work that relates to the styles covered in this chapter (you will find artwork by two other students in Chapter 12). This small sampling of work is just a taste of the phenomenal body of magnificent work that my students at all levels have created in my classes over the years. All photography and Painter artwork is by the student in whose section the artwork appears. The students shown here have all participated in my Painter Panache Master Series Seminars, and most of the artworks shown were created as seminar projects during class time. The pieces shown here are not necessarily completed artworks but are studies with which the student explored different techniques and themes. Where possible I have included the original and the muck up stage of the paintings, which tell you so much about the artist's creative process. I have also included what the students wrote to me about their process and how Painter has influenced their art. You will see even from this small sampling the incredible diversity of what is possible.

Fuzzy Duenkel (Figures 4.101 Through 4.105)

Figure 4.101 Original photograph.

Figure 4.102 Muck up stage.

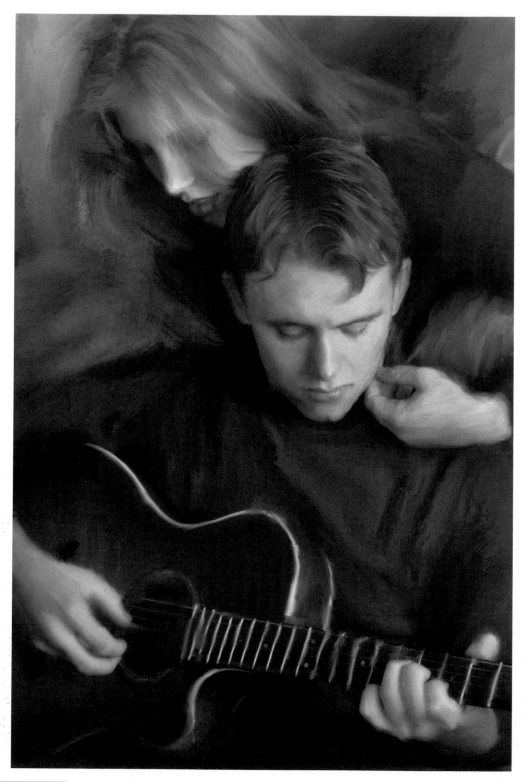

Figure 4.103 "Music of Love."

Figure 4.104 Original photograph.

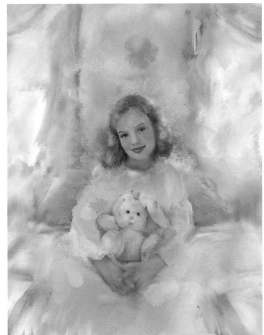

Figure 4.105 "Candi."

Painter is a program that I have long wanted to be comfortable with, because I feel that it is the direction that the more advanced portraitists are headed. We've reached a point where our portrait skills seem to be near a plateau. And yet we still yearn for some way to make the final image match the image in our minds. Photographic techniques, diffusion, and special effects are wonderful to produce an image that conveys an intended message. But often an image needs something more. Painter is that extra touch that allows us to transform an image from a raw state to the finished state. I cringe when I hear that it turns pictures into art. That's silly. Art is a not a filter or a technique. It's a complete, emotional statement that touches the viewer. Painter is simply the final brushstroke that the image needed, and was destined for, from conception.

Why paint an image? I feel that Painter permits the maker to obscure details that interfere with his or her vision of the piece's feeling. Sometimes it needs to be in black and white. Sometimes all that is necessary is to diffuse the image. Sometimes it needs extensive Photoshop manipulation. Painter is another tool in our repertoire of knowledge.

It is extremely versatile and powerful, so much that it that can completely alter an image. In fact, with that power comes the danger of relying on its abilities, rather than our own. It can take over. And that's OK too. But at all times, the maker needs to be able to know what is best for the image. Sometimes it's better to stay focused on our original intent. Other times it's wise to let happy accidents happen, and go with that. But at

no time should the effect overpower the core image. At that point it ceases to be art and becomes an exercise in heartless technique. Much like a barrage of heavy-handed lightning-fast guitar notes, excessive computer manipulation can lead to an image that impresses the viewer . . . for short while.

Art is as timeless as we are. It can express a dated moment. Or it can share a feeling that could have been felt at any moment in the history of human existence. But it should be capable of being appreciated and understood for all time.

Scott Dupras (Figures 4.106 Through 4.110)

Figure 4.106 Original photograph.

Figure 4.107 "An Artistic Passion."

CHAPTER 4 PHOTO TECHNIQUES I: *PASTEL, WATERCOLOR, AND OIL*

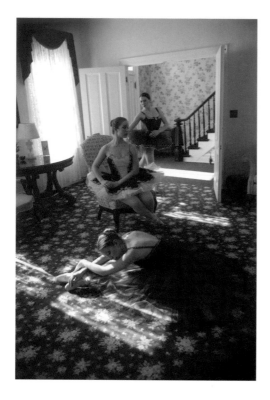

Figure 4.108 Original photograph.

Figure 4.109 Muck up stage.

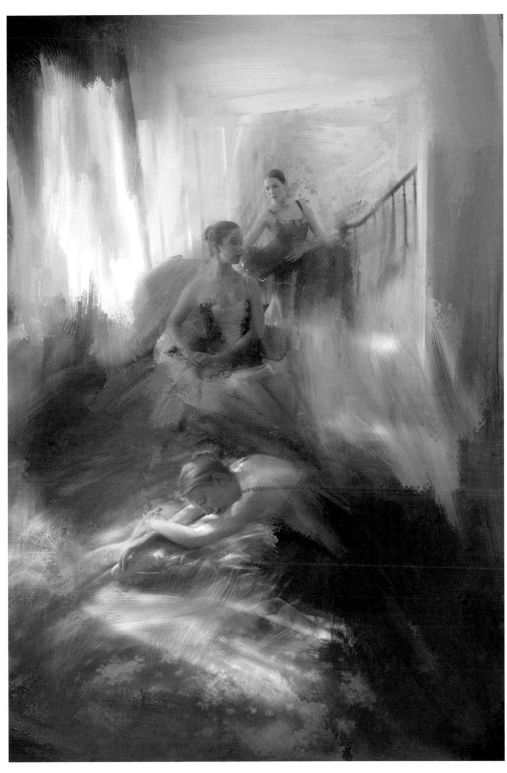

CHAPTER 4 PHOTO TECHNIQUES I: *PASTEL, WATERCOLOR, AND OIL*

Figure 4.110 "Three Ballerinas."

Myra Gordon (Figures 4.111 Through 4.113)

Painter allowed me to transition from photography to painting, creating my own unique artistry. Photography sees light as it is. Painting sees color as I feel. Painter allows my heart to mix light and color, capturing slices of life more realistically than it ever was.

During my 20 years of private practice as a marriage, family, and child counselor, I listened to and analyzed life with verbal communication. My job was to guide others into thinking about a new way of interacting with the world around them. Painter allows me to analyze life with color and form as I wish others to see it. Rather than using verbal skills, I have asked others to open their eyes to see the world through feeling. Once again, I have touched the hearts and minds of those around me, but through arousing all of their senses.

I now write with light and color about the very pixels of life. Those pixels are my story and I choose not to leave out any. I indeed have the world on my screen.

Sam Gray

The techniques that I have acquired through the Painter program and through studying under Jeremy's Painter Panache Master Series have transformed my work. After 35 years I am more excited about my work than I have ever been. I believe this has opened up a whole new creative avenue for me that does not exist through the medium of photography alone. I am able to express emotions in my work that truly reflect the essence of art. Being able to create one-of-a-kind art pieces for individuals, which they can display as one would any fine art but with the unique advantage of being personalized, is truly rewarding to me as an artist.

After satisfying the client's wishes I wanted to create an abstract of this young ballerina. My goal in "Dancer at Rest" was to paint this image in such a way that any admirer of fine art and ballet would appreciate the fluidity and grace of this young performer. [See Figures 4.114 Through 4.116.]

My intention in "The Kiss" was to capture a moment in time for this couple. I allowed the brushstrokes to create the serene, pensive, and romantic mood obviously being shared by the two. Again the techniques used were paramount in accomplishing this scene—photography alone would have fallen short in setting the mood and raising this image to a level worthy of the description of fine art. [See Figures 4.117 and 4.118.]

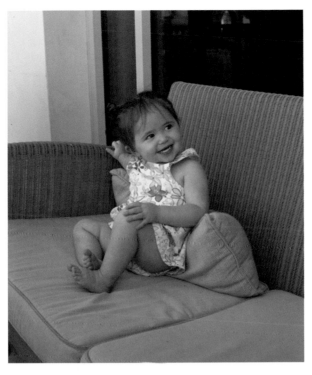

Figure 4.111 Original photograph.

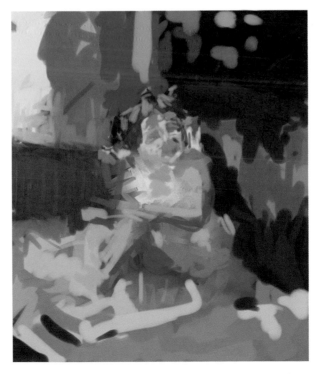

Figure 4.112 Muck up stage.

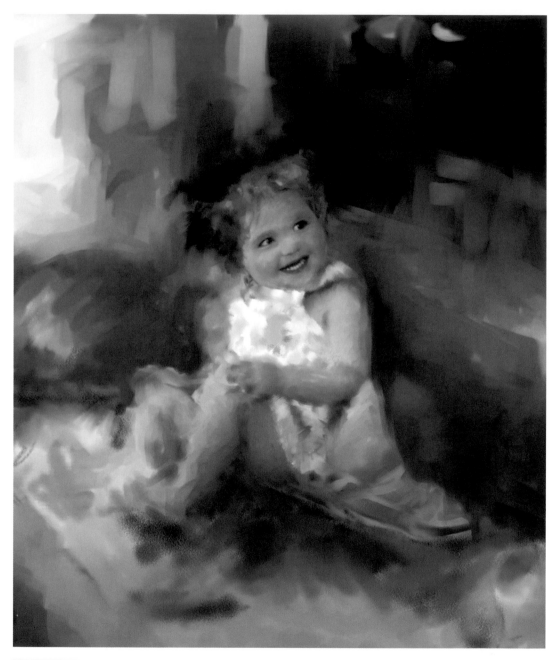

Figure 4.113 "Jiana Smile."

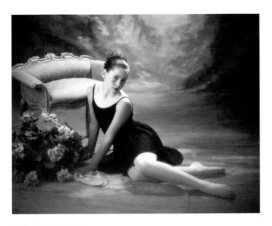

Figure 4.114 Original photograph.

Figure 4.115 Muck up stage.

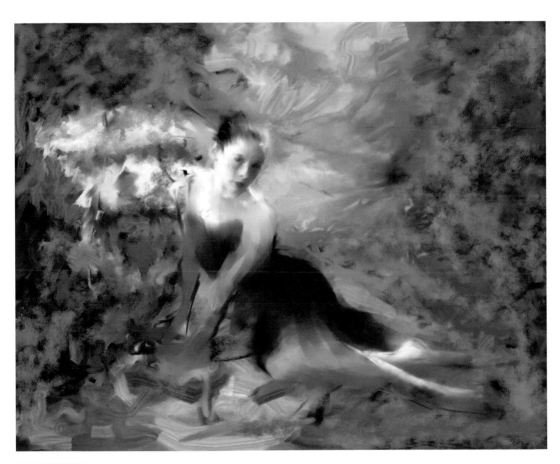

Figure 4.116 "Dancer at Rest."

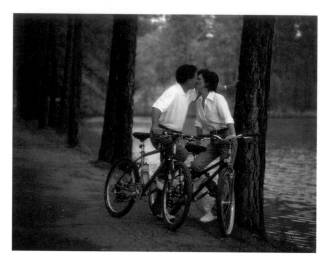

Figure 4.117 Original photograph.

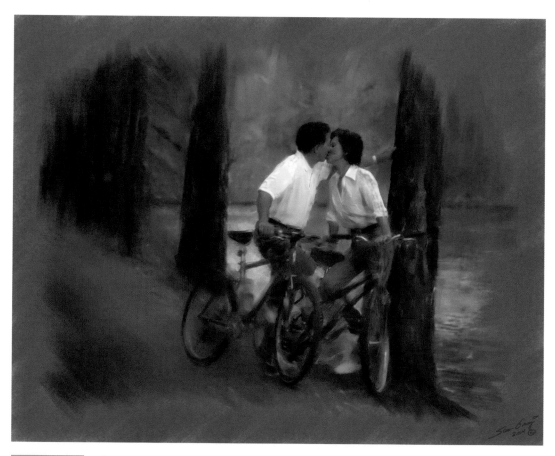

Figure 4.118 "The Kiss."

Jolyn Montgomery (Figures 4.119 and 4.120)

Figure 4.119 Original photograph.

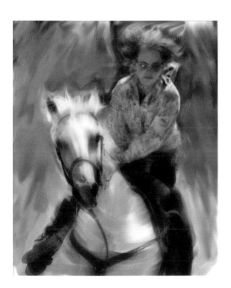

Figure 4.120 "Destorto."

Sherron Sheppard (Figures 4.121 Through 4.126)

Painter has given me many new tools for unlimited experimentation, and the ability to "undo" has freed me from the fear of ruining a piece of work while trying out new ideas. I love to sit down with an ordinary image, create "something from nothing," and then see how far I can "push" that image in painter. Painter has expanded my creativity by opening a whole new artistic world. Through Painter, I have been able to explore new ideas as well as give new life to existing methods.

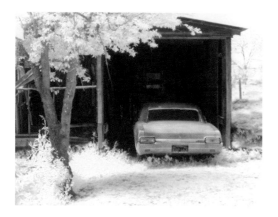

Figure 4.121 Original photograph.

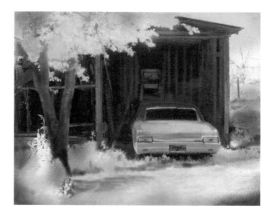

Figure 4.122 Mid-stage.

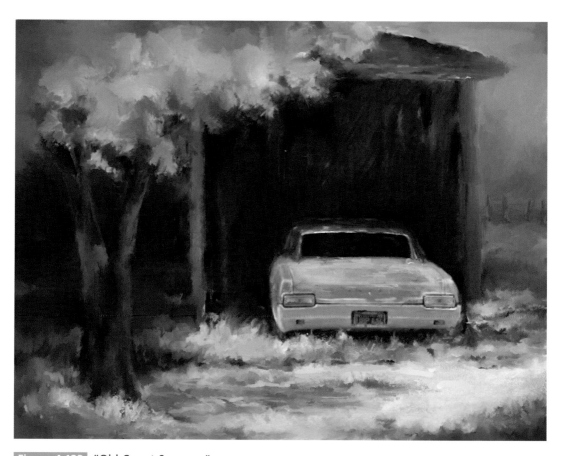

Figure 4.123 "Old Car at Sonoma."

Figure 4.124 Original photograph.

Figure 4.125 Mid-stage.

Figure 4.126 "Red Rose Wonder."

CHAPTER 4 PHOTO TECHNIQUES I: PASTEL, WATERCOLOR, AND OIL

Paul Tumason (Figures 4.127 Through 4.129)

Without a doubt, Painter has pushed me into an arena in which I never thought I would be allowed to enter. I always thought my work was well planned and executed photographically and reminded clients and colleagues alike to ask if my portraits were painted in any way. I would always appreciate that sentiment because I always wanted to paint portraits. But my photographic portraits would never have the nuances that would be painted by a skilled artist. I hope to achieve those subtleties,

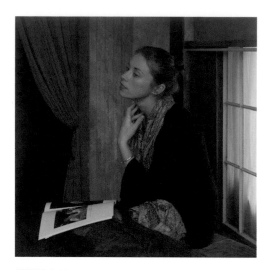

Figure 4.127 Original photograph.

Figure 4.128 Mid-stage.

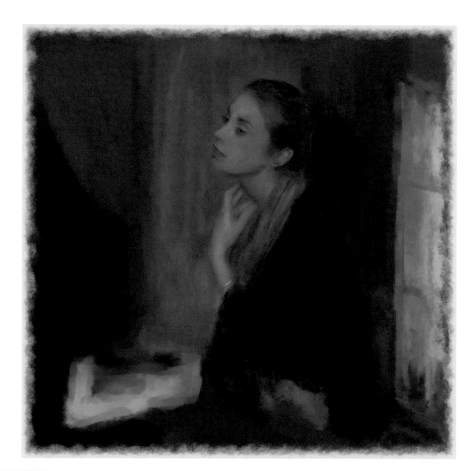

Figure 4.129 "Voice."

and more. I must admit, though, that I can't believe how humbling this program is. I have a long way to go. But it's like a rebirth for my portraiture and has brought me to a higher level of achievement. Thank you.

4.10 Wrap

Congratulations on familiarizing yourself with the techniques covered in this chapter. I hope you've already made wonderful discoveries along the way and are itching to explore deeper! What I have shared in this chapter is just scratching the surface of what's possible. As I stated in the chapter introduction, the case studies are not recipes to be followed exactly, but frameworks from which you can branch out using your own combination of brushes and settings and procedures. These case studies do not represent the definitive way to achieve a Chalky Pastel or a Watercolor Sketch or Oil Impressionism. They each represent just one of many approaches.

The following chapter expands your horizons as to what you can do with your photographs in Painter. I have included a variety of different techniques and looks that I think may interest you. Once you have completed working through the next chapter you'll have a rich and diverse range of options at your fingertips whenever you approach transforming a photograph.

Do not get stuck on techniques, but focus always on your vision, on the story you wish to share. Techniques are secondary to your vision. Your vision is what moves others and, ultimately, changes the world.

CHAPTER 4 PHOTO TECHNIQUES I: *PASTEL, WATERCOLOR, AND OIL*

5

**Photo
Techniques
II:
*Printmaking
and Mosaics*

Creativity requires the courage to let go of certainties.

—*Erich Fromm*

5.1 Introduction

Are you ready for even more fun with your photographs? Now is your opportunity to play with your images and expand your range of visual possibilities, particularly in your use of layers and creation of effects that emulate some of the artifacts seen in fine art printmaking techniques. I have structured this chapter around specific case studies, each shared here to get you to think outside the box, to expand your creative approach to image making. Making artwork does not follow generic formulae. I cannot say, for example, "This is the general way to apply the woodcut effect in an image to create an interesting result." Every image suggests its own path of transformation, which may include experimenting with several different effects and brushes. The creative process is intuitive and spontaneous rather than preplanned and calculated. Embrace serendipity and treat every unexpected result as an opportunity to explore a direction you may not have previously considered.

As a general approach I recommend generating variations, to go along a number of different paths with each image, and then have these variations all be potential clone sources that you can combine in the final mix. To do this requires the courage to take risks and to let go of certainties, which, as psychoanalyst Eric Fromm's quote at the opening of this chapter points out, is a requirement for creativity in general. You may not use all the variations you generate. You may find you return to an image after thinking it's finished and mix in a little bit of some earlier variation you'd previously ignored. With a vision of what you want to say in the final artwork, you can generate variations that you may or may not use. You do not know where the creative process will take you. Let serendipity play its role. When you follow my step-by-step instructions, it probably sounds like I set out with a clear plan in mind and simply executed the plan. The reality isn't like that. The reality is that I have a hunch of what may look good and I go for it. I suspect this or that effect or brush may be good and I try it out. Then I try something else, and then something else. This messy process continues until suddenly I know "That's it!" The picture works.

If you overwork a piece and get frustrated, then take a break. Go back to it later, look back over your saved stages. You may look at a piece and realize that it just needs to have some of an earlier stage mixed into the latest stage. This is a good reason to methodically save sequentially numbered versions of everything as you work.

I suggest you first follow the specific techniques shared in this chapter and then experiment and discover your own unique methods and techniques. With Painter almost anything is possible. You are limited only by your imagination.

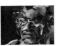

5.2 The Wild Wild Wes Overlay Monoprint (Figures 5.1 and 5.2)

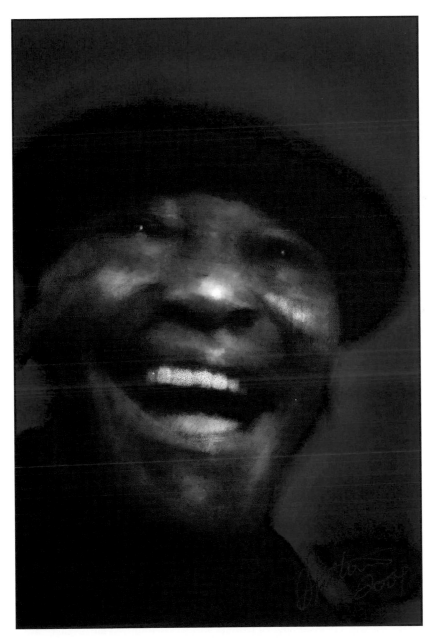

Figure 5.1 "Frankie's Joy."

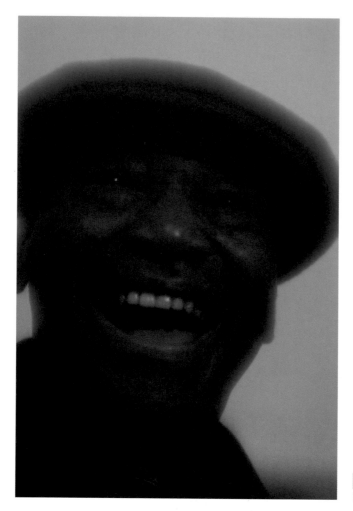

Figure 5.2 The original source photograph of Frankie Manning.

Technique Overview

This technique is named after its creator, Wes Pack of Corel Corporation. He has used this technique in various forms in his Painter demonstrations at tradeshows as well as his own artwork. The principle of the Wild Wild Wes overlay monoprint technique is very simple: Start off by creating a sketch or painterly version of your image (you can use Photoshop's Watercolor filter, the KPT Pyramid Paint, or Painter's Sketch effect, or simply clone brushes), float that sketch/painterly version of your image as a layer, set the layer blend mode (composite method) as Overlay, and then paint underneath the layer with clone and nonclone brushes. The result is an interesting blend of the texture and color of the layer with the texture and color of the paint underneath it. This effect adds a richness that mirrors the richness found in certain traditional combined print and paint techniques, such as the monoprint, a technique in which paint is applied to a flat surface, usually plastic or glass, and that surface is then pressed against the paper.

Steps

Prepare Your Image

1 Choose your source image. I chose Figure 5.2, the photograph of legendary Lindy Hopper, Frankie Manning, that was used for the Charcoal Drawing in the previous chapter.

2 Adjust your source image if needed. In my case the original photograph of Frankie was underexposed, so I adjusted the levels and hue/saturation in Photoshop to produce a lighter, more saturated version of the image. I then opened both the original (underexposed) and the lightened, more saturated version in Painter. I set the original image to be the clone source in Painter (File > Clone Source) (Figure 5.3).

3 Using the Cloners > Soft Cloner, I cloned in the background from the original (darker) image into the lighter one. I then used the Photo > Saturation Add brush to increase the saturation in the background and Effects > Tonal Control > Equalize to pump up the contrast a little. This produced my source image for this technique. I saved this image with version number 01.

Clone Your Source Image

1 Choose File > Clone (Figure 5.4).

2 Choose File > Save As. Delete "Clone of" from your clone copy name. Save as a RIFF file with the next sequential version number 02. I am choosing here not to use Iterative Save only because I like to add notes in my file names after the version number. When you follow this technique you are welcome to use Iterative Save. Just remember to end your initial file name with _001.

3 Choose Cmd/Ctrl-M. This mounts your image.

Manipulate Your Working Image

1 At this stage you have several choices for how to manipulate the image prior to floating it as a layer. To give you a sense of the possibilities, I shall use one method of altering the

Figure 5.3 Setting the original photo as clone source.

Figure 5.4 Cloning the source image.

image here and then show you, after completing this case study, what happens using the same image but with other manipulation techniques. My choice here is to use the KPT Pyramid Paint plug-in filter. I had placed the KPT Collection (which is supplied with Painter IX) in Painter's plug-in folder. This adds the filters to the bottom of the Effects menu. If you don't have the Pyramid Paint filter, then I suggest at this stage that you use Photoshop's Filter > Artistic > Watercolor to achieve a comparable effect. If you have it, choose Effects > KPT Collection > KPT Pyramid Paint (Figure 5.5).

2 In the Pyramid Paint window you have several sliders to experiment with. Click the check mark in the bottom right corner (not shown here) when satisfied. Remember the purpose of this filter is not a finished product but to create an altered, textured version of the original (Figure 5.6).

3 Choose File > Save As, and save this version with a note that it is the pyramid version.

Float Your Manipulated Image to Form a Layer and Set to Overlay Composite Method

1 Choose Cmd/Ctrl-A (Select > Select All).

2 Choose Select > Float (Figure 5.7). This lifts the painted layer into a separate layer above the canvas. Note the layer (Layer 1) appears in the Layers palette when you do this (Figure 5.8).

Figure 5.5 Selecting the Pyramid Paint filter.

Figure 5.6 The Pyramid Paint window.

Figure 5.7 Floating the selection.

Figure 5.8 Layer 1 in the Layers palette.

3 If you click on the eye visibility icon to the left of Layer 1 you will see your canvas go white. That is because underneath the layer is just a white canvas. Click on the visibility icon again to bring back the layer.

4 Double-click on Layer 1. This opens the Layer Attributes window. Change the layer name from the default "Layer 1" to "Pyramid" or something similarly descriptive and meaningful (Figure 5.9).

5 Change layer composite method in the Layers palette from Default to Overlay (invisible until merged with paint underneath (Figure 5.10)—initially you see white, since there is no paint underneath).

6 Choose File > Save As and save your next version with a note that it is the overlay version. I recommend saving new versions whenever you make a significant change, such as adding a layer, dropping a layer, or using a particular brush. By noting what you use or do in the file names, you'll be able to reconstruct your process in the future if you ever wish to repeat an effect. It's much easier to document as you're creating than to try to remember all your steps later.

Work into the Background Canvas

1 Click on Canvas in the Layers palette. This selects the background canvas (now highlighted in blue in the Layers palette).

Figure 5.9 Renaming Layer 1 in the Layer Attributes window.

Figure 5.10 Change Layer 1 composite method from Default to Overlay.

2 Pick a relatively dark color (this is a personal choice—try out different colors and values and see what works best with your image). In my case I picked a deep blue.

3 Choose Cmd/Ctrl-F and fill the background canvas with the Current Color (Figures 5.11 and 5.12).

4 Choose a brush to start painting with on the background canvas. I chose Chalk > Square Chalk 35.

5 Check the Clone Source icon in the Colors palette. Your clone source (File > Clone Source) should still be your starting image.

6 Paint on the background canvas, underneath the Pyramid Overlay layer. As you paint you'll see a merging effect of the sketch layer. You may need to adjust the size and opacity of your brush. In my case I increased the size and reduced the opacity (Figure 5.13).

Figure 5.11 Fill the background canvas with a dark color.

Figure 5.12 After filling the background canvas with blue.

Figure 5.13 Painting on the background canvas with Square Chalk using clone color.

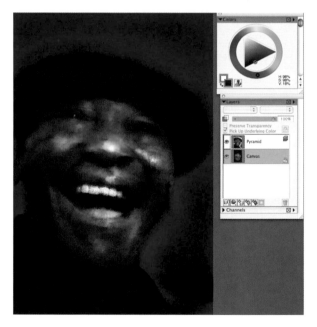

Figure 5.14 Having painted underneath the Overlay layer.

7 If you need to take away some of the paint you've added, just uncheck the Clone Color icon in the Colors palette and paint using the same color with which you filled the background canvas.

8 When you feel the image is complete, or at least this stage of it, SAVE it as a RIFF file. Also save a backup copy as a Photoshop format file. Photoshop format will preserve the layer and also the blending mode. Figure 5.14 shows what this image looked like at this stage. What's fascinating is to see the actual brushstrokes you've made that produced this image. Temporarily click on the Overlay layer visibility icon to see what's underneath.

Final Touches

1 To complete this painting I selected Drop All from the Layers pop-up menu (Figure 5.16).

2 I made a clone copy of the flattened image and resaved it. I do this as a precaution so that I can always come back to my earlier stage using the Soft Cloner. I recommend you get in the habit of also making clone copies so that you can always clone back to the previous version.

3 I applied a little Photo > Dodge in the eyes, plus a little Burn and Saturation Add, to bring out the eyes more (Figure 5.17).

4 I used a couple of brushes, with Clone Color, to put in more hand brushstrokes and get rid of some of the filtered-looking structure left over from the Pyramid Paint. The two brushes I used were the Artists' Oils > Default Brush and the Jeremy Faves 2.0 > JS-Grainy Oil Dabs (Figures 5.18 and 5.19).

Figure 5.15 The actual painting underneath the Overlay layer.

Figure 5.16 Flattening the image.

Figure 5.17 Brightening up the eyes.

Figure 5.18 Adding Artists' Oil brushstrokes to the skin.

Figure 5.19 Adding JS-Grainy Oil Dabs on the teeth.

5. I used the Jeremy Faves 2.0 > JS-SumiPollock Splash for my signature, turning Clone Color off and using the Dropper to pick up color from within the image (Figure 5.20).

6. The final step was to add a simple border. I picked up a dark blue from within the image. I then chose canvas > Set Paper Color (Figure 5.21).

7. I then chose Canvas > Canvas Size and added 10 pixels of the selected color all the way round (Figure 5.22).

Figure 5.20 Adding the signature.

Figure 5.21 Setting paper color.

Figure 5.22 Adding a 10-pixel border.

5.3 Inverse Paper Texture Photo Screen Print (Figures 5.23 and 5.24)

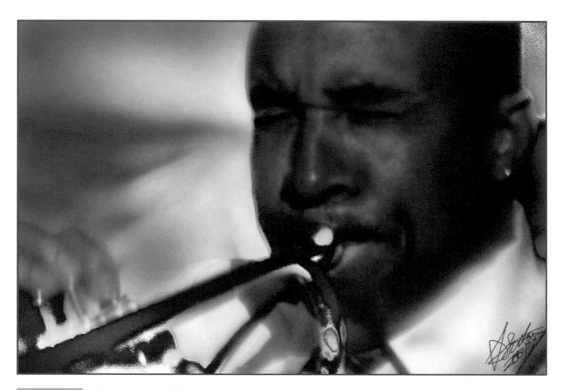

Figure 5.23 "Soul to Sound."

Figure 5.24 Original source photo.

Technique Overview

One of the powerful aspects of working with Painter is the ease with which you can capture and apply your own custom paper textures. In this technique, and the following one, you use your entire source photograph as a paper texture. The result, as you can see in the trumpet area of this picture "Soul to Sound," has the feel of a screen print, where you can have smooth gradations of color bounded by hard graphic edges, mixed in with your actual photograph; hence I refer to this as a *photo screen print* technique.

Before diving into step-by-step instructions, let's first understand exactly what is meant by *paper texture*. In the traditional, nondigital world, paper texture is an intrinsic property or characteristic of a piece of piece of paper relating to the roughness of the surface. Any chalky tools (including charcoals, conte crayons, pastels, oil pastels, and so on) applied to that piece of paper will show the paper's texture as pigment adheres to the "mountaintops" of the surface, i.e., the parts that stick out, and leave the "valleys," the parts of the surface that sink into the paper, unmarked. As you press harder with your chalk or use a wetter or oilier chalk, the pigment sinks deeper into the paper texture until at some point it no longer shows (except by the way it catches the light).

In Painter, *paper texture* is not an intrinsic property of your canvas. In fact it's completely independent of your canvas. In Painter, a paper texture is a repeating grayscale tile that acts rather like a filter for certain brushes known as grainy brushes (brushes that have the word *grainy* in their method subcategory, which you can see in the General Brush Controls palette). Paper texture can also act as a mediator for many effects (anytime you see the "Using:" menu, Paper is one of the options, usually the default one). The dark regions of the paper texture act like the mountains, and the light regions act like the valleys. You have in Painter the ability to invert your paper grain so the mountains become the valleys, and vice versa. Grainy brushes include the Chalks, Conte, Charcoal, Pastel and Oil Pastel categories. As you apply any of these brushes they appear to respond to the current paper texture just like natural media brushes, sinking into the paper the harder you press. You can change the paper texture at any time using the paper selector (three icons up from the left bottom of the Toolbox or in the Papers palette). When you change paper texture, any existing paint remains unchanged on your canvas. However, the *next* time you apply a grainy brush you will see it responding to your newly selected paper texture.

Via the *inverse paper texture photo screen print* technique described here, by making your paper texture your entire photo and then using a chalky brush in a canvas exactly the same size as your photo, you have a wonderful way to paint into the lighter regions and darker regions of your image.

Steps

Preparing Variations from the Source Image (Photoshop)

1 Choose your image. In this case I chose a photograph I took of Doug Ellington (www.dougellington.com), musician, arranger, and band leader (Figure 5.24). This shot

captured the intensity and passion with which he plays his music. It was taken at Club 23 in Brisbane, California.

2 Prepare your image for Painter by first adjusting the Levels and Hue/Saturation in Photoshop. My methodology is fairly straightforward: I first open the RAW file in Photoshop CS, using the RAW file adjustments to make initial corrections for exposure, white temperature, and contrast. I then use Adjustment Layers for further refinement of the image. I save the resulting image as a Photoshop master file. I then flatten the image and save a version with "flat" in the image title. It is the flat version that I'll open in Painter.

3 Create variations in Photoshop for possible use later on as clone sources in Painter. This is speculative work. I do not know ahead of time how these variations will turn out and whether I'll use any in the end. I like to have them on hand just in case. Since I want to share with you here my real, as opposed to sanitized, creative working method, Figures 5.25 through 5.29 show the five variations I generated in Photoshop. The minimum requirement for this technique is just to have your original image and a black-and-white version of the same image (though you can do without the back-and-white, I have found the technique works better with a separate black-and-white version of your image).

Here's how I generate a black-and-white version of my image in Photoshop. I first change the color mode from RGB to Grayscale (Image > Mode > Grayscale). This discards the color information. I then change the color mode back to RGB (you need an RGB file to work on in Painter). I then apply a Levels Adjustment Layer and pump up the contrast a little, making sure I have good blacks and whites in the image (this will help make a good paper texture in Painter). I end up with two versions of each variation, one with all the Adjustment Layers and one flattened. The flat files are the ones I will open in Painter.

Figure 5.25 Generating a red variation using a Hue/Saturation Adjustment Layer.

Figure 5.26 Generating a red, yellow, black variation using a Curves Adjustment Layer.

Figure 5.27 Generating an orange-green variation using a Channel Mixer Adjustment Layer.

Figure 5.28 Generating a posterized variation using Filter > Artistic > Watercolor.

Figure 5.29 Generating a grayscale variation using the Grayscale color mode.

Capture and Apply Paper Texture

1 Open in Painter all the flat files prepared in Photoshop. These should include your original source image and the black-and-white version of it.

Express Texture

You can save a paper texture directly from a color photograph, the black-and-white image, or, in fact, from any image open in Painter. In this particular example I applied an effect called Express Texture to the black-and-white image in order to exaggerate the contrast of the paper texture. This is an optional subtechnique and is not necessary.

1 First choose Effects > Surface Control > Express Texture (Figure 5.30).

2 Experiment with the sliders until you get the right balance of contrast with detail in your preview window (Figure 5.31).

3 Click OK.

Figure 5.30 Choosing Effects > Surface Control > Express Texture.

Figure 5.31 The Express Texture window.

Another effect that can produce a high-contrast black-and-white image suitable for a strong paper texture is the Effects > Surface Control > Distress effect.

2 Make sure your Papers palette is open (Window > Library Palettes > Show Papers).

3 With the image you wish to make into a paper texture the active image in Painter, choose Capture Paper from the Papers pop-up menu (Figure 5.32).

4 In the Save Paper window name your paper texture and also take the crossfade slider to zero (the default crossfade value is 16) (Figure 5.33). Crossfade determines how much the repeating paper tiles fade into each other. For this and the next technique you don't want any crossfade.

5 Click OK.

6 Choose Chalk > Large Chalk. Many other grainy brushes can work equally well with this technique. This just happens to be the one I like to use.

7 Lower the Grain slider value. The default grain value is 23%, which I find too high. Experiment with different values. The lower the value, the more dramatic the grain shows, until you get to the point at 0%, when nothing shows. 4% to 10% gives good grain.

8 Choose the original color source image.

9 Choose File > Quick Clone. This will make a clone copy and automatically clear the image. You want the clone color to remain unchecked. If the Quick Clone has checked the clone color icon in the Colors palette, then uncheck it (all these Quick Clone settings can be adjusted in the General Preferences window).

10 Now you are ready for painting. You will initially be applying paint in the parts of the canvas that correspond to where the deeper (darker) values of the image were. Therefore you may wish to start by choosing a darker tone and color. Apply the chalk in your canvas (Figure 5.34). Change color from time to time. If you wish to see a reference for the original image, just choose Cmd/Ctrl-T to toggle Tracing Paper on and off.

Figure 5.32 Choosing Capture Paper from the Papers pop-up menu.

Figure 5.33 The Save Paper window.

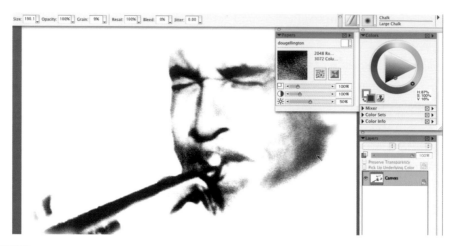

Figure 5.34 Apply the Large Chalk in the image.

Figure 5.35 Activate Invert Paper.

11 The next step is to work into the negative space of your image, that is, the space left white, corresponding to the valleys in the paper texture. Click on the Invert Paper icon in the Papers palette (Figure 5.35).

Opening a Custom Color Set

In this case I wanted to use colors that fit the mood of the piece. I decided to use a color set I'd created based on an old 1950s album cover (you can make a color set from any scanned image by opening it in Painter and selecting "New Color Set from image" in the Color Set pop-up menu.) You'll find the color set I used here on the Painter Creativity Resource CD that comes with this book. Here's how to open a custom color set.

1 Choose Open Color Set from the Color Set pop-up menu (Figure 5.36).

2 I then located the JeremyChoice Color Sets folder that I had placed in the Painter IX application folder and selected the 50s RnB color set (Figure 5.37).

11 You can now paint into the light areas of the image (Figures 5.38 and 5.39).

Figure 5.36 Color Set pop-up menu.

Figure 5.37 Selecting a custom color set.

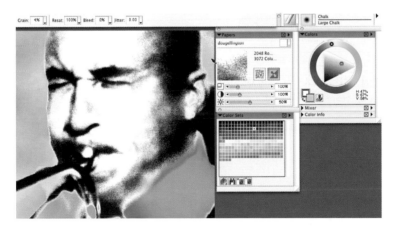

Figure 5.38 Painting into the negative space with inverted paper texture.

12 At this stage I returned to the original color image and decided to further enhance it prior to cloning portions into my painted image. The first step was to choose Effects > Tonal Control > Equalize (Figure 5.40).

13 Adjust the sliders in the Equalize window to increase contrast without losing detail (Figure 5.41).

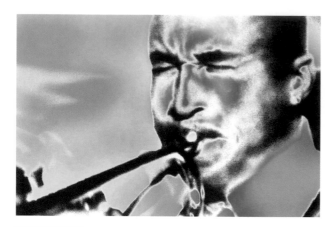

Figure 5.39 The image after painting into the positive and negative spaces.

Figure 5.40 Choosing Equalize.

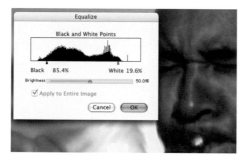

Figure 5.41 Adjusting the sliders in the Equalize window.

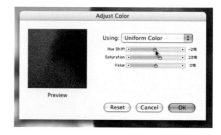

Figure 5.42 Adjust Color window.

14 My next step was to adjust the color slightly. I chose Effects > Tonal Control > Adjust Color (Figure 5.42). The resulting image is presented in Figure 5.43.

15 Your adjusted original color image should still be the current clone source (you can always double-check by looking at File > Clone Source). Make the working image, the one you have just painted on, the active image.

16 Place your working image in screen mode (Cmd/Ctrl-M).

17 Choose Cloners > Soft Cloner. Clone in the face (Figure 5.44).

18 The final stage here was to return to the chalk, select blue with positive paper, and paint into select areas of the image for artistic harmony (Figure 5.45). At this stage I felt the image was complete. I did do some experiments with the other variations generated in Photoshop but ended up coming back to this stage. Sometimes leaving things simpler is better.

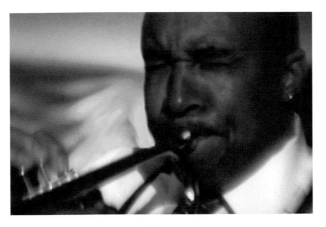

Figure 5.43 Source image after equalizing and adjusting color.

Figure 5.44 Cloning into the painted image.

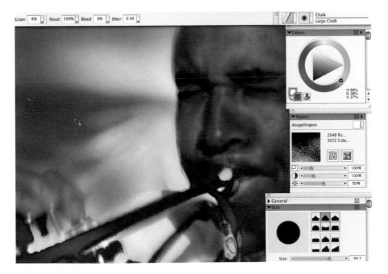

Figure 5.45 Painting back into the image with the Large Chalk.

5.4 Warhol Multiples (Figure 5.46)

Figure 5.46 "Joanna May."

Technique Overview

As the title suggests, this technique owes its artistic inspiration to the pop art icon Andy Warhol. The technique leads directly from the last technique, in that you begin by capturing your source photo as a paper texture. In this technique you also need to capture your image as a pattern.

A *pattern* in Painter is a repeating color tile that can be applied to your canvas in many ways (through the Fill effect, Pattern brushes, Cloners, and so on). Pattern is the default clone source in Painter and can be assigned to be the clone source at any time from the File > Clone Source menu.

The beauty of this technique is that it allows you to playfully create variations on a theme, and it is ideal for your family photographs or, if you are a professional portrait photographer, for your child and high school senior portraits.

Steps

Prepare Your Source Image (Color and Grayscale Versions)

1. Choose your source image. My source image is a photograph I took of my lovely niece, Joanna May, on a visit to London. A key requirement for this technique is an image that will make a good paper texture. Generally that means an image with fairly distinct tonal contrast and a balance of light and dark regions. An image that is almost all black or almost all white won't work well.

2. As with the last technique, first prepare your image in Photoshop, pumping up the contrast and saving a flat version for opening in Painter.

3. Also prepare a black-and-white (grayscale) version of your image, as described in the last technique.

4. Open both the color and the black-and-white versions in Painter.

Capture Your Grayscale Source Image as Paper Texture

1. Make the black-and-white image the active image.

2. Choose Cmd/Ctrl-A (Select > All).

3. Choose Capture Paper from the Papers pop-up menu (Figure 5.47).

4. Save the paper, setting the Crossfade to zero (very important for this technique) (Figure 5.48).

Capture Your Color Source Image as Pattern

1. Having saved the black-and-white image as a paper texture, choose the color image.

2. Choose Cmd/Ctrl-A (Select > All).

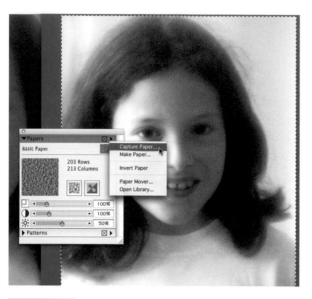

Figure 5.47 Choosing Capture Paper from the Papers pop-up menu.

Figure 5.48 Setting the Crossfade slider to zero in the Save Paper window.

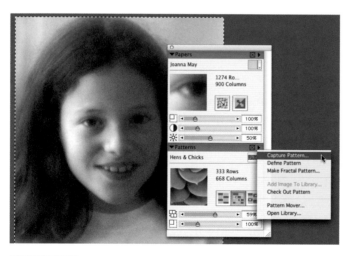

Figure 5.49 Choosing Capture Pattern from the Patterns pop-up menu.

Figure 5.50 Name your pattern in the Capture Pattern window.

3 Choose Capture Pattern from the Patterns pop-up menu (Figure 5.49).

4 Name your pattern and click OK (Figure 5.50).

Rescale Paper and Pattern

1 To create a four-up multiple (2 × 2) we need the scale for the paper and pattern to be 50% instead of the default 100% (Figures 5.51 and 5.52). Note the pattern scale slider is the second one down in the Patterns palette, unlike the Papers palette, where it is the top slider.

Figure 5.51
Default settings
for the Papers
and Patterns
palettes.

Figure 5.52
Rescaling the
paper and
pattern to 50%.

Figure 5.53
Open Color Set.

Figure 5.54 Selecting the
Candy color set.

Figure 5.55 Adjusting color swatch size.

Select a Playful Color Set

1. If you want to use a playful color set, choose Open Color Set from the Color Sets palette (Figure 5.53).

2. Locate the Color Sets folder in the Painter IX application folder and select the set called Candy (Figure 5.54).

3. The default setting for this color set was with very small color swatches. Adjust the color swatch size in the Color Sets pop-up menu (Figure 5.55).

Apply Colors from Color Set Using Large Chalk

1. I started applying colors from the Candy color set using the Chalk > Large Chalk brush (Figure 5.56).

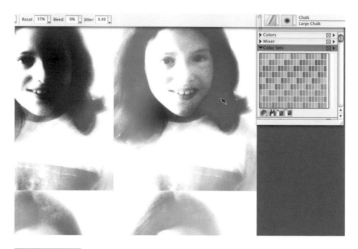

Figure 5.56 Applying color with the large chalk.

Figure 5.57 Invert Paper icon.

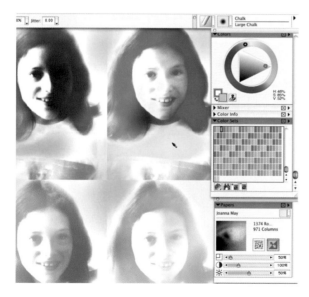

Figure 5.58 Painting in the negative space.

2 Click on the Invert Paper icon in the Papers palette (Figure 5.57).

3 Paint into the negative (light) space (Figure 5.58).

Soft Clone in from the Pattern

1 Check that the Current Pattern is the current clone source (File > Clone Source) (Figure 5.59) and that the current brush is the Cloners > Soft Cloner.

Figure 5.59 Check that the Current Pattern is the clone source.

Figure 5.60 Change Size Expression to None.

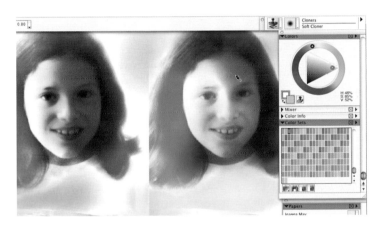

Figure 5.61 Painting with Soft Cloner.

Figure 5.62 Canvas Size window.

2 In the brush Controls Size palette (Window > Brush Controls > Show Size) change the Expression menu from Pressure to None. This keeps your brush size large even when you press lightly (Figure 5.60).

3 Paint with the Cloners > Soft Cloner in the faces (Figure 5.61).

Create an Interesting Border

1 Choose Cmd/Ctrl-A (Select > All).

2 Choose Cmd/Ctrl-C (Edit > Copy).

3 Choose Canvas > Canvas Size (Figure 5.62).

4 Add 50 pixels (or whatever is appropriate for your scale of canvas) all the way around. How much you add depends on how large your image is and how much border you wish to add.

Figure 5.63 Adding a new layer.

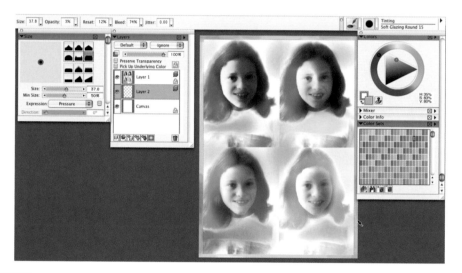

Figure 5.64 Painting the border.

5 Hold the Spacebar down, which converts the brush cursor into a grabber hand, and click once on the desktop. This centers your image.

6 Choose Cmd/Ctrl-V (Edit > Paste). This pastes a copy of your image in the center of your expanded canvas. You see the layer in the Layers list.

7 Click on the Canvas in the Layers palette.

8 Choose New Layer from the layers pop-up menu (Figure 5.63).

9 Choose Tinting > Soft Glazing Round 15.

10 Paint into the new layer (Figure 5.64). The advantage of painting onto a layer rather than just straight into the background canvas is that the layer gives the added flexibility of fading the border by lowering the layer opacity.

11 Click on the multiples image layer in the Layers palette.

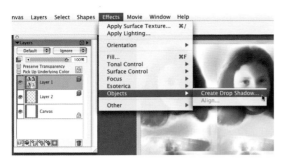

Figure 5.65 Creating a drop shadow.

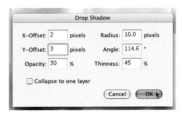

Figure 5.66 Lowering Drop Shadow displacement and opacity.

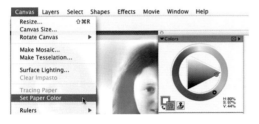

Figure 5.67 Setting the paper color.

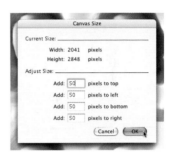

Figure 5.68 Canvas Size window.

12 Choose Effects > Objects > Create Drop Shadow (Figure 5.65).

13 Lower the Drop Shadow displacement and opacity for a subtle, slightly offset shadow (Figure 5.66).

14 Once the border is painted, select the background canvas.

15 Choose a suitable outside liner color.

16 Choose Canvas > Set Paper Color (Figure 5.67).

17 Choose Canvas > Canvas Size. I chose to add another 50 pixels all the way around (Figure 5.68).

Example Image: Daniel

As another example of this technique, I created, from a photograph (Figure 5.69), a multiple portrait of Joanna May's sweet brother, Daniel (at least Uncle Jeremy only sees the sweet side of him!) (Figure 5.70). This time I added some outlines and used a different color set (the PrismaColor Pencils color set from the JeremyChoice Color Sets folder).

CHAPTER 5 PHOTO TECHNIQUES II: *PRINTMAKING AND MOSAICS*

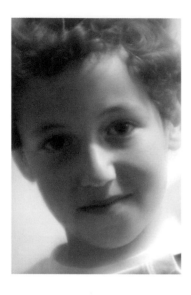

Figure 5.69 Original source photo.

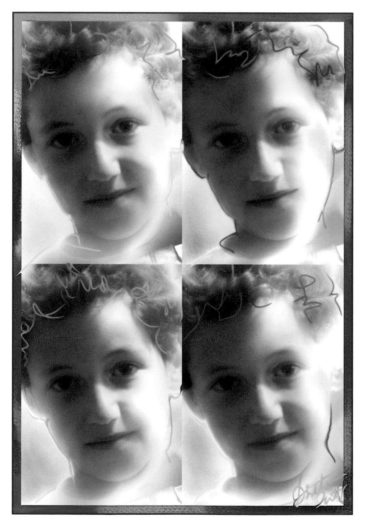

Figure 5.70 "Daniel."

5.5 Painterly Woodcut (Figures 5.71 and 5.72)

Technique Overview

The woodcut technique has been used in China since the 7th century A.D. and in Europe since the 15th century A.D. Woodcuts are prints created when paper or some other substrate, such as fabric, is pressed down on ink that has been applied to the raised surface of a wooden block. Comparable relief printing techniques have been applied using many other block materials besides wood. The principle of a relief print, like a woodcut, is that the artist carves away the negative space, that is, the regions of the image that will not take up ink and therefore will be left as highlights in the image. Woodcuts can be monocolored or multicolored. Typically a multicolored woodcut design involves the artist's creating a series of woodcuts that can be printed on top of one another, each with a different color of ink. There has been a diversity of woodcut looks throughout history, varying according to the culture, artist, and materials. What generally makes a woodcut distinctive is the well-defined blocks of color (though delicate line work is also possible in finely worked woodcuts).

The Woodcut effect (Effects > Surface Control > Woodcut) in Painter is a great way to generate a posterized view of your image, that is, one in which the gamut, or number, of colors is reduced (down to even just stark black and white if you wish) and in which the image is divided into distinct regions of flat color. The other Painter effect that gives the ability to divide your image by color region

Figure 5.71 Source image.

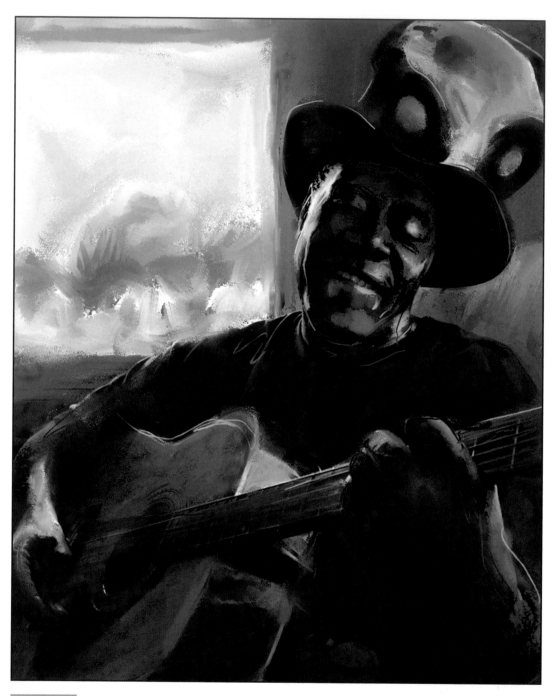

Figure 5.72 "Strummin."

is the Serigraphy effect (Effects > Surface Control > Serigraphy), an effect not covered here but worth checking out. I treat effects like the Woodcut and Serigraphy as means to generate variations from which I can clone into a final image rather than as an end in themselves.

In this example I generated a variation of my original image for use as a basis for an interesting woodcut, which in turn I used as a clone source variation that I cloned back into a painting.

Steps

Prepare Your Source Image

1. Choose you image. I chose a photograph I'd taken of musician Todd Gilbert in Half Moon Bay, California (you can just make out the famous Half Moon Bay Pumpkin Festival going on outside the window) (Figure 5.71). What struck me about Todd was the beauty and soul he put into his music. In this image the expression on his face and the way his hands caress the guitar say it all. I wanted to create a painting that conveyed and emphasized the soul with which he played.

2. I first prepared the image in Photoshop, using the Levels Adjustment Layer to increase contrast from the original photograph, which was somewhat washed out.

3. I then opened a flattened version of the image in Painter.

Make and Modify the Clone Copy

1. Choose File > Clone.

2. Choose File > Save As and rename your clone copy.

3. Choose Cmd/Ctrl-E (Effects > Tonal Control > Equalize).

4. Bring the black-and-white prints toward the center to increase contrast in the image (Figure 5.73).

Figure 5.73 Equalize window, applied to the original image.

5 Choose Effects > Tonal Control > Adjust Colors (Figure 5.74).

6 Play with the Hue Shift slider in the Adjust Color window to give a warmer feel to the picture. I shifted the slider a few percent to the left, making the image slightly redder (Figure 5.75).

7 Choose Cmd/Ctrl-E (Effects > Tonal Control > Equalize). Note that your last two effects will be visible at the top of the Effects menu (Figure 5.76), so you don't have to drag down to Tonal Control each time.

8 Choose File > Save As. Save this stage of your image. Now you are ready to apply the Woodcut effect.

Figure 5.74 Choose Adjust Colors.

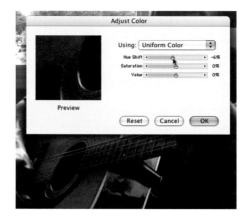

Figure 5.75 Adjust Color window.

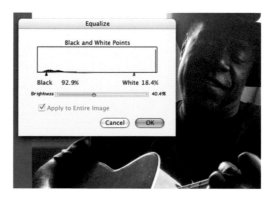

Figure 5.76 Equalize applied to the redder image.

Apply Woodcut Effect

1 Choose Effects > Surface Control > Woodcut (Figure 5.77).

2 Play with the sliders and buttons and see their effect (Figure 5.78). If you wanted just a black-and-white effect you'd uncheck Output Color. In this case I wanted both black and color. Note that there is a Use Color Set button, which allows you to impose the colors from your current color set. I left that unselected in this case, just wanting to base the woodcut on the colors that were already there. (Figure 5.79).

3 Choose File > Save As. Save the woodcut version of your image. We'll come back to it later.

Create the Painting

1 Select your original image.

2 Choose File > Clone (Figure 5.80).

3 Choose a big oily brush. In this case I chose Jeremy Faves 2.0 > Big Wet Luscious.

4 Check Clone Color in the Colors palette.

Figure 5.77 Choose Woodcut effect.

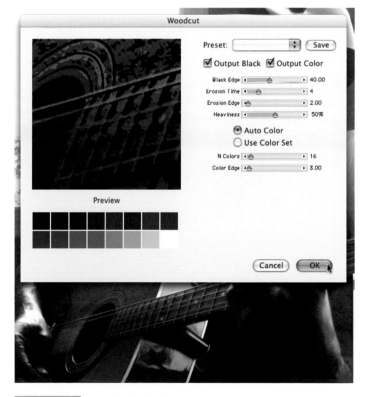

Figure 5.78 Woodcut window.

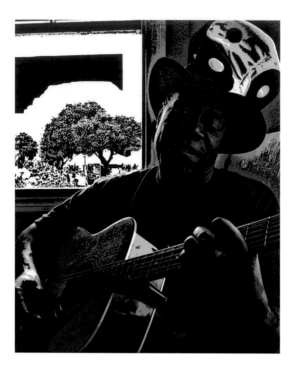

Figure 5.79 Resulting image after the woodcut effect has been applied.

Figure 5.80 Clone your original image.

Figure 5.81 "Mucking up" the image.

5 Apply large brushstrokes throughout the canvas until you have filled the canvas with brushstrokes. This is the "muck up" stage. Don't worry about detail. Use the direction and energy of your brushstrokes to help form an expressive undercoat (Figure 5.81).

6 Turn off the Clone Color and start adding accent colors of your own (Figure 5.82).

7 Choose File > Save As and save this painted version of your image.

8 Choose File > Clone and make a duplicate of your painted image.

Figure 5.82 Adding accent colors.

Figure 5.83 Setting the woodcut as Clone Source.

Figure 5.84 Cloning in from the woodcut.

9 Choose File > Save As and save this clone copy of the painted version of your image as your next sequential version.

Clone in the Woodcut Image

1 Choose File > Clone Source and set your woodcut version of your image as Clone Source (Figure 5.83).

2 Choose Cloners > Soft Cloner and clone in elements from the woodcut into your mucked-up painted version (Figure 5.84).

3 Having the painted version of your file as another file open in Painter is useful anytime you wish to paint away some of the woodcut and return to the painted version. Use the File > Clone Source menu to go between different clone sources as you add your final touches.

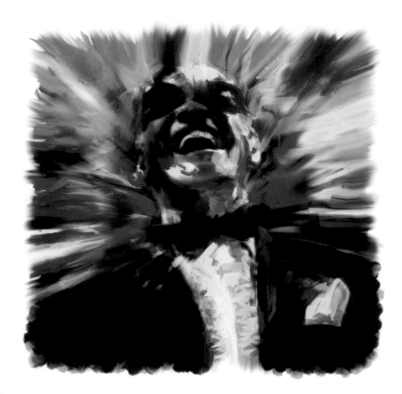

Figure 5.85 "Brother Ray."

Example Image: Brother Ray

The picture in Figure 5.85, a tribute to the late, great Ray Charles, is based on an Associated Press photograph of Charles by Ira Schwartz. It was created by first making a colorful painting, applying the Effects > Focus > Zoom Blur to that painting, and then pasting both the Zoom Blur and a woodcut version of the photo as layers (woodcut on top), with the layer composite methods set to Overlay and Magic Combine, respectively.

5.6 Majestic Mosaic (Figures 5.86 and 5.87)

Technique Overview

The art of mosaic, in one form or another, has been practiced for thousands of years. Early Mesopotamian mosaics can be traced to as far back as 3000–5000 B.C. Mosaics are designs or pictures created by embedding small pieces of glass, stone, terracotta, etc. into a bed of clay or other form of fixative, known as *grout*. These early basic mosaics consisted of thin cones of clay that were

Figure 5.86 "Crimson Beauty."

Figure 5.87 Source image.

baked and painted and then pushed into mud walls. This form of decoration was often used in Greek and Roman times for wall panels, ceilings, and floors and was especially effective on curved surfaces.

Painter's mosaic mode brings the art of making mosaics into the 21st century. Painter offers you the ability to create beautiful, intricate mosaic designs with full control over the size, shape, spacing, randomness, color, and texture of your tiles and grout. Whereas the ancient mosaicists would spend countless hours and days painstakingly selecting their tiles and embedding them in the grout, the

modern mosaicist can paint a beautiful mosaic in a relatively short time using Painter. As with the woodcut, I see mosaics as a variation you can use in a completed work. You can also treat them as an end in themselves.

Although this example involves creating a mosaic based on a photograph, you can also create a freehand mosaic and treat it just like an alternative paint medium (with bigger "pixels").

Steps

Prepare Your Source Image

1 Choose your image. I chose a photograph of a rose from the Golden Gate Park Rose Garden in San Francisco (Figure 5.87). This particular rose is from the rose family Crimson Bouquet.

2 Prepare your image in Photoshop or Painter, increasing the contrast and saturation.

3 Open your image in Painter.

Clone Your Source Image

1 Choose File > Clone (Figure 5.88) (Quick Clone would work equally well). This is key to using the mosaic mode of Painter with photographs. A common mistake is to open an image and then select the mosaic mode and, presto, the image mysteriously disappears! If you wish to work from a photo, you have to make a clone copy and then apply the mosaic

Figure 5.88 Make a clone copy of your original photo.

Figure 5.89 Save your clone copy as a RIFF file.

mode to that clone copy, not to the original. Besides its usefulness for mosaics, I always recommend making a clone copy anyway.

2 Choose Cmd/Ctrl-M (Window > Screen Mode Toggle).

3 Choose File > Save As. Save your clone copy as a RIFF file (Figure 5.89). This is very important! The mosaic mode of Painter preserves its special characteristics only in this format. In any other format you will not be able to return to mosaic mode and continue editing or working on your mosaic.

Make Mosaic Mode

1 Choose Canvas > Make Mosaic (Figure 5.90).

2 Your canvas will automatically be cleared to white when you choose mosaic mode. Don't be shocked—that's meant to happen. A Make Mosaic window will appear. Check Use Tracing Paper (Figure 5.91). You'll see your original photo showing through the white canvas.

3 In the Colors palette check the clone color icon (Figure 5.92). This will make your mosaic tiles look at the original image for color information. If you wish to paint your own colors, then just uncheck the clone color icon and choose the color you wish to paint with in the Colors palette (or Mixer or Color Sets palettes).

4 Start painting in the tiles, following the forms of your image. Note how in the Settings menu you can adjust either the dimensions of the tiles or the randomness. I started out with the maximum-size tiles and worked from the outside of the picture in toward the center, reducing my tile size as I approached the center. I also initially made some rows of tiles that followed the main lines of contrast.

Figure 5.90 Choose Make Mosaic.

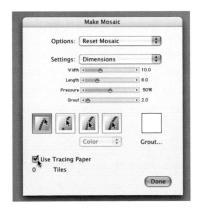

Figure 5.91 Check Use Tracing Paper in the Make Mosaic window.

Figure 5.92 Check the clone color icon in the Colors palette.

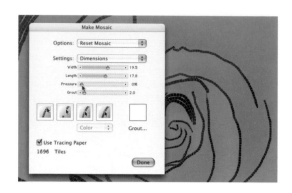

Figure 5.93 Adjusting pressure sensitivity.

Maximum Tile Size

A limitation of Painter's mosaic mode is the maximum size of the tiles. If you are working on a high-resolution file, your maximum size will appear quite small. If you want large tiles relative to the scale of your picture, then you'll first need to reduce your original image size (Canvas > Resize), create your mosaic, and then resize your final RIFF file up again. Mosaic tiles are mathematically described regions and are therefore scalable without loss of quality; in other words they are resolution independent.

5 The thickness of your tiles can be controlled by pressure. This is more noticeable the lower the pressure slider value is (Figure 5.93). A pressure of 0% gives the most extreme sensitivity to pressure, and 100% gives no sensitivity to pressure. I know it seems anti-intuitive, but that's just the way it is.

Display Control While in Mosaic Mode

While in Mosaic mode you may notice that the Toolbox and top menu are inaccessible. You cannot zoom in on or out from your image or save the stage you're at. To do all these operations you first need to click Done in the Make Mosaic window. This takes you out of mosaic mode into regular painting mode, where you have access to all operations and menus. Then, when you are ready to continue making your mosaic, you choose Canvas > Make Mosaic. This returns you once again to the Make Mosaic window. During the course of making a mosaic I regularly go in and out of mosaic mode to save sequential versions of my file (as a RIFF, of course).

6 At a certain stage in your mosaic you may wish to experiment with different colors of grout. If you know right away what you want, you could do this at the beginning. I did it halfway through. Click on the grout icon (plain white box) in the Make Mosaic window and select your grout color in the ensuing grout color picker. Click OK (Figure 5.94).

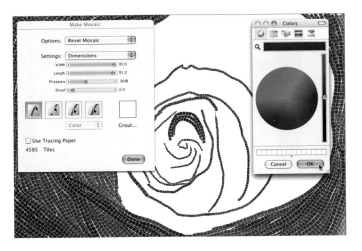

Figure 5.94 Changing grout color.

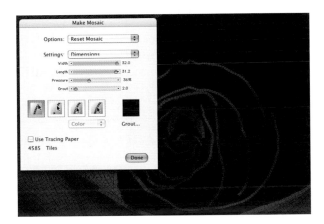

Figure 5.96 Increasing tile randomness.

Figure 5.95 The image with the new grout color and Use Tracing Paper unchecked.

7 Uncheck the Use Tracing Paper button so you can see what your mosaic looks like with the new grout color. Go back and alter the grout color if needed (Figure 5.95).

8 I experimented with increasing the tile randomness (randomness of shape and size) slightly as I got closer to the center (Figure 5.96).

9 Toward the end of the process I selected the third of the four main icons in the center of the Make Mosaic window (Figure 5.97). The left icon is for regular mosaic laying down of tiles. The second icon is for removing tiles (you select that icon and then just click on tiles and they disappear). The third icon gives you a number of options for coloring your tiles. I selected the Tint option, which gradually imbues a tile with the current color, almost as if you are gently airbrushing the color on.

Figure 5.97 Selecting Tint.

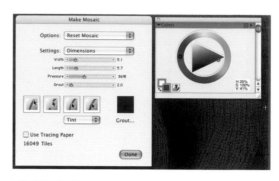

Figure 5.98 Tinting tiles.

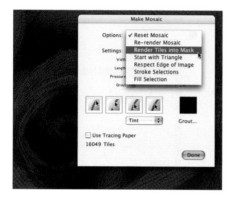

Figure 5.99 Rendering the tiles into the mask.

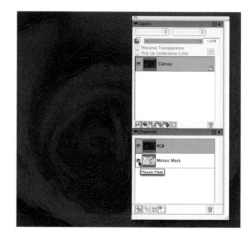

Figure 5.100 Viewing the Mosaic mask.

10 I wanted the green tiles on the right to become more crimson. I went out of mosaic mode, used the Dropper tool to select color from the image, and then returned to mosaic mode and tinted the tiles (Figure 5.98).

Render the Tiles into the Mask

1 When complete, the final step within the Make Mosaic window is to select Options: Render Tiles into Mask (Figure 5.99).

2 Click Done.

Work on the Tiles and the Grout in Painting Mode

1 In regular painting mode, open the Channels palette and click on the eye icon next to the Mosaic Mask. You'll see the mask appear in bright red. It is shaped exactly to where the grout is (Figure 5.100).

Figure 5.101 Choose Load Selection.

Figure 5.102 The Load Selection window.

Figure 5.103 Hide the selection marquee.

Figure 5.104 Choose Apply Surface Texture.

CHAPTER 5 PHOTO TECHNIQUES II: *PRINTMAKING AND MOSAICS*

2 Turn the eye icon off so that you don't see the mask.

3 For working on the tiles separately from the grout, and vice versa, choose Select > Load Selection (Figure 5.101).

4 Click OK (Figure 5.102).

5 You'll see "dancing ants" everywhere! Choose Select > Hide Marquee (Figure 5.103). The ants will disappear, though the selection of just the tiles will remain active (until you deselect).

6 Choose Effects > Surface Control > Apply Surface Texture (Figure 5.104).

7 Using: Paper, the default in the Apply Surface Texture window, will give your tiles a rough texture (Figure 5.105).

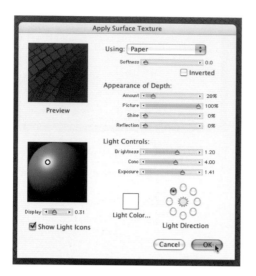

Figure 5.105 Giving tiles a rough surface texture.

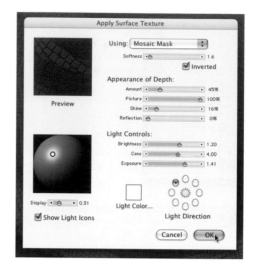

Figure 5.106 Choose Using: Mosaic Mask with a little softness for adding three-dimensionality.

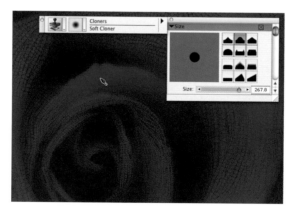

Figure 5.107 Cloning some photo back into the tiles.

8 To give your tiles a three-dimensional look, choose the Apply Surface Texture effect again, and this time choose Using : Mosaic Mask.

9 Add a little Soften and click OK (Figure 5.106).

10 You can clone some of your original photograph into your tiles using Cloners > Soft Cloner (Figure 5.107).

11 As a final touch you can apply any of the regular brush tools to fine-tune the image, such as the Photo and Tinting brushes (Figures 5.108 and 109).

Figure 5.108 Applying the Photo > Burn brush.

Figure 5.109 Applying the Tint > Soft Glazing Round 15 brush.

Example Mosaics by John Derry and Mark Zimmer

The mosaic samples shown in Figures 110 and 111 are by two of the geniuses behind Painter—John Derry, one of the creators of Painter from the early days (who also wrote the Foreword for this book), and Mark Zimmer, who, along with Tom Hedges, was one of the original inventors and developers of Painter.

Mark has kindly shared some insights that shed light on the background and significance of his mosaic, "The Miracle of the Can."

"The Miracle of the Can" was my entry in the Painter 4 poster, whose theme was "Painter 4—Making History." The various contributors to the poster conspired to each construct a Painter Can image for a different point in history—hopefully one where artistic themes flourished. I chose the Byzantine period because of my interest in mosaics. I still think it's the best Painter poster of all.

In the image are mosaic portraits of: John Derry, Tom Hedges, Steve Guttman, Glenn Reid, and myself, Mark Zimmer.

Each posed in a specific pose, individually, with special consistent lighting, for the picture. I hand-painted the robes from scratch (with hints from the existing clothing) in separate layers over the figures. The final result was cloned in mosaics, and surface texture was added for the extra "oomph." There was also some Apply Lighting as well. The whole image took about 36 hours of hard labor to create.

The Latin phrase, reminiscent of the text that adorns architecture in St. Peter's in the Vatican, is Mediae Naturae Semper—which is loosely equivalent to "Natural Media Forever"—perhaps an homage to Strawberry Fields Forever. The position and shapes of the characters in the text was suggested by existing Byzantine designs from the Hagia Sophia in Istanbul. And, of course, Ravenna, Italy. You can find a burning ice cube in mosaics in there as well, a reference to the Painter 3 poster and campaign (So Hot, So Cool).

The group comprised the leaders in the design and implementation of Painter 4. As usual, it was always a miracle that we made our schedule for the product (the real miracle of the can).

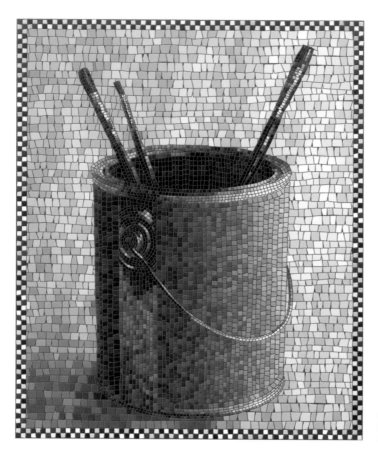

Figure 5.110 "Painter 4 Can Art" by John Derry.

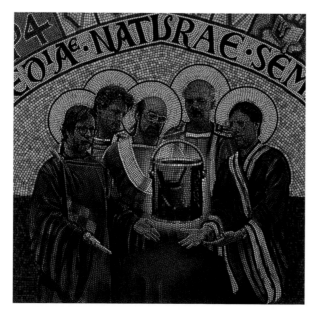

Figure 5.111 "The Miracle of the Can" by Mark Zimmer.

5.7 Wrap

I hope you have thoroughly enjoyed this chapter's exploration through various combinations of Painter's wonderful brushes and effects. The case studies only touch the surface of what is possible. There is still much left for you to discover!

Beyond learning specific techniques, the most important lesson of this chapter is adopting an open-minded, creative approach to transforming your imagery. Think beyond just applying a single effect or technique. Think, instead, of entering a journey of transformation in which you may use several effects in addition to hand-painting. Along the journey you may create many variations that you can clone into one another. You may generate multiple layers and then flatten your image to blend and smear, and so on. Be open-minded and allow your creativity to flow.

Now that you have tasted the joy of transforming single images, the next step is to work with multiple images and explore ways to bring them together into powerful, dramatic, evocative collages.

CHAPTER 5 PHOTO TECHNIQUES II: *PRINTMAKING AND MOSAICS*

6

Photo Techniques III: *Adventures in Collage*

Painting is poetry that is seen rather than felt, and poetry is painting that is felt rather than seen.

—*Leonardo da Vinci*

6.1 Introduction

What is a Collage?

A collage is an assembly or composition of diverse elements. Traditionally, gluing various materials, such as paper, cloth, and wood, onto a surface has created collages. With the advent of programs like Photoshop and Painter, we can now easily combine diverse elements on the digital canvas with great flexibility and ease.

Like the assembly of words in a poem, an assembly of images in a collage conveys emotion and meaning. To take da Vinci's quote one step further, collage is poetry that is seen and felt.

What Do You Wish to Say?

No matter whether you create a collage traditionally or on the computer, your starting point remains the same: What do you wish to say? It is important to start a collage with a goal and a vision. Collages are a powerful storytelling medium. Our minds naturally seek meaning and patterns. When we see a variety of diverse elements brought together, we infer meaning into those spatial and visual relationships. The juxtaposition of different elements causes a subliminal linkage in our mind. The use of layered and juxtaposed visual elements can suggest movement in time and/or space, which we then relate to the subject, or theme, of the collage. We naturally look to understand the story. We make inferences and assumptions, reading between the lines, filling in the silences. What is left out is as important as what is put in.

Art Principles

All the principles of traditional art and composition apply to the collage composition itself: the use of line, shape, and direction to guide the eye; the use of color, contrast, and detail to bring into focus certain elements; the use of balance and harmony in combining elements and forms and textures; and so on. In a painting the medium is your paint. In a collage the medium is your imagery, your visual elements. Just like mixing colors on the canvas, your challenge as a collage artist is what to put on the canvas and how to mix and blend it together into a harmonious whole that conveys the meaning and emotion of your story.

Choices

Within the technical details, the "how to," there are many choices to be made along the way. The first choice is medium: whether to work traditionally, digitally, or in a combination of both (e.g., by scanning traditional work in and adding it to the digital canvas, or painting on and adding elements to the digital print). Once you have decided to use the digital medium, your next choice is: Which tool to use? With Photoshop you can easily combine image elements together as layers, an approach that offers great versatility for controlling the layer opacity and experimenting with layer blending modes. With Painter you can follow a multilayer collage approach similar to what you may do in Photoshop. With Painter you have the additional versatility of mixing and blending imagery with hand-painted brushstrokes using Painter's phenomenal range of organic, natural media brushes. These hand-painted strokes can be applied on layers or on the flat canvas, used to add new color or to introduce clone color from a source image, or used simply to move, smear, and distort imagery. The artistic texturing and brush effects possible with Painter are unparalleled. Thus Painter can add a whole level of richness to collage that is unattainable with any other graphics software.

Case Study

This chapter is based on a single case study, "love & kisses," a collage portrayal I created of my father, Maurice Sutton. Although "love & kisses" is just one sample, the principles and techniques used can be applied to any collage project. In dissecting and analyzing the steps that went into making this collage, I share an intuitive creative approach to combining imagery. I have not sanitized the serendipitous nature of the way the collage unfolded. It didn't go exactly as planned, and it didn't end up looking how I initially envisioned it. The steps didn't follow the most logical or efficient path. Real-life creativity is not a perfectly running, preprogrammed script—it is a series of mini-adventures and unscripted happy accidents. That is what this book is all about—"real-life creativity." My goal here is to empower you to choose which techniques are best for what you wish to achieve while at the same time having the confidence to flow with the unexpected twists and turns of your creative process. There are no hard-and-fast rules. Each project has its own unique path.

Your Project

After reviewing the case study in this chapter, create a collage of your own. Choose a theme or subject you feel passionate about. You could create a special "personality portrait" or "memory lane montage" of someone you love. You could create a collage for a memorial, tribute, graduation, birthday, anniversary, special event, or wedding. Take your time. This is your opportunity to express your voice, to experience the adventure of collage. Enjoy exploring this wonderful form of visual storytelling.

6.2 Key Strategies and Techniques

Key Strategies

To help you distill the key strategies and techniques from this chapter, I summarize here six basic principles that will help you with any collage project. When working on complex, multilayered, multiple clone source projects, these basic organizational and strategic principles make an enormous difference to the ease and efficiency of your creative process.

1 *Set a goal, have a vision.* Start off your collage project with a goal in mind. What would you like to express? What is your goal? What is the story? What is important to you? Research your imagery. Visualize what imagery you wish to create, what the base image will be that you can build upon, and what you want to communicate. Even though your goals may change as the project progresses and the end result may differ considerably from what you initially visualized, having that initial goal and vision is still important.

2 *Work at maximum quality.* Scan source material, if possible, at resolutions as high as you will need. Save scans as TIFF files rather than JPEGs. Work at the size and resolution you want to end up at.

3 *Organize your palettes.* Make sure you have all palettes showing that you need. This will include the Property Bar, Toolbox, Brush Selector Bar, Colors, Papers, Layers and Channels palettes, and a custom palette with Clone, Save As, and Layer Attributes command buttons. Save the palette arrangement for easy recall (Window > Arrange Palettes > Save Layout).

4 *Work on clone copies.* Always work on clone copies, rather than originals, for added flexibility. Besides protecting your originals, it allows the convenient "erase to save" function with Cloners > Soft Cloner.

5 *Rename consistently and meaningfully.* Always rename clone copies and new layers immediately, consistently, and meaningfully.

6 *Document meticulously.* Periodically save sequentially numbered versions as you work. Always Save As immediately before applying any effect or dropping layers. Keep all of your saved versions in a project folder that you archive for future reference. I recommend adopting the folder organization strategy I used in this case study. First create your Project Folder. Then within that Project Folder create two more folders: "Source Images" and "Working Images." Save all your source material in the Source Images folder and all versions of your work in progress, as well as your final image, in the Working Images folder. In the case study, "love & kisses," I ended up with a Source Images folder containing 29 documents (taking up a total of 485 MB), and a Working Images folder containing 46 saved versions (taking up a total of 1.41 GB), each sequentially numbered. Make sure you have cleared sufficient space on your hard drive or wherever you will be saving your files prior to starting a collage project.

Key Techniques

In this case study I make use of three basic techniques for introducing and blending image elements into a collage composition: (1) revealing from a clone source, (2) subtracting from a layer, and (3) applying as a paper texture.

Revealing from a Clone Source

With this technique you place each image element you wish to add to the collage as a layer in a clone source file that is the exact size of the working image. You generate the identically sized clone source by cloning from the working image. You resize, reorient, and reposition the element as needed and then clone from that source image into the background canvas of the main working image, which can remain a flat image (no need for layers in the working image in this technique). The clone source approach allows an intuitive way of gradually revealing imagery rather than making it disappear. It also allows a more painterly feel to the introduction of imagery than layers, since you can use almost any brush as a clone brush (just click the Clone Color icon in the Colors palette). It also has the advantage that you can integrate blending and smearing brushes into the way you manipulate the paint on the background canvas. In this case study I combine some freehand painting based on observation (that is, painting based on looking at a photograph, without use of Tracing Paper or clone color) with subsequent use of Tracing Paper and clone color. This combination gave my painted portrait a more expressive feel.

Subtracting from a Layer

The simplest, quickest way to introduce an image element is to copy and paste from one image into another (or select a region in one image and hold the Option/Alt key down while you drag and drop the selection from one image into another). A pasted image automatically appears as a layer. Layers have the advantage of flexibility. You can continually reposition, reorient, and resize layers (although repeated resizing and rotating will reduce image quality, unless you keep the layer as a Free Transform). You can adjust layer opacity, composite method, and rearrange the ordering of layers. You can also control which parts of a layer are visible by painting black (to take away or conceal) or white (to add or reveal) in the layer mask using a soft, low-opacity Airbrushes > Digital Airbrush variant. You generate a layer mask by clicking on the mask icon (right-hand square button at the bottom of the Layers palette) while the layer is selected. You activate the mask mode (i.e., the mode where black takes away layer visibility and white adds layer visibility) by clicking on the mask icon that appears immediately to the left of the layer name in the Layers palette layers list. You return to regular mode (i.e., the mode where you can paint and apply effects directly on the layer) by clicking on the regular mode icon to the left of the mask mode icon in the layers list.

I recommend concluding your collage process by flattening your image (ensuring you save the multilayered stage prior to flattening) and working on the flat background with tools for blending (Blenders category) and enhancement (such as Dodge and Burn from the Photo category). You can also add an artistic border as a last step.

Applying as a Paper Texture

Any image can be captured as a paper texture. Those images with strong tonal contrast make the best paper textures. There are many ways to apply a paper texture to your collage. You can use different special effects to emboss your image, such as Effects > Surface Control > Apply Surface Texture. However, my preferred method of adding imagery that has been captured as a custom paper texture is to paint it into my image with a grainy brush like Chalk > Large Chalk. This method gives me the most control and the most subtlety and results in a more personal image, since I am involving my hand in the process rather than just a button on the computer. In capturing custom paper textures you can either capture a small image and have it be a repeating texture tiled across your canvas as you paint or capture an image the same size as your canvas and thus preposition precisely where your texture will appear in your image. There are examples of both in this case study.

6.3 Case Study: "love & kisses" (Figure 6.1)

Choose Your Subject

The starting point for a collage is choosing your subject. Pick a subject you feel strongly about. The subject could be yourself, someone you love, someone important to you. Make it personal. Make it meaningful. Of course you can apply the technique of collage to any subject or theme. The subject doesn't have to be a person. You can also apply collage in your professional work, for illustration, design, fine art, or commissioned portraiture. My suggestion here is to create an artwork for yourself that is personal and meaningful. Creating a personal collage will be a valuable learning experience and a priceless gift to yourself, which you will treasure forever.

My choice of subject for this case study was my father, Maurice Sutton. I lost my Dad in December 1988 (6 months after I moved to California), when he tragically and unexpectedly died of a heart attack. I think of him often and miss being able to talk with him, see him, or just know he is there. He had a great sense of humor and an inquisitive mind. Creating this collage was a scary yet exciting proposition. I felt a sense of responsibility to his memory, to create something worthy of him. I felt a fear of judgment from other members of my family. What if they didn't like it? I also felt a sense of responsibility to my feelings. Would I express myself in a way that would convey how deeply I love him and miss him?

In starting off there is only a blank canvas. I could not predict what would emerge, or how successful it would be, or how beautiful, or how powerful. I had only the trust in the process, the trust in the journey. I had to acknowledge and then let go of my fears. I had to jump in and take the risk. It felt like stepping off a high diving board, trusting that I would survive the fall.

Research and Collect Imagery

Having selected your subject, the next step is image research and image collection. By "image" I mean all kinds of images, not just photographs. An image can be anything visual that conveys or relates

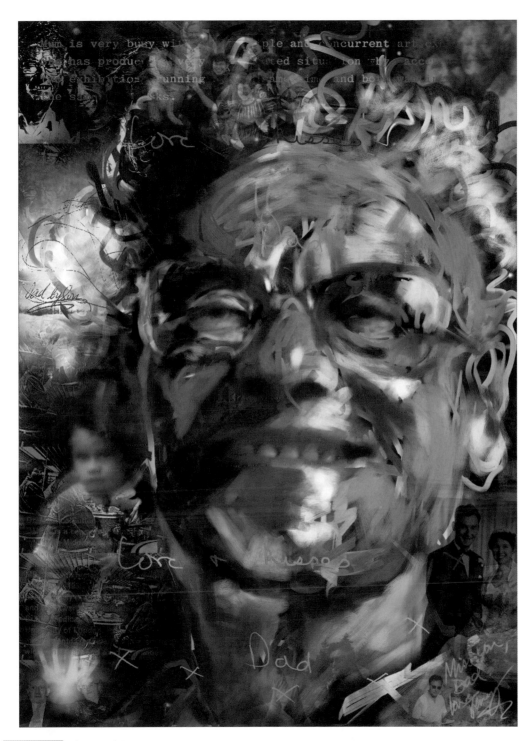

Figure 6.1 "love & kisses".

to your subject. It can be a sample of the individual's writing, an object or place you identify with that person or that was or is meaningful to him or her, and so on. Take your time over this stage. Sometimes I research and collect material for a collage over many months or even years. Create a folder, both outside and inside your computer, for collecting potential source material. As I suggested earlier, create a main Project Folder in your computer, and within that folder create a "Source Images" folder into which you collect all your potential source images and a "Working Images" folder into which you save all your working images.

In the case of my Dad, there were a few source images that were particularly significant. These included the following.

1 A picture of when my Dad was a little boy (2½ years old) with his two older sisters (taken in London, 1930).

2 A wedding picture of my Mum and Dad (London, U.K., 1954).

3 A picture of Grandma and Grandpa Sutton (London, 1963).

4 The author description from the back cover of my Dad's book "Cancer Explained" (published in 1966).

5 A picture of Mum and Dad hiking (Lake District, U.K., 1973).

6 A sketch I did of my Dad at a conference (Oxford, U.K., 1983).

7 The last pictures taken of my entire family together, one outside my parents' home and one at Heathrow Airport, as I was leaving to come and live in America (April 1988).

8 Pictures of me, my Mum, and my Dad at Big Sur, California (October 1988).

9 A picture of outer space from the *Times Atlas of the World* that Mum and Dad gave me after visiting me in California (Dad loved astronomy and space).

10 A letter my Dad sent me on November 18, 1988, just a month before he died.

Use Photoshop's Adjustment Layers (Levels, Hue/Saturation) to optimize your source imagery. Save flattened versions of the files for opening in Painter. You can get a quick overview of your source images using the Photoshop browse viewer (File > Browse) (Figure 6.2). Painter also has a browse viewer (only works on a Macintosh, File > Open, click Browse), though it does not show thumbnails of images not saved within Painter.

To give myself the maximum flexibility and choice of imagery, I sometimes digitally capture the same image using both my digital SLR (single lens reflex) camera with a soft focus lens and my flatbed scanner. You may notice in the browser view shown in Figure 6.2 that I have several pairs of the same image, but one (the one taken on the SLR with the soft focus lens) looks slightly fuzzier than the other. I will not necessarily want to use the most precise or detailed image in my collage. Sometimes a more diffuse, abstract image works better.

Figure 6.2 Using Photoshop's browsing function to view source images.

Decide on Your Key Foundation Image or Images

It's easy to put a jumble of overlapping and juxtaposed images together on a page. However, it's a whole other challenge to create a powerful, evocative composition that grabs the viewer's attention and tells your story in a compelling way. Just like a painting, your collage composition needs a focus of attention, a simple key image or group of images that ground the piece and form a foundation or framework that you can build upon. The key foundation image or images may also act as a background to start the collage with, rather like an underpainting, or I may select another background image and combine that with my foundation images. Frequently the main foundation image jumps out. It speaks loudly. In this case I envisaged from the start a central main portrait of my Dad being the root of the collage. I found one head shot photo of Dad smiling, his hair blowing in the wind, with the sea in the background, that I thought would work perfectly as a foundation image. I pictured using the stars in the background around the edges of the collage.

As I did further image research I came across the letter dad had written to me the month before he died. I loved the way he'd signed off at the end with a joyful "love & kisses from all of us, Dad xxxxxxx." As soon as I saw that I knew the title for this piece was "love & kisses" and I knew I wanted to have that portion of his letter clearly visible in the collage.

Customize Your Palette Layout

Before diving into action in Painter, take time to create a "collage shortcuts" custom palette (those commands and brushes you are likely to use repeatedly while creating a collage), and then set up and save a custom palette layout called "Collage" specifically suited to working on collages.

What to Put in Your "Collage Shortcuts" Custom Palette

My suggestion for the content of your "Collage Shortcuts" custom palette are the following command buttons:

- File > Clone (for making copies of your working files)
- File > Save As (for saving sequentially numbered versions of work in progress)
- Layers palette pop-up menu > Layer Attributes (for naming your layers)
- Layers palette pop-up menu > Drop All (for flattening your working image)
- Cloners > Soft Cloner (for cloning in imagery)
- Airbrushes > Digital Airbrush (for adjusting layer visibility by painting white or black on the layer mask)
- Chalks > Large Chalk (for painting in custom textures).

Please refer to Chapter 1 for detailed instructions on how to set up your custom palette. Also, to access the Layer Attributes and Drop All commands after choosing Window > Custom Palette > Add Command, you will need to open a canvas and create a layer in that canvas (which you can do by choosing New Layer in the Layers palette pop-up menu) before choosing Add Command.

Besides the Collage Shortcuts custom palette, you'll want to have open on your Painter desktop the Toolbox, Property Bar, Brush Selector Bar, Colors palette, Brush Controls Size palette, Layers palette, and Papers palette. Other optional palettes you may wish to consider are the Mixer and Color Sets, if you like choosing color with either of those, the Channels palette, though you don't need it to do any of the techniques discussed here, and the Text palette, if you intend to include text in your collage. Try to limit what you have visible to just those palettes that are essential. The more you clutter your workspace, the harder it is to work efficiently. When you have everything laid out to your satisfaction, choose Window > Palette Arrangement > Save Layout (Figure 6.3).

Name your layout "Collage." As you work more with collages, you are likely to fine-tune your favorite palette layout. You can always update your saved layout by saving another with the same name.

Establish Your Canvas Size

The foundation canvas is the canvas from which you will start building up the collage. The foundation canvas sets the scale, proportion, and size of your artwork, at least for the duration of the creative process, after which you can always resize the final image. Establish first the proportions of the canvas (ratio of height to width) and then the overall size of the canvas (the physical dimensions and pixel resolution of your artwork).

Figure 6.3 Save a custom palette layout.

Figure 6.4 Establish canvas proportions.

1. In this case the proportions were determined by the scale of the central portrait versus the overall size of the canvas. In other words, how much of the canvas would be taken up with the central portrait. I opened the scan of the central portrait, my main foundation image, in Painter.

2. I chose Cmd/Ctrl-M (Window > Screen Mode Toggle).

3. I chose Canvas > Canvas Size and added 200 pixels all the way around (Figure 6.4).

4 After adjusting the proportions I saved this version of the file (Figure 6.5). Throughout this collage project my layered working files were saved as RIFF files, with sequential version numbering, and intermittently backed up in Photoshop file format (especially before closing Painter). While you are working with layers and various different composite methods it is essential to save your working files as RIFF files. Although there is some overlap between Painter Composite Methods and Photoshop Layer Blending Modes, there are Composite Methods in Painter that will not be preserved in Photoshop file format (see Chapter 1 for a detailed discussion of this).

5 The next step is to look ahead at the final print size you envisage making. I envisaged a print approximately 20 inches by 30 inches, and I resized (Canvas > Resize with Constrain File Size unchecked) the file to that size with a pixel resolution of 150 ppi (Figure 6.6).

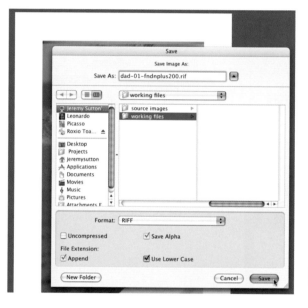

Figure 6.5 Save your reproportioned image.

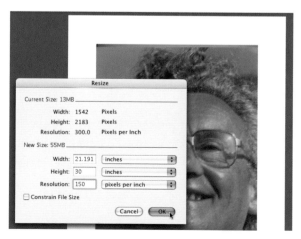

Figure 6.6 Resize the foundation canvas to suit the final envisaged print dimensions.

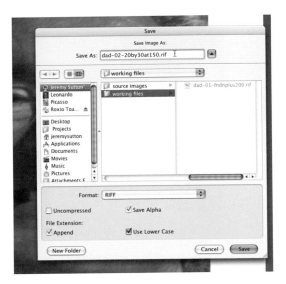

Figure 6.7 Save the resized foundation canvas.

6 I then saved and renamed (as "dad-02–20by30at150.rif") the resized file (Figure 6.7). This is my foundation canvas.

Having generated my foundation canvas, my next stage was to generate a series of variations that I could use as clone sources to bring imagery into my collage. The key point with any clone source for this project is that it have exactly the same dimensions as my working file (that is, the same dimensions as my foundation canvas). I use my foundation image to create a series of clone copies (using the Clone button in my Collage Shortcuts custom palette), which will automatically be of exactly the same size and proportions, and use these clone copies as "base canvases" for my clone source variations.

Preparing a Background Canvas from the Stars Image

1 I clicked on the Clone button in my "Collage Shortcuts" custom palette. This created a clone copy of the foundation image into which I would be pasting the stars background.

2 I chose Cmd/Ctrl-M (Window > Screen Mode Toggle), which mounted my clone copy in screen mode.

3 I opened the stars source image in Painter.

4 I chose Cmd/Ctrl-A (Select > All).

5 I chose Cmd/Ctrl-C (Edit > Copy).

6 I chose Cmd/Ctrl-W (File > Close) and closed the stars image without saving the changes.

7 With the clone copy of the foundation canvas as the active image in Painter, I chose Cmd/Ctrl-V (Edit > Paste). This pasted the stars image as a layer above the background canvas.

Figure 6.8 Lowering the opacity of the resized free transform star layer.

Figure 6.9 Dropping the resized star layer.

8 With the stars layer active (highlighted) in the Layers palette, I chose Effects > Orientation > Free Transform.

9 Holding the Shift key down, I dragged one of the corner Free Transform control handles and resized the layer to cover the whole canvas.

10 In the Layers palette I lowered the layer opacity slider so I could see the portrait underneath (Figure 6.8).

11 I used the ability to see through the stars layer to position it so it would work compositionally with the portrait.

12 I increased the layer opacity to 100%.

13 I chose Drop from the layer pop-up menu. I drop the layer primarily to keep the file compact and to prevent accidentally moving the layer. Note that you can equally well keep the layer and just click on the padlock icon in the Layers palette while the layer is selected in order to lock it in position. The advantage of keeping the layer is that you can vary its scale or position in the future if you wish to (Figure 6.9).

14 I saved the flattened file, renaming it with the file name "dad-03-starbckgnd.rif." It is important in collage to name every file clearly so you know exactly what it is. This is especially true of those files you may use as clone sources, since you'll be searching for the right file to assign as clone source purely by file name in the File > Clone Source menu. For this reason I do not recommend using Iterative Save in collage (it creates file names automatically that do not include descriptive notes, just sequential numbers added at the end of the file name).

Capturing a Paper Texture from the "love & kisses" Letter

1 I selected the foundation canvas (it is listed at the bottom of the Window menu) and made that the active image in Painter.

2 I followed the exact same procedure for the letter image as I did for the stars, first making a clone copy of the foundation image, then pasting in, resizing, and repositioning the letter layer until I was satisfied (Figure 6.10), and finally saving that resulting file as "dad-04-letterbkgnd.rif."

3 My vision with the writing from Dad's letter was to introduce that into my collage as a paper texture rather than just clone it in with the Soft Cloner. To do this I needed to capture the letter as a paper texture. Capturing a paper texture the same size as my foundation canvas is the best way for me to control exactly where the writing appears in the image and what scale it is. Thus my goal was to take the letter background image I had just created, change it into a high-contrast black-and-white image, and then save that as a paper texture. The first step of this was to select the background canvas in the Layers palette.

4 I then chose Cmd/Ctrl-A (Select > All).

5 I then pressed the Backspace/Delete key. This cleared the background image, which I didn't want to be part of the texture.

6 I then clicked on the Drop All button in my Collage Shortcuts custom palette. This flattened the image.

7 I then chose Effects > Tonal Control > Adjust Colors.

8 I then reduced the Saturation slider in the Adjust Color window to the minimum (−139%). This desaturated the image (Figure 6.11).

9 I clicked OK.

10 I then chose Cmd/Ctrl-E (Effects > Tonal Control > Equalize).

Figure 6.10 Creating the letter background image.

Figure 6.11 Desaturating the image using the Adjust Color effect.

11 I then brought the black and the white points close together in the Equalize window histogram. This created extreme contrast in the image so that the writing was black and everything else was white (Figure 6.12).

Saving Large Papers into a Custom Paper Library

Before capturing this relatively large image (3179 pixels by 4500 pixels) as a paper texture, I knew ahead of time it would be a memory hog and I wouldn't want such a large paper texture sitting in my default paper library. Therefore I chose Open Library from the Papers pop-up menu and opened a custom library, "JeremyExtraPapers," I had created specially for my large custom papers. I recommend you do the same. The detailed technique for creating your own Paper Library, involving use of the Paper Mover, is described in Chapter 2. After opening and using this custom paper library, I would then open the default "Paper Textures" library so that was the one open next time I worked with Painter. That way I could avoid the large custom papers affecting the efficiency of Painter when working on other projects.

12 I then chose Cmd/Ctrl-A (Select > All).

13 I then chose Capture Paper in the Papers palette pop-up menu (Figure 6.13).

14 I named the paper, adjusted the Crossfade slider to zero, and clicked OK. The paper was then saved in my custom papers library for use anytime in the future.

Maximum Custom Paper Size

When I first tried to capture the paper, I kept getting the error message "Unable to save paper." To overcome this problem I reduced the size of my letter background image by a factor of 4.

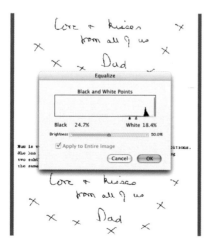

Figure 6.12 Increasing contrast using the Equalize effect.

Figure 6.13 Capture Paper in the Papers palette pop-up menu.

Figure 6.14 Testing the captured paper texture.

The paper was then saved without any problems. When applying the paper, I increased the paper scale to the maximum, which is 400%, and therefore it was the right scale for the artwork. I did a test just to be sure (Figure 6.14).

Capturing Photocopies as Paper Texture

One great aspect of capturing material as paper textures in Painter is that it frees you from having to have perfect color reproductions of your images. The source images of my Dad and me and of my family at Heathrow Airport as I was about to leave for America were both poor-quality black-and-white photocopies dating back almost 15 years! However, I knew that it would make a great paper texture. In fact the poor quality was almost an asset, since the picture was already a high-contrast black-and-white image. I did add a little Equalize to increase the contrast even further.

With these photocopies, I just chose Cmd/Ctrl-A (Select > All) and then chose the Capture Paper command from the Papers palette pop-up menu and captured these images as a paper textures in my custom papers library (Figures 6.15 and 6.16).

Pasting a Childhood Photo into the Image for Use as a Clone Source

I chose to use the softer, fuzzier version of the photograph of my Dad and his sisters, the one I recorded with my SLR rather than the scanner. I increased the contrast a little and then copied and pasted the

Figure 6.15 Choosing Capture Paper for the photocopy of Dad and me.

Figure 6.16 Choosing Capture Paper for the photocopy of my family saying goodbye to me at Heathrow Airport.

Figure 6.17 Photo pasted and positioned on the base canvas.

image into my base canvas (clone of the foundation image). I positioned the newly pasted image layer in the bottom left corner of the canvas (Figure 6.17).

Making a Paper Texture from the Sketch

I copied and pasted the sketch onto another base canvas (a clone copy of the foundation image in which I had cleared the canvas to white). After positioning the sketch I dropped the pasted image layer. I increased the contrast with the Equalize command and then captured the entire canvas as a paper texture (Figure 6.18).

Use Paint Bucket to Fill the Foundation Canvas Border with Blue

I wanted to fill the white border around the central portrait image in my foundation canvas with blue instead of white. I wanted to avoid any accidental harsh boundaries when cloning.

1 I chose the Paint Bucket tool in the Toolbox.

2 In the Colors palette I picked the color I wanted to fill the border with.

3 I clicked once in the white border region. I noticed that some of the blue had "leaked" into the photograph (Figure 6.19). In other words, the default Painter Bucket Tolerance setting of 32 (in the Property Bar) was too high.

Figure 6.18 Naming the sketch paper texture.

Figure 6.19 After filling the border with default Paint Bucket properties.

Figure 6.20 Paint Bucket Fill with Tolerance lowered to 9.

Figure 6.21 Setting the blue-bordered foundation image to be clone source.

4 I lowered the Paint Bucket Tolerance setting to 9. It worked perfectly (Figure 6.20).

5 Using my Save As button, I then saved the foundation image with an appropriately descriptive name.

6 I chose File > Clone Source and set the blue-bordered foundation image to be clone source (Figure 6.21).

Freehand Painting from Observation and Using Clone Reference

1 With a clone copy of the stars background image as my active working image and the foundation image with a blue border as my clone source, I started the process of painting the main central portrait onto the stars.

2 I chose the Artists > Sargent Brush.

3 I was about to use Tracing Paper and clone color when I stopped myself. I picked up the photo of my Dad that I had scanned for the central portrait and decided to start painting it just from observation of the photo that I had sitting beside my computer, rather than using Tracing Paper. I specifically wanted to create an expressionistic portrait with loose, free, gestural brushwork. I knew that relying on the Tracing Paper would stilt the expressive quality of my brushstrokes. Thus I started the portrait (Figure 6.22).

4 At a certain point in my painting process I turned on Tracing Paper (Cmd/Ctrl-T) to compare my freehand brushstrokes with the underlying photo. I had painted the portrait larger and displaced it down to the lower right side of the canvas. Rather than try to distort my painting to match the scale and location of the underlying photo in the clone source, I decided to do the opposite and resize and reposition my underlying photo to more closely match the brushstrokes I had already placed on the working image. This is an example of what I referred to earlier as "flowing with the unexpected twists and turns of your creative process." Don't be too attached to your plans!

5 I made the clone source the active image in Painter.

6 I chose Cmd/Ctrl-A (Select > All).

7 I chose Select > Float. This made the whole source image a layer.

8 I chose Effects > Orientation > Free Transform. This made the layer a reference layer, which I could resize with minimum loss of quality.

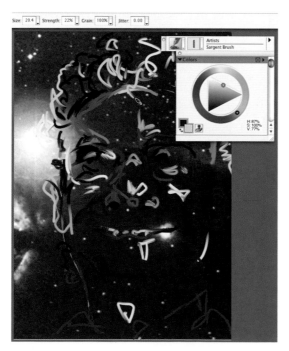

Figure 6.22 Painting the portrait freehand against the stars background.

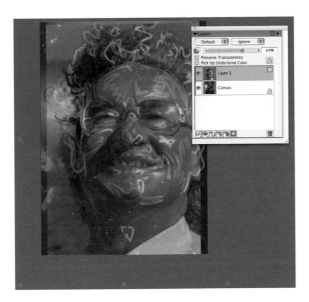

Figure 6.23 Aligning the eyes of the underlying photo with the painted portrait using Tracing Paper to view both simultaneously.

9 I held the Shift key down while dragging one of the corner Free Transform control handles away from the center. This enlarged the layer image. I adjusted the layer size until it matched my painted version of the portrait.

10 I then dragged the layer (with the Layer Adjuster tool, which had been automatically selected when I created a layer) into a position that matched the painted version. To accomplish this I had to do some trial-and-error moving, returning to the working image and turning on and off Tracing Paper to align the features like the eyes (Figure 6.23).

11 Once I had rescaled and repositioned the clone source, I then started using a combination of clone color with my own color on the portrait.

12 I chose the Jeremy Faves 2.0 > JS–Luscious Squiggle brush (Figure 6.24).

13 I continued the painting process with a modification of the Cloners > Oil Brush Cloner, one in which I changed the Brush Controls Impasto "Draw to" setting from "Color and Depth" to "Color" (Figure 6.25).

14 I continued painting until I reached a stage where I felt there was a sufficient likeness combined with sufficient roughness of brushstrokes. I didn't want the portrait to look photographic or overly realistic (Figure 6.26).

Adding the "Mum and Dad at Big Sur" Image Using the Difference Composite Method

1 I opened the source photo of "Mum and Dad at Big Sur."

2 I selected the Lasso tool in the Toolbox.

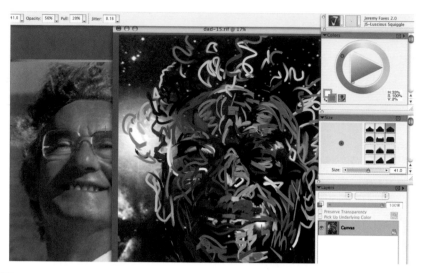

Figure 6.24 Applying the Luscious Squiggle brush using clone color.

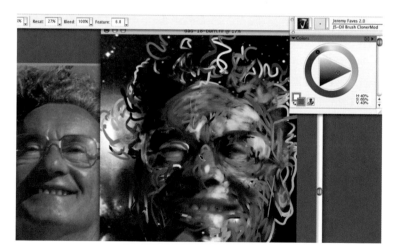

Figure 6.25 Painting with a modified Oil Brush Cloner.

3 I made a rough selection around Mum and Dad.

4 I selected Select > Feather (Figure 6.27).

5 I then set the feather to be 20 pixels to give a diffuse soft selection (Figure 6.28).

6 I chose Cmd/Ctrl-C (Edit > Copy).

7 I made the working image, the large one with the painted portrait, the active image in Painter.

8 I chose Cmd/Ctrl-V (Edit > Paste).

9 I moved the pasted layer around to the top right corner.

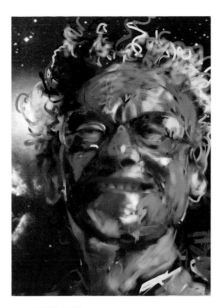

Figure 6.26 The painted portrait.

Figure 6.27 Choosing Select > Feather.

Figure 6.28 Setting the feather to 20 pixels.

Figure 6.29 "Mum & Dad at Big Sur" layer set to Difference composite method.

CHAPTER 6 PHOTO TECHNIQUES III: ADVENTURES IN COLLAGE

10 I experimented with every composite method in the Layers palette and chose the Difference Composite method as the one that gave the best effect (Figure 6.29).

Difference Composite Method

Composite methods in Painter are the equivalent of layer blend modes in Photoshop. They influence the way that every pixel in an image layer interacts with, and is influenced by, the

Figure 6.30 Airbrushing out stars.

Figure 6.31 Creating a Layer Mask.

Figure 6.32 Airbrushing with black in the layer mask.

pixels directly below it. The Difference composite method subtracts one color from the other, depending on which color has a greater brightness value. When a Painter document is saved as a Photoshop format document, the Painter Difference composite method converts to the Photoshop Difference blend mode.

11 The stars in the background beneath the "Mum & Dad at Big Sur" layer appeared as dark spots in the layer. To eradicate these spots I selected the background canvas in the Layers palette.

12 I chose the Airbrushes > Digital Airbrush.

13 I held the Option/Alt key down and clicked on the dark part of the starry background to select that color.

14 I then airbrushed out the stars beneath the layer (Figure 6.30).

15 With the "Mum & Dad at Big Sur" layer selected (highlighted) in the Layers palette, I clicked on the Layer Mask icon (the rightmost of the six small icons at the bottom of the Layers palette). This created a layer mask associated with that layer (Figure 6.31).

16 With the current color black and the layer mask selected in the Layers palette, I airbrushed out the outer parts of the layer (Figure 6.32). When applied to a layer mask, black reveals what is underneath the layer, while white conceals.

Adding a "Dad Hiking" Image as a Layer Using the Gel Composite Method

1 I copied and pasted the photo of dad hiking into the working image and moved it down to the lower right corner.

2 I clicked on the Layer Attribute button I had added to my Collage Shortcuts custom palette and named the layer (Figure 6.33). In a project like this, where you will end up with multiple layers, it is very important to meticulously name all your layers. If you leave the default names, Layer 1, Layer 2, and so on, you are guaranteed to get mixed up and confused. Get into the habit of immediately naming layers when you first introduce them. Also get in the habit of saving a sequentially numbered RIFF version of your work in progress every time you add a new layer.

3 I then experimented with all the composite methods and decided on using the Gel composite method for this layer. I also created a layer mask and painted out the edge of the layer (Figure 6.34).

Figure 6.33 Naming the layer.

Figure 6.34 "Dad hiking" layer with the Gel composite method and layer mask.

Gel Composite Method

The Gel composite method tints the underlying image with the layer's color. Painter automatically sets a layer's composite method to Gel if you paint on it with a brush that uses the Buildup method (see Window > Brush Controls > Show General). When a Painter document is saved as a Photoshop format document, the Painter Gel composite method converts to the Photoshop Darken blend mode.

4 At this stage I locked the layers I had completed (Figure 6.35). Locking a layer protects it from being painted on, dropped, or moved. This is useful when you have complex multilayered images since it is easy to accidentally paint on or move the wrong layer. To lock a layer, you first select the layer in the Layers palette and then click once on the padlock icon. To unlock a layer, you just click once on the padlock icon within the layer in the Layers palette.

Applying "Dad and I" Paper Texture

1 I selected the "Dad and I" paper texture in the Papers palette paper selector.

2 I chose the Chalk > Large Chalk brush, increased its size, and reduced the grain slider (Property Bar).

3 I made some test brushstrokes to determine the scale of the paper texture I wanted. I settled on 56%. Note that every time you change paper textures, when you return to a texture you were just using the scale is automatically reset to 100%. This means that if you wish to use a consistent paper texture scale you need to either write it down somewhere (or note it in the file name) or save a Brush Look that includes paper data.

4 I selected the background canvas in the Layers palette.

5 I applied the paper texture in the upper left side of the working image (Figure 6.36).

Figure 6.35 Locking layers.

Figure 6.36 Applying the "Dad and I" paper texture.

Adding the "Grandparents" Image as a Layer Using the Luminosity Composite Method

1 I used the lasso to select a portion of the "Grandparents" photo.

2 I feathered the selection.

3 I then copied and pasted that selection into the image.

4 I moved the layer to the bottom left.

5 I rescaled the layer (Effects > Orientation > Free Transform).

6 I softened and reshaped the edges of the layer by painting into the layer mask.

7 I experimented with all the composite methods and chose Luminosity.

8 I reduced the layer opacity to about 50% (Figure 6.37).

Figure 6.37 Adjusting the opacity of the "Grandparents" layer.

Luminosity Composite Method

The Luminosity composite method creates a new color from the hue and saturation of the image color and the luminance of the layer color. It is the opposite of the Color composite method. When a Painter document is saved as a Photoshop format document, the Painter Luminosity composite method converts to the Photoshop Luminosity blend mode.

Adding the "Mum & Dad Hiking" Image as a Layer Using the Shadow Map Composite Method

1 I used the lasso to select a portion of the "Mum & Dad Hiking" photo.

2 I feathered the selection.

3 I then copied and pasted that selection into the image.

4 I moved the layer to the bottom middle.

5 I rescaled the layer (Effects > Orientation > Free Transform).

6 I experimented with all the composite methods and chose Shadow Map.

7 I reduced the layer opacity to about 50% (Figure 6.38).

Shadow Map Composite Method

The Shadow Map composite method blocks light, letting you create shadows without changing the image. When a Painter document is saved as a Photoshop format document, the Painter Shadow Map composite method converts to the Photoshop Multiply blend mode.

Figure 6.38 "Mum & Dad Hiking" layer with the Shadow Map composite method.

<div style="float:right"></div>

Adding the "Family Goodbye Outside House" Image as a Layer Using the Default Composite Method

This layer I pasted in, moved to the top of the canvas, painted into the layer mask a little, and reduced the layer opacity (Figure 6.39).

Default Composite Method

The Default composite method does not interact with the color beneath the layer. If the layer visibility is 100%, then the layer will be opaque. When a Painter document is saved as a Photoshop format document, the Painter Default composite method converts to the Photoshop Normal blend mode.

Applying "Family Goodbye at Heathrow" as Inverted Paper Texture

1. I selected the background canvas in the Layers palette.
2. I selected the "Family Goodbye at Heathrow" paper texture.
3. I used the Large Chalk to apply the texture on the left of the picture. I inverted the paper texture and painted in the "negative" space of the texture (Figure 6.40).

Figure 6.39 "Family Goodbye Outside House" layer in the Default composite method.

Figure 6.40 Painting with inverted paper texture.

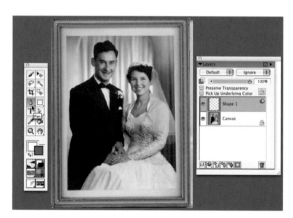

Figure 6.41 Creating a precise path around the frame using the Pen tool.

Adding the "Mum & Dad Wedding" Image as a Layer Using the GelCover Composite Method

1 I opened the "Mum & Dad Wedding" source photo.

2 I selected the Pen tool in the Toolbox.

3 I used the Pen tool to make a precise straight-edged path along the outside of the picture frame in the photo, clicking once at each corner (you have to be careful not to inadvertently click and drag, since that will lead to a Bezier curve instead of a straight path).

4 I closed the path by clicking on my beginning point. I had previously set my Shapes preferences not to fill or stroke a shape on drawing or on closing. Note that the shape appears listed in the Layers palette (Figure 6.41).

Figure 6.42 Converting a shape or path to a selection.

Figure 6.43 "Mum & Dad Wedding" layer in the GelCover composite method.

5 A shape or path in Painter is a vector path. In other words it is a mathematically defined path that is independent of resolution and is not made of pixels. To convert a shape or path to a selection, you just choose Shapes > Convert to Selection (Figure 6.42).

6 I copied and pasted the selection into the main image.

7 I converted the layer to a Free Transform (Effects > Orientation > Free Transform) and adjusted its size (hold the Shift key while dragging a corner) and rotational orientation (hold the Cmd/Ctrl key down while dragging a corner).

8 I experimented with all the composite methods and chose GelCover (Figure 6.43).

GelCover Composite Method

The GelCover composite method, new in Painter IX, acts like a halfway point between the Default composite method and the Gel composite method. When a Painter document is saved as a Photoshop format document, the Painter GelCover composite method converts to the Photoshop Normal blend mode.

9 As a final stage with this layer I wanted to paint into the layer mask. To do that I first created a layer mask.

10 When I went to paint on the layer mask, a window popped up asking "Commit reference layer to an image layer?" I clicked Commit (Figure 6.44). I then had to reselect the layer mask (after clicking Commit, the Layers palette selection goes back to being the regular image layer, not its mask). You have to keep on your toes. It is easy to accidentally paint with your airbrush on the actual layer instead of on the layer mask.

Figure 6.44 Committing a reference layer (Free Transform) to an image layer.

Figure 6.45 Saving the file as a TIFF file.

Flattening the Working Image

The next stage of this creative process was focused more on the custom paper textures than on introducing more layers. For this reason I wanted to flatten the image. One option, after saving a RIFF version of the image, of course, would be to go through each layer in turn and unlock each layer individually. Only then could I choose Drop All from the Layers pop-up menu. A slight work-around that saves doing all that unlocking of layers is simply to save the file as a TIFF (Figure 6.45), close the file, and then open it again. Painter TIFFs do not support layers, so it automatically flattens the file (Figure 6.46).

Figure 6.46 Warning that appears when saving an image with layers as a TIFF.

Figure 6.47 Applying the "Sketch" paper texture.

Applying Custom Papers ("Sketch" and "Letter") to the Flat Image

Using the Large Chalk, I then applied the "Sketch" and "Letter" paper textures in the flattened image (Figures 6.47 and 6.48).

Adding a Personal Note

1. In lieu of a signature, I decided to add a personal note. I chose the Pencils > 2B Pencil.

2. I adjusted the Method and Subcategory from Buildup > Grainy Soft Buildup to Cover > Grainy Soft Cover.

3. I picked a color from within the image and wrote my personal message (Figure 6.49).

Figure 6.48 Applying the "Letter" paper texture.

Figure 6.49 Adding a personal note.

4 I found the writing too strong. I could have written the writing on a layer and then just reduced the opacity of the layer. I generally like to write directly on the background canvas, especially with oily brushes that smear paint. To reduce the brightness of the writing, I set an earlier version of the image as clone source and gently faded away the lettering with the Cloners > Soft Cloner (Figure 6.50).

Adding Book Back Cover Writing as a Layer

At this juncture in my creative process I recalled that I had not yet introduced the write-up on Dad that was on the back of his book. I wanted this in the collage. The text was black writing against an orange background.

1 I chose Select > Color Select (Figure 6.51).

2 I clicked in the orange and reduced the HSV (hue saturation value) Extents sliders in the Color Select window (Figure 6.52).

Figure 6.50 Deemphasizing the writing with use of the Soft Cloner.

Figure 6.51 Choosing Color Select.

Figure 6.52 The Color Select window.

Figure 6.53 Selecting Auto Select.

3 I clicked OK.

4 Having selected all the orange, I chose the Delete/Backspace key and cleared the orange background.

5 I increased the contrast using Cmd/Ctrl-E (Effects > Tonal Control > Equalize).

6 I chose Select > Auto Select (Figure 6.53). This is an effect that makes a selection on the basis of luminance values (lights and darks) (Figure 6.54). It's a great way to separate black writing from a white background.

7 The Auto Select effect selected just the writing. I copied and pasted this selection into the main collage image.

Figure 6.54 The Auto Select window.

Figure 6.55 Painting on the writing layer.

Figure 6.56 Painting into the layer mask.

8 I moved the writing into position and converted it to a Free transform to get the scale right.

9 I then used the Digital Airbrush to gently paint on the writing (after committing the reference layer to an image layer) (Figure 6.55).

10 I clicked on the Layer Attributes button and renamed the layer, trying to set a good example for you to follow.

11 I created a layer mask and applied black with a soft Digital Airbrush to fade away regions of the writing (Figure 6.56).

Final Blending

My final steps were to blend away a couple of harsh straight edges that I found distracting. I chose the Blenders > Round Blender Brush 30 and applied this gently to the back of the couch behind my Grandparents (bottom left) and also where the edge of the original portrait photo was showing on the upper right (Figure 6.57). At this point I felt the image was complete.

6.4 Gallery

Here are four examples of collages I have created that illustrate some of the same techniques used in this case study.

"Song for Peace" (Figure 6.58), is a portrait of Yitzhak Rabin, the Israeli Prime Minister who was assassinated in 1996. It is a combination of a freehand painting and a collage of symbolic images that relate to Rabin's life and death. After Rabin was assassinated I saw the stark image of the bloodied songsheet that was found in Rabin's breast pocket. It had a bullet hole through it. The song on the sheet was Shir Hashalom, "Song for Peace," a beautiful peace song from the 1960s that Rabin had just joined in singing with the crowd at the peace rally in Tel Aviv immediately before he was killed (see jeremysutton.com/rabin.html for a translation of the lyrics). The bloodied songsheet formed the background on which this portrait collage was built.

Figure 6.59 is a portrait of Jan Sung, owner of the Chinese restaurant Eliza's located in San Francisco's Potrero Hill neighborhood. I wanted to combine the feel of a woodcut in this collage to reflect a connection with the ancient Chinese form of printing.

The mixed media montage in Figure 6.60 was created for the cover of the 2004–2005 Center Arts Brochure of Humboldt University. The artists depicted in the image are singer Angelique Kidjo and dancers Martha Graham (photo by Fang Yi) and Andres Marin (photo by Corinne Moronta). The goal was to create a lively image that spoke of the vitality and diversity of the season's cultural performances.

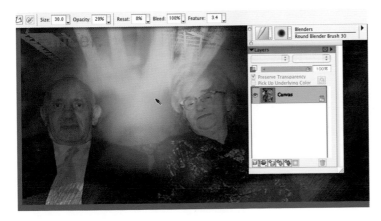

Figure 6.57 Blending away a harsh edge.

Figure 6.58 "Song for Peace."

Figure 6.59 Eliza's.

The collage portrayal of Quinn Delacy Evans in Figure 6.61 was created using a variety of photographs, scanned drawings, and writings that were meaningful to Quinn. The writing in the top left of the picture is what Quinn wrote when I asked her to write down what was important to her in her life.

6.5 Combining Digital and Traditional Collage Techniques

The techniques discussed here are limited to working in the digital environment. Once you have output your collage onto a physical substrate, you can continue your creative journey by applying traditional art materials, tools, and processes and adding further collage elements onto your print. A book that reviews many innovative collage techniques is *Digital Art Studio: Techniques for Combining Inkjet Printing with Traditional Art Materials* by Karin Schminke, Dorothy Simpson Krause, and Bonny Pierce Lhotka (Watson-Guptill; see DigitalAtelier.com).

6.6 Wrap

It's time to start researching images for your collage. Be open to letting your collage go in unexpected directions. Don't be too attached to your initial ideas. This can be an inspiring, educational, and

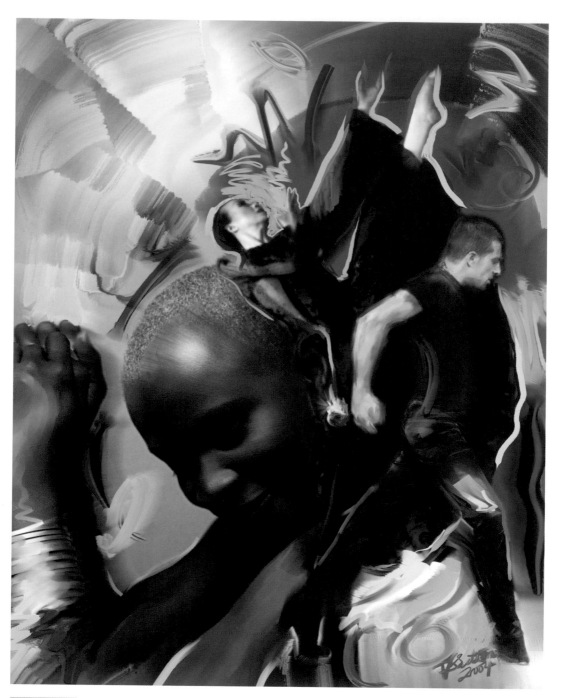

Figure 6.60 Kazaam!

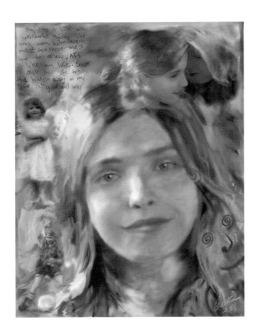

Figure 6.61 Quinn.

emotional journey. As I was putting together the collage of my Dad, I found I felt my grief and sadness at his loss, as well as my joy and appreciation for all the wonderful things he had brought into my world. By the time I completed "love & kisses" I was in tears.

When you have completed your collage, come back to this book and enter the painting phase of the book (Painting Fundamentals followed by Painting Mastery). As I mentioned in this chapter's introduction, collage is painting with images. Everything discussed in the painting section of this handbook will strengthen your skills in creating powerful and beautiful collages. Enjoy the adventure!

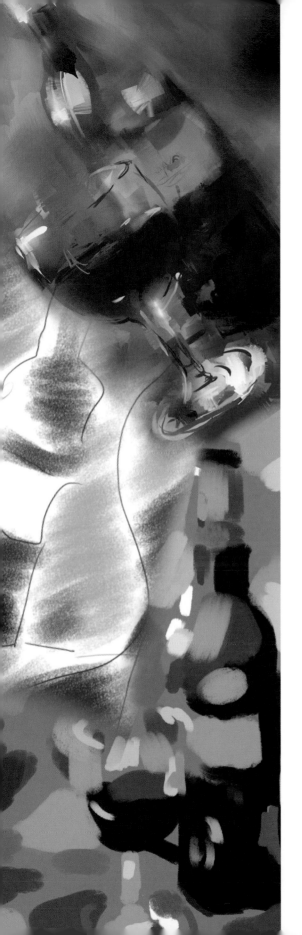

III

Painting Fundamentals

7

Painting Fundamentals I: *Tune In*

I do not literally paint that table, but the emotion it produces upon me.

—*Henri Matisse*

7.1 Introduction

A Personal Approach

In the remaining chapters of this handbook I share my personal approach and philosophy to painting and to making art. These lessons are not intended to replace any formal art training. I recommend learning from diverse sources and teachers. Fine art training with traditional media will be a valuable complement to what you learn in this handbook. To derive the most benefit from these chapters and to help you get the most from your use of Painter, I recommend you follow the chapters and do the exercises in the order they appear.

Painter as Illusionist

Painting is a medium of illusion. Paintings evoke symbols, meaning, and emotion in the viewer's mind, based on his or her experience and background. This applies to all paintings, whether abstract or representational, whether of a still life, a landscape, a figure, or a portrait, and whether based on a photograph or on direct observation of nature. As painters we are illusionists. Pablo Picasso expressed this by saying, "We all know that Art is not truth. Art is a lie that makes us realize truth, at least the truth that is given us to understand. The artist must know the manner whereby to convince others of the truthfulness of his lies." Though we cannot control the preconceptions and experiences of those who view our paintings, we can control the message and meaning we put into our brushstrokes and influence how our illusions, that is, our paintings, are read.

Every Painting Is a Personal Statement

The chapter-opening quote from Matisse makes the point that when he painted a table he was really painting his feelings about that table. He communicated through his brushstrokes not just that this is a representation of a table, but what he felt about that table. There is a story woven into the fabric of a painting that goes beyond just the plain, superficial description of an object. The story can be a feeling, a mood, a sense of suspense, or anger, or love, or attraction or repulsion, or mystery, and so on. Story is meant here in the general context of being some form of a personal statement rather than a narrative. Every painting is a personal statement.

Start by Tuning In

The starting point for painting is not the paint medium. The starting point is tuning in to your subject, observing carefully and without judgment, paying attention to what you see and feel, being aware of what it is you wish to say and express about your subject in your painting. Use all your senses. Experience your subject. A painting reflects the whole relationship between artist and subject. A painting of a subject is as much a painting of the artist as of the subject.

The tuning in process is just as important when working from a photograph as when working from any other source. Taking the time to study your photograph, to become aware of how you feel about it and what you want to say, will make a big difference in the quality of painting you end up creating.

The Goal of Tuning In

The goal of "tuning-in" is to help you go beyond depicting just the physical surface characteristics of color, texture, light, and shade. The goal is to capture the essence of your subject—the soul, character, and personality—at the same time as expressing your own personality in your portraits. These inner qualities make a portrait jump from the canvas. As George Bernard Shaw said, "We use a mirror to see our faces, we use art to see our soul." Art provides us with a window through which we see beyond the surface. Aim to create paintings that move the viewer, that embody emotion and feeling.

Tuning in helps you to depict the spirit as well as the physical form of the subject. Here is an apt quote from the Sumi-e Society Midwest Web site philosophy page (www.silverdragonstudio.com/sumi-e/philos.html) that expresses this in the context of the ancient art of brush painting known as Sumi-e:

The philosophy of Sumi-e is contrast and harmony, expressing simple beauty and elegance. The art of brush painting aims to depict the spirit, rather than the semblance, of the object. In creating a picture the artist must grasp the spirit of the subject.

Tuning in is not simply about accurate observation and awareness, though that is an important part of it. Tuning in is also about entering a creative "zone" or "mode of being" where you become one with your subject and the creative process, where you let go of judgment, and where you listen to and follow your intuitive senses.

Understanding How We See the World

This chapter is about understanding and changing the way we see the world. Rosamund Stone Zander and Benjamin Zander, in their book *The Art of Possibility* (Penguin 2000, ISBN 0-14-200110-4), explain:

Experiments in neuroscience have demonstrated that we reach an understanding of the world in roughly this sequence: first, our senses bring us selective information about what is out there; second, the brain constructs its own simulation of the sensations; and only then, third, do we have our first conscious experience of our milieu. The world comes into our consciousness in the form of a map already drawn, a story already told, a hypothesis, a construction of our own making.

This same point is made by Margaret Livingstone in her book *Vision and Art: The Biology of Seeing* (Abrams 2002, ISBN 0-8109-0406-3): "Vision is information processing, not image transmission. At every stage in vision, neurons perform calculations or operations on their input signals, so that the end result is information about what is out there in the world, and how to act on it—not a picture to be looked at."

The way our mind constructs the world around us affects us as artists interpreting what we see, and expressing how we feel, in our artwork. It also affects the way a viewer responds to our artwork and the meaning they attach to it. By seeing beyond the usual lens with which we see the world, we can express ourselves with greater clarity and power and hence exert greater influence over the viewers' experience of our artwork.

In this chapter we will focus on that invisible yet invaluable part of the painting process: the tuning in that occurs before any brush touches our canvas, when we create a space and openness to carefully observe and experience our subject and identify the story we wish to tell in our painting. Every painting tells its own story.

Representation versus Expression

One of the fundamental decisions we make, either consciously or unconsciously, in creating a painting intended to depict a subject (as opposed to creating a purely abstract artwork) is the degree to which we focus on representing appearance versus expressing emotions. On the one hand, we can represent the appearance of our subject in a literal, illustrative way. Paint can be used to create an impression or illusion of three-dimensional form and can be used to accurately represent a physical likeness. On the other hand, we can express our feelings and impressions of the subject through loose, spontaneous gestures and colors that do not accurately depict the literal appearance of the subject. Such spontaneous paintings often capture the heart and soul of the subject better then photographic realism.

When asked to explain the difference between illustration and nonillustration, painter Francis Bacon answered: "An illustrational form tells you through the intelligence immediately what the form is about, whereas nonillustrational form first works upon sensation and then slowly leaks back into the fact."

Visit your local library, art museums, galleries, and the Web, and start looking at the way different artists approach painting: their use of media, composition, colors, scale, and so on. Is their approach more representational or expressionistic? Make a note of paintings you particularly like or dislike. Think about why you react to them the way you do.

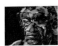

7.2 Tuning-In Process for Creation of the Portrait of Sigifredo

I show here two portraits of the same subject, Sigifredo Cruz (Figures 7.1 and 7.2). Figure 7.1 was created without concern for where it would go or what I wanted to say. With this first portrait I sat my subject down and immediately started painting. I didn't take time to experiment with posing or lighting. It is a sketch based on the outer appearance of my subject. There was no extra attention applied to bringing out character, personality, mood, or sensitivity. There was no goal beyond a basic likeness. Although I could have continued filling in more detail, I chose to stop at this stage, where the basic outlines and contours had been established.

In making the second portrait (Figure 7.2) I took time before starting the painting to look into the eyes of my subject, to become aware of my feelings, to become aware of the qualities I wanted to bring out in my painting. I took time to breathe. I closed my eyes, placed my hands palms down on my tablet, breathed deeply and slowly, and then opened my eyes and just took in what I saw (Figure 7.3). I endeavored to let go of judgment and preconceptions, to just see what was before me. I looked at my subject from different points of view. I looked at the physical forms and the way light and shadows played on the crevices of his face. I looked into his soul, at his 70 years of lifetime experiences that led to who he was at that moment. I looked into the reflection of his ancestors in who he was today. I saw a sensitivity and yet hardness all at the same time. His eyes were deep set and vulnerable. Our communication was just visual—he didn't speak English and I didn't speak Spanish (Sigifredo was from Machu Picchu, Peru). At one moment he turned his head to look out the window and that was it—I knew immediately that was the expression and lighting and look I wanted to capture (Figure 7.4).

From that moment everything flowed. The result, as you can see, was significantly more powerful than the first portrait. The difference was the time put into tuning in to my subject before the second painting began and the amount of time spent on the painting itself. I spent more time on the second portrait as a direct result of the tuning-in process since it set me on a directed, purposeful, motivated path.

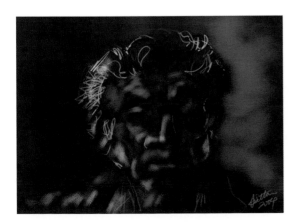

Figure 7.1 Portrait of Sigifredo without tuning in.

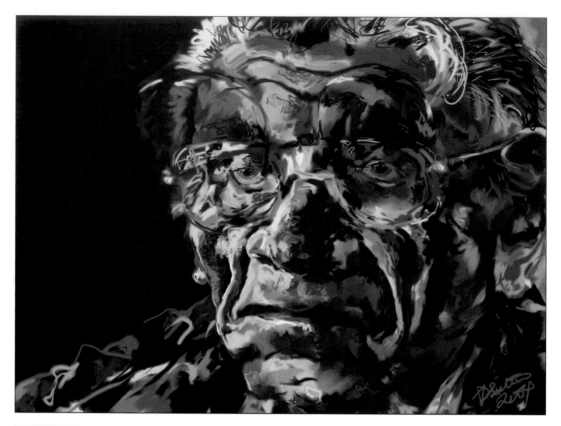

Figure 7.2 Portrait of Sigifredo with tuning in.

Figure 7.3 Sigifredo being painted.

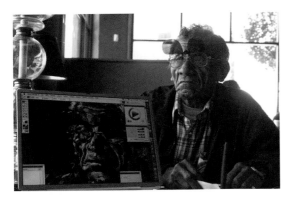

Figure 7.4 Drawn in by the character of his face.

The point of sharing this case study of my portraits of Sigifredo is to encourage you to take the time, before painting, to carefully observe your subject and pay attention to what you want to say.

7.3 Tools for Tuning In Applied to Wine Still Life

The Power of Unfamiliarity

A key tool to tuning in is seeing your subject from different points of view. Like picking up different wavelengths on the radio, we can tune in to different points of view, different ways of looking at and perceiving our subject. One powerful point of view is that of unfamiliarity. Familiarity is the habit of seeing what we "know" is there, which is our natural way of seeing the world, rather than seeing what is there. In painting we have to pay attention to the world around us, see beyond our habit, see beyond our assumptions and labeling. We have to let go of familiarity. This is expressed eloquently by Paul Siudzinski in his book *Sumi-e: A Meditation in Ink* (Drake, 1978): "Paying attention means to 'see' something and not know what it is." Siudzinski has two exercises you can try out to help with this:

Paradox 1: Look around you at this moment and see what you are not paying attention to.

Paradox 2: Look at something without knowing its name.

Try out these exercises when you are about to paint a subject. If you are painting a portrait, look at the face as a sculptural object—observe the qualities of its surface, the way light plays on its forms. Look at your subject as an abstract. Half close your eyes and cut out detail—see what stands out, what you notice.

An excellent book for learning the power of unfamiliarity, of seeing the world afresh, is the Betty Edwards' classic tome *Drawing on the Right Side of the Brain* (Tarcher, 1979), packed full of great drawing exercises you can try out using Painter. As Edwards explains in her book, our brain has two modes or ways of seeing, one of which allows us to draw a better representation of what we see on

a flat canvas than the other. When I am painting I am constantly going between being familiar and being unfamiliar with my subject. When I am aware that I am back in "familiar-land," I make an effort to distance myself from habitual seeing and look with a fresh, "unfamiliar" eye.

Here are some exercises to help you become unfamiliar with familiar objects. I suggest for these series of exercises, as well as for all the remaining exercises in the Painting Fundamentals and Painting Mastery parts of this book, that you apply the exercises to the following four different types of subjects:

1 Yourself from direct observation (without use of photography)—creating a series of self-portraits using a mirror

2 A subject you observe directly (without use of photography)—the subject could be a person, an object, a still life arrangement of objects, a buildingscape or a landscape

3 A printed photograph you look at as visual reference

4 A digitized photograph you use as visual reference within Painter using Tracing Paper and cloning brushes where appropriate

Each of these types of subjects will offer its own set of challenges and opportunities and thus will broaden your learning experience.

Do the Opposite: Paint a "No Tune In" Painting

What you resist persists. If you are holding on to a way of drawing or of looking at the world, then embrace it rather than fight it. Purposely make a quick drawing of your subject where you look at it on the most superficial level possible.

1 Choose a subject. I set up a simple still life of a wine bottle with a glass of wine next to it as an example for this exercise (Figure 7.5).

2 Open a canvas in Painter. I opened a canvas that was 7 inches wide by 9 inches high at 150 ppi (1050 by 1350 pixels).

3 Choose a midtone background color. I chose a light yellow-orange.

4 Choose Cmd/Ctrl-F (Effects > Fill) and fill your canvas with the chosen background color.

5 Choose File > Save As. Save and name your file.

6 Choose Cmd/Ctrl-M and mount your canvas.

7 Choose Sumi-e > Coarse Bristle Sumi-e.

8 In the Brush Controls Size Palette or the Property Bar, reduce the brush size to a few pixels.

9 Choose a dark color. Make some test brushstrokes on your canvas. You want a fairly thin, well-controlled line. You could use many other different brushes for this.

10 Create a simple line drawing in which you draw first one object and then another. I drew first the wine glass and then the bottle and then added in some lines indicating the background (Figure 7.6). Don't worry about shading and detail. Also don't worry about making

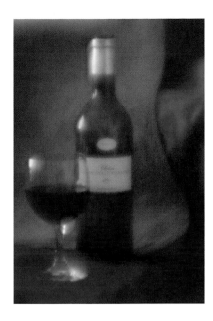

Figure 7.5 Still life arrangement.

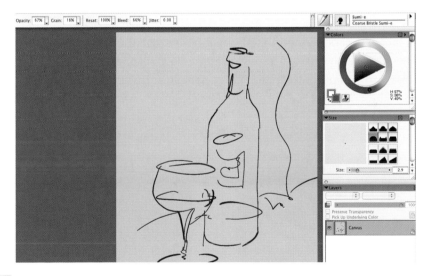

Figure 7.6 "No tune in" sketch.

a beautiful picture. The idea here is just to get used to purposely drawing a "no vision" drawing, where you don't think beyond the superficial qualities of your subject.

Tonal Statements

Tone, or value, refers to lightness and darkness. The concept here is to look at your subject with half-closed eyes and see it in terms of blocks of light and dark tone. Start off depicting the lightest and darkest regions (first tonal statement), and then work your way toward greater definition of tone

(introducing more levels of gray), building up a series of tonal "statements," each one with more information than the previous ones.

1 Open a new canvas in Painter the same size as the one you used for the previous exercise.

2 Choose a midtone gray color by placing the Saturation-Value triangle cursor on the far left (zero saturation) and halfway up (mid-gray).

3 Choose Cmd/Ctrl-F (Effects > Fill) and fill your canvas with the mid-gray background color.

4 Choose File > Save As. Save and name your file.

5 Choose Cmd/Ctrl-M and mount your canvas.

6 Choose Oil Pastels > Chunky Oil Pastel 30. You could use many other different brushes for this.

7 Choose black as the current color.

8 Paint the darkest regions (Figure 7.7). Treat your subject as part of an abstract. Don't worry about depicting an object, subject, or likeness.

9 Now choose white as the current color.

10 Paint the lightest regions. This is your first "statement" (Figure 7.8). Save this version with an appropriate descriptive name (for instance, tonal-01.rif).

11 Choose a medium-dark gray and fill in the intermediate dark tonal regions. Do the same for the medium-light regions. This will produce your second statement (Figure 7.9). Save this version with an appropriate descriptive name (for instance, tonal-02.rif).

Figure 7.7 Depict darkest tonal regions.

Figure 7.8 First statement, depicting the darkest and lightest tonal regions.

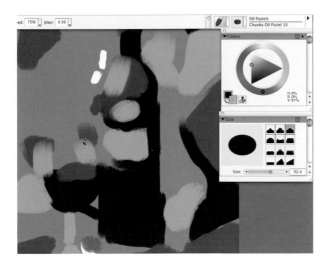

Figure 7.9 Second statement, with medium tones.

Figure 7.10 Tonal region sketch.

12 Continue this process, gradually adding more levels of tone, saving stages as you the image develops (Figure 7.10). Keep focused on the relative tonal values of adjacent regions in your painting, not on whether the picture looks "right."

This exercise is challenging for the untrained eye since it requires translating the multicolored world we see into a tonal one. When we see colored objects and reflective surfaces, shadows on light-colored surfaces, and highlights on dark-colored surfaces, it can get confusing. However, the skill of being able to see the world in relative tonal values is key to being able to master the art of depicting the world when we paint. As you will see in Chapter 11, on color, no matter what colors you choose to use in a painting, it is always critical to get the relative tonal values in your painting accurate.

Value and Depth Perception

Luminance, the quality of light known to artists as value or tone, is perceived lightness. The luminance of light of a certain color is influenced by both the intensity of the light (how many photons are striking our retina) and how sensitive our eyes are to that particular wavelength (corresponding to the color, or hue) of light. The part of our visual information processing system that leads to our perception of depth responds only to luminance and is insensitive to color. Thus, as artists endeavoring to create a sensation of three-dimensionality in our two-dimensional paintings, we have to train our vision to become sensitive to luminance independent of color. By doing so we can then paint shading that effectively evokes the sensation of three-dimensionality.

For more information on this topic see Margaret Livingstone's book *Vision and Art: The Biology of Seeing* (Abrams 2002, ISBN 0-8109-0406-31).

Shape Statements

Related to the tonal statements exercise, this exercise involves looking at our subject in terms of basic shapes: ovals, rectangles, and triangles. In a similar manner to the developing tonal statements, start with large basic shapes and create a shapes first statement. Then introduce smaller shapes, building up a series of more detailed shape statements.

1 Open a new canvas in Painter the same size as the one you used for the previous exercise. Leave the canvas white.

2 Choose File > Save As. Save and name your file (use a descriptive name like shapestmnt-01.rif).

3 Choose Cmd/Ctrl-M and mount your canvas.

4 Choose Felt Pens > Thick n Thin Marker 20. You could use many other different brushes for this.

5 Choose black as the current color.

6 Sketch the main shapes you see in your composition. This is your first shape statement (Figure 7.11).

7 After saving the file, reduce the size of your brush and sketch out smaller shapes (Figure 7.12).

8 Further reduce your brush size and continue the process to create your third shape statement (Figure 7.13).

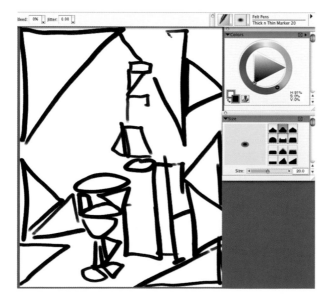

Figure 7.11 First shape statement.

Figure 7.12 Second shape statement.

Figure 7.13 Third shape statement.

Using Layers

It can be interesting to create the tonal and shape statements using layers, adding each stage of development as a new layer. To do so you select New Layer from the Layers palette pop-up menu. When using a brush with a Buildup method in the Brush Controls General palette, like the Thick n Thin Marker, the new layer is automatically in Gel Composite Method. Double-click on the layer name in the Layers palette and rename the layer with an appropriately

Figure 7.14 Using layers for each shape statement.

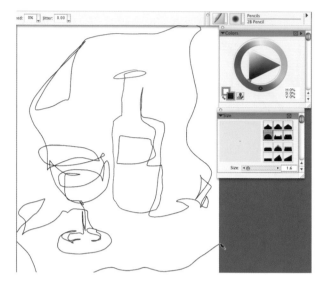

Figure 7.15 Single-line contour drawing.

descriptive name. When you have completed one statement you then create a new layer and start painting the next level of detail into that new layer, making sure to rename every layer as you do so (Figure 7.14).

You can conveniently turn on and off the layer visibility using the "eye" icon and thus compare different stages. You could even combine the tonal and shape statements and work beneath the shapes with color. There are a lot of creative possibilities.

Taking a Line for a Walk

Swiss artist Paul Klee said, "Drawing is nothing more than taking a line for a walk." In these exercises we do exactly that.

1. Open a new canvas in Painter the same size as the one you used for the previous exercises. Leave the canvas white.

2. Choose File > Save As. Save and name your file (use a descriptive name like singleline-01.rif).

3. Choose Cmd/Ctrl-M and mount your canvas.

4. Choose Pencils > 2B Pencil. You could use many other different brushes for this.

5. Choose black as the current color.

6. Make a drawing of your subject with a single line, following as much as you can the lines of the main forms in your composition. Do not take your stylus off your tablet at all for the entire duration of this exercise. Your line may leave and re-enter the canvas, but don't lift your stylus from the tablet until you have completed your drawing (Figure 7.15).

7 Choose File > Save As. Save your drawing (for instance, singleline-02.rif).

8 Open a new canvas in Painter the same size as the one you just used. Leave the canvas white.

9 Choose Calligraphy > Dry Ink.

10 Create a quick gesture drawing with just a few dynamic brushstrokes that follow the movement and flow of your composition rather than the outlines of the forms (Figure 7.16).

11 Choose File > Save As. Save your drawing with an appropriate descriptive name (for instance, gesture.rif). Repeat a few quick gesture drawings.

12 Open a new canvas in Painter the same size as the one you just used. Leave the canvas white.

13 Choose Pens > Scratchboard Tool.

14 Keep your eyes on your subject and make a sketch of your subject, with your eyes following the outlines of the forms and without looking at your screen. This is known as a blind contour drawing (Figure 7.17). (You may find it useful to initially "calibrate" your feel to where the edge of your canvas is on the tablet by moving your stylus around and looking at the screen.)

15 Choose File > Save As. Save your drawing with an appropriate descriptive name (for instance, blndcntr.rif).

16 Open a new canvas in Painter the same size as the one you just used. Leave the canvas white and keep using the Scratchboard Tool.

17 Swap your stylus from your favored hand to your nonfavored hand.

18 Draw your subject using your nonfavored hand (Figure 7.18).

Figure 7.16 Gesture drawing.

Figure 7.17 Blind contour drawing.

Figure 7.18 Drawing with your nonfavored hand.

19 Choose File > Save As. Save your drawing with an appropriate descriptive name (for instance, nonfvrdhand.rif).

Exercising Your Creative Muscles

The exercises described here may not be easy the first time you try them, especially if you are not in the habit of drawing. Part of the challenge is just getting over the fear of making a mess. Don't worry what your sketches look like. These exercises are more about learning different ways of seeing than about what actually ends up on your canvas. Treat them as loosening-up exercises, rather like an

athlete will go through a series of warm-up movements prior to a race. In this case you are exercising your creative muscles rather than your physical muscles.

Listen to Your Intuition

By relaxing, breathing, being still, observing carefully, detaching ourselves from the busy chatter of everyday judgment and assumptions, we open ourselves to listening to our intuition. This is an important step in the creative process. The intuitive voice we all have is our guide during painting, helping us decide what brush to use, what color to apply where, when to stop, and so on. This tuning-in process is as much about accessing our intuitive nature as it is about external observation.

Identify Your Story

Look at your subject and identify what it is you wish to say in your painting. What mood do you want to convey? What emotion do you wish to evoke? In the case of the still life the mood and atmosphere is one of mystery (who is going to drink the wine?) and of luxuriousness (rich colors, sense of leisure and indulgence).

Identify Your Main Focal Point

Decide where you are going to lead the viewer's eye. What is your main focal point? What do you want to jump out? If unsure, try different ideas in your mind and see which feels best. I wanted the highlights and reflections in the wine glass and the poured wine to be the main focal point, with the wine bottle secondary.

Compose Your Picture

Visualize the composition of your picture. Choose the relative proportion and placement of your subject with respect to the background and the edge of the canvas. Where are you going to crop the subject? How large will the subject be relative to the boundaries of the canvas and the background? Where will your main lines, shadows, and highlights be? Are you going to paint on a tall, narrow canvas (portrait orientation) or a short, wide canvas (landscape orientation)? How are you going to use the border of the composition to add dynamism and strength to the picture? Dramatic cropping, and the use of some elements within the picture that frame the portrait, can help bring the viewer's eyes back into the central focal point of the picture. How are you going to position the subject in the canvas? Centrally or off to one side? If a portrait, is your subject looking straight out of the canvas or at an angle? The eye naturally likes a little asymmetry in a composition. Try placing the subject

Figure 7.19 Initial line compositional thumbnail.

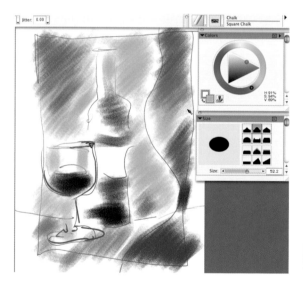

Figure 7.20 Color and line compositional thumbnail.

off-center or cropping the composition so there are interesting shapes cut between the subject and the edge of the canvas (creative use of positive and negative space).

You may choose to leave large portions of your canvas as free space, breathing space for the brushstrokes you paint. This is a compositional choice. Treat the subject, background, and border with awareness to the effect of one on the other. Don't be afraid to exaggerate, go to extremes. Be bold.

Seek balance in your composition. The eye naturally likes balance in a composition. Balance is not the same as symmetry. Balance relates to the distribution of contrasts such as lights and darks, small and big forms, and so on. Stand back and look at your subject through half-closed eyes and

picture your composition. Ask yourself if anything jumps out. If it does, did you intend it to? If not, how can you improve the composition?

Create a simple compositional thumbnail by sketching out the main outlines (Figure 7.19) and blocks of color and tone (Figure 7.20).

7.4 Wrap

Once you have tuned in to your subject, identified what you wish to communicate; decided you we wish to focus attention, and planned your composition, the remainder of the creative process unfolds naturally from that foundation. Paradoxically, once you have set your goal for where you want your painting to go, you can let go of that goal and flow with the process. The acting of tuning in and setting a goal has already created a pathway. Now you just need to be open to following where it leads you.

8

Painting Fundamentals II: 'Muck Up'

I like to sully the paper, to get into it and make a bit of a mess and get going.

—Jim Dines

8.1 Introduction

The 'Muck Up' Approach to Making Art

Having tuned in to your subject and decided what it is you wish to convey in your painting, the next stage is to set up your ground color and then create a *muck up* under-painting on which you will add selective detail. What I share here is just one of many approaches to making art. There is no best approach, only different approaches. Another approach is to initially map out your composition carefully and precisely using guidelines and light pencil work and then to fill in tonal blocks and add color and detail. My approach is to start rough and messy and then selectively introduce detail and precision into the mess. *Muck up* is an English term meaning to "make a mess of something." It sums up the spirit of this initial stage of my painting process, which is about letting go of attachment to perfection and detail. The 'muck up' stage is not aimless chaos but purposeful mess. This is where the tuning in preparation plays an important role. Your tuning in shapes how the 'muck up' unfolds. Your 'muck up' brushstrokes, even though large and rough, still have purpose.

Benefits of Mucking Up

There are five specific benefits of mucking up.

1 The 'muck up' approach makes it easy to start. It is a great way to overcome any fear of the blank canvas and hesitancy over how to begin.

2 The letting go of perfection and attachment to detail frees you up. You don't have to worry about getting it right or looking good. This liberates your brushstroke to be loose and fluid.

3 The spontaneous, lively, gestural nature of muck up brushstrokes captures flow, energy, emotion, movement, and dynamism more powerfully and deeply than tighter, smaller, more precise brushstrokes. Your 'muck up' stage forms a dynamic under-painting on which to build selective detail. The overall energy, pizzazz, and impact of your final painting is profoundly influenced by the 'muck up' stage.

4 The diffuse, unfocused quality of the 'muck up' parallels the dramatic drop-off in the acuity (sharpness or resolution) of our vision away from the center of our gaze. When we gaze at an object, only a small area in the center of our gaze is in sharp focus; the rest of our visual field is significantly out of focus. Margaret Livingston explains this in her book *Vision and Art: The Biology*

of Seeing (Abramr 2002, ISBN 0-8109-0406-3): "We have a surprisingly low visual acuity (resolution) in parts of our visual field that are not at the center of where we are looking—the center of gaze. We are not aware of this because we usually move our center of gaze to whatever we want to look at." By starting off our painting with the 'muck up', we are representing the majority of our visual field, which is out of focus.

5 The 'muck up' is an easily accessible way to create your first tonal and color statement, setting out the main blocks of lights and darks and the main color regions.

The 'Muck Up' Concept is Widely Applicable

You will find that you can apply the 'muck up' approach described here to many facets of life, including your approach to other expressive and creative endeavors, such as writing, singing, and dancing. The key thing to bear in mind is that you don't have to get it right immediately. By letting go of that constraint, you free yourself to flow with your creative intuition.

8.2 Preparing Your Canvas

Canvas Size

Just as in traditional painting, we first need to prepare our canvas prior to applying any paint. The principle for setting up your canvas is to start with the end in mind. Think through how large you may wish to print the final image and what resolution you would need. Then work backwards from there to determine how large your canvas should be in Painter. This is not an exact science. There is plenty of wiggle room. You do not have to be limited to the size you start with; it is just a good idea to bear the end result you have in mind as a factor. In the case of my Sigifredo portrait (shown in the last chapter) I created a blank canvas that was 16 inches by 12 inches at 150 ppi (Figure 8.1).

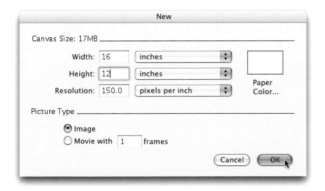

Figure 8.1 New canvas window.

Choosing Your Ground Color

By choosing a mid-tone color to fill your canvas you create a "ground," or "base," on which to paint that can show both shadows and highlights. It gives you a neutral surface to work into and contrast with. The default white canvas, on the other hand, drowns out any highlights and generally creates too much distracting contrast. Pure white and pure black tend to 'shout out' in a painting. Historically, traditional painters have used a variety of mid-tone ground colors, such as burnt umber (a warm, dark yellow-brown), burnt sienna (a warm, light yellow-brown), and yellow ochre (a pale yellow-orange).

Using the Ground Colors Color Set

I have included the traditional ground colors mentioned here in the "Ground Colors" color set that you'll find on the Resource CD that comes with this handbook. To load this color set:

1 Copy the "Jeremy Choice Color Sets" into your Painter IX application folder.

2 Within Painter, choose Open Color Set from the Color Sets palette pop-up menu.

3 Select the "Ground Colors" color set from within the "Jeremy Choice Color Sets" folder (Figure 8.2).

In choosing a color, I consider whether I want an underlying warm or cool feel to the painting and what colors I want to pick up in the subject. In the case of Sigifredo I chose a pale, somewhat desaturated yellow-brown, keeping an over all warm feel to the painting. In the case of the wine still life I chose a teal blue that was the analogous complement (opposite and slightly to one side on the color wheel) of the orange and purple background cloths. Choosing teal would bring vibrancy to the picture by creating a vivid contrast with the orange and purple brushstrokes.

Figure 8.2 The "Ground Colors" color set.

Adding Texture to Your Ground Color

You can easily apply a paper texture to your ground color with either Effects > Surface Control Apply Texture or Effects > Surface Control > Dye Concentration (which I prefer), both with Using: Paper. In the case of the Sigifredo portrait I decided not to add any paper texture. I knew I would be printing on a textured substrate in any case.

8.3 The 'Muck Up'

Choose a Good 'Muck Up' Brush

A good 'muck up' brush is fairly large and can make long strokes. It is also useful if it is responsive to your stylus movement (some memory-intensive brushes tend to lag behind the cursor), has some blending/smearing quality to it, and has some structure within the brushstroke. You can use almost any brush that paints color as a 'muck up' brush, with appropriate adjustment of the brush size. In Chapter 4 you'll see the Chalks > Square Chalk used as a 'muck up' brush for the Lindsay portrait. A popular 'muck up' brush from my Jeremy Faves 2.0 category is Den's Oil Funky Chunky. In the Sigifredo portrait I started experimenting with a few different brushes and settled on the Jeremy Faves 2.0> JS SumiPollock Splash brush (Figure 8.3).

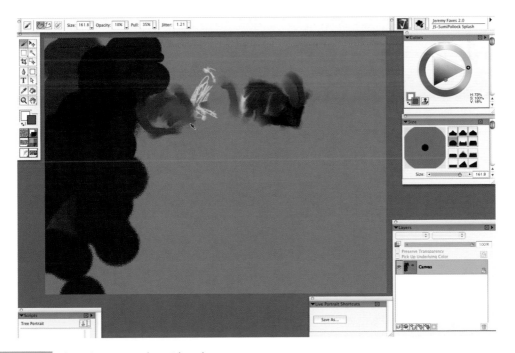

Figure 8.3 Choosing a 'muck up' brush.

'Muck Up' Goal

You goal in mucking up is to completely cover the canvas with big, rough, bold brushstrokes (though it's ok if a little ground color shows through here and there). Use your brushstrokes to map out the most basic forms, tones, colors, and movement within your composition. Don't get attached to detail.

Mucking Up Photographs

If you working from a photograph, make a clone copy of your photo first (File > Clone) and work on the clone copy. Fill your clone copy with a ground color. Use either a brush with clone color or a brush with your own color and just use Tracing Paper as a visual reference, or try a combination of the two.

Visit the Student Gallery at the end of Chapter 4 to see examples of different 'muck up's.

Make Marks Fearlessly

We all draw as children. Sometimes we just have to rekindle our former skills of making marks fearlessly. Artist and educator Howard Ikemoto tells this story: "When my daughter was about 7 years old, she asked me one day what I did at work. I told her I worked at the college—that my job was to teach people how to draw. She stared back at me, incredulous, and said, 'You mean they forget?'"

In creating the 'muck up' we need to get back to the freedom of brushstroke we had as a child. Get the paint down on the canvas. Be rough. Follow the flow of the composition, but don't get attached to, or distracted by, any details. Work quickly and boldly, with big, thick brushstrokes. Start working all over the canvas, not spending too much time in any one place. Don't be timid! Cover your whole canvas with paint. Work with bold blocks and regions of color rather than lines and contours. Use the 'muck up' stage to experiment with contrasts in the composition. You can even employ some of the exercises from earlier, such as the tone and shape statements, to help you work into the canvas.

Be Committed to Your Brushstrokes

Don't undo. Be committed to every mark you make. The history of your canvas, with the buildup of overlapping brushstrokes, is what adds richness and depth to your painting. Avoid the temptation to undo 'mistakes.' If something looks wrong, paint over it or blend it or smear it. Integrate everything

into the structure of your painting. 'Mistakes' are gifts from heaven—they often result in taking your painting in the most interesting directions.

Depict Lights and Darks Continuously

As you paint, no matter what color you choose and which brush you apply, use every mark to depict the relative tonal values (lights and darks) you observe. Use the Painter Color Picker Value-Saturation Triangle to control value. Bear in mind that some colors, such as blues, are naturally darker in tonal value than others, such as yellows. The tones are the foundations of your painting. To check on relative tonal values, half-close your eyes and look back and forth between your subject and your painting. Compare the lights and darks. You can also temporarily choose Effects > Tonal Control > Adjust Colors (Figure 8.4) and reduce the Saturation slider to the minimum (−139%) (Figure 8.5).

Click OK. This will make your painting look like a grayscale painting (Figure 8.6). By looking at your painting as a grayscale image you will see what needs adjusting with regard to tone in the next phase of your painting process as you refine and focus your image. After you've viewed your image as a grayscale in this way, choose Cmd/Ctrl-Z to return to full color. It's useful to do this every now and then during your painting process. A painting can be forgiving of wild color choices but less forgiving of incorrect tonal values.

When Is Your 'Muck Up' Finished?

There are varying degrees of 'muck up'. On one end of the scale is the timid 'muck up', where you can still clearly make out the envisaged composition (or, in the case of a photograph, where you can clearly make out the original photograph). On the other end of the scale is the bold 'muck up', where someone seeing the 'muck up' without having seen your subject (or the original photograph) could not figure out what it is. A bold 'muck up' often makes a great abstract painting in its own right. In the case of the Sigifredo portrait I made what would call a *medium 'muck up'* (Figure 8.7).

Figure 8.4 Choosing Adjust Colors.

Figure 8.5 The Adjust Colors window.

Figure 8.6 The 'muck up' as a grayscale picture to check tonal values.

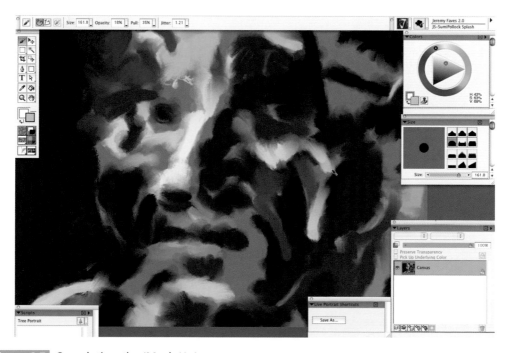

Figure 8.7 Completing the 'Muck Up'.

I used the 'muck up' stage of Sigifredo to carve out the main forms and establish the proportions and placement of my subject on the canvas (like a large compositional thumbnail). I recommend that when you first use the 'muck up' technique, you go for bold, not medium or timid. The natural tendency of most people is to be scared of making their 'muck up's too bold, so it is a good idea to over-compensate initially and make it bolder than you might otherwise do.

Save Your 'Muck Up'

No matter what you are doing in Painter, save versions of your file regularly (using the File > Save As or File > Iterative Save commands) (Figure 8.8). When you complete your 'muck up', make sure you save a version of your image in which you add the word *muck* after the version number. Only add the word to this one version (otherwise it renders it useless since if you have many versions with the word *muck*, you don't know which was the most mucked-up stage).

Figure 8.9 is an example of the wine still life 'muck up' stage, created over a teal ground color with a mixture of JeremyFaves > Den's Oil Funky Chunky and Artists > Sargent Brush.

Figure 8.8 Saving the 'muck up'.

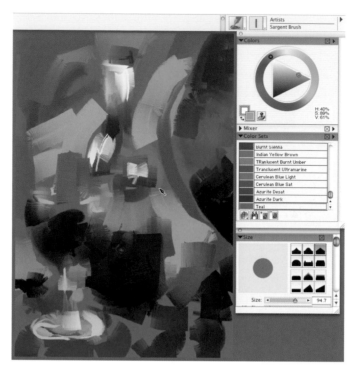

Figure 8.9 Wine still life 'muck up'.

8.4 Wrap

Experiment with the 'muck up' technique. See how it helps you break through into a new way of expressing yourself on the digital canvas. Once completed, the 'muck up' stage is a great platform from which to launch into selective detail and bring out the features and focal point of your subject, which you shall explore in the next chapter. The energy of your 'muck up' will be present in everything else you do in your painting.

9

Painting Fundamentals III: *Refine and Focus*

You may not always succeed, but attempt to produce the greatest effect in the viewer's mind by the least number of things onscreen. Why? Because you want to do only what is necessary to engage the imagination of the audience. Suggestion is always more effective than exposition. Past a certain point, the more effort you put into wealth of detail, the more you encourage the audience to become spectators rather than participants.

—*Walter Murch*

9.1 Introduction

Having created a dynamic 'muck up' underpainting, our next task is to refine our image and define our focus. After refining the tonal contrasts to sculpt the forms, we then selectively apply detail and contrasts to lead the viewer's eyes to our main focal point. It is as is if we are adjusting the focus of a magical painting camera lens, one in which we have complete control over what is and isn't in focus and where the viewer's eye is led. This is the stage where we define critical contours and contrasts, add focal point detail, and apply the highlights. The power of our painting to draw a viewer in is shaped by our choice of what we emphasize and deemphasize through selective detail and contrast.

Before sharing the case studies, we will first review some fundamental art principles that will help you refine and focus your painting.

9.2 Fundamental Art Principles

Yin Yang: The Harmonious Balance of Opposites

The ancient Chinese dualistic philosophy of yin and yang is a way of explaining our world in terms of a balance of opposites. All entities include their opposite as part of their nature. Two things that are against each other also support each other in a balanced relationship. . . . Good paintings always exude an energy that flows from a harmonious balance of contrasts. Opposites pull and push, and the successful artist learns to control them to his or her advantage.

—*Hongnian Zhang and Lois Woolley, The Yin/Yang of Painting*
(Watson-Guptill, 2000, ISBN 0-8230-5983-9)

Strive for balance and harmony in your painting while you selectively use opposing contrasts to lead a viewer's eyes around your painting and to add life, movement, and form to your work. Work with opposites, determining a balance in your picture between opposing and contrasting qualities. Sharper boundaries between opposing contrasting regions can increase their dramatic effect. I sometimes

finish off a portrait with a little Photo > Burn and Dodge to bring out light–dark and intense–dull contrasts in the areas of the picture I wish to draw attention to.

Contrasts

There are many examples of opposing contrasts that you can use in your paintings. Here is a summary of the visual qualities and the pairs of opposing contrasts associated with those qualities.

Quality	Opposing Contrasts
Detail	Detailed–rough
Value	Light–dark (chiaroscuro)
Paint application	Light–heavy
Paint opacity	Transparent–opaque
Paint thickness	Thick–thin
Brushstroke width	Broad–narrow
Boundaries and edges	Sharp–diffuse
Pressure	Soft–hard
Spaces and shapes	Positive–negative
Orderliness	Chaos–order
Color loudness	Loud–quiet
Busyness	Busy–uncluttered
Smoothness of edges	Smooth–rough
Feature size	Large–small
Surface area	Much–little
Vertical stature	High–low
Movement	Rest–motion
Color temperature	Cold–warm
Color intensity	Intense–dull
Paint purity	Pure–diluted
Line direction	Perpendicular lines, horizontals/verticals, diagonals
Paint texture	Textured–flat
Color complements	Pairs of colors from opposite sides of the color wheel

Each of the opposing contrast pairs listed here can form the basis for an exercise in which you use that one contrast pair to bring out your main focal point.

Physiological Basis for the Power of Contrast

There is a physiological basis for why opposing contrasts draw our attention. "Many visual perceptions, such as luminance, color, motion, and depth, exhibit greater sensitivity to abrupt

than to gradual change," explains Margaret Livingstone in her book *Vision and Art: The Biology of Seeing* (Abrams 2002, ISBN 0-8109-0406-3). Livingstone goes on to explain that in the first stage of visual information processing, center/surround cells are stimulated by light falling on a small part of the retina and suppressed by light falling on the surrounding region. This center/surround organization leads to sensitivity to abrupt changes and discontinuities in luminance and color. There are also other levels of sensitivity built into our visual information processing that lead to sensitivity to contours or edges of a particular orientation and to extended contours. All of this results in our perception and sensitivity to contrasts that we can use as a tool in painting.

Imaginary "Yin Yang Sliders"

Think of these opposing contrast pairs in terms of a series of imaginary "Yin Yang sliders" that you have at your fingertips. At every point on your canvas you can adjust the imaginary "slider" corresponding to any of these opposing contrasts, pushing your paint toward one contrast extreme or its opposite or leaving it in the middle. To draw attention to a point, juxtapose a region with the "slider" at one extreme next to another region with the "slider" at the other extreme, for instance, contrasting a very light area next to a very dark area, with a sharp boundary. Where you don't want to draw attention, such as the background, adjacent areas may have similar moderate "slider" values and soft, diffuse boundaries with gradual changes in color and tone.

Attention Grabbers

Besides the contrasts, the following attention grabbers will also draw the viewer's eye:

Highly saturated (intense) colors

Bright reds, yellows, and greens

Strong rightward-leaning diagonals

Strong verticals

Perfect straight lines

Forms that break the pattern or rhythm

Coincidences (such as when there is an object in the background that appears to be sitting on someone's head or a finger appears to touch something that's far away in the background)

All of the examples of attention grabbers listed here exhibit a quality known as *salience* or *conspicuousness*. These are tools for the artist. Be aware of these and use them appropriately.

Work Toward Selective Detail

An example of selective contrast is the use of selective detail. Identify the areas of the image you want to bring attention to and then work in greater detail in those areas. The viewer does not need to be

overwhelmed with precise detail. Leave something to the imagination. As the chapter-opening quote from Walter Murch says, encourage viewers to be participants rather than spectators. Don't create the same amount of detail everywhere. Be selective about where you zoom in, and spend more time with smaller brushes and more variety of brush marks, working in greater detail and making features sharper and more precise. Zoom out periodically to see the effect you are having. Think of your painting as a snapshot taken at a very short focal length so that most of the picture is out of focus and only selected parts are in focus. You can exaggerate this effect to bring more attention to your focal point.

Use the Full Dynamic Range of Brushstrokes

Treat the full dynamic range of your brushstrokes, from soft diffuse to sharp linear, from short dabs to long, flowing brushstrokes, like the imaginary "slider" concept—know when to use the extremes and when to stay in the middle. Make sure you are aware of the full dynamic range of what is possible. Do your brush research before or during your painting.

Create Movement

The viewer's eye is naturally led along the boundary between two strongly contrasting regions and along a strong linear form, such as a bold line or the edge of a shape. Use this effect to create movement in your composition. Lead the viewer's eye back to your focal points. Imagine a racetrack with curves that lead you back to where you started. Create lines and curves in your compositions that do the same. Bear in mind that people react differently to lines in different directions. Diagonals leading upward toward the right tend to feel more positive than diagonals leading downward to the right.

Use Rhythm and Repetition

The eye naturally likes some rhythm and repetition, although not overdone. A good guide when applying color to an image is to add it in about five places around the canvas, even if it is only a small amount here or there. The more evenly spaced the dabs, the more rhythmic the effect (like beats in music). An odd number of dabs or similar image elements seems to work better than an even number. You can experiment with this concept. By placing similar colors around the canvas, you build up a subconscious visual resonance. When I work in the eyes I often pick up colors from all over the painting and add traces of those colors in the irises.

Intermittently Critique

Regularly stop painting, step back, and look at your picture as if seeing it for the first time. One of the advantages of working on the computer is that you can easily zoom out and see a small version of

your image on the screen. Do this from time to time. Looking at a small version of your image is equivalent to an artist's stepping back from a canvas to get an objective over view of the image. When looking at your image, ask yourself the following questions.

What do I like and dislike about it?

What works and doesn't work?

Where is my eye led?

Is there a natural focal point?

What feelings or emotions does it evoke?

Is there any quality about it I'd like to remember when I paint a portrait?

If you see something that sticks out and looks wrong, ask yourself what's not working, what could make the portrait better. Run through the following checklist of questions.

Is the shape working?

Are the lines working?

Is the composition balanced?

Is the coloring working?

Is the lighting working?

Are the details and contrast working?

Make a point of looking at paintings in galleries and books, on the Web, on billboards, anywhere and asking these same questions. Train your critical faculties.

Go for Extremes

Don't be shy! Go for the extremes. As in the theater, if you are going to make a gesture, make it big! Test the limits of your tools. You can always edit and scale back later. If you edit yourself as you paint, you contain and limit your creativity rather than express it.

Go for Emotion

Emotion trumps all! If there's a choice between making cruder marks that express and evoke emotion and applying carefully controlled marks that may accurately depict the physical likeness of a subject but flatten the emotions, go for the cruder marks. Emotion is key.

Tweak Until Your Picture Lights Up

Something I always tell my kids, great films have as many flaws and bad things about them as bad films. I could take you through Citizen Kane or any number of films and just point out all the flaws and give notes

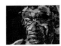

on all that's wrong with them. The difference is the good films light up, the illusion works, so when you see them you're not looking at the flaws. What it tells me when someone sees a film and says I don't like that or it gets bad reviews, the film didn't light up for them, so that you tend to only see the bad things.

I tell my kids it's the cigarette lighter theory: You have a cigarette lighter and that's your movie. You try to light it and you flick it and it doesn't light. Then you pull the wick out and do it and it doesn't light. Then you pour more fluid and you put too much and it doesn't light. You dry it off with a hairdryer and it doesn't light. Then you pull the wick out some more and all of a sudden it lights! And once it lights all the bad things that didn't have the conditions of lighting go away because it's lit. That's what a movie is like. You have this thing and it doesn't work. The audience comes out and they just talk about the bad things. But then you change it, you move it around, you move it here, you do this, and you tweak it a little. And when it lights, all the bad things go away. They don't go away. But you don't look at them any more because you're lost in the illusion.

—*Francis Ford Coppola* (in an interview on the National Public Radio Forum program)

Coppola sums up what we do as painters—tweak our paintings, adding, taking away, covering up, emphasizing here, deemphasizing there, until the picture lights up and the illusion works.

9.3 Applying the Fundamental Art Principles to the Sigifredo Portrait

Define Your Main Focal Point

Decide what your main focus is. In the case of the Sigifredo portrait I knew that the eyes were key. That is where I wanted the focus of attention. My first stage of focusing in on detail was to apply the Jeremy Faves 2.0 > Distorto Jeremy med brush to better define the eyes. This brush is a simple customization of the Distortion > Distorto, with added opacity and with size expression changed from velocity to pressure (Figure 9.1). From the eye I started defining the glasses and the main structural lines in his face (Figure 9.2).

Add Color and Detail to the Iris and Pupil

I started working colors into the eye, using the Blenders > Smear to soften the colors within the iris (Figures 9.3 and 9.4).

Figure 9.1 Defining the eye detail with the Distorto Jeremy med brush.

Figure 9.2 Further definition of the region around the eye.

Figure 9.3 Smearing color in the left iris.

Figure 9.4 Smearing color in the right iris.

Define the Forehead and Hair Details

I then returned to the Distorto Jeremy med brush and started adding detail in the forehead and eyes (Figure 9.5).

Sculpt, Smooth, and Blend

Having added details and structure I went back over the face with the Jeremy Faves 2.0 > Artists Palette Knife (Figure 9.6). I prefer the smoothness, shape, control, and quality of this palette knife over the default palette knives in Painter IX.

Figure 9.5 Adding forehead and hair details.

Figure 9.6 Sculpting with the Artists Palette Knife.

Final Touches

I returned to the "Distorto Jeremy med" brush and worked into the clothing and shoulder (Figure 9.7). I finished with a little Photo > Burn and Dodge to emphasize highlights and shadows around the eyes, nose, and mouth. I used the Distorto Jeremy med for the signature, picking a color from within the image. You can see the final portrait in Chapter 7 (Figure 7.2).

Figure 9.7 Painting the shirt and shoulder.

9.4 Applying the Fundamental Art Principles to the Wine Still Life

Detail was applied in the wine still life, focusing particularly on the glass, using the Artists > Sargent Brush. I used the Jeremy Faves 2.0 > Sable Chisel Tip Water brush to blend the background and reduce the sharpness of the contrast of the boundary between the orange and the blue on the right of the picture. I left the bottle fairly mucked up since I wanted the wine glass to be the focal point (Figure 9.8).

9.5 Gallery

Figures 9.9 through 9.12 present the 'muck up' and final stages of two of my paintings. These two examples were both portraits created from direct observation of the model. The same principles apply if you are starting with a photographic image and using Tracing Paper and cloning brushes as part

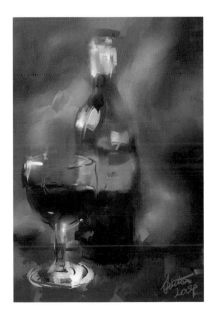

Figure 9.8 Still life study.

Figure 9.9 Portrait of Joe Bryant at the 'muck up' stage.

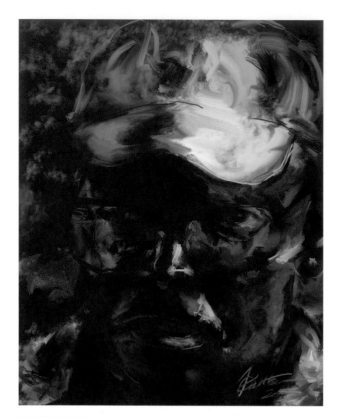

Figure 9.10 Completed portrait of Joe Bryant.

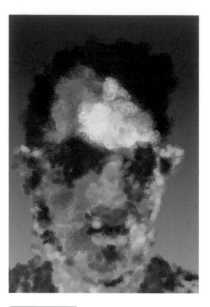

Figure 9.11 Portrait of Bradford Gibbons at the 'muck up' stage.

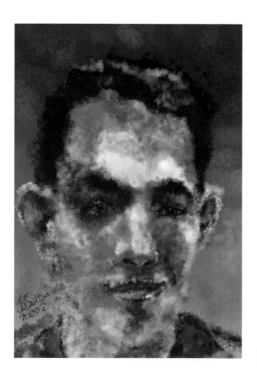

Figure 9.12 Completed portrait of Bradford

of your process. Notice in both cases how I started general, avoiding detail in the early stages, and then selectively focused the pictures on the key focal areas in the completed portraits.

9.6 Focus Exercise

Pick a subject. Create a 'muck up'. Make sure it is a real 'muck up'! Don't be timid. Let go of all your attachment to making a pretty picture and having to look good. Just have fun with it. Once you have mucked up, then create a selective focus using all the techniques covered in this chapter. Purposely exaggerate the focus. That is, exaggerate the difference between what is in focus and what is out of focus. Make your main focal point jump out at the viewer.

9.7 Wrap

Well done! You've mastered the basic principles of painting. Now is the time to practice, to reinforce what you have already learned, to build on your knowledge, to refine and hone your skills and expand your creative repertoire. I encourage you to have the attitude associated with the Chinese "gongfu" method of tea preparation. "Gongfu" denotes skill developed from serious practice—the idea being that expertise is derived not so much from learning as from experience. Practice is an end in itself, not just a means to an end. Success in gongfu tea preparation requires patience, attention to detail, and, of course, extended practice, but the rewards are well worth the effort. Likewise with painting.

Take the time now, as part of your gongfu practice, to complete several paintings following the principles outlined thus far.

After completing your practice of the principles covered thus far, the next step on your journey through this handbook, is to experience the power and beauty of recording your brushstrokes and sharing your whole creative process as a painterly animation.

10

Painting Fundamentals IV: *Replay*

Any sufficiently advanced technology is indistinguishable from magic.

—*Arthur C. Clarke*

10.1 Introduction

The Magic of Replay

One of the hidden benefits of working with the advanced digital technology of Painter as your painting medium is that you are able to record and replay your entire creative process from beginning to end. As Arthur C. Clarke so aptly puts it, such technology is indistinguishable from magic. By seeing your painting evolve before your eyes, you can observe how your image transforms during your painting process. This capability is a powerful learning tool for you and for others. You can entertain, educate, and inspire others by sharing the evolution of your paintings. Your painting process can be an end in itself, an ever-evolving experiment in which you treat your canvas as a malleable liquid medium that undergoes continuous transitions and where the process is more important than the "final" image.

Scripts: The Modern-Day Music Roll

Painter achieves this replay ability by generating scripts. A *script* is a small text file that faithfully records your every move in Painter—which brush you've selected, what settings you've adjusted, what pressure you apply, where your brushstroke goes, any effects you apply, any saving of your file, and so on. You can think of a script like the old player-piano music roll, a roll of paper with holes in it that represent the sequence of piano key depressions of a pianist playing a piece of music. When a music roll is fed into a pianola (a special piano designed to read music from rolls), the instrument plays the recorded piece of piano music with all the keys moving just as if a real person were sitting at the piano. Likewise when you replay a script in Painter the same brushstrokes occur (without any pen input) in the same order and manner as when they were recorded. The script playback is continuous, not frame by frame. The speed of the playback is related to the power of your computer, the size of your file, and the memory intensiveness of the actions being played back. Some brushes and effects take much longer to play back than others. The script doesn't record lack of activity. Thus you can take a break while recording a script without any effect on the script.

Powerful Tools for Working with Process

Scripts are a powerful tool for working with your process. They can act, in effect, as an "infinite Undo," since you can pause your playback at any point and save the image at that stage. Scripts allow you

to generate unlimited variations of your paintings. For instance, you can replay a script against different backgrounds, at different resolutions, into different aspect ratios (stretched or squashed), or using different brushes (you can change the brush selections while pausing the script). QuickTime Movies, AVI Movies, Animated GIFs, or numbered files can be generated from a script, allowing you to preserve, share, and recycle your creative process as movies or slideshows. To generate these various movie formats you first have to generate a *frame stack*, a special form of animation file that can only be played in Painter and that contains a series of separate frames. You can use the frame stack mode of Painter to paint on movies with Painter's brushes and apply Painter's special effects. You can combine and integrate your recorded painterly transitions into animations for film, TV, video, or the web by exporting the movie files generated in Painter into video editing and special effects applications such as Apple Final Cut Pro, Adobe Premiere, and Adobe After Effects.

Besides its use for replaying painting processes and making movies, scripting in Painter can be used rather like Actions in Photoshop, to record sequences of actions you repeat regularly. In that circumstance the script acts as a shortcut when you wish to repeat that same sequence of actions.

What This Chapter Covers

The full breadth of Painter's animation and video capabilities is explained in detail in the Painter User Manual and also in an extensive Help > Help Topics menu available from within the program. My intention here is to share just one small part of these powerful capabilities with you, the part that relates to recording a painting process and converting that recording into a movie format you can play and share outside of Painter. I also discuss one other aspect of scripts—the use of something called the *background script* (recorded in the background whenever you open Painter) as a last-resort rescue.

In this chapter you will learn the following procedures:

1 Recording a script

2 Playing back a script

3 Generating a frame stack from a script

4 Generating a QuickTime movie from a frame stack

5 Generating numbered files from a frame stack

6 Using background scripts as a last-resort rescue

The example I use to illustrate these operations is the portrait of Sigifredo shown in Chapters 7, 8, and 9.

Worth the Time and Effort

Working with scripts requires taking a little extra time, being patient, being methodical and organized, and being careful to back up your work before you replay a script. It is well worthwhile investing that extra time and effort. You will be amply rewarded.

10.2 Recording a Script

When to Record a Script

I encourage you to get into the habit of recording scripts when your project is painting directly, without clone color or layers, on the background canvas.

Painter's scripting and animation capability was introduced in Painter 4 (1995) and, for the most part, has not changed much since that time (Painter IX includes a small enhancement allowing a variable frame stack play rate). My experience, however, is that scripts do work with layers and cloning, it is best to avoid layers, cloning, or any interruptions to your painting process once you are recording and until you stop the recording. Conduct your recording in a single session of Painter.

The problem with working with clone sources and cloning brushes in a script is that your replay will tend to resort back to the current pattern as clone source, making it difficult to consistently reproduce a cloning paint process.

You are welcome to try scripts with cloning and layers—they may work perfectly for you. Just don't rely on being able to reproduce your exact artwork faithfully and consistently. My suggestion is to keep everything as simple as possible.

Starting a Script

It is easy to record a script. For maximum reliability, always restart Painter afresh when you are about to begin a new script. Close your file and quit out of Painter when you've completed everything and after you've saved your script. The following are generic steps you can apply any time you create a painting in Painter.

1. Choose Cmd/Ctrl-N (File > New). Open a new canvas to paint on and mount it in screen mode (Cmd/Ctrl-M). Make sure you can see the edge of the canvas on your screen. Fill with a ground color if desired.

2. Set up a palette arrangement that includes the Scripts palette (Window > Show Scripts) showing on your desktop.

3. Choose Window > Arrange Palettes > Save Layout.

4. Name the palette layout something like "Recording Basics." I often add the screen resolution (e.g., "Recording Basics 1024 × 768"). This is helpful if you are doing presentations and need to adjust your screen resolution for a projector. You can then select the right layout to suit your current screen resolution (otherwise some palettes may seem to disappear beyond the edge of the screen).

5. Choose File > Save As.

6. Give the file a name indicating this is your starting point and including a version number (e.g., subjectname-01-start.rif). You will be returning to this first version (-01-start) when

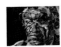

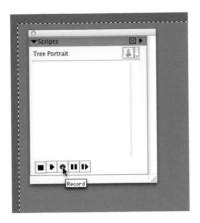

Figure 10.1 After selecting all, press the red Record button in the Scripts palette.

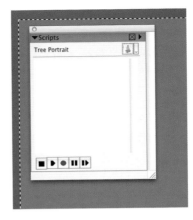

Figure 10.2 Notice the red Record button is bright red after being turned on.

CHAPTER 10 PAINTING FUNDAMENTALS IV: *REPLAY*

you replay your script. Adding "-start" to the file name will help you immediately recognize the original background canvas when you want to open it for replaying the script.

7 Choose Cmd/Ctrl-A (Select > All). You'll see dancing ants surrounding your canvas. This is not necessary for recording a script but adds a whole level of extra flexibility in what you can do with the script (such as replay into a higher-resolution canvas or replay into any rectangular selection).

8 Click on the central dark red, solid circular Record button in the center of the five script control buttons in the Scripts palette (Figure 10.1). The circle goes bright red, indicating that recording has begun (Figure 10.2). Make sure you have started the script recorder— it's easy to think you're recording a script when you're not. Avoid accidentally pressing any of the other script control buttons at this stage.

9 Minimize the Scripts palette by clicking once on the little triangle to the left of the word Scripts in the palette title bar. This is for safety, to prevent you accidentally turning off the recorder before your image is complete. Alternatively you could drag the Scripts palette down to the bottom of your screen so only a small part of it is showing.

10 Choose Cmd/Ctrl-D (Select > None). This gets rid of the selection and the dancing ants. You have now started your script. Start painting.

While a Script Is Being Recorded

Only have one canvas open in Painter while recording the script. Do not close your current image, resize your canvas, open a new canvas, or start working on another canvas while recording a script.

The replay of a script is not 100% reliable and should never be relied on as your means of saving an image or as a substitute for saving sequentially numbered versions as you work. Regularly choose

File > Save As, and save sequentially numbered versions as RIFF files into the folder for this project. I recommend doing this as a safety backup, even though your script may allow you to go back to any intermediate stages.

I always end my painting sessions with a signature. This is not only a good habit for protecting your artwork but also makes it easy to see when your script replay is completed.

Stopping, Naming, and Saving a Script

1 When you have completed your image and are ready to stop the recorder, open the Scripts palette.

2 Click on the black square button on the left of the five Scripts buttons (Figure 10.3).

3 In the Script Name window you will see "Save As: Untitled." Untitled is highlighted.

4 Type in the name of your script, which will replace the default script name "Untitled" (Figure 10.4).

Script Naming

Think carefully about your script name. You may find it useful to include the reverse date nota-tion (YY.MM.DD). If I you plan to create a second script to start where you left off, then add a sequential version number to the end of the script name. Since the naming convention for scripts is very similar to the convention for naming the image files, you can save yourself time by copying the file name (excluding the file format tag) when you do a Save As (by highlighting the name and choosing Cmd/Ctrl-C) and then pasting (Cmd/Ctrl-V) the name into the Script Name window.

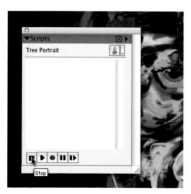

Figure 10.3 Press the Stop button when you are ready to stop the recording.

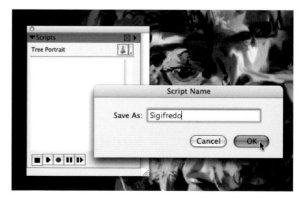

Figure 10.4 Script Name window.

5 Select OK. It is important *never* to accidentally select Cancel. You cannot undo Cancel. You will have lost your script forever if you do select Cancel.

Save a Final Backup Version of Your Completed Image

After you have saved the script, choose File > Save As again. Save one last version of your image. It will be exactly the same as your previously saved version, which was saved within the recording. Name this final version with a different, higher version number, and add the letter *F*, for final. The *F* helps when you are looking to print the image to know immediately which was your final version that was saved outside the script recording and therefore won't have been accidentally altered during script replay.

Make a Backup Copy of All Your Saved Versions

Scripts record every time you save a file. Thus if you play back a script and make any changes to the process as you do so (e.g., different background, brushes, dimensions), or if the script doesn't perfectly reproduce your image, you run the risk of accidentally modifying all your original saved versions. The replay will not show you any window asking if you wish to save changes, it'll just replace your original files! Before replaying a script, locate the folder on your computer hard drive where you saved all the versions of your image, and copy those files into a backup folder in a different location. On a Macintosh you would drag your cursor over the files to select them and then, holding down the Option key, drag the files into the backup folder.

Close Painter

When you've completed a recording and backed up your files, close Painter (Cmd/Ctrl-Q).

10.3 Playing Back a Script

Basic Replay

1 Open Painter.

2 Open the original background canvas (version -01-start) that you started with prior to recording the script.

3 Choose Cmd/Ctrl-M (Window > Screen Mode Toggle).

4 Select your script from the Scripts selector menu in the Scripts palette (Figure 10.5).

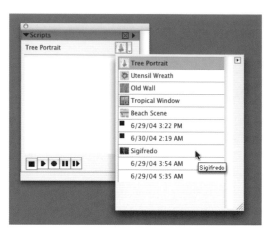

Figure 10.5 Select your script in the Script Selector.

Figure 10.6 Press the Play button.

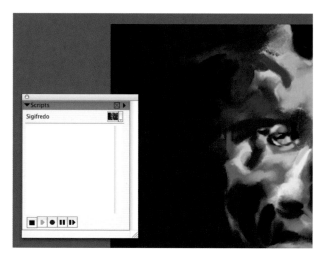

Figure 10.7 Replay your process.

5 Select the black triangular Play button, second from the left of the five Scripts control buttons. When you click on the triangle, it goes bright green (Figure 10.6), indicating that you are now replaying the currently selected script. You should now see your painting process replay seamlessly and continuously (Figure 10.7). Note that to get an authentic replay of exactly what you originally created you will need all the same libraries in Painter. If any of the Brush Variants or Art Materials are missing or have different names, you'll be prompted to locate them.

6 The replay will continue until the end, at which time the green triangle button will become black again. If you did a concluding signature at the end of your session, you can also look out for that signature to appear, as an indication of when the replay is complete.

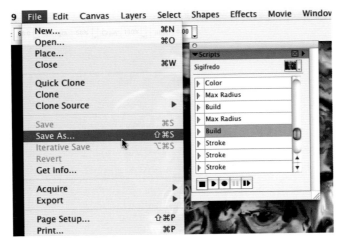

Figure 10.8 Pausing your replay allows you to do a Save As at any stage of your process.

Pausing During Replay

During replay you may see a stage of your painting that you'd like to take time to look at. You may wish to save the stage or to recall which exact brush settings you were using at that moment in the creative process.

1. To pause the replay at any time, just click the Pause button (two vertical black lines, the second button from the right). You'll see the Pause button go bright orange, and all action will halt. During this pause you can choose Save As to save that stage (Figure 10.8), or you can look at all the palettes to find out exactly what Brush Variant settings and Art Materials you were using at that moment. This can be useful when you want to remind yourself of a great brush you used at a certain stage of the painting process.

2. When you wish to continue your replay, you just click the Pause button once again (or click the Play button) and the replay continues where it left off.

Changing Background on Replay

1. Open the original background canvas (version -01-start).

2. Fill the canvas with a different background.

3. Choose File > Save As.

4. Rename this new beginning canvas.

5. Replay the script (following the instructions given earlier).

Changing Brushes During Replay

1 Click the Pause button to pause the replay.

2 Change the selected brush variant. You can also alter the current color at this time.

3 Click the Pause or Play button and the replay will continue with the new brush variant (Figure 10.9).

Once you have generated a series of variations based on the same recorded painting session, you can mix and match them by treating them all as alternative cloning sources (using File > Clone Source to move between them). Use the Soft Cloner variant in the Cloners category to clone them together. I recommend making a master working file the same size as the clone sources (the easiest way to do this is just to pick one image and choose File > Clone).

Distorting Your Image on Replay

You can stretch or squash your replayed image either vertically or horizontally, provided you remembered to Select All immediately prior to starting the recorder. Distorted replays can lead to interesting results.

1 Open your original background canvas (version -01-start).

2 Map a rectangular selection in your canvas using the Rectangular Selection tool (keyboard shortcut "r"). Make the selection wide and short or thin and tall for the most noticeable results.

3 Replay your script as normal. You will see it replay into the selection, no matter how different the shape of the selection from that of the original canvas (Figure 10.10).

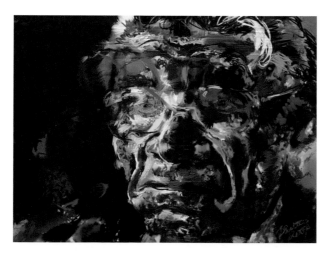

Figure 10.9 Modified portrait of Sigifredo generated by replaying the script and applying different brushes from those originally used to paint the portrait.

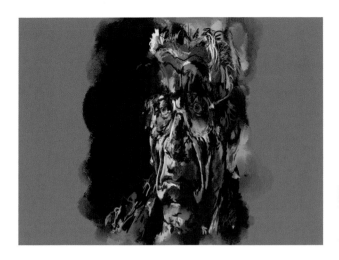

Figure 10.10 Distorted version of the Sigifredo portrait generated by replaying the script into a tall, thin rectangular selection.

Besides the convenience (and fun) of being able to make Alberto Giacometti or Amedeo Modigliani versions of your paintings (i.e., stretched out and thin), there is another benefit to this technique of replaying into rectangular selections. If the selection contour is smaller than the size of your canvas, then the edge of your replayed painting can have wonderful, organic forms because the replayed brushstrokes can extend beyond the selection area.

Playing Back at Higher or Lower Resolution

One of the powerful practical benefits of the Select All prior to the recording is that you can paint a quick gesture sketch on a small canvas with small, fast, responsive brushes and then replay the same painting onto a large high-resolution canvas for printing. You can also replay a large painting into a very small canvas (as I did in preparing the frames for the flipbook images you see in this book). The key thing when playing back into a larger or smaller file is keeping the aspect ratio (width to height) constant. Otherwise you distort your image.

1 Open your original background canvas (version -01-start).

2 Choose Canvas > Resize.

3 Uncheck the Constrain File Size check box in the Resize window.

4 Set your Width and Height units to inches (the default unit is pixels).

5 Change the resolution from 72 ppi to 300 ppi.

6 Click OK.

7 Make any changes you wish to the background.

8 Choose Cmd/Ctrl-A (Select > All).

9 Replay the script. It will replay into the larger file.

If you forget to do the Select All just before you replay the script, the script will replay at the original pixel size, aligned in the top left corner of the canvas.

Replaying into Smaller Area

If you are playing back into a smaller file or a smaller selection area, you may come across the error message "Insufficient Memory to Complete Operation." This error appears every time your brush size becomes less than 1.0. To overcome this error, hold your cursor over the Pause button in the Scripts palette, click on the Return/Enter key, and immediately afterwards click on the Pause button. Then change the brush size to 1.0. Press the Pause button again and the script continues playing (until the next time the brush size becomes less than 1.0).

10.4 Generating a Frame Stack from a Script

To do something with your recorded painting process outside Painter, you will first need to convert the script, which is a continuous record of all your actions, into a series of individual frames. That is achieved by creating, in Painter, a special file known as a *frame stack*, which, as the name suggests, is a file containing a stack of frames or images. Frame stacks can be very large files. Their size is simply the addition of all the images that make up the frames. So if you have a frame stack with 450 frames, each frame being about 1.5 megabytes (MB) if saved as a RIFF file, then the frame stack will be about 675 MB. Frame stacks with hundreds of frames can easily exceed a gigabyte (GB) in size. Make sure you have plenty of free hard drive space (I recommend at least 5 GB of free space) at the location where you are saving the frame stack. Before you begin generating frame stacks, check how much memory you have available in your computer and, if needed, clear some extra space. If you can, maximize the RAM in your computer. I often save the frame stacks onto the desktop and then trash them as soon as I've saved my final movie in QuickTime format.

The frame stack can only be opened within Painter. If you make any changes to a frame stack and then close the frame stack, you will not be asked if you wish to save changes, like you are when you make changes to a regular image file. The changes will simply become part of the frame stack. This makes frame stacks vulnerable to unintended changes. Therefore treat the frame stack as a temporary transition state before saving the frames in a more versatile and stable format that can be opened in programs other than Painter.

The frames that make up the frame stack can be saved either as separate, sequentially numbered images (each file name ending in a three-digit sequential number like 001, 002, and so on) or as movie files (QuickTime is the most common format, although AVI movies and GIF animations are also options). Within Painter the word *movie* is used to denote both frame stack and conventional movie formats such as QuickTime and AVI. This can be confusing. I recommend you always differentiate your file name for frame stacks by adding .ftk at the end and that for QuickTime movies by adding .qtm at the end. This makes it clear from the file name whether you're dealing with a frame stack or a QuickTime movie.

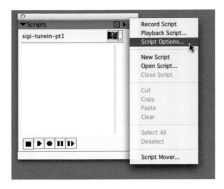

Figure 10.11 Select Script Options from the Scripts palette pop-up menu.

1 Open the original background canvas (version -01-start) that you started with prior to recording the script.

2 Choose Cmd/Ctrl-M (Window > Screen Mode Toggle).

3 Open the Scripts selector pop-up menu in the Scripts palette and make sure the script you wish to convert into a movie is selected as the current script. When you close and then reopen Painter, the current script defaults back to the one at the top of the scripts selector menu ("Tree Portrait").

4 Select Script Options from the Scripts pop-up menu that appears when you click on the small triangle in the top right of the Scripts palette (Figure 10.11).

5 Click on the Save Frames on Playback checkbox in the Script Options window. You should now see a check appear in that checkbox.

6 Leave the Record Initial State checkbox checked (the default state). The Record Initial State means that whenever the script is replayed, the program will look for the same Libraries that were present in Painter when the script was originally started.

7 In the Script Options window type in a number of tenths of a second to determine how frequently Painter will save a snapshot of the image as the script is replayed. Each of these snapshots becomes a frame in the frame stack.

Understanding the Script Option Snapshot Rate

It is a common misconception that the figure you type into the "Every . . . 1/10ths of a second" represents the frame rate (frames per second) of your final movie. This is not the case! The figure you type in has nothing to do with the frame rate of your movie. It is only going to determine how many, or how few, frames you end up with. The default figure, which is 10 ("Every 10 1/10ths of a second"), means that at intervals of 10 tenths of a second (i.e., every second) during the replay of a script, Painter will take a snapshot of the current image (assuming you have Save Frames on Playback checked). These snapshots become frames in the frame

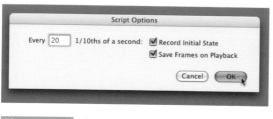

Figure 10.12 The Script Options window.

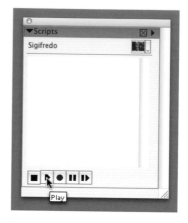

Figure 10.13 Click the Play button to start the script replay.

stack. If you doubled the figure from 10 to 20 ("Every 20 1/10ths of a second," i.e., every two seconds), then the interval between snapshots will be doubled, so the total number of snapshots will be halved.

Conversely, if you halved the figure from 10 to 5 ("Every 5 1/10ths of a second," i.e., every half a second), then the interval between snapshots will be halved and the total number of snapshots will be doubled. To get the most frames you'd make the figure 1 ("Every 1 1/10ths of a second," i.e., every one-tenth of a second), whereas to get a very few frames you'd make the figure very large, e.g., 100 ("Every 100 1/10ths of a second," i.e., every 10 seconds). This is not exact science! The rate of replay of a script is determined by a number of factors, including what brushes or effects you used and how fast your computer is. Thus a slow computer, ironically, allows you to generate more frames than a superfast one.

You may find yourself doing several trial runs in order to end up with a frame stack with the right number of frames. Painter's scripting and animation capability doesn't give you control over the speed of script replay or the total number of frames in a frame stack.

8 Click OK in the Script Options window.

9 Select the black triangular Play button, second from the left of the five Script buttons (Figure 10.13). When you click on it, the triangle goes bright green, indicating that it is replaying the selected script.

10 You will now see a window titled "Enter Movie Name," where you can name your frame stack and determine the location on your computer where the frame stack will be saved (Figure 10.14). Note that the use of the word *movie* here refers to a frame stack, not a QuickTime or AVI movie. Remember that you may make a few trial frame stacks; therefore, it is best to name them with an indication of the Script Options setting you chose for saving frames. Also, if you are on a Macintosh, add a file format tag at the end of the file

Figure 10.14 Naming your frame stack.

name that indicates it is a frame stack (Windows systems do this automatically). Thus if you selected "Every 10 1/10ths of a second" in Script Options, then the frame stack name may be something like "subject-10tenths-01.ftk." Put this name where you see Save As: Untitled.

Frame Stack Vulnerability

Note that when you close a frame stack, you are never asked whether you wish to save changes; any changes are automatically saved. This makes the frame stack an unreliable, as well as an unwieldy, format in which to save your animation. Frame stacks are vulnerable to unintentional modification. It is better to rely on your QuickTime movie as your means of saving your movie. The QuickTime movie has the advantage of being independent of Painter. The script will only work with the exact same brushes and art materials loaded in Painter as when you originally recorded the script. If you used custom brushes and libraries, it is unlikely your script will still work when you upgrade to future versions of Painter and have different custom libraries and brushes.

11 After you've named the frame stack and determined where it will be located, click Save.

12 You now see the New Frame Stack window (Figure 10.15). Leave the defaults Layers of Onion Skin: 2 and Storage Type: 24-bit color with 8-bit alpha. Click OK.

13 The script will now replay. You will see a Frame Stack palette with small previews of the frames as they are saved (Figure 10.16).

When the script has replayed completely, the frame stack is completed.

Figure 10.15 New Frame Stack window.

Figure 10.16 Replaying a script into a frame stack.

Capturing More Frames

You may find that your script plays back too fast and therefore doesn't allow you to capture a sufficient number of frames (e.g., you're recording your signature and it replays into a single frame) even on the 1/10ths of a second setting. Unfortunately in Painter there is no scripts replay speed control; the replay speed is a function of the speed of your computer and the memory intensiveness of your actions in Painter. In the situation where you can't capture enough frames, rerecord your script on a much larger canvas (with same aspect ratio, width/height, as your original file), using Select All before you start the script. This will automatically slow the replay. You will then need to alter the movie frame size in a program outside of Painter.

10.5 Generating a QuickTime Movie from a Frame Stack

1 Choose File > Save As (Figure 10.17).

2 Select your option from the Save Movie window. If you are unsure of which option to use and want to be able to replay your movie in slide shows and presentations, I recommend selecting Save Options: Save movie as QuickTime (Figure 10.18). The rest of these instructions will be based on that choice.

3 Click OK.

4 You now see the Enter Movie Name window (Figure 10.19). This is now referring to saving the QuickTime movie, not the frame stack. If you are on a Macintosh, name the QuickTime movie with a name ending in .qtm (Windows systems do this automatically) to identify it as a QuickTime movie. I recommend including resolution (pixel height and width) and total number of frames in your QuickTime movie name. This will be useful if you are experimenting with different file sizes and total number of frames.

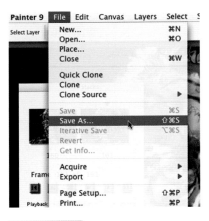

Figure 10.17 Choose Save As.

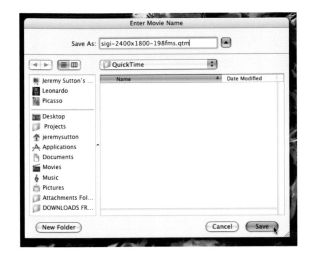

Figure 10.19 Name and save your QuickTime movie.

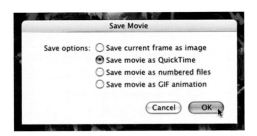

Figure 10.18 Choose "Save movie as QuickTime" in the Save Movie window.

Figure 10.20 QuickTime compression choices.

CHAPTER 10 PAINTING FUNDAMENTALS IV: *REPLAY*

5 Choose where you wish to save the QuickTime movie.

6 Click OK.

7 In the Compression Settings window select Compression: Animation (the default is Video) (Figure 10.20). You have many different compression formats to choose from.

8 In the Animation Compression Settings window, select "Millions of Colors +" and move the Quality slider to the right (Best) (Figure 10.21). I suggest leaving the Frames per second at

Figure 10.22 Choose "Save movie as numbered files" in the Save Movie window.

Figure 10.21 QuickTime Compression Settings window for Animation compression format.

12 and unchecking "Key frame every . . . frames," unless you have specific needs, such as a faster frame rate for video (typically 29.97 fps).

9 Click OK.

Congratulations! You've now succeeded in converting your script into a QuickTime movie. You can now play this movie on any QuickTime player or integrate it into a movie or film or video using other software, such as Apple Final Cut Pro or Adobe Premiere or Adobe After Effects. If you ever wish to recreate the frame stack without going through the time consuming effort of replaying the script again, you can just open the QuickTime movie from within Painter and it will open as a frame stack.

10.6 Generating Numbered Files from a Frame Stack

The flipbook animation you see in the top corner of the pages of this book is an example of the Sigifredo script converted into individual sequentially numbered files. Here's the procedure for saving as individual files.

1 Open the frame stack you wish to generate numbered files from.

2 Choose File > Save As.

3 In the Save Movie window select "Save movie as numbered files" (Figure 10.22).

4 Save your first file with 001 at the end of the file name (Figure 10.23). Save it into a dedicated folder. Painter will now generate a series of individual files, each sequentially numbered (Figure 10.24).

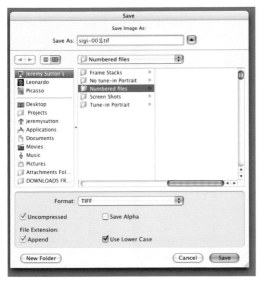

Figure 10.24 Sequentially numbered files.

Figure 10.23 Save your first file with –001 at the end of the name.

Opening Numbered Files as a Frame Stack

You can open a sequence of numbered files in Painter as a frame stack. Here are the steps.

1 Choose the regular File > Open command.

2 Check the Open Numbered Files checkbox in the lower right of the Open window.

3 Locate your folder containing the numbered files.

4 Choose the first numbered file (you will be prompted to do so by a message beneath the Open Numbered Files checkbox).

5 Choose the last numbered file (Figure 10.25) (you will be prompted to do so by a message beneath the Open Numbered Files checkbox).

10.7 Using Background Scripts as a Last-Resort Rescue

Last-Resort Rescue

Think of Painter's background scripts as your lifeboat of last resort in the event of a disaster, such as a computer crash. Every time you start Painter, a background script is automatically recorded without your needing to turn on any recorder. The recording session continues in the background (hence the name *background scripts*) until Painter closes (either because you quit Painter or because the program

Figure 10.25 Choosing the last numbered file.

or the computer crashes). This recording is saved as a background script that can be replayed. The background script contains everything you did from the moment you opened Painter to the moment it closed (with some exceptions: Painter's scripts do not work with all the plug-in dynamic layers). The background script can allow you to rescue a piece of artwork you had failed to save (of course it's better to save meticulously and regularly and avoid the need for rescue). The background script can also allow you to replay a sequence of steps and pause the sequence so you can identify a particular brush you used at one point. But be cautioned: The background scripts do not always work. They are sometimes corrupted by a bad crash. Never rely on them for your backup. Always save methodically as you work.

Open the Painter General Preferences window (Edit > Preferences > General) and you will see "Auto-Save scripts for 1 days(s)." This means that each background script will be saved for 24 hours from the time Painter closes and then be destroyed, unless you rename the script before that time. The purpose of destroying the scripts is to prevent your computer from getting clogged up with thousands of scripts. Close the Painter General Preferences window.

Playing Back a Background Script

1. Open the Scripts palette.
2. Select the appropriate script name in the Scripts selector pop-up menu. Background scripts are automatically named with the date and time you initially opened Painter for that session (e.g., 6/9/05 7:11 PM). Their icons are plain white squares.
3. Click the Play button (the black triangle second from the left in the row of Scripts control buttons). The Play button turns bright green as the script replays.

4 Pause the script by clicking on the Pause button (the two vertical black lines, second from the right in the row of Scripts control buttons). The Pause button turns bright orange while the script pauses. This allows you to save the current image or look at the brush settings.

5 Click on the Pause button a second time to continue the script replay.

Saving a Background Script

When your replay has finished, if you wish to save the background script from being destroyed automatically, you need to either save a copy of the script in a separate scripts library or change the script name. Both of those actions are achieved in the Script Mover.

1 Select Script Mover from the bottom of the Scripts pop-up menu, which is accessible by clicking on the small triangle in the top right corner of the Scripts palette.

2 In the Script Mover, select the appropriate background script in the current script library. The default library name is Painter Script Data. On the left side of the Script Mover window you will see the little icons that correspond to all the scripts in the current script library. The background scripts have blank icons; they just look like white squares. Unfortunately there is no drop-down menu with all the script names listed in the Script Mover. Thus you need to identify the correct background script just by trial and error, clicking on each one in turn to see what its name is. The name of each script you click on will appear in the center of the Script Mover window.

3 When you have selected the appropriate background script, click on the Change Name button.

Figure 10.26 Changing the name of a background script.

4 In the Change Script Name window (Figure 10.26), alter the background script name. This will prevent it from being automatically deleted.

Saving Scripts into a Custom Script Library

You can also create a new script library, by clicking on the New button on the right side of the Script Mover window. Name your new custom script library. You can then drag any script across from the left to the right of the window. This makes a copy of the script in your new script library. If you wish to clear out any scripts from the default library, just select the script and click Delete. Be aware that you can't undo the delete operation. These instructions apply to any Mover in Painter. There are Movers for all libraries except the brushes library.

10.8 Wrap

This chapter has just touched on the powerful creative potential offered by using scripts. Have fun experimenting with them. I hope they help you treat your creative process as being as valuable as your final image. Placing value on your creative process will be a great asset in developing your painting skills and will help you mature as an artist.

This concludes the Painting Fundamentals part of this handbook. The final part, Painting Mastery, will guide you into a deeper understanding of color and of developing your own unique identity as an artist.

IV
Painting Mastery

11

Painting Mastery I: *Color*

Color is the keyboard, the eyes are the harmonies, the soul is the piano with many strings. The artist is the hand that plays, touching one key or another, to cause vibrations in the soul.

—*Wassily Kandinsky*

11.1 Introduction

Welcome to the painting mastery part of your journey. In the painting fundamentals section you covered the basics of tuning in to, observing, and depicting a subject. In the painting mastery section you will look deeper at how to apply and use color as a tool for expression in your paintings and how to develop your own unique voice as an artist, creatively improvising in the moment and being yourself in your art.

We begin gaining painting mastery with an understanding and mastery of color. Take a stroll around an art gallery or museum and look closely at the paintings. You'll discover an intricate world of many colors, tones, textures, and shapes. As you draw away from the artwork, forms emerge, the subject is revealed. You become aware only of the essence of the subject, losing sight of the many colors that make up the illusion. The richness, depth, diversity, and range of colors in a painting extend far beyond colors present in a photograph and come closer to approaching the richness of color we perceive in the world around us. Therein lies the power of paintings.

In the painting fundamentals section you encountered the challenge of seeing contours, shapes, and tonal variations and using the relationships among them to depict three-dimensional form on a two-dimensional canvas. Your mind filters what you see, tells you what to expect to see, and gets in the way of accurate observation. To overcome your knowledge of what you expect to see, you have to make an effort to observe accurately. You can play "tricks" on your mind (drawing with your nonfavored hand, for instance) that liberate you from your visual expectations. The same challenge of overcoming your mind's expectations applies to seeing, describing, and depicting color.

In this chapter you'll explore different approaches to working with color and the tools provided within Painter for choosing and controlling color. Color is a way of creating focus, describing form, generating energy and movement, and expressing emotion in your paintings.

Using color can be challenging and intimidating. A typical computer system offers around 24 million possible colors for each pixel in your image. That's a lot of choice! When you make color choices, you need to be clear about your goal. Are you trying to render as accurately as possible the colors you perceive, or are you are using color to express emotion in your paintings? Both goals are equally valid but can lead to quite different results.

The exercises in this chapter are designed to help you choose and apply color, to become confident in making color decisions, and to realize the full power of color in expressing yourself and your impression of your subject.

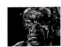

11.2 About Color

Color is a Perception

Sir Isaac Newton, the 17th century scientist and mathematician who made some of the most profound discoveries about the nature of light, wrote: "To determine . . . by what modes or actions Light produceth in our minds the Phantasms of Colours is not so easie." Unlike light, color is not a physical entity. Color is a perception.

The color we perceive when we focus our gaze on a specific region in our visual field reflects how our brain processes information about the wavelength, intensity, and luminance (value) of light from that region as well as the influence of the light from surrounding regions.

Categorizing Colors by Hue, Saturation, and Value

Colors can be categorized by many different schemes. One scheme that is used within Painter, and commonly by artists, is that of hue (the named color independent of luminance), saturation (brightness/dullness), and value (luminance or lightness/darkness). Pure black, pure white, and pure grays are luminance in the absence of hue and are rarely observed in nature.

Primary Colors

When you create an image on the computer, you can view it either on a computer display or as an actual print. On a computer screen, or using projected light, the colors you see are generated directly from a light source, such as a phosphor, and transmitted through space to your eye. Color viewed in this way is known as *additive* color. When you combine red, green, and blue transmitted light you get pure white. These three colors are known in the world of physics as the *primary* colors of light.

When you view the same artwork as a print, you are seeing light that is reflected off the print. Any color seen in a print, as in traditional painting, is simply color that is not absorbed when light strikes the surface of the print. Such color is known as *subtractive* color. When you mix red, yellow, and blue pigments you get black (or close to black). In traditional painting these three colors—red, yellow, and blue—cannot be created by mixing other colors together. Red, yellow, and blue are known in traditional painting as the *primary* colors (*different* from the primary colors in projected light).

The color range, or gamut, of each of the two types of color—additive and subtractive—is quite different. Thus we never see on our computer screens the same exact colors we see around us in the environment or in print, though through assiduous color management we can minimize the difference and maximize our consistency of output.

Color Wheel

A traditional artist's color wheel is created by initially placing dabs of the three primary colors—red, yellow, and blue—equidistant around a circle. Adjacent primary colors are then mixed to create secondary colors (for instance, yellow and blue are mixed to create green). Dabs of the secondary colors are placed halfway between the primary colors from which they are made. This process is continued with tertiary colors, made up by mixing primary colors with secondary colors around the wheel, and so on until there is a continuous range of colors around the wheel.

Painter's Hue Ring is a color wheel based on the physics primary colors of red, green, and blue. These three colors are equidistant around the wheel. The secondary colors on this Hue Ring are cyan, magenta, and yellow.

Complementary Colors

Two colors are *complementary* when they are opposite each other on the color wheel. When juxtaposed adjacent to each other on a painting, complementary colors can have a powerful effect on one another, bringing out a vividness in each. The complementary color of a paint primary color (red, blue, and yellow) is the color you get by mixing the other two primary colors. So the complementary color for red is blue + yellow = green, for blue it's red + yellow = orange, and for yellow it's red + blue = purple. As painters we can take advantage of the fact that our eyes naturally seek to balance any given color by its complementary color. When the complementary color is not present, the eye spontaneously generates the complement. We can use combinations of complementary colors in a work to provide harmonious balance as well as to bring attention to specific areas of the image. An excellent book that deals with these issues, plus a lot more concerning color contrast of all kinds, is *Elements of Color* by Johannes Itten (John Wiley & Sons, 1970). There are also many excellent resources on the web that explain and illustrate the use of complementary colors. Here are a few: http://webexhibits.org/colorart http://www.artsparx.com/color_complementary.asp http://www.colorschemer.com/tutorial.html

Experiment with Color

Use the Color Picker to select colors from opposite, or almost opposite, sides of the Hue Ring (Color Wheel). One of the great advantages of the color wheel representation of color, as used in Painter's standard Color Picker, is the convenient access to harmonious color schemes and combinations.

Harmonious Color Schemes

Here are some examples of color wheel–based schemes.

1 *Analogous*—any three hues that are adjacent to each other on the color wheel (including their tints and shades, which are created by adding white or black, respectively)

2 *Complementary*—direct opposites on the color wheel

3 *Secondary*—combining the secondary hues of orange, green, and violet

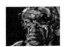

4 *Split complementary*—a hue plus the hues on either side of its complement

5 *Tertiary triad*—three tertiary hues equidistant from each other on the color wheel (e.g., the tertiary triad of red-violet, yellow-orange, and blue-green).

Color Surround Effects

Our perception of color, when looking at a region of color in a subject, is influenced by the colors in the environment around that region. Every color is influenced by every other color. The physiological basis of this is the opponent-color processes built in to our visual information processing system. This is an effect you can use to your benefit when applying color in a painting. A touch of color here and there can affect the whole mood and feel of the painting. The underlying issue in perceiving color is color relationships. How do we relate the colors and tones we see to the colors we put down on the canvas? How do the colors on our canvas relate to, and contrast with, each other and affect the viewer's perception of the image? These are questions we are constantly addressing in our paintings.

Perceived Tone

Colors have inherent perceived tone (lightness and darkness). For instance, yellow has an inherently lighter tonal value than blue. The inherent value of a color is independent of the value adjustments you can make in Painter's Saturation/Value Triangle to lighten or darken, or saturate or desaturate, a color. Every color we paint on our canvas creates a perceived tonal value, which relates to the hue as well as the actual value of the color.

As discussed in Chapter 7, an artist is continually depicting tone to create the perception of depth. Besides depicting tone accurately through our shading, we have to take into account the salience or conspicuousness of the color we observe and adjust our painting accordingly. For instance, if we are observing an intense pure color surrounded by other colors that are less intense, then the intense color may appear to jump forward when the luminance would indicate that it should recede into the background. In that case we may purposely reduce the intensity of the color we paint.

While working in Painter, if you are unsure of the tonal value of your colors at any time, you can employ the grayscale "cheater" technique of temporarily turning your color painting into a grayscale (black-and-white) image. To check color tonality, choose Effects > Tonal Control > Adjust Colors and set the Saturation slider all the way to the left (−139%). After you've examined the image and noted any areas that need darkening or lightening, select Cmd/Ctrl-Z to undo the effect. Temporarily desaturating your image in this way does not take account of the effect of perceived color tone, so you still have to look at your color image and decide if there are any colors that stand out unintentionally and just look wrong.

11.3 Progressive Color Statements

The progressive color statements project is about identifying and then painting the color and shape and relative position of color regions to build up an image. You do this by applying the same progressive statement approach used for the tonal and shape statements in Chapter 7. Start off painting big, rough forms with few colors and then refine the painting in stages toward greater detail and a larger range of colors. Throughout this exercise, be conscious of selecting the tone of the colors you apply to suit the appropriate tonal value of the section of the portrait you are painting. This is an exercise about seeing. It forces you to look beyond the assumed color of an object.

In the example in Figure 11.1 I took a simple, plain-colored object, a yellow lemon, and placed it on a purple cloth. The main light source was natural sunlight coming through the window and creating a main highlight in the upper left side of the lemon. There was a secondary light source, a small desk lamp, that created some secondary highlights within the shaded side of the lemon.

You can apply this exercise to direct observation an object in nature or to working from a photograph. I recommend trying it with both cases to derive the maximum educational benefit.

1. Choose Cmd/Ctrl-N.

2. If you are working from direct observation of nature, choose File > New and open a new canvas. For convenience I suggest keeping the size within about 1500 pixels in the maximum dimension initially, though you can apply this technique at any resolution. If you are working from a photograph, open the photograph in Painter and then make a clone copy of it (File > Clone). You will work on the clone copy, not the original photograph.

3. Choose Cmd/Ctrl-M to mount the canvas.

4. Choose Window > Zoom to Fit. Zoom out slightly using the Cmd/Ctrl-"-" command, to suit your screen size and palette arrangement.

5. Hold down the Spacebar and drag your canvas into a convenient position on the screen.

6. If you are painting from direct observation, choose a ground color in the Colors palette or from a Color Set, and fill your canvas (Cmd/Ctrl-F) with current color. If you are working from a photograph you can keep your image in the clone copy canvas.

7. Select the Acrylics > Opaque Acrylic 30 brush.

8. Look carefully at your subject with half-closed eyes and identify which regions are the lightest and which the darkest. Starting with the lightest and darkest regions, paint in the main color blocks until you have filled your canvas with paint. Work rapidly and loosely. Don't get attached to details (keep your brush size relatively large) or to trying to get perfectly accurate colors or to trying to make a likeness of your subject.

If you are working from a photograph you could use the Option/Alt key to pick color from within your image as well as choose colors from the Colors palette.

In this first stage, or first color statement (Figure 11.1), you are reducing the subject to the minimum number of colored tonal areas that will convey the essence of the subject. You are reduc-

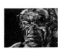

Figure 11.1 The lemon still life.

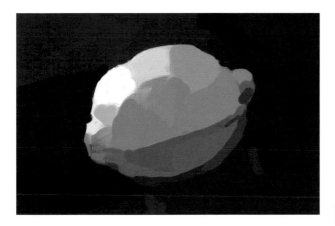

Figure 11.2 First color statement.

ing the complex array of colors, tones, and textures into a few simple light and dark color spots or regions. The most important aspect of this exercise is getting used to seeing color in terms of tonal values.

9 Intermittently zoom out (Cmd/Ctrl-"-") and see what your painting looks like when it is postage stamp size on the screen.

10 Also intermittently apply the grayscale "cheater" technique, where you choose Effects > Tonal Control > Adjust Colors and set the Saturation slider all the way to the left (−139%). After you've examined the grayscale version of the image (Figure 11.3) and noted any areas that need darkening or lightening, select Cmd/Ctrl-Z to undo the effect.

11 When you have completely covered the canvas with paint and have captured the essence of the subject in your first color statement, choose File > Save As and save it with a file name indicating that it is the first color statement.

12 Select the Acrylics > Captured Bristle brush.

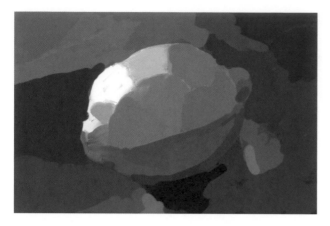

Figure 11.3 Desaturated version of first color statement.

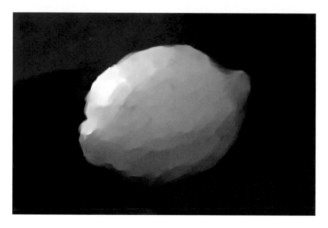

Figure 11.4 Second color statement.

13 Now look more carefully at your subject and observe the subtler changes in tone and colors. Observe the smaller blocks of tone and color within the regions that you painted as large rough blocks in the first color statement. Paint over the large blocks with these smaller blocks, making your brush a suitable size. This is your second statement, which is more detailed than the first and conveys more subtle differences in tone and color (Figure 11.4). If you are working from a photograph you could use some clone color at this stage.

14 Choose File > Save As and save the image with a file name indicating that it is the second color statement.

15 Continue this process with smaller brush size, developing a series of statements, each one more detailed (Figure 11.5).

Questions

1 What did you learn from this exercise?

2 What were the challenges?

3 How do you feel about the end results?

Figure 11.5 Third color statement.

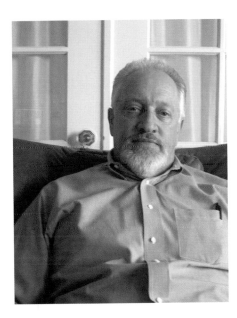

Figure 11.6 Tim sitting for his portrait.

11.4 Observed Color

Create a painting of a subject using colors close to the natural, or "realistic," colors that you observe. Figure 11.6 shows a subject of mine (Tim Mathiesen) sitting for a portrait; Figure 11.7, the portrait, reveals how I kept my colors close to the colors I observed.

11.5 Limited Range of Color

It can be a valuable experience to limit your color palette via a color set. If there is an artist whose color palette you admire, this exercise will be a good opportunity to generate a color palette based on

CHAPTER 11 PAINTING MASTERY I: COLOR

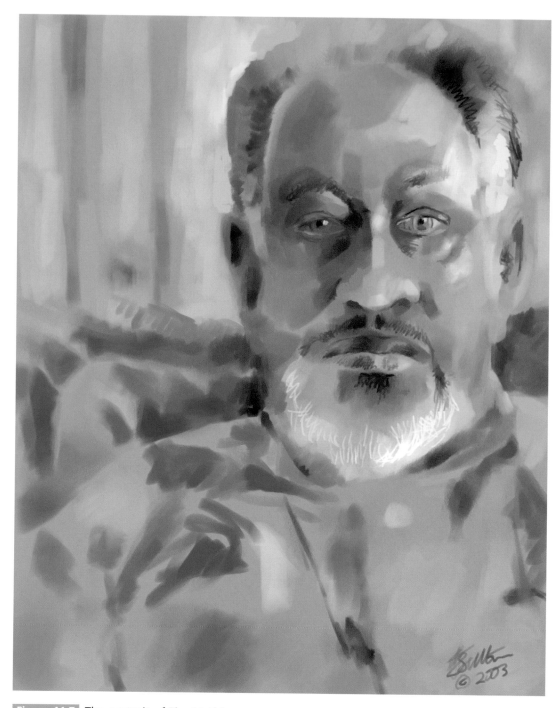

Figure 11.7 The portrait of Tim Mathiesen.

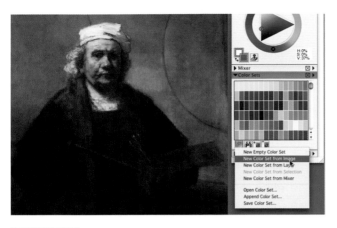

Figure 11.8 Selecting "New Color Set from Image."

Figure 11.9 Saving the Rembrandt color set.

one of his or her paintings and then limit yourself to choosing colors from within that color set. In the example in Figure 11.8, I first created a color set from a self-portrait by Rembrandt van Rijn (1661) and then used that color set to make my own self portrait.

1. Open an image whose colors you wish to capture in a custom color set.
2. Select "New Color Set from Image" from the lower left-hand icon pop-up menu in the Color Sets palette (Figure 11.8). This will automatically generate a custom color set based on the colors in the current active image.
3. Choose Save Color Set from the same pop-up menu (Figure 11.9).
4. Use this custom color set to pick colors for your painting (Figures 11.10 and 11.11).

Challenge yourself by working with colors you may not usually choose. For instance, I chose subdued browns and yellows, whereas I typically work with intense bright blues, purples, yellows, teals, and reds.

Questions

1. Which color set did you choose?
2. How did using the color set, instead of the Color Picker, influence your colors and your picture?

11.6 Wild Color!

This assignment is totally the opposite of the previous ones in this chapter. Instead of striving to accurately observe and depict color or to limit your color palette, this exercise is about letting go of rules and restrictions and instead giving yourself license to be free and expressive with color. The colors you choose need not bear any relationship or resemblance to the actual colors you see. It's as if you've

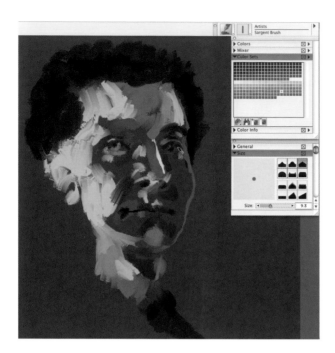

Figure 11.10 Painting with colors from the Rembrandt color set.

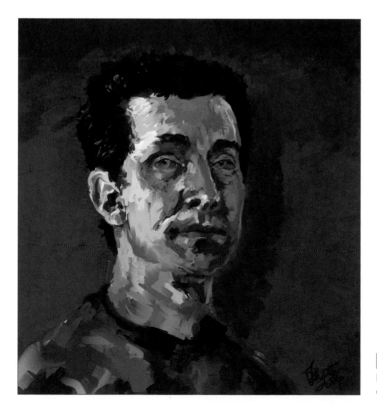

Figure 11.11 The final self-portrait with the limited range of color.

Figure 11.12 "Jeremy Painting Barry Through Multicolored Glasses" by Gisele Bonds.

Figure 11.13 John sitting for his portrait.

been given special multicolored glasses (as depicted in Figure 11.12, Gisele Bond's picture of me paint-ing her cousin, Barry) which expand your color horizon and permit you to see a vastly increased range of colors in the world. Be free from worry about what color should be where. Be bold, be daring, be crazy, be wild! Play with different combinations of colors next to each other. Test out the effect of juxtaposing complementary colors from opposite sides of the color wheel. Paint in a way you may not have dared to before. Use whatever brushes you like. This is an exercise where you are have per-mission to step away from being safe. Your canvas is a laboratory for experimentation. Make the most of it and enjoy it!

I share here three colorful portraits: of John Gardiner (Figures 11.13 through 11.16), Jim Golden (Figures 11.17 and 11.18), and Paige and her daughter Lexi (Figures 11.19 and 11.20). John and

CHAPTER 11 PAINTING MASTERY I: COLOR

Figure 11.14 Applying Jeremy Faves 2.0 > Retro Dots in the background.

Figure 11.15 Applying the Jeremy Faves 2.0 > Goodbrush in the face.

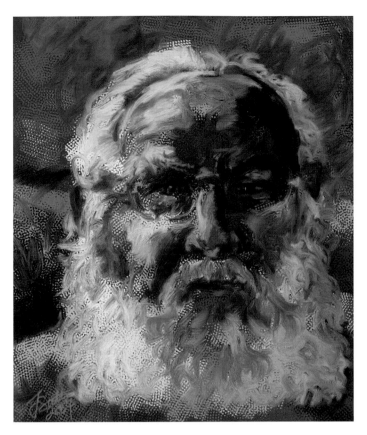

Figure 11.16 "John."

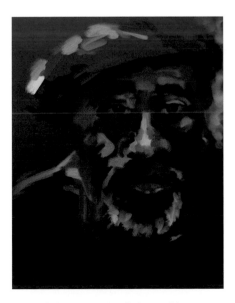

Figure 11.17 Intermediate stage of the portrait of Jim Golden.

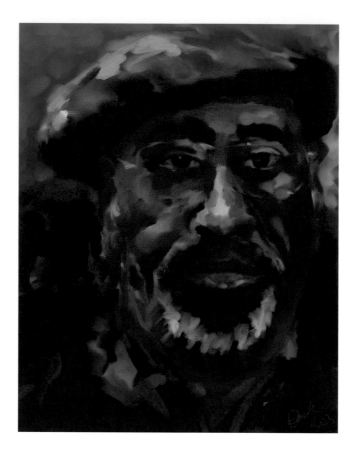

Figure 11.18 "Jim."

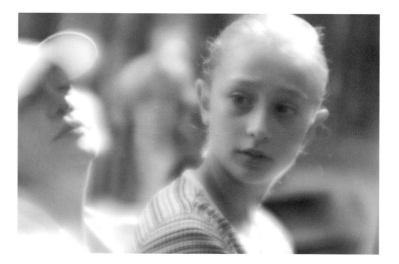

Figure 11.19 Original photograph of Paige and Lexi.

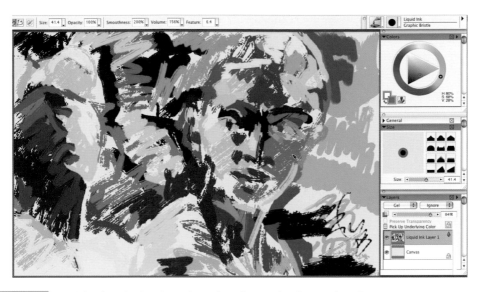

Figure 11.20 Liquid Ink painting based on the photo of Paige and Lexi.

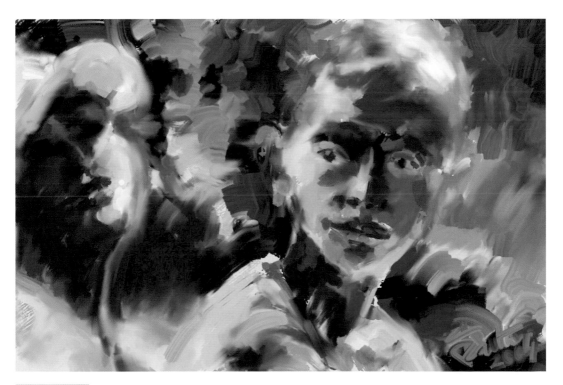

Figure 11.21 "Glance."

Jim were both painted from direct observation in a live sitting, and the painting of Paige and Lexi is based on a photograph I took. In all three paintings I used colors expressively and pushed the color range beyond the observed colors.

Questions

1 Did you have fun?

2 Was choosing color easy or difficult?

3 What's your impression of the end result?

11.7 Wrap

Mastering color, like all skills, takes time and practice. The more practice the better. Try out ideas. Be bold. Experiment. Have fun. Every step taken with the use of color, even when you don't like the results, adds to your understanding and mastery of the tool. Having dived first into line, then tone, and now color, you are ready for the next step: developing your own style and expressing your personality in your work.

12

Painting Mastery II: *Being Yourself*

I started thinking about [who I was as a musician and establishing my own sound] in 1950 or '51. But I was scared to try. I could get a lot of work sounding like Nat (King) Cole. I woke up one morning and I started to thinking, nobody knows my name. Everybody said to me, "Hey kid, hey kid, you sound just like Nat Cole, hey kid." It was always "Hey kid." Nobody never said "Ray," never, never, never. So I started telling myself: "Your Momma always told you to be yourself. And you got to be yourself if you're going to make it in this business. I know you love Nat Cole. But you got to stop that."

—*Musician Ray Charles* (from an interview with Terry Gross on
National Public Radio's Fresh Air program, 1998)

12.1 Introduction

We have covered the process of painting and the mastery of your tools; the final step in this part of your creative journey is developing your own identity as an artist. There is no magic formula for artistic style and identity. You will naturally express who you are in your art the more you make art and the more you let go of judgment and fear. Letting go of fear is the key to surfing the wave of creativity, to improvising in the moment, listening to your intuition, to your inner voice. Through letting go of fear you can be yourself.

What Ray Charles said about his own fears and how they'd held him back resonates for artists in all expressive media. Ray's Momma's advice "to be yourself" is good advice for us all. Painter is an intuitive art medium that allows you to express who you are in a unique way. This final chapter is about expressing who you are in your art.

12.2 The Challenges of Painting

The "I'm Not an Artist" Challenge

Many of us are conditioned from a very young age to draw stick figure faces, with circles with dots for eyes, and to accept that we are not, and never can be, "artists." In fact, we are all artists. Every child is born an artist. Every child is born with a natural ability to make marks fearlessly in the world (whether on canvas or on the floor or walls).

The "I Want To Look Good" Challenge

Fear of judgment is a natural human tendency. We all want to look good in our own eyes and those of others around us. Making art is a risky business. As an artist you are continually putting yourself

out on a limb, taking risks, and venturing into unknown territory. Allow yourself to be vulnerable and humble in the creative process. Allow yourself to make images you don't like. Don't worry about what others think while you're creating, even if, in the end, you need to impress and win the approval of a client.

The "There's Too Many Tools" Challenge

All of those tools, palettes, and menus in Painter can be intimidating. How do you know where to go or what to adjust? Part of the purpose of this book is to help you master the choices and feel comfortable with Painter's tools and interface.

"The Blank Canvas Scares Me!" Challenge

The blank canvas can be scary. The blank canvas is both an opportunity and a challenge. It is pure potential, a masterpiece waiting to be actualized. Using the 'muck up' approach frees you of worrying about that first mark and having to "get it right." Your first mark is the key that turns on the ignition and starts the engine.

The "Decision Overload" Challenge

There are so many decisions to be made. How do I start? What do I include in my picture? How much background do I include? Where do I crop the composition? At what scale do I depict the subject? In what way do I apply brushstrokes to describe the subject? Which brushes should I use? It seems like an endless stream of questions. By following the methodical processes presented in this book, building up your foundation step by step, you transform the intimidating mountain of decisions into straightforward, manageable choices that follow one another in a logical order.

These challenges can all be overcome with training, practice, and patience. Whatever our experience and conditioning, we are all capable of mastering the beautiful brushes in Painter, overcoming our fear of the blank canvas, and expressing ourselves in our paintings.

12.3 Creativity

Process of Continual Transition

The Merriam Webster's Dictionary describes *creativity* as a quality of making, or an ability to make, something original rather than copied. Creativity can be looked at as a journey or a way or a path or a process, as opposed to a destination or a quality or an ability. Creativity is a process of continual

transition and discovery, where the end result evolves in an organic way, taking on a life and voice of its own. A good analogy is to imagine yourself surfing on a wave of creativity, where you have to continually respond to and improvise around ever-changing and unpredictable forces of nature. Awareness, balance, vision, trust, and intuition all come into play. You know the end result will be traveling from one location to another closer to the shore, but the exact place you end up and the experience along the way are different every time.

When you diligently follow a formula or recipe or set of instructions, you take a single fixed path to achieving a predetermined result. This may involve fighting the unexpected, suppressing and ignoring surprises, and getting frustrated when the end result differs from your original expectation. By contrast, creativity welcomes and celebrates the unexpected.

Discovery of a Path

Walter Murch, in his fascinating book *In the Blink of an Eye* (Silman James Press 2001, ISBN 1879505622), beautifully describes the process of surfing the wave of creativity. Murch makes the point, in discussing the enormous task of editing the film *Apocalypse Now*, that the actual rate of cuts per editor per day turned out to be 1.47, a process that takes under 10 seconds. It took Murch a year to edit his sections of the film. If he'd known exactly where he was going at the beginning, he could have just come in for 10 seconds of work each day and taken the same time! His point is that creativity, in this case film editing, "is not so much a putting together as it is a discovery of a path."

Murch describes the creator/editor as evaluating different pathways. The more possibilities that compound on each other, the more pathways there are and the more time is needed for evaluation. Designer Barbara Barry expresses a similar sentiment when she says, "Creation is about making layers of complex decisions to arrive at a profound and simple final product."

In Painter, whatever my visual goal, I find myself entering a path of creativity that's always full of surprises and discoveries. I find myself exploring many different pathways and possibilities, trying this brush, trying that effect, tweaking this slider, and so on.

Surfing the wave of creativity is discovering a path. This is true even when you have a specific visual destination, or end result, in mind. Treat the digital canvas as an ever-changing, continually malleable clay or liquid surface. Let intuition, spontaneity, improvisation, and serendipity guide your creative process. Value the creative process as highly as the end result or final product. Part of the magic of Painter is that it allows you to continuously utilize and recycle your creative process to generate new possibilities for evaluation.

Surfing the wave of creativity is an ongoing process and attitude, not just an end result. There are countless potential end results along the way. This applies whether you are painting a portrait or transforming a photograph.

Surfing the wave of creativity frees you from the tightness and fears associated with needing to get things right. It allows you to let go of the preciousness of the end product. Your artwork will show more life and integrity by taking a process-oriented approach to creativity.

Improvising in the Moment

Surfing the wave of creativity involves improvising in the moment. The unexpected will always happen. The only question is how we react to the unexpected. Surfing the wave of creativity involves flowing with what *is* rather than giving up. It involves seeing the unexpected as an opportunity rather than a barrier. Treat your journey in creating a painting as a path of continual improvisation. When something happens that you don't like, see it as an opportunity to make your picture more interesting. The unexpected can often be a launching point or catalyst for creative growth.

Improvising in the moment requires being in the moment. We have all experienced that sensation of being one with the moment at one time or another. Paul Siudzinski describes this beautifully in his book *Sumi-e: a Meditation in Ink* (Drake, 1978) under a section titled "A Painter Is a Dancer with a Brush":

We all know the difference between self-consciously watching ourselves dance and being swept away with the music. When we simply allow our body to move, the mind empties. Knowing we are free and one with the music, we experience an exhilarating feeling of release. The energy that comes from being directly connected to our inner self is so powerful that even those who do not consider themselves dancers will, at such moments, want to "dance all night."

Overcoming Fear

The biggest barrier to surfing the wave of creativity is fear: fear of letting go, fear of missing out, fear of starting, fear of completion, fear of imperfection, fear of failure, fear of inadequacy, fear of computers, fear of the unknown, and fear of other people's judgment. Do any of these ring a bell? They certainly do for me! As Earl Wilson once said: "Courage is the art of being the only one who knows you're scared to death."

The blank canvas can elicit both fear and excitement. To start creating, we need to overcome our fears and open ourselves to being vulnerable and exposed. We also need to forget old patterns, attitudes, and habits. This is always easier said than done.

Every time I am about to begin a live digital portrait in front of an audience, I face fear. A voice in me asks: What if it ends up looking nothing like the subject? What if I make a fool of myself? and so on. Yet it is that very risk, of plowing into the unknown, of being vulnerable, of creating something spontaneous and unrehearsed, that excites and interests the audience and that keeps me learning and developing. The presence of the audience may amplify my fear, but those fears are present to some extent even when I'm on my own and no one is watching. Thus my creative process is a continual dance with letting go and overcoming fears. The keys to overcoming these fears are commitment, trust, and acceptance. A book that explores the fears that get in the way of art making is *Art and Fear: Observations on the Perils (and Rewards) of Artmaking* by David Bayles and Ted Orland (Image Continuum, 1993). Helen Keller expressed a simple truth regarding the futility of fear: "Avoiding danger is no safer in the long run than outright exposure. Life is a daring adventure or nothing at all."

Commitment

Commitment has power. Be committed to the process of learning and experimenting. Be committed to taking risks. Be committed to persevering even when the going gets tough! The easiest way to be committed is to be highly motivated. The easiest way to be highly motivated is to focus on something you care about. Passion is the great motivator. When you care and are passionate about what you are doing, the creative process becomes an exciting and energizing journey. In this situation there is no effort in appreciating the process: Work becomes pleasure.

Commitment applies on the micro-level as well as the macro. Be committed not only to the creative process in general, but in the case of painting also be committed to your individual brushstrokes. I recommend avoiding undo's and erasing. Commit yourself to your marks on the canvas. When you hit a block, when you feel like giving up, when it's no longer fun, be committed to pushing a little further, to entering the region of discomfort, not to giving up immediately.

Every brushstroke and mark on your canvas adds richness and depth to your painting, even those marks you may feel were wrong. There's no such thing as a mistake, only transitions in the creative process.

Trust

Trust in yourself and in the creative process. We are all born artists. Babies are not separated into artists and nonartists. All children will naturally draw when they get their hands on mark-making tools (after trying to chew and eat them, of course!). If you have any doubts about being an artist, just think back to being a child, when the label *artist* didn't matter. Allow yourself the freedom to be creative. Listen to your inner voice. In trusting the creative process you become one with the creative process—totally absorbed. It is safe to be vulnerable. It is safe to express your emotions honestly in the creative process.

Acceptance

Acceptance means acceptance of how we are, who we are, and what we create. Do not be overcritical of yourself. You may initially struggle with finding your way around the Painter palettes, you may not be satisfied with your artwork, you may get frustrated, and you may get stuck—that's okay. Sometimes it's necessary to go through discomfort to be able to progress.

Accept imperfection. Accept that the creative process sometimes involves frustration. Acceptance allows us to open ourselves to the intuitive, to flow with the organic unfolding of the painting, to enjoy improvisation, to relish the role of serendipity, the accidental, and the unintentional. There is no such thing as a mistake in your creative process, simply marks that add to the richness and character of your creation.

Take Time to Smell the Roses

Everything written here could equally well apply to any creative, expressive activity —dance, making music, writing, and so on. Understanding the nature of the creative process will help you make the most out of Painter's incredible potential. Using Painter is unlike using Photoshop and other digital imaging tools in that it is not a formula- or technique-driven activity. The beauty and power of Painter is as much what emerges that is unexpected as it is achieving a predetermined result.

Surfing the wave of creativity can result in unintended positive consequences that go far beyond realizing your creative potential in using Painter. You may find yourself being less attached to perfect end results in other aspects of your life, and you may discover that the journey itself is a source of great joy and satisfaction. Take time to "smell the roses" on your creative travels on and off the digital canvas!

12.4 Learning from Other Artists

Expand Your Vocabulary

Studying and exploring other people's art can help you find your own artistic voice. In this section the focus is on how other people have expressed their voices through their art. It is the unique, individual, and recognizable style of an artist that expresses his or her voice. By copying, emulating, and learning from the style and technique of other artists, by trying on their visual mindset, you can feel what works for you and what doesn't. Doing this expands your expressive vocabulary.

We shall start this section by looking at four different contemporary artists who take different approaches in their use of Painter. These four artists give an interesting variety of styles and approaches to learn from. Each artist was asked to share reflections on the influence Painter has had on the development of his or her own artistic identity and style. Darrell Chitty and Tana Powell are both students of mine who have taken my Painter Panache classes. I recommend you refer back to the Student Gallery at the end of Chapter 4 and look at the magnificent work shown there. Just from those few samples in the Student Gallery you will see how each artist expresses his or her own individual style and identity in the artwork, ranging from Myra Gordon's bold, colorful brushstrokes to Paul Tumason's richly detailed oil paintings. Any one of those artists featured in Chapter 4 could equally have been featured here as examples of artists expressing their own individual style.

A common element in the body of work from the four artists featured here is that of experimentation. For instance, Bill Hall and Tana Powell each show a distinctive style in their commissioned artwork and show a looser style in their personal artwork. You can see this looking at other artists throughout history. Compare John Singer Sargent's commissioned 'high society' portraits with his loose landscape and scenic watercolors from his trips to Italy. The lesson here is: Don't be constrained by fitting in to just one style.

Some of these case studies include techniques you may find useful (such as Bill Hall's multilayered art-in-motion technique).

Following the case studies are two specific projects, one copying the work of different artists and one emulating the styles of those artists whose work you copied.

Other Artists Case Study I: Darrell Chitty

Darrell Chitty has been a photography portrait artist for 24 years. His plantation studio is located in Bossier City, Louisiana. An admiration of the great master painters of the past and the Impressionistic style in particular are why he became attracted to Corel Painter. With only two years' experience using Corel Painter, his excitement for this painting program has driven him to learn as quickly as possible.

Through the years I have made it a point to seek out and associate with some of the world's greatest artists in both photography and traditional painting. I also submerge myself in the lives of the great masters of the past, with the belief that by doing so I will eventually discover my own personal identity. My greatest fear is that I will go through my professional life without making a lasting contribution.

Painter has provided a tool which I feel will revolutionize the art world as we presently know it. It is a challenging program that dares the artist to attempt to master. It complements, not replaces, the vital fundamentals of art creation.

My love for portraiture and for impressionism draws me towards the styles of Sargent, Renoir, Sorolla, Hassam and the list goes on. I would describe my style as "Expressive Realism," which allows the best characteristics of impressionism and realism. While I have been a student of Painter for only a short time, I am excited for where it has led me and am anxiously looking forward to tomorrow.

Thank you for opening the door which now allows me to create paintings I see and feel in my heart but could never be reproduced only with photography. It is gratifying to be able to offer a product that very few in the country can duplicate. I cannot wait to see where Painter will lead me in another two years!

The "Bayou Belle" (Figures 12.1 through 12.3) and "Lady at the Window" (Figures 12.4 and 12.5) were both created by Darrell during Painter Panache Master Classes. He continued the theme of Expressive Realism in "Contemplation" (Figures 12.6 and 12.7).

Figure 12.1 Source photograph for "Bayou Belle."

Figure 12.2 Muck-up stage in the creation of "Bayou Belle."

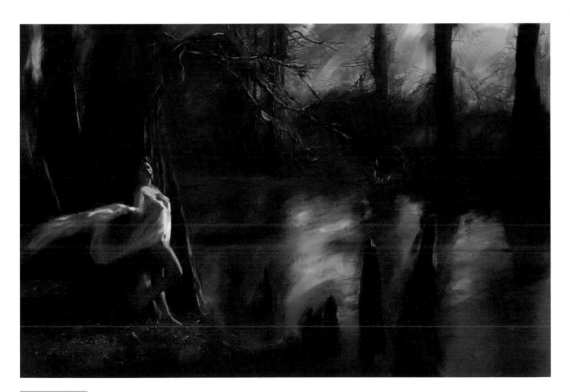

Figure 12.3 "Bayou Belle."

Figure 12.4 Source photograph for "Lady at the Window."

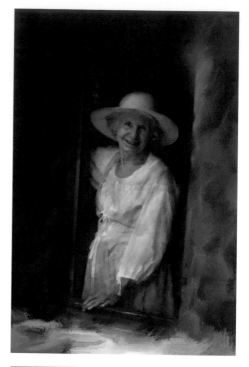

Figure 12.5 "Lady at the Window."

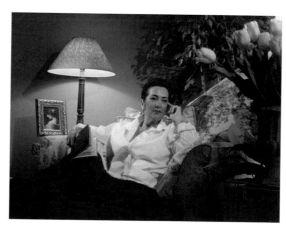

Figure 12.6 Source photograph for "Contemplation."

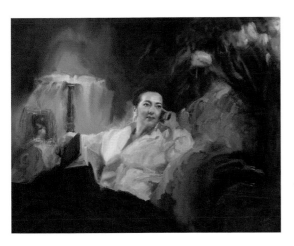

Figure 12.7 "Contemplation."

Figure 12.8 Source photograph for "Captain My Captain."

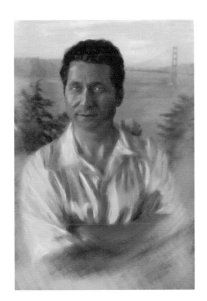

Figure 12.9 "Captain My Captain."

Figure 12.10 Source photograph for "Beacon of Hope."

"Captain My Captain" (Figures 12.8 and 12.9) shows a departure from the classic oil painting approach of the previous three examples.

In "Beacon of Hope" (Figures 12.10 and 12.11) you can see how Darrell is exploring the effects of light and atmosphere, changing a scene from daylight to moonlight.

Figure 12.11 "Beacon of Hope."

Other Artists Case Study II: Bill Hall (billhall.com)

Bill Hall is an artist and illustrator based in Cedar Hill, Texas. Bill has been painting for over 25 years and using the computer and Painter for 10 years. His clients include: MasterCard, Chrysler, Frito-Lay, Coca-Cola, Federal Express, Pepsi, Miller Brewing, Ameritech Seniors Open, the LG Championship, and the New York Marathon. His paintings are included in many public and private collections.

I am a traditionally trained artist who stumbled onto Painter purely by chance. I was struck by how it allowed me to paint essentially the way I had always painted. I could select a brush, select a painting surface, and simply start painting. I could use thinned paints or opaque. I could use large brushes or small. The big difference was Painter gave me a safety net. It allowed me to be brave, experiment, and take chances. In essence, it allowed me to develop as an artist, much quicker than I would have if I had worked only on canvas.

Finding your personal voice as an artist has to take place on an emotional level. It is a search for self. You discover, through your work, your likes and dislikes, what appeals to you on a gut level. Through this creative process, you learn from your failures as well your successes. Your uniqueness is defined by your likes and dislikes, and those tastes are developed through your experiences as an individual. If you are honest with your feelings, your style will develop naturally. This process can't be forced. It is necessary to produce a lot of bad art before you can produce good art. Painter can help make this process a lot less painful.

Because Painter is so similar to traditional media, I can take what I learn and apply it to my art, no matter what media. In fact, many times I do studies for a piece, and work out many of the kinks in Painter. I will then use that reference as a springboard or starting point for the final oil or acrylic on canvas painting.

Figures 12.12 through 12.16 are good examples of Bill's commercial work. They show his distinctive style of using loose, freehand brushwork to capture action in motion. What follows is a brief summary of how Bill creates this look using Painter.

Prepare Reference Image
Bill starts with a printed photograph, which he uses for visual reference. Sometimes he may scan two or three photographs and piece them together in Photoshop to get the design he wants. In the example

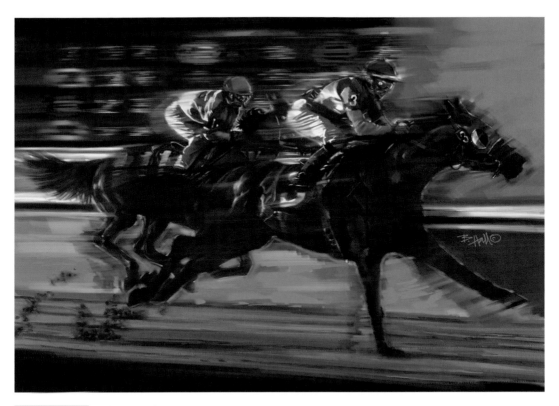

Figure 12.12 "The Stretch."

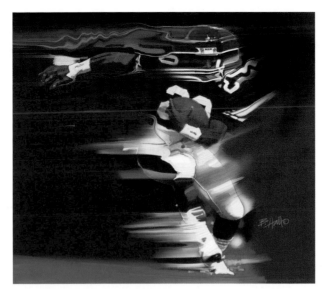

Figure 12.13 "Football."

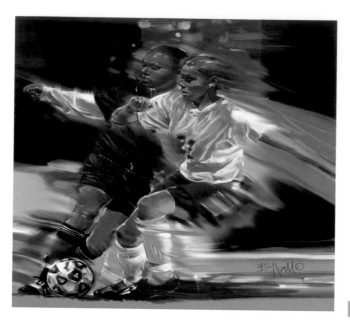

Figure 12.14 "Women's Soccer."

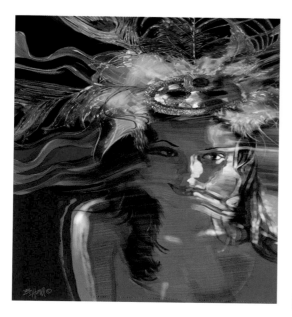

Figure 12.15 "Mardi Gras."

shown in Figure 12.12, "The Stretch," Bill picked his reference image (Figure 12.16) because most of the detail is lost in shadow. He usually deviates considerably from his original photographs, though in this case he elected to go with the positions pretty much as is and changed the faces, numbers, and silk colors. Once Bill has his reference image ready, either he will have a printed version on hand to look at as visual reference or he will open the image in Painter and place it on his second monitor to look at.

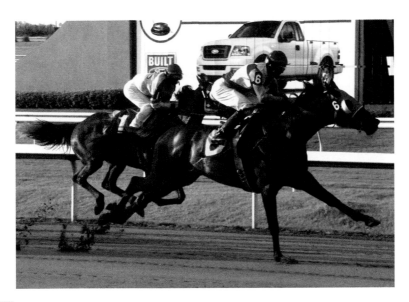

Figure 12.16 The reference image.

Create a Pencil Drawing on a Layer Above the Blank Canvas

Bill opens a new, blank white canvas in Painter. He creates a new layer (New Layer from Layers palette pop-up menu), which he names "pencil" (double-click on a layer to name it). He makes sure Preserve Transparency is unchecked in the Layers palette. He chooses one of the pencils, for instance, the Thick and Thin Pencil, and modifies it, changing the Brush Controls > General > Method Sub-category from Buildup to Cover. He picks a gray color, with a value of about 13% and hue and saturation both zero. He reduces the brush opacity to about 30% and experiments until he gets the feeling of pencil sketch.

Once he has his pencil adjusted correctly, he then creates a freehand line drawing of his composition in Painter (Figure 12.17). He does so without using the Tracing Paper feature or Clone Color. Instead he relies on direct observation of his reference image (which is either on a second monitor or a hard-copy print). This approach produces a looser sketch than if he used Tracing Paper. Another way Bill finds he gets a looser, more natural feel to his pencil drawing is to wear on his drawing hand a thin cotton glove (of the type sold for handling fine art), with the fingers cut off for holding the stylus, so that his hand slides smoothly across the tablet surface as he draws.

Once he is done with the drawing he cleans it up by erasing lines that are confusing, leaving just the main contours. He erases by turning his stylus on its end and using the erase tool at the end.

Fill in Blocks of Color Using Lasso Selections on the Canvas Below the Pencil Layer

Bill selected the canvas below the pencil layer in the Layers palette (Figure 12.18). Using the pencil layer as a loose visual reference, Bill starts making quick, rough selections with the Lasso tool over regions that he wants to fill with a uniform color. He doesn't worry about following the pencil lines exactly. After making each selection he feathers it by about 12 pixels (Select > Feather). The feather-

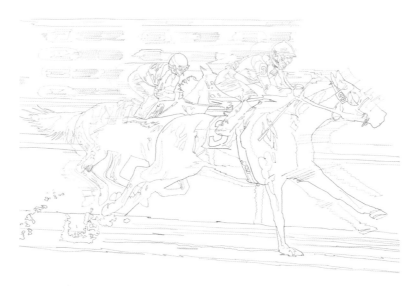

Figure 12.17 The pencil drawing created on a layer above a blank canvas in Painter.

Figure 12.18
Selecting the canvas
below the pencil
layer.

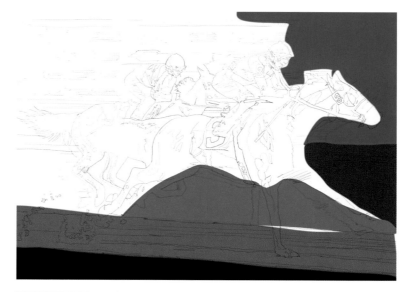

Figure 12.19 Filling in color blocks beneath the pencil layer.

ing gives a softer edge to the blocks of color. After feathering, Bill chooses the color he wishes to fill that area with, typically a mid-tone color. He then chooses Cmd/Ctrl-F (Effects > Fill) and fills with the current color (Figure 12.19). He hides most of the white as quickly as possible. The resulting rough blocks of color are imprecise and loose. They serve as an undercoat for the painting.

Bill commented that this method of quickly filling big color areas overcomes any fear of tackling the blank canvas and allows him to feel good about the image before proceeding with detailed rendering. Bill likes the advantage of working digitally, with the pencil drawing preserved in a separate

layer (Figure 12.20). By not losing or destroying the pencil drawing as he fills with color, he is freed up to be looser on the canvas.

Apply the Loaded Palette Knife in a Modeling Layer Below the Pencil Layer

When the blocking out of the canvas is complete, Bill creates a new layer, which he names "modeling," above the canvas and below the pencil layer (Figure 12.21). Here he applies his lights and darks to define the forms (Figure 12.22). He uses the Palette Knives > Loaded Palette Knife, size 8 to 15,

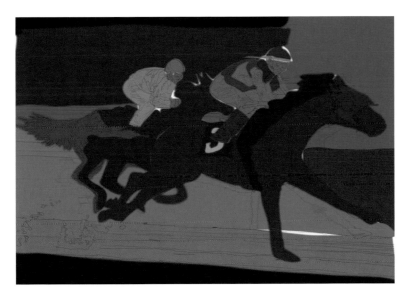

Figure 12.20 The blocked-in canvas with the pencil layer above it.

Figure 12.21 The modeling layer is active.

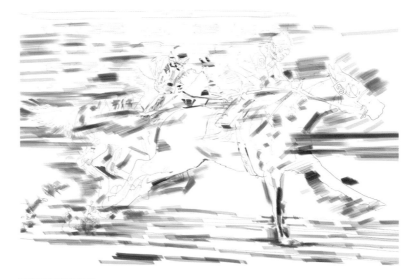

Figure 12.22 The modeling and pencil layers superimposed.

opacity 48%, resat 14%, bleed 78%, feature 0.8 with color variability set to value 6%. He ensures Pick Up Underlying Color is checked in the Layers palette. This Loaded Palette Knife has the dual property of both moving paint around and adding color to the canvas.

Bill starts modeling the part of his image that intimidates him the most—for example, the face, putting in opaques (darks) and lights with the palette knife (Figure 12.23). Bill comments that when the tough part starts feeling good, the rest of the painting seems easy. He finds he sometimes overworks a piece. His goal is to save the freshness of the beginning.

Creating a Blending Layer Above the Pencil Layer

One of the last things Bill does is to create a new layer above the pencil, which he names the "blending" layer (Figure 12.24). He applies the Loaded Palette Knife to add paint and a regular (unloaded)

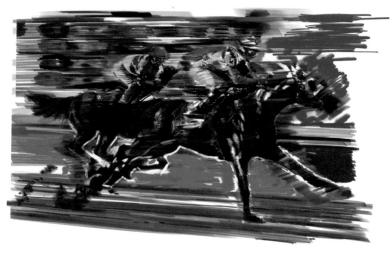

Figure 12.23 The modeling layer in progress.

Figure 12.24 Bill creates a blending layer above the pencil layer.

palette knife just to move paint around. Using these tools he works the pencil into the paint so that some disappears and some doesn't (Figures 12.25 and 12.26).

Through the entire creative process, Bill endeavors to keep his painting spontaneous and loose. This is reflected in the energy and vitality of his work. Bill saves all his work in progress files in Photoshop file format. Photoshop file format is convenient for him to switch back and forth to between

Figure 12.25 Starting to blend the colors and pencil line work.

Figure 12.26 Note the use of the palette knife brushstrokes to create the impression of speed and movement.

 "Sansei."

Figure 12.28 "Agave."

Painter and Photoshop while preserving the layers (he doesn't use Watercolor or Liquid Ink). He keeps his file in layers until he is totally satisfied. He then flattens the artwork and, in Photoshop, converts the file from RGB to CMYK for printing.

Personal Fine Art Work

To Bill, the difference between his commercial and fine art work is not so much technical or stylistic as it is a matter of motivation. He considers his work fine art, no matter what style, if it is painted to please himself, and commercial if it is painted to please someone else. Figures 12.27 and 12.28 represent two studies that Bill did in Painter as part of a new series of abstracts he is excited about. From these studies Bill will paint the final compositions about 6' square, oil on stretched canvas. He works in thinned oil washes, relying on brushwork to blend and diffuse the subtle colors.

Other Artists Case Study III: Richard Noble (nobledesign.com)

Richard Noble is a commercial illustrator and fine artist based in Eagle, Idaho. Richard has been creating designs, illustrations, and fine art since the 1970s and has used Painter since it was first released in 1991. He was a pioneer of digital archival printing and was responsible for applying an outdoor billboard printer (the Vutek printer) to the fine arts field back when it was the only printer to use pigmented ink. I was one of the artists that Richard turned onto the very large Vutek fine art prints in the early to mid-1990s. Richard continues to work commercially while actively pursuing his fine art painting in his new studio with an Epson printer for output.

I started painting very early and long before there were computers or the software Painter. I attended art school and learned the traditional methods for both fine arts as well as commercial art and illustration. For years

after graduating, I used the skills in various advertising agencies, and then the Mac arrived and began to change everything in the advertising and marketing world. I could see the potential and began to fully employ the computer in the advertising world in my day-to-day business. As software became better and CPUs became faster, more and more of the work was done digitally and it improved with the changes.

However, on the fine arts side of my brain there was no good program to allow artists to sketch and paint digitally. Finally along came Painter and filled the void. It harnessed the traditional skills, added speed and more complexity to enhance images. Now I use Painter as a vehicle to sketch and paint as before, but also to combine images that could never have been. In addition, I can work on several levels, sketch on one layer, paint on another, and paste images on a third or fourth. All of this doesn't take away from the artist's hand work; it just enhances the ability to explore far more complex expressions. Old World craftsmanship and New World tools. Good combo.

The first painting shown here, "Piano" (Figure 12.29), is the image that blew me away when I saw it in the Ansel Adams Gallery, San Francisco, during a Macworld Conference art event in 1992. It was printed on canvas, approximately 7 feet wide by 5 feet high. That image inspired me to create large works and experiment with the Vutek prints.

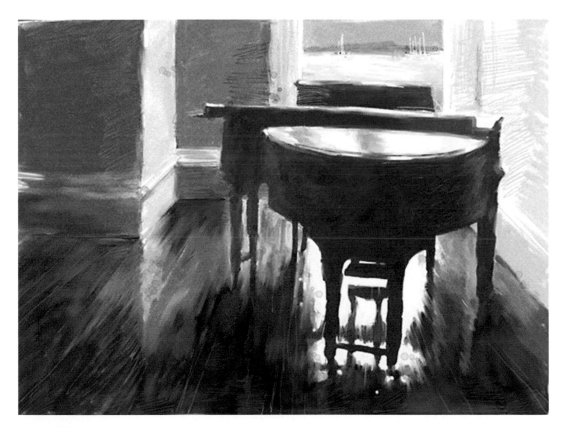

Figure 12.29 "Piano."

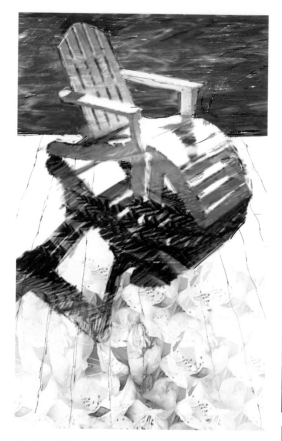

Figure 12.30 "Chair."

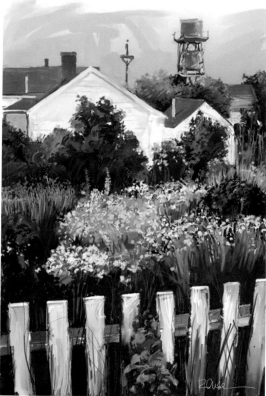

Figure 12.31 "Garden."

"Chair" (Figure 12.30) is another painting of Richard's from the early 1990s. You can see here how he mixed paint with photography in interesting juxtapositions.

The paintings in Figures 12.31 through 12.35 are part of a contemporary series of works based on Richard's visits to the Mendocino coast in northern California. To create these paintings he initially uses the Oils > Round Camelhair brush, making it larger and smaller. Richard then works into the details with the Airbrushes > Fine Detail Air and a small Pastels > Artist Pastel Chalk. He then goes back with a blending tool and softens certain areas so it doesn't look like he's sketched over a painting. He also used the Artists > Sargent Brush at various times in the construction of these works because it blends and adds a specified color at the same time, giving a nice "painterly" look.

The final work of Richard's presented here (Figure 12.36) shows a watercolor style.

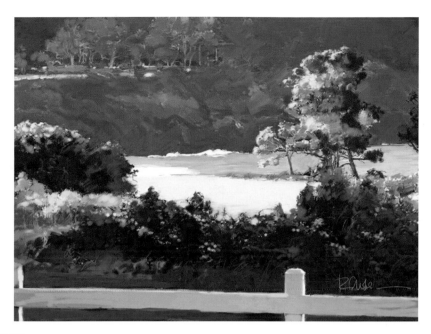

Figure 12.32 "Coast."

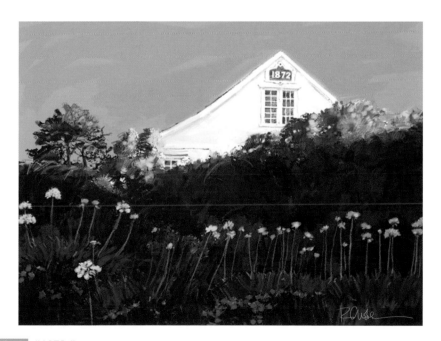

Figure 12.33 "1872."

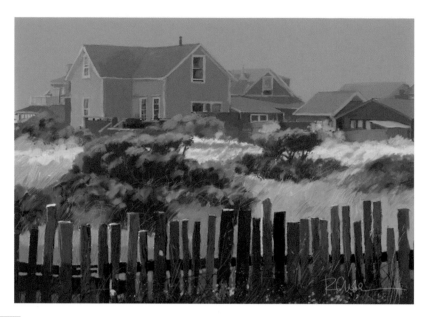

Figure 12.34 "Fog."

Figure 12.35 "Geese."

Figure 12.36 "Marsh."

Other Artists Case Study IV: Tana Powell (tanapowell.com)

Tana is a commercial illustrator and fine artist based in San Francisco, California. Her extensive client list includes Pacific Bell, Kaiser Permanente, Southwest Airlines, Hallmark Cards, Pacific Gas & Electricity, and Young & Rubican. Tana was trained in the fine arts and has been painting with acrylics and other media commercially for over 20 years. She started using Painter in 2004.

I work as both a commercial illustrator and a fine artist. My styles are different for each discipline. I have found Painter to be a magnificent too for all of my work. The biggest advantage for me is that I travel so much, and not having to bring my entire studio of brushes, paints, canvas, and large pads of tracing paper is fantastic. I can work as a travel, be more productive, and still achieve the various facets of my life.

As I came to know Painter it has influenced me in how I approach my illustration style. I now follow the direction of a wetter and looser feel after having successful experimented and created fine art pieces.

As Painter is so flexible and provides many choices in style, brushes and variants, and color sets. The range of freedom and choice is unlimited, and hence I feel free to push my capabilities and visions. The undo factor and ease of accessibility for choices is so readily available that I do not hesitate to explore. It is a perfect fit for my style and technique to build subtle layers, exposing underlying layers, edges, and textures.

I slipped into Painter with great ease. How I handle my tools traditionally and with Painter is very intuitive. I have found the time in creating pieces much quicker and no cleanup.

The first three images of Tana's shown here (Figures 12.37 through 12.39) are all created nondigitally with acrylic paint on various substrates. They give a good sense of Tana's distinctive illustration style.

The "I Forgive You" image (Figure 12.40) was created during a Painter Panache class that Tana attended. It shows her adapting Painter's capabilities to her own style of artwork. Here are the main steps she followed in creating "I Forgive You."

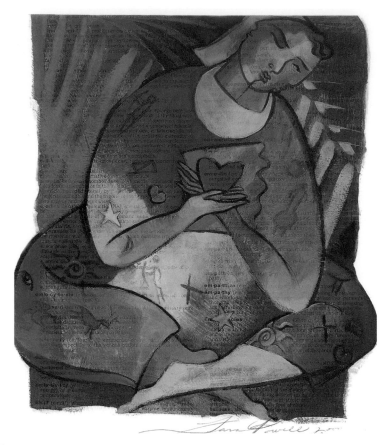

Figure 12.37 "Heart" (16" × 12" acrylic on dictionary page).

Figure 12.38 "Dance" (48" × 30" acrylic on canvas).

Figure 12.39 "Tree of Life" (14″ × 11″ acrylic on gessoed paper).

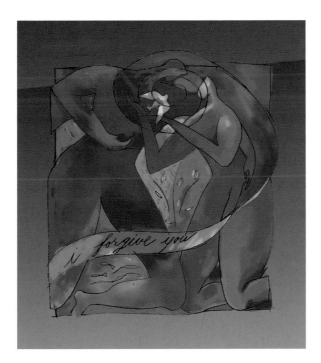

Figure 12.40 "I Forgive You," created with Painter.

Making the Scanned Line Drawing into a Layer

Tana chose Select > Auto Select. In the Auto Select window she chose Using: Image Luminance. This selected just the dark pixels in the image. She then chose Select > Float. This lifted the selected region, which was the black lines from the drawing, into a separate layer (Figure 12.41).

Filling the Canvas Beneath the Line Drawing Layer with Two-Point Gradient Fill

Tana then selected the first color of the Two-Point gradient, clicked on the swap arrows to swap around the main and additional colors. She then selected the second color for the gradient. She chose Window > Library Palettes > Show Gradients. She moved the red dot around in the gradient window to orient the colors correctly. She selected the canvas in the Layers palette and chose Cmd/Ctrl-F (Effects > Fill), using current gradient (Figure 12.42).

Painting on the Canvas Beneath the Line Drawing Layer

Tana then painted and blended paint on the canvas layer below the line drawing layer (Figure 12.43). As with Bill's technique, Tana was appreciative that her line drawing remained visible and intact.

Figures 12.44 and 12.45 show the fine art side of Tana's work. Tana's daughter, Landis, is featured in them.

Figure 12.41 Scanned line drawing originally created on paper with ink pen.

Figure 12.42 Two-point gradient fill beneath the line drawing layer.

Figure 12.43 Painting and blending on the canvas beneath the line drawing layer.

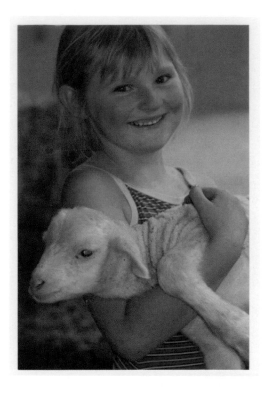

Figure 12.44 Original photograph of Tana's daughter, Landis, holding a lamb.

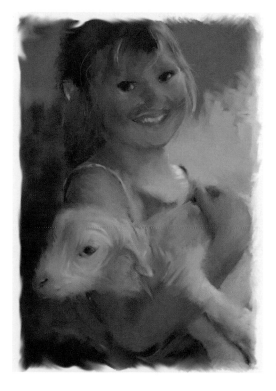

Figure 12.45 "Landis and Lamb."

Copying from Other Artists

In this lesson you learn from copying the artwork of other artists. Research different approaches to painting. Visit the library, surf the Internet, look at art postcards, art books, and art magazines, and visit art museums and galleries. Select two paintings, one each by two artists with contrasting and distinctive styles. It's good practice to choose one style you feel an affinity to and one you'd never normally choose to do. Make a copy of each painting. Ideally choose a painting you can look at directly, since photographs and prints in books cannot reproduce faithfully the colors in a traditional oil painting. Don't just scan a photograph and clone it. Actually copy by observing and painting.

I chose to copy "Femme au Chapeau" (Woman with the Hat), a 1905 oil on canvas painting (31″ × 23″) by Henri Matisse. It is a painting that appeals to me in its vibrant, bold use of color. I was fortunate to be able to paint it (Figure 12.46) with reference not just to photographs but also to the real painting, which sits in the permanent collection of the San Francisco Museum of Modern Art. I was amazed how different, and more vibrant, the colors in the real painting were compared to any photographic reproduction (I also referred to a postcard of the painting).

Figures 12.47 and 12.48 show a couple of stages of my copy. In addition to looking directly at the real painting, I scanned the postcard image and placed it next to my canvas on my screen for visual reference. I would have preferred to paint the whole image from direct observation of the real painting, but the museum guards weren't keen on my sitting in front of the piece with my laptop!

Here's what the museum display description says about "Femme au Chapeau":

Matisse infused this portrait of his wife, Amélie, with a formal dynamism that helped define early Modernism. One of the "radical" paintings that ignited controversy at the 1905 Salon d'Automne in Paris, Femme au Chapeau was placed under the mantle of Fauvism, a movement christened by the art critic Louis Vauxcelles when he denigrated the canvas's on view in a Salon gallery as "fauves" (wild beasts).

The painting exhibits a number of pictorial strategies common to Fauvism. Matisse deliberately composes his figure with unexpected and shocking colors, and each bright brushstroke maintains its autonomy as paint on the canvas. Above all, color functions expressively: Matisse's vibrant palette is intended to convey the essence of the painting's subject. When asked about the hue of the dress Madame Matisse was actually wearing while she posed, the artist allegedly replied, "Black, of course."

As you paint your own copies of the two pieces you choose, try putting yourself in the mind of the artist. Imagine what she or he felt like creating the piece and what she or he was trying to convey. When you've completed your copy, compare it to the original and ask if it works as well. If it doesn't, try to understand what's not working, and correct it. This can be the most useful part of the exercise. It makes you realize what goes into making a painting work. In the case of "Femme au Chapeau" I was surprised at how much I still had to adjust to get the picture feeling right.

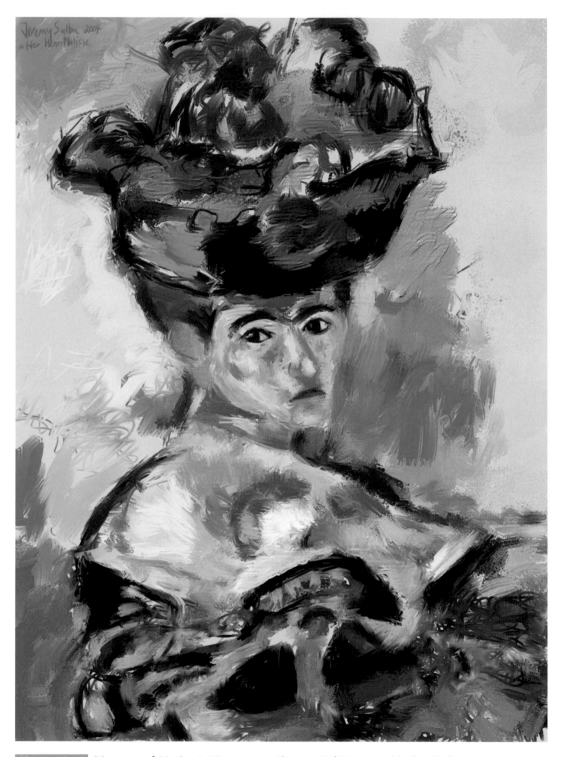

Figure 12.46 My copy of Matisse's "Femme au Chapeau" (Woman with the Hat).

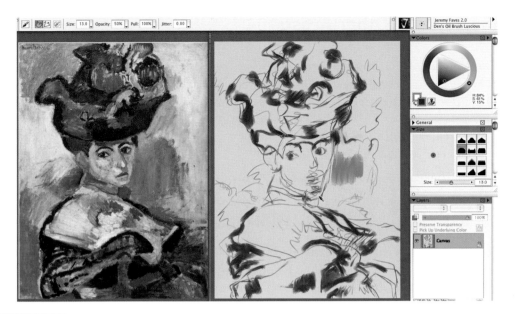

Figure 12.47 Beginning stage.

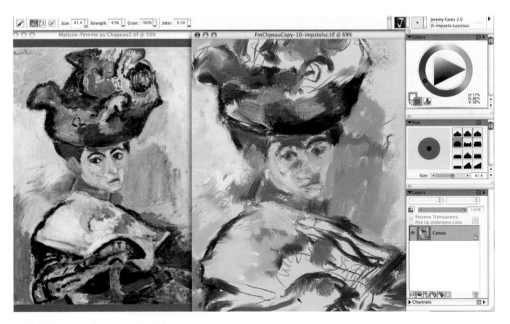

Figure 12.48 Coloring in the copy.

In the Style of Other Artists

This project is a continuation of the previous exercise. This time you are to create two original paintings of your own subjects and compositions. The project goal is that your paintings should emulate the style of the two artists you chose in the last exercise. These exercises are designed to:

1 Expose you to different approaches to portraiture.

2 Put you in the mindset of the other artist.

3 Get you to imagine the process the other artist went through.

4 Expose you to a wide range of exciting stylistic possibilities.

5 Help you explore stylistic choices you might not make otherwise.

Figures 12.49 through 12.52 present my painting of my mother, Margaret, created following the style of Matisse's "Femme au Chapeau," the original photo, and two intermediate stages. You may notice that the portrait in the midway stage looks a little wider than the final picture. I tried an experiment and placed the source photo under the plastic flap in the active area of the Wacom tablet. What I forgot was that the entire tablet active surface is set to map to the entire screen and, since they have slightly different aspect ratios, there's a slight distortion. I later corrected for this. As I was finishing

Figure 12.49 "Femme sans Chapeau."

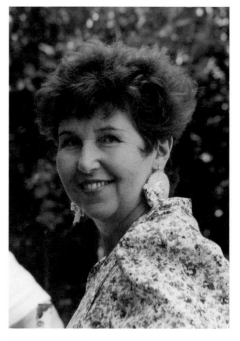

Figure 12.50 The original photo.

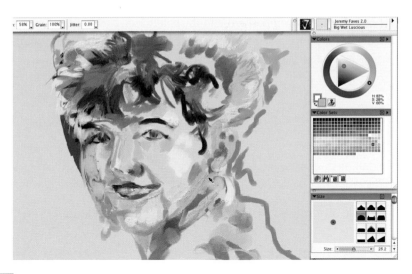

Figure 12.51 Early stage.

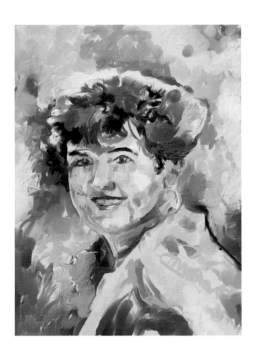

Figure 12.52 Midway stage.

the painting I struggled with the composition and the balance of dark contour lines to bright color patches, trying to create a balance and power that matched the original Matisse painting. My struggles gave me a whole new appreciation of the talent and skill employed by Matisse in his work.

Questions

1 Which artists did you select?

2 Why did you select these artists?

3 How did you find the task of trying to both copy and then emulate other artists' styles?

4 Which was easier, and why?

5 How has this experience influenced how you want to approach painting?

12.5 Order from Chaos

Project Overview

The principle of this exercise is simple: First create a chaotic abstract painting, and then work into the paint and start shaping the chaos into a subject, gradually refining the painting, adding paint, and moving paint around, until you have depicted your subject. Try this with direct observation of yourself in a self-portrait or of another subject. Do not use Tracing Paper or clone color.

This project deals with transformation and trust in your creative process. Now is the time to allow yourself the luxury of forgetting everything you've done prior to this. You are going to focus on enjoying flowing with the organic nature of the painting process. Don't try to get things right. Trust yourself to integrate all of your experiences over time and to allow newly learned skills to become second nature. This is the point where you fully immerse yourself in the creative process.

This exercise aims to:

1 Expose you to living on the edge, to trusting your intuitive creative flow.

2 Free you from the fear of making a mess or a mistake.

3 Help you embrace chaos and generate order out of chaos.

4 Encourage you to exercise freedom of transformation and regeneration on the digital canvas.

5 Enable you to experience the perpetual destruction–creation cycle in the creative process.

6 Get you to express your voice, your personality, your feelings, and your individuality.

Steps

If you would like step-by-step guidance, here are some suggested steps. Feel free to use a different file size.

1 Choose Cmd/Ctrl-N.

2 Open a new canvas 700 pixels wide by 900 pixels high (7 inches by 9 inches at 100 dpi).

3 Choose Cmd/Ctrl-M to mount the canvas.

4 Choose Window > Zoom to Fit. Zoom out further, using the Cmd/Ctrl-"-" command, to suit your screen size and palette arrangement.

5 Hold down the Spacebar and drag your canvas into a convenient position on the screen.

6 Place a mirror next to your computer screen.

7 Spend a minute just observing yourself in the mirror. What do you see? What do you feel? What do you want to express about yourself in your self-portrait?

8 Create a chaotic mess. Have some fun. Be bold. Be wild here. Play! Don't be timid and don't try to make the picture look like a portrait at this stage.

9 When you have filled the canvas with paint and had sufficient fun, click your Save As button and save the file at this stage.

10 Now start bringing in the influence of what you see in the mirror. Start indicating the major areas of light and dark. Be loose and free in your brushstrokes. Avoid getting bogged down in detail. Try using brushes that move paint around, such as the Gooey: Pinch or the Brushes: Palette Knife, to build up the shapes you observe and to communicate form.

11 Keep working on this picture. Work through the "ugly stages." Treat the canvas as ever-transforming malleable clay. Layer paint on top of earlier strokes. Don't erase or undo, just continue painting.

12 When you have worked the entire canvas thoroughly and are satisfied that you've reached a point of closure, click your Save As button. Save the resulting image.

An alternative version of this exercise is to recycle other artwork and start a portrait, with your canvas being another image.

Questions

1 How did you find this assignment?

2 What was challenging?

3 What did you learn?

4 What do you think of the final result?

Figures 12.53 through 12.57 present my Order from Chaos Self-Portrait and some stages from the process of creating it.

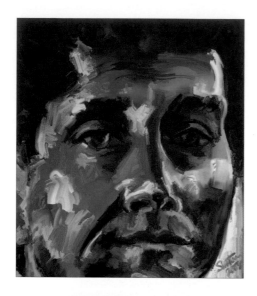

Figure 12.53 Order from Chaos Self-Portrait.

Figure 12.54 The Open > Browse window in Painter, showing all the saved versions of the painting (the browse feature seems to work only on the Macintosh platform).

Figure 12.55 The chaotic abstract image.

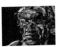

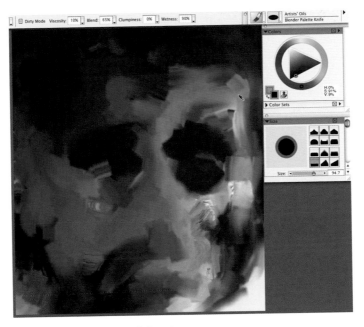

Figure 12.56 Sculpting the forms out of the chaos.

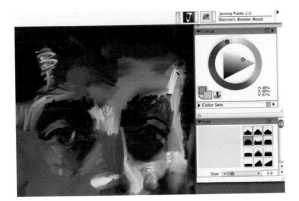

Figure 12.57 Detailing in the face.

12.6 Wrap

Congratulations! You've arrived at a stepping stone in your creative journey. I hope this handbook has been a helping hand along the way, a catalyst to your continued growth and development on all levels, and has propelled you to stretch yourself into new, exciting territory. Remember to be bold, to experiment, and, above all, to be yourself.

Appendix I
Project Checklists

Start with the End in Mind

1 What is my goal for this project? What do I wish to say? What size is my final product going to be? What medium will I use? To what use will it be put?

2 What sort of border do I want to create? Do I want the paint to blend into white for printing on water color paper and float mounting, or do I want the paint to bleed off the edge for a matted print or framed canvas? Do I need to add extra pixels to my original source image?

3 Based on my goals, what size of file do I need to work on (dimensions and resolution)?

Organize

1 Have I restarted Painter afresh?

2 What is the folder location where I shall save my project files on my hard drive?

3 How will I group saved versions (e.g., by project or date or subject)?

4 What naming convention will I adopt for all files connected with this project (e.g., YY.MM.DD-subject-01-brushused.rif or subject-01-brushused.rif)? (Make sure all title data to the left of the version number remains the same for all files for a given project.)

5 Have I resaved my original image with a name that clearly defines the file as my original (e.g., subject-00-ORIG.tif)?

6 Have I made a clone copy of the original?

7 Have I renamed the clone copy, getting rid of "clone of " and "ORIG" and adding a version number 01 (e.g., subject-01.tif)?

8 Have I saved the final version as a TIFF or Photoshop file with the letter F after the version number to signify Final (e.g., subject-12F.tif)?

Apply Art Principles

1 Is there a visually satisfying abstract underlying the image? Is there enough asymmetry to make an interesting composition? Are there strong, simple, diverse shapes?

2 Does the painting have a focus?

3 Am I painting lines when painting masses (solid regions) might be more effective?

4 What details can be eliminated to strengthen the painting?

5 Can the value range be increased? Is the balance between lights and darks working?

6 Do the lights and shadows successfully describe the form?

7 Do edges need sharpening or softening, and contrasts increasing or decreasing, to draw the eye to the focal point? Are the edges dynamic enough?

8 Are the shadows warm enough?

9 Do the whites have enough color in them?

10 Are the colors working from the points of view of tone, temperature, and contrast? Do my colors help generate the illusion of depth? Do my colors convey the right mood?

11 Is there enough variation in the texture of my paint? Is my choice of brushstroke length, thickness, shape, opacity, texture, and direction adding to, or distracting from, the power and beauty of my painting?

Appendix II
Troubleshooting

The World's Greatest Troubleshooters

I would like to begin this appendix on troubleshooting by sharing a story from my friend and adventure guide Olaf Malver (explorerscorner.com) about the world's greatest troubleshooters, the Eskimos—the Inuit indigenous people of the Arctic.

Eskimos have survived living in the most stressful conditions of almost any peoples. Every day presents them with troubleshooting challenges, whether it is their boat outboard motor's stopping without a garage in sight or a sudden snowstorm and subfreezing temperatures. They have adapted to surviving and thriving in harsh conditions over thousands of years by following three rules. These rules are surprisingly relevant to surviving and thriving in Painter.

Eskimo Survival Rule 1: Be Alert
The Eskimo people are at all times fully aware of their complete environment. They are at one with nature and respectful of nature. They are constantly observing the land and the sky, seeing potential dangers near and far, sensing what weather is coming. They are also constantly in touch with their bodies, heading off any chance of frostbite or injury. They are alert inside and outside.

This links up to the Painter Feng Shui discussed earlier in this book (Chapter 2). Be aware of the clutter and distractions in your environment and your Painter workspace, and, where possible, take actions to eliminate them. This will prevent many problems that arise out of confusion, such as hiding one palette behind another. Pay attention to giving meaningful names to files and layers; this saves a lot of time and effort trying to work out what's what. It's easy to get so absorbed on the computer that you lose track of time. Hours can pass with little body awareness or movement. Make sure you stretch and get fresh air regularly.

Eskimo Survival Rule 2: Be Practical
Eskimos live in desolate, isolated conditions. They cannot rely on technicians, mechanics, garages, or repair shops to solve their problems. When anything goes wrong, no matter what it is or how simple or complicated, they repair it. They recycle almost everything and improvise constantly with whatever is at hand.

In our busy lives it is easy to become reliant on quick fixes and having someone else around to take care of practical matters. In Painter, try thinking like the Eskimo. When you run into a problem, improvise and experiment. See every problem as an opportunity. This is the essence of the creative process. You'll find that whatever the outcome of the improvisation and experimentation, you will always learn something along the way. You will deepen your understanding of Painter.

Eskimo Survival Rule 3: Have a Sense of Humor

When all else fails, when the Eskimo people are in a situation they can't fix, they *laugh*! They grab every opportunity offered by adversity to laugh. They are very jolly people despite great hardships. Humor is their emotional valve—their way of externalizing rather than bottling up.

When you run into a problem, just as *The Hitchhiker's Guide to the Galaxy* says, don't panic! Instead pause, relax, reflect, and, if you feel totally lost, laugh! Don't give up in despair or frustration. If necessary, take a break, turn your computer off, and come back to Painter later. It's amazing what a bit of subconscious processing, or just restarting your computer, can do to help solve problems.

Ounce of Prevention Is Worth a Pound of Cure

As the saying goes, "An ounce of prevention is worth a pound of cure." By thorough preparation and organization, and by following the troubleshooting precautions covered here, you'll be able to minimize the amount of trouble you need to shoot. Just like a trained streetwise martial artist is much less likely to be picked on than a naive head-in-map tourist, a well-prepared, organized Painter artist is much less likely to run into problems than an unprepared, disorganized one.

Structure

However prepared you are, it is almost inevitable that, at some time, you'll get stuck or confused by something that happens (or doesn't happen) on your screen. I encourage you to take risks and experiment. That means inevitably that at some time you will try something and what you expect to happen won't happen. That may mean that you try to paint a brushstroke and nothing appears on your canvas, or you try to clear your canvas and something's left behind that you don't want. Whatever form trouble takes, there are some simple steps to sorting it out. That's where this section comes into play. I've divided this section into five topics:

Precautions

Brush or effect not working?

Painter display not looking right?

Tablet not working?

Crashes and launch errors

Under Precautions I suggest some simple things to do before you run into problems. Each of the other topics has a list of suggested actions. Follow these actions in sequence. After the first action, each subsequent step can be thought of as being prefaced by "if you still have a problem . . ." Some actions are repeated in different sections. Fortunately you'll find that 99 percent of problems are solved before you go through all the actions.

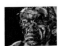

Precautions

1 *Close any nonessential applications.* As a general rule I suggest you close any other nonessential applications when working in Painter.

2 *Keep your system as clean and lean as possible.* Free up as much memory and hard drive space as possible.

3 *Reopen Painter with every new project.* Always start and quit Painter at the beginning and end of any project. This helps memory management and also allows you to conveniently use the background script to rescue unsaved artwork in the event of a computer crash (Chapter 10).

Troubleshooting Tips

Brush or Effect Not Working?

1 *Quit any other applications that are open.* If Painter is struggling for memory, it is worthwhile making sure you have no other applications running at the same time.

2 *Select a simple palette arrangement.* Make sure you can see the Tools, Property Bar, Brush Selector, Colors, and Layers palettes.

3 *Check which file you're working on.* Go to the Window drop-down menu and check which file (at the bottom of the menu) has a check by it. This is the file that is currently active. If it is not the file you thought you were working on, drag down to the file name of the file you want to work on. If there are any files open in Painter that you are not using and that are not needed as clone sources, close them. Make sure that Painter is active and that you haven't accidentally selected the Finder or another application.

4 *Check your tool.* Are you using the tool you thought you were? If painting, make sure the Brush tool is selected (shortcut "b").

5 *Check for selections.* Is there a current selection on the canvas? It's possible that you may have accidentally created a tiny selection by brushing the Lasso tool on the canvas inadvertently. If you don't want a selection, then deselect with Cmd/Ctrl-D to be sure.

6 *Check Brush Category, Variant, and settings.* Confirm the Brush Category and Variant. It may be that your variant settings have been changed. If in doubt, go to the Brushes palette and select Restore Default Variant from the pop-up menu.

7 *Check the Colors palette.* Look at the Main/Additional Color squares. What is the Main color? Make sure the Main color square (the foremost one) is selected. If in doubt, click on the Main color square. Are you painting white on white? Is the Clone Color icon in the Colors palette active? If so, do you want to be using Clone Color? If you are using Clone Color, reset the clone source in File > Clone Source (unless you want the current pattern to be a clone source, in which case just reselect the pattern in the Patterns section of the Art Materials palette).

8 *Check the brush Size in the Brush Property Bar.* How large is your current brush? Adjust the size if necessary.

9 *Check the Layers palette.* Carefully check what, if any, layers there are and which, if any, are selected in the Layers palette. One by one, go through all the layers and turn the eye of each one off so it disappears. Then reopen the eyes one at a time to make sure you know what each layer is. Now select what you want selected. If you do not want any layer or mask selected, click on the Canvas in the Layers section. Make sure any layer you want to affect has the padlock icon open. It's easy accidentally to lock a layer. Also check that the Preserve Transparency checkbox is unchecked. It is easy accidentally to check it or for it to be checked when you open Painter.

10 *Check for active Layer Masks in the Layers palette.* Check if any Layer Mask layer is selected. If you have an image layer selected, make sure the eye next to the image layer mask is closed.

11 *Quit out of Painter.* Quit out of Painter File > Quit. If you are frozen in Painter, you can try a forced quit out of the program. To force quit out of Painter for Macintosh OSX users, choose Option-Cmd-Esc. To force quit out of Painter for Windows users, choose Ctrl-Alt-Delete and select the Task Manager. The Task manager will let you quit a program that's not responding. Choose the Applications tab and select Painter in the Task list and click the End Task button. It might take a few moments to quit Painter. If that doesn't work, then choose Ctrl-Alt-Delete a second time to reboot your system.

12 *Restart the computer.* Restart your computer (Mac users choose Ctrl-Cmd-Start to force a restart on the Mac; Windows users hit the power button or the reboot button, depending on what computer you have).

13 *Consult Help Topics.* Within Painter select Help > Help Topics. This gives you an onscreen version of the User Guide. Look up the topic of concern. The Help Topics are very thorough.

14 *Contact Painter technical support.* Within Painter select Help > Tech Support for a summary of support options.

15 *Post a message on the Painter List, Painter Forum, or other online Painter community.* See the resources link from www.paintercreativity.com. Describe your system, the exact symptoms, and what you've tried as solutions.

Painter Display Not Looking Right?

1 *Change the color setting.* If you are using Windows and you see strange colors in the palettes, choose Start > Settings > Video Display (or similar) and change the color setting to 24-bit color or higher.

2 *Quit out of Painter.* Quit out of Painter File > Quit. Reopen Painter.

3 *Check all connections.* Check all connections between your monitor and your computer.

4 *Restart your computer.*

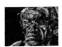

Tablet Not Working?

1 *Quit out of Painter.* Quit out of Painter File > Quit. Reopen Painter.

2 *Check the tablet Control Panel.* Open the tablet Control Panel. If the scaling is off, reset the scaling in the Control Panel.

3 *Restart the computer.*

4 *Install the latest driver.* Download the latest driver from the Web (Wacom users go to www.wacom.com). Install the latest driver and restart your computer.

5 *Contact tablet technical support.* Look in your tablet user guide or refer to the tablet manufacturer Web site for your local technical support contact information. Through the Wacom Web site (www.wacom.com), Wacom users can contact technical support, download the latest drivers, and access a Frequently Asked Questions Web page.

Crashes and Launch Errors

1 *Force a quit out of Painter.* If everything has frozen in Painter, then force a quit out of Painter (Cmd-Option-Esc on the Mac).

2 *Restart the computer.* If your whole computer is locked, then force a restart (Ctrl-Cmd-Esc on the Mac).

3 *Eliminate possible conflicts.* If you continue to have persistent crashes or see an error message come up every time you launch Painter (e.g., "Profile Processor Error: File not found"), try to eliminate possible software conflicts.

4 *Regularly clean up and defragment the hard drive.* Mac users should regularly run a program such as Symantec's Norton Utilities, or something similar, to defragment their hard drive.

5 *Windows disk maintenance.* Clean up and defragment your hard disks to keep your system healthy.

6 *Restore defaults.* Reset all Painter custom data to defaults by holding down the Shift key as you start Painter. This will destroy any custom variants you created, so be careful to back up your custom data first. See Chapter 3 for more information on this.

Appendix III
Keyboard Shortcuts

Here are a few of the default keyboard shortcuts that you might find handy. Remember that you can customize keyboard shortcuts for almost all menu items and commands in Painter through Corel Painter IX/Edit > Preferences > Customize Keys, in addition to which you can create your own short-cut buttons in a custom palette (Window > Custom Palettes > Add Command).

Tab	Hides/shows palettes
Cmd/Ctrl-O	Open file
Cmd/Ctrl-N	New file
Cmd/Ctrl-M	Mounts/unmounts your canvas on the screen
Cmd/Ctrl-0 (number zero, not letter "O")	Zoom to Fit
Cmd/Ctrl "l"	Zoom in
Cmd/Ctrl-"–"	Zoom out
Shift-Cmd-S/Shift-Ctrl-S	Save As

Spacebar held down when the Brush tool is selected turns the cursor into a Grabber Hand that you can use to reposition your canvas (by clicking and dragging on the canvas).

Shift-Option-Cmd/Shift-Alt-Ctrl when Brush tool selected allows you to click and drag within image to resize brush.

Shift-x	exchanges the Main and Additional colors
]	increases brush size
[decreases brush size
b	Brush tool
d	Dropper tool
Option/Alt	turns the Brush tool into the Dropper tool if Clone Color not active
Option/Alt	resets clone source start position if Clone Color active
r	Rectangular Selection tool
c	Crop tool
f	Layer Adjuster tool (useful when you are working with layers in a photo-collage)

The number keys adjust brush opacity (1 is the lowest, 0 is the highest).

Index

This index is designed to provide you with a convenient way to access and cross-reference specific subjects and concepts discussed in this book. It is not intended to be a comprehensive Corel Painter IX index. If you are looking for specific Painter-related topics and cannot find them in this index, then I recommend you look them up in the excellent Corel Painter IX User Manual (also available from the www.corel.com web site in PDF format).

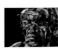

About Your Instructor

Portrait artist Jeremy Sutton, is the author of four books, two video training series, and two DVD tutorial sets. He has been a platform speaker at prestigious international conferences such as SIG-GRAPH and Macworld, and has presented Painter workshops, seminars, and demonstrations throughout the world, including in the U.S., Brazil, Israel, Italy, U.K., and Japan. Besides running his own workshops and classes, Jeremy, known for his lively, knowledgeable, and entertaining teaching style, has also taught on the faculty of institutes such as the Academy of Art College, San Francisco, and the American Film Institute, Los Angeles. Jeremy's articles, artwork, and tutorials have been featured in numerous international magazines including *Design Graphic World*, *EFX Art & Design*, *IdN*, and *Rangefinder*, to name a few. He is included in the Corel Painter Masters, a group of world-class Painter artists featured on the Corel web site. Jeremy's publications, besides this book, include the following:

Painter IX Simplified for Photographers, a 4-DVD tutorial set (PhotoVision, 2004)

Painter 8 Creativity: Digital Artist's Handbook (Focal Press, 2003)

Painter Creativity for Professional Portrait and Wedding Photographers, a 4-DVD tutorial set (PhotoVision, 2003)

Secrets of Award-Winning Digital Artists (Wiley, 2002)

Total Painter video series (Total Training, 1998)

Painter 4 video series (MacAcademy, 1996)

Fractal Design Painter Creative Techniques (Hayden Books, 1996)

Currently a resident of San Francisco, Jeremy was born in London in 1961 and has drawn since he was three years old. He has a degree in Physics from Oxford University, and studied art at the Ruskin School for Drawing and Fine Art, Oxford University, and at the Vrije Akademie, the Hague, in the Netherlands. Jeremy has specialized in painting portraits since the early 1980s and has shown his work in both solo and group shows. Jeremy was first introduced to using the computer as a fine art tool in 1991 and has been exploring the digital medium ever since. Today he paints commissioned portraits of individuals as well as family groups. Subjects who have sat for portraits by Jeremy include Willie L. Brown, Jr., former Speaker of the California State Assembly and former Mayor of San Francisco; Barry Bonds, the legendary baseball player with the San Francisco Giants; Giles Henderson, Master of Pembroke College, Oxford University; and Sir Richard Branson, the Founder and Chairman

of the Virgin Group of Companies. Jeremy's studio tool set includes a Macintosh G5 Duo computer, 20″ Apple Cinema Display, Wacom Intuos3 tablet, Epson Stylus Photo 2200 printer, and the Epson Stylus Pro 9600 wide format printer.

You can see samples of Jeremy's paintings at his art web site, jeremysutton.com. You can learn about his seminars and publications, see tutorials, follow useful links, purchase books, DVDs, Corel Painter IX, and Wacom tablets through his educational web site paintercreativity.com, the companion web site to this book. There are separate email lists you can sign up for on each site to be kept informed of new art shows (sign up on jeremysutton.com), publications and classes (sign up on paintercreativity.com).

To let Jeremy know any thoughts and comments you have regarding this book, suggestions for future editions, or discuss the purchase of a print or commission of a portrait, please contact Jeremy via e-mail at jeremy@paintercreativity.com or call him at (415) 626-3971.

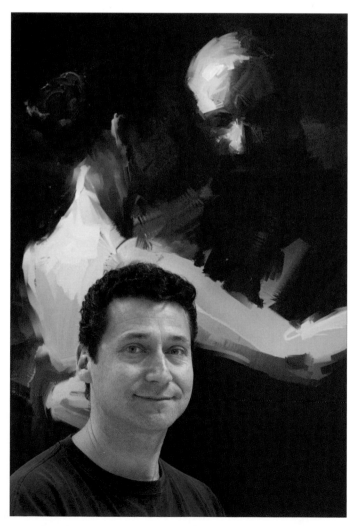

Photograph by Ken Forcier. Shows Jeremy in front of his painting 'Moment in Time.'

Contributors

Thank you to everyone who has contributed to this book, whether by sharing with me their artwork, resources and insights, or by being portrait models, or by inspiring me with their words. Listed here, alphabetically by last name, are those who have kindly given permission for reproduction of their artwork, words and/or photographs in this book, and/or inclusion of their custom brushes or color sets on the Painter Creativity Companion Resource CD.

Gisele Bonds
Positive Images
Oakland, California
(510) 832-3686
PImages@aol.com
www.positiveimages-portraits.com
Figure 11.12 (page 361)

Darrell Chitty
Heritage Portraits
Bossier City, Louisiana
(318) 741-1141
dchitty@networktel.net
Figures 12.1–11 (pages 374–8)

John Derry
Overland Park, Kansas
derry@PIXLART.com
www.pixlart.com
Foreword and Figure 5.110 (page 234)

Julie Douglass
Torrance, California
(310) 370-8001
jvdouglass@aol.com
Figure 4.16 (page106)

Fuzzy Duenkel
West Bend, WI
(262) 338-2779
fuzzy@duenkel.com
www.duenkel.com
Figures 4.101–5 (pages167–70)

Scott Dupras
Lemon's Studio
Marquette, Michigan
(906) 228-9636
duprasinc@aol.com
Figures 4.106–10 (pages 170–3), *Scott's fuzzyflury2* and other custom brushes

Lisa Evans
Lisa Evans Portrait Design
Lafayette, California
(925) 284-3777
lisaevansart@aol.com
Photograph used for front cover image *Quinn Between*, Figure 4.98 (pages 165–6), subject, with Quinn, for *Precious* (pages 143–4 and page 277)

Ken Forcier
MB Historic Decor
San Francisco, California
(415) 695-1480
ken@mbhistoricdecor.com
www.mbhistoricdecor.com
Author photo (page 426 and back cover)

Myra Gordon
Laguna Beach, CA
(949) 497-9301
sklar1@cox.net
Figures 4.111–3 (pages 174–6)

Sam Gray
Raleigh, North Carolina
(919) 781-7501
samgray@samgrayportraits.com
www.samgrayportraits.com
Figures 4.114–8 (pages 174, 177–8)

Bill Hall
Cedar Hill, Texas
(972) 291-0347
bill@billlhall.com
www.billhall.com
Figures 12.12–28 (pages 378–86)

Ron Kempke
Urbana, Illinois
rkempke@precisiongraphics.com
Ron's Old Master Mix custom color set

Denise Laurent
London, UK
den@imagine.co.uk
www.imagine.co.uk
Den's Oil Funky Chunky (one of my all time favorites, mentioned on pages 305 and 309) and other custom brushes (plus help with the *paintercreativity.com* companion web site)

Susan LeVan
LeVan/Barbee Studio
Kingston, Washington
(360) 297-3836
lvbwa@earthlink.net
www.bruckandmoss.com
LeVan's Lively Favorites and *LeVan's Lively Mix* custom color sets

Rheba K. Mitchell
Lampasas, Texas
rkm@starband.net
www.lair-wildscape.com
Rheba's Lair Wildflowers and *Rheba's Mix* custom color sets (plus helping test and prepare the Painter Creativity Companion Resource CD)

Jolyn Montgomery
Portola Valley, California
(650) 851-2510
jolyn@mm-photography.com
www.mm-photography.com
Figures 4.119–20 (page 179)

Richard Noble
Eagle, Idaho
(208) 429-1802
rnoble@mac.com
www.nobledesign.com
Figures 12.29–36 (pages 386–91)

Tana Powell
San Francisco, California
(415) 759-6453
artana@concentric.net
Figures 12.37–45 (pages 391–6)

Paulo Roberto Purim
Curitiba, Paraná, Brazil
(011) 55 41 676 1231
paulo@brabo.ppg.br
www.brabo.ppg.br/en
Paulo's Goodbrush custom brush

Sherron Sheppard
Ventura, California
(805) 647-4121
sheppardphotography@adelphia.net
www.sheppardphotography.com
Figures 4.121–6 (pages 180–1), *Sherron's Blender Wood* custom brush, and *Sherron's Skin-Color* custom color sets

David Taylor
Taylor & Roger's of Kailua
Kailua, Hawaii
(808) 261-0381
info@photokailua.com
www.photokailua.com
Source photograph for *Ballerina*, Figure 4.42 (page 125)

Paul Tumason
Tumason Portraits
San Jose, California
(408) 286-7285
ptumason@earthlink.net
www.tumasonportraits.com
Figures 4.127–9 (pages 181–3)

Mark Zimmer
Aptos, California
mzimmer@apple.com
Figure 5.111 (pages 233–4)

CONTRIBUTORS